DESIGNING
INTERACTIVE
WEB SITES

DESIGNING INTERACTIVE WEB SITES

James L. Mohler and Jon M. Duff

Delmar
Thomson Learning™

Africa • Australia • Canada • Denmark • Japan • Mexico
New Zealand • Philippines • Puerto Rico • Singapore
Spain • United Kingdom • United States

NOTICE TO THE READER

Delmar Staff:
Publisher: Alar Elken
Acquisitions Editor: Tom Schin
Editorial Assistant: Fionnuala McAvey
Executive Marketing Manager: Maura Theriault
Channel Manager: Mona Caron
Production Manager: Larry Main
Art/Design Coordinator: Nicole Reamer
Cover Design: Michael Prinzo

For more information, contact Delmar, 3 Columbia Circle, PO Box 15015, Albany, NY 12212-0515; or find us on the World Wide Web at http://www.delmar.com

Library of Congress Cataloging-in-Publication Data

Mohler, James L.
 Designing interactive Web sites / James L. Mohler and Jon M. Duff.
 p. cm.
 Includes index.
 ISBN 0-7668-1485-8
 1. Web sites—Design. 2. Web publishing. 3. Interactive multimedia. I. Duff, Jon M., 1948- . II. Title.
 TK5105.888.M58 1999
 005.7'2—dc21
 99-38061
 CIP

WITHDRAWN

Contents

PART TWO
WEB PAGE DESIGN WITH TABLES

Chapter 7 Using the HTML <TABLE> Structure85

PART FOUR
ADVANCED GRAPHIC TECHNIQUES

Chapter 20 Using Layered Web Pages and Other Effects271

PART FIVE
MULTIMEDIA TECHNIQUES

Chapter 21 Training the Page to Speak281

Preface

Welcome to *Designing Interactive Web Sites.* The success of our first book, *Graphics and Web Page Design,* has prompted many of our readers to ask for more on the subject of making graphics for Web pages. To those of you who have sent us e-mails with your thoughts and suggestions, we thank you. Your input is essential to our growth and the success of these books, and others in the future.

When we began work on the first book, the use of tables, frames, and multimedia was in its infancy. These three topics are, just a few short months later, necessary parts of any Web designer's technical tool kit. Recognizing the dynamic nature of Web communications, browser manufacturers have responded with even greater power included right in their products, so that today's Web designer has even greater range of tools available than are provided in the Hypertext Markup Language (HTML) standard—style sheets and layers—just to name two.

If you had a chance to use our beginning book, you are no doubt ready for the advanced topics covered in the pages that follow. If you began designing pages after reading any of the other fine texts currently on the market, or after hammering out your own Web pages by the sheer force of your own design experience and an ability to slug through HTML code, welcome! You will find that we approach this topic from a decidedly graphic direction, yet with an appreciation for the technology that makes it all happen. Not a techno-nerd approach, and not an art approach. We think, and we hope you will think, that it is an approach that is just right.

One thing you will notice about our approach is that we do not rely on products like PageMill or FrontPage. It is not that these tools do not do a good job—they do. It is just that we find them too limiting, too predictable in the pages that are made with them. Additionally, they have a tendency to introduce extraneous HTML code, recognized by their own preview browser but not by commercial browsers. We find this unnecessary and even harmful, both in learning Web page design, and when delivering (and maintaining) commercial Web sites. Realistically, you will use a WYSIWYG page editor sometime in the future. It is just not the way to first learn how pages are designed, structured, and delivered. When you do use such a product, you will approach the tool from a position of knowledge, and not out of helplessness.

Who Should Read This Book

We hope no one simply reads this book. If we have done our job, you will read, try, read, and try some more. You will flip through the pages, looking for examples that trigger your own creative ideas. You will try the code in the listings and hopefully, improve on it as you fine-tune it for your own needs.

Web communication is a huge industry, potentially monumental in its scope and impact. Because the field is so new, the first graduates of programs designed specifically to prepare Web designers are just now hitting the job market. Still, many of you will begin your Web careers from diverse fields and it is mostly to you that this book is directed.

This book is directed to:

• Teachers and students of electronic publishing and communications. You will find the questions and answers at the end of each chapter an invaluable teaching

and learning tool. This book, and its predecessor, can become helpful additions to your developing curricula.

• Art directors and communications managers. Although you may never create Web pages yourself, the knowledge gained from this book will be your "guide on the side" as you contract and evaluate work for the Web.

• Technical writers and communicators. More and more of your work must be done for multimode distribution: traditional paper publications, portable documents, and Web communications. The paradigm for publications will be "distribute and print" as opposed to "print and distribute." You will find hundreds of pointers to make your documents more effective.

• Web page designers and Web artists. You need the best tools and brightest ideas to give you the edge in a highly competitive field. In these pages you will find examples, hints, tips, and tasks that will start and keep your creative juices flowing.

• Web masters and Internet service providers. You need the big picture of Web page and site design—especially in terms of file formats and multimedia. We will show you what they are.

What This Book Contains

Most of the introductory graphics and design concepts covered in *Graphics and Web Page Design* have not been repeated in this volume. We have, however, expanded several topics such as color and palette management, file formats, and structural design that were covered in the first book, but this time, discussing each topic—not from the point of a beginner—but from the vantage of someone who has tried the technique, and has questions as to how to make it better.

This book also contains more in-depth discussion on the actual production of Web publications, from planning the pages to selecting an Internet Service Provider (ISP).

We have tried to anticipate your questions, and even the questions that the answers might pose.

This book is organized into five sections. By no means are they intended to be read and practiced in order. We suggest that you skim the Table of Contents to familiarize yourself with the topics and jump in where you have the most immediate interest and need.

As an overview *Designing Interactive Web Sites* contains:

• Part One: Before You Crank That Code or Push Those Pixels... These six chapters introduce much of the content that is presented in the rest of the book. The general approach is "Okay, you can make Web pages, but how can you take your design and its effectiveness to the next level?" We will look at the production process, the potential of multimedia, importance of content, and significance of audience analysis. We will also discuss the client-server relationship in Web communications and what that means to you as a Web designer. For those who require a review of HTML, or are using this book as a starting point in Web communications, the final chapter of this section contains an HTML primer.

• Part Two: Web Page Design with Tables. The six chapters in this section get at the heart of powerful design of interactive Web pages. You will see how the HTML TABLE structure provides the control for you to design pages any shape, any form, any way you want. We will give you help on text, graphics, and multimedia in tables. You will develop a systematic method of analyzing existing print publication structure so your Web pages can have a more finished, polished look.

• Part Three: Page Design with Frames. The three chapters in this section form the basis for changing how you divide your browser window into information areas. As we did with the TABLE structure, you will quickly learn the FRAMESET commands that let you organize your Web page into dynamic, responsive links to HTML documents and content. You will see how tables and frames work together, and how to use frames to your greatest advantage.

• Part Four: Advanced Graphic Techniques. The five chapters in this section demonstrate topics such as using vector graphics on your Web pages and this graphic format's strengths and limitations. You will become more familiar with bitmap graphics and how to manage images of multiple resolutions and sizes. The importance of color management, color depth reduction, and browser-savvy color palettes are all topics you will find in this part.

• Part Five: Multimedia Techniques. Nothing makes a Web page more distinctive than multimedia, and this section covers audio, animation, video, integration, and plug-in issues. You will see how interactive pages can be built using the full range of tools available today—HTML, tables, frames, JavaScript—as well as tools like Flash and Shockwave.

What You Need to Make Interactive Pages

In order to make Web pages that really stand out, you need two things: great design and killer content. Some of the content you will have no control over. But design and visual, auditory, and interactive content are your domain, and to get the best results, you will need the best equipment. We have put together a list of equipment that you will need to get the most out of this book, and your own design abilities.

Note: The equipment listed here is simply a suggestion. It is probably best to start simple and add to your Web workshop as you need. Consider renting specialized equipment or contracting for specialized services. Purchasing equipment that is obsolete in two years is the surest way to bankruptcy. Better yet, barter services and equipment with other professionals in your area. Get active! Go to local users' meetings.

If you are a Windows shop, go to UNIX users' group meetings. Hook up!

• Multiple browsers and multiple platforms. You cannot develop true Internet Web pages without previewing your pages on just about every anticipated browser and platform. You should have Netscape and Internet Explorer (current and several past versions), along with the common ISP browsers from the likes of America OnLine and Compuserve.

• A capable raster editor. Whether you use Photoshop, Live Image, Fractal Painter, Xres, or some other product, you need access to 24-bit RGB images and the ability to output 24-bit Joint Photographic Experts Group (JPG) and 8-bit Graphic Interchange Format (GIF) images.

• Debabilizer. There are several graphics utilities out there, but if you are serious about Web graphics, this is the product to have. Debabilizer will solve many of your color reduction, matching, and conversion problems.

• A suite of graphics utilities. You will want to create interlaced, transparent, and animated GIFs as well as progressive JPGs. You will want to easily select colors by their hexadecimal value.

• A capable modeler, renderer, and animator. There are several low-level products on the market like Simply 3D, but you will soon want more. Consider 3D Studio for the PC or Strata Studio Pro for the Mac.

• High-quality scanning equipment. You will need a 24-bit flat bed color scanner. Some come with a raster editor so you may be able to check off two things here.

• Good quality video capture equipment. The higher quality the original video, the better it will look when you reduce the frame rate and color depth, and hit it with the compression necessary for streaming broadcast on the Web. SVHS or Beta camcorders are fine that record to ½″ tape.

• Flexible video editing software. Once you have the video, you will need to output it in three formats: Video for Windows (AVI), Motion Picture Experts Group

(MPEG), and QuickTime (MOV). Adobe Premier is a favorite and is multiplatform.

- Fair quality audio equipment. Unless your Web site's entire purpose is to deliver 44 MHz streaming stereo music, you can get by with a lot less. Mostly, you will want to convert clips from CD to digital sound, 22 MHz stereo or 11 MHz mono.

The Web As a Dynamic Marketplace

The Web is not static—it changes almost daily. We have tried to bring you current information that you can use right now, to help you be more productive. We have touched on several emerging techniques and issues to help you become aware of what will be available in as short a time frame as several months. We acknowledge that some examples listed in this book may be inactive or changed by the time you read this. We had to update resources between the time we finished writing and final editing—such is the nature of the Web. We hope that the Web's dynamic nature is as intriguing and challenging for you, as it is for us.

Acknowledgments

The authors and the publisher would like to thank the following reviewers:

David Oscarson
Brevard Community College
Melborne, FL

Diana Sphar
Texas State Technical College
Waco, TX

Elizabeth Bennett
University of Alaska SE
Juneau, AK

John Berwick
SUNY Cobleskill
Cobleskill, NY

Dan Leighton
Clinton Community College
Clinton, IA

Meg Otto
Sanford Brown College
Hazelwood, MO

Rich Sumner
Platt College
Cerritos, CA

PART ONE

BEFORE YOU CRANK THAT CODE OR PUSH THOSE PIXELS...

CHAPTER 1

Taking Web Page Design to the Next Level

Today the Web is quickly becoming the communication medium of choice for many people. Ask professionals from a range of varying disciplines to research a particular topic or find out information on a new fangled device and likely their first response is to log onto the Web.

It is amazing that we are evolving from a society that thrives on vaults of traditionally published works (libraries) to one that depends on the virtual and almost limitless expanse of information on the Web. The computer on your desk has the potential of accessing many thousands of resources worldwide. The Web, as was its purpose, is quickly becoming a massive resource of information to which anyone can connect or from which anyone can receive.

The advantages of the Web are numerous, the two primary being time independence and spatial independence. How many of us have gone to the library to check out a book only to find the library closed, or the book checked out?

Yet, this is not the case on the Web. Web materials are unique in that they are time-independent. They are accessible 24 hours a day, 7 days a week, assuming the server on which the materials reside is running and not overworked.

However, what is even worse than the closed library scenario is that often the book or materials for which we are looking are in the hands of someone else, or that the particular library does not have those materials. Again, the Web excels in that an individual has access to materials in not only one "virtual library" but also all the libraries of information in that city, county, state, nation, and the world. In addition, there are not a finite number of copies of the resource. Multiple people in multiple locations can access and utilize a single online resource. Connecting your desktop to the World Wide Web expands your information reception capability by connecting you to thousands of resources simultaneously.

In this book, we will not spend a lot of time talking about the advantages of the Web. It is assumed since you are reading this book that you already know how powerful the Web is. Yet, we will look in-depth at the current technological possibilities, the current state of Web content, and how to create Web-based materials that sizzle. We will also include discussions concerning the many limitations of Web delivery and how you can conscientiously design around them.

Note: *You will find that much of the discussion concerning the Web is moving away from "why we should use the Web" and on to "how to best use the Web." This is the main concern today: How can you effectively and efficiently use the Web to communicate your message?*

Undoubtedly you have probably surfed the Web and seen both pages that communicate well and pages that did not communicate well. In this chapter, we are going to take a look at the state of the Web today. What is being done on effective Web pages? In this mass of information, how can you make your pages and sites stand out among the crowd? How can you get the reward of all rewards (a bookmark)? To begin answering these questions, we must begin with a look at the genré of the Web today.

OBJECTIVES

In this chapter, you will:

• Look at trends found in Web page design and how the public at-large judges effective Web delivery.

• Analyze the general qualities of pages and sites that communicate effectively.

• Learn how to analyze your audience, content, and graphics to create a communicative balance in your pages.

• Understand the various software tools that can be used to aid in developing HTML code for Web pages.

• Analyze Web design tools such as graphic editors and other accessories.

• Look at the overall process of developing a Web site.

Understand Today's Web Pages

One of the things all designers understand while striving to create ingenious and creative Web pages is that this entire process is a grand experiment. Never before have we had a communication medium that could be so easily used worldwide by so many people.

Much of what is being published on the Web is exploratory in nature, and much of the public's evaluation of a site is based on real world use and not on empirical

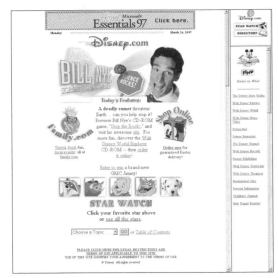

Figure 1.1 An example of a digital publication (http://www.disney.com).

data or research findings. Those things that make an effective Web page are based on utilitarian ideals more than on research describing what works and what does not work. Let us face it, we really have not had time to do lengthy research studies on the best means of designing or delivering Web media as of yet. However, we can adapt many of the things we have learned about traditional media and CD-ROM multimedia to this new medium as well as use some common sense as design rules. Much of what is being published on the Web is experimental. Above all else, you will find that the Web is a natural place for fluid experimentation to occur.

Note: One factor we must note about Web media is that, like other publishing media, there are responsibilities that come with publishing authority. What you print, publish, or push over a public network can come back to haunt you. You are responsible for what is published on your Web pages, and even e-mails and newsgroup postings. The same legalities concerning defamatory and libelous statements in a traditional document also apply to digitally "published" information. If you would not print something in a public

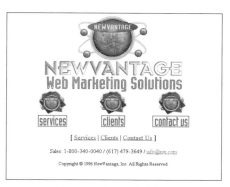

Figure 1.2 An example of a digitized publication
(http://www.nvi.com/default.html).

document, do not publish it electronically either. The same laws apply to both traditional and electronic publishing.

Look at Current Design Trends

At first glance, the Web is quite an impressive place. Likely the first wave you catch in cyberspace is exciting and exhilarating. Most people are just excited about getting online, let alone using the information they stumble on. However, over time you begin to get an idea of what the Web is all about, as well as an idea of what works and what does not work.

In general, Web sites fall into two major categories: digital publications and digitized publications. This may sound confusing but the distinction is important. Digital publications are those which are designed around the positives of the Web. They are interactive and nonlinear. They are aesthetically pleasing and define a "Web genré." Sometimes they include multimedia elements, but they do not have to. Ultimately, they communicate very effectively and utilize the media efficiently. Figure 1.1 shows an example of an effective Web site making use of visual appeal and obvious navigation.

Opposite digital publications are digitized publications. Figure 1.2 shows an example of a digitized publication. Digitized pages often look good, as does Figure 1.2;

however, often they do not present depth in the medium. Often interactivity is lacking and the structure of content is quite poor. As their name indicates, digitized documents are basically a digitized version of a traditional document and provide very little uniqueness from a traditional method of publication. To the extreme, it is little more than linear pages of information that can be browsed on the Web.

Note: In the static images found in Figures 1.1 and 1.2, it may be difficult to tell the difference between a digital and digitized document. I suggest taking a little time to check out these two sites to see the difference. The biggest difference lies in interactivity, document design, and use of the media.

Even though a lot of what is being created and distributed on the Web is experimental, there are several things or key attributes that contribute to effective and efficient Web page delivery. These attributes include communicative value, appropriateness for the audience, visual appeal, utilitarian design, interactivity, and multimedia elements. It is the collaborative effectiveness in these areas that makes a Web page or site successful. If any of these elements is weak, more than likely the Web site will not be a successful venture.

Communication

The first and foremost mission of the Web is communication. From its very beginnings, the Web was conceptualized as a mass of computerized information resources where communication could occur from one person to another, universally and without regard to protocol or platform. To some extent, it has met this mission. Yet, as Web page designers, we often forget that the main mission of what we are doing is communicating. Whether it be to inform, educate, persuade, or entertain, a message is being communicated from us to our audience. Anything that hinders the message is contrary to your overall mission.

Note: One of the factors you must address, whether you are communicating via the Web, a brochure, or a lecture is

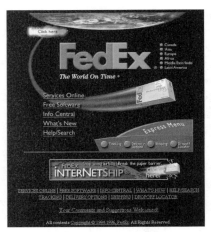

Figure 1.3 Using design to enhance the message
(http://www.fedex.com).

the idea of noise. Noise is anything in the communication process that distracts the receiver from your message. On the Web, noise is exhibited through poor or misguided design, unrelated graphics, animations, or video, gaudy colors, and hard-to-read fonts. Also realize that it is not just the aesthetic design concerns that can hinder your message. A page that takes 10 minutes to download will also impede your message. There are many aesthetic and technical qualities that can contribute to misinterpreted or ignored messages portrayed in Web materials.

One of the foremost things that Web designers must accomplish is a means of satisfying all of the other attributes of effective Web design and delivery (audience centered, visually appealing, utilitarian, etc.) without allowing the means to those items to get in the way of the message. Too often, designers create aesthetically pleasing designs, only to find that they do not contribute to the message or audience, or both. Design can significantly aid in delivering a message, as shown in Figure 1.3, but the design should not overshadow or confuse the message. Alternatively, it should aid in delivering the message.

Much like design elements, it is often tempting to use advanced media elements such as video, audio, or animation without first considering whether it significantly contributes to the message or whether it is advantageous for the audience. Many a Web page is filled with all sorts of dancing and animated elements that really communicate very little. Integrating animations or other graphical elements into a Web page for the sake of doing so adds little. Above all other visual aspects or effects, communication is the most important aspect of the Web page or site. All the other attributes should support, reinforce, or complement the message being conveyed to be effective.

Audience Centered

One of the ways to ensure that your Web pages communicate effectively is by sincerely looking at your audience. Not only should you look at your message but also at who the audience is and how to best communicate the message to them. Take a look at why they are coming to your site and what they are looking for. What will satisfy most of their needs or reasons for coming to your site, and what is the best way to present the message or content to them? These are only a few of the questions that should arise as you are developing both the content and the pages for your site. Nonetheless, looking at the audience is vitally important to determine the look of your pages as well as what content is delivered and how it is delivered.

Let us take a look at several examples to see how important the audience really is. Let us say you are designing a page for kids. How can you guarantee that kids will enjoy the site as well as be able to navigate through it? Figure 1.4 displays a sample of a Web site designed for kids. Notice large pictorial-type buttons. Undoubtedly, this would appeal to kids (of all ages)!

Yet, your audience may not be kids and thus may demand a different look for your site. Ultimately, your target audience must be considered when you are designing the look for your Web site. As the audience changes, so does the means for appealing to them. Figure 1.5 displays an example of a Web site with a completely different audience than the previous example. It is important that the design not only support your content but also your intended audience.

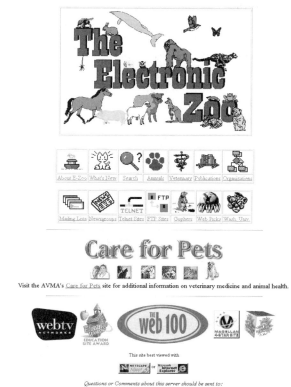

Figure 1.4 Designing around the audience ensures a more successful site (http://netvet.wustl.edu/e-zoo.htm).

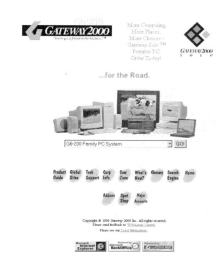

Figure 1.5 The style of your pages will depend on the intended audience (http://www.gw2k.com).

No matter your target audience, you must make sure that you target them within this entire process. Whether you are creating graphics, designing the page, or laying out the content, you must begin with the end user in mind.

Visual Appeal

Often in mixed professional circles, the artist, graphics specialist, or "visual person," if you will, is viewed as a dif-ferent breed—marching to the beat of a different drummer. Over time, and mostly due to conditioning, people have viewed the arts as lesser or different in some way, seeing it as more of a hand or psychomotor skill than of the mind or thought skill. But it is amazing to see the sudden change of attitude as many of the communication media now utilize and require graphic skills to be effectively created. This paradigm shift is rapidly changing the demand for individuals proficient in graphics.

One of the most important aspects of the Web is undoubtedly the visual component, and yes, these skills can be acquired. It requires learning what makes good graphic composition, what makes an effective graphic, and what the appropriate time is to use those graphics. In a nutshell, this is what composes the thought process of the applied computer graphics artist.

Yet, artistry on the computer also requires as much technical prowess as it does aesthetic prowess. From bit depth, to dpi, to kilobytes per second, it is important to understand the underlying technological components that affect computer graphics delivery over the Web.

Figure 1.6 Visual appeal is a result of effectively designed and implemented graphics (http://www.mrshowbiz.com).

The predominance of this book focuses on these two issues concerning graphics: aesthetics and technology. Realize that effective Web pages utilize graphics. And the graphics and other media elements are what distinguish a Web page from other digital communication media. Without graphics, sounds, animations, and videos, the Web would be nothing more than a glorified Gopher menu. It is the graphics that make the Web a more powerful communication medium than Gopher or other previous technologies ever envisioned.

It can be said that visual appeal is predominantly affected by the graphics that are embedded within Web pages. Visual appeal includes graphics elements used for navigation, eyeflow, and content. These are the main uses of graphics in Web pages. Throughout this book you will see a myriad of examples, such as shown in Figure 1.6, as well as lengthy discussions about the aesthetic and technological issues surrounding effective graphical Web pages.

Utilitarian Design

Besides the graphical elements that fill the pages at your site you must also be concerned with how your pages will be used. Never design a Web site without considering a customer-centered approach or how many clicks it takes to get to what the user is looking for. Consider the main objective of your site and pages and determine the best means of providing what the user wants.

Note: I do not know how many times I have accessed a computer software vendor's page, looking for an update or piece of software to download, and had to search for 15 to 20 minutes to find what I was looking for. If this is your niche or the goal of your site, present what they need when they need it plainly to the user. In these software sites I usually find what I came for but it is frustrating to have to search for the "download" link.

One design decision that you can use to make your site more utilitarian is to list or define objectives for your site. Generally, these short statements define the main goals of having a Web site at all. Almost all Web sites begin with a planning stage in which the involved individuals

Figure 1.7 The interactive structure of a site, in addition to the graphics, contributes to the effectiveness of the site (http://www.softimage.com).

begin by listing objectives for the site as well as a brief abstract describing the site. These two elements help tremendously when deciding what will be included at your site and how it will be integrated into the overall mix of pages.

TIP: *No matter what your purpose, always design around the audience. Consider what they want and then present it precisely when they need it. If they are coming to your site for something specific, do not require them to dig for 15 minutes to find it. Present it plainly on the first page of your site.*

Interactivity

A key element of materials found on the Web is the ability to interact with the information. Unlike traditional documents, a person using the Web can choose where he wants to go and does not have to digest information in a linear fashion. Realize that the Web is much more than traditional linear documents in digital form on the computer.

One of the keys to effective interactive products, and therefore effective Web documents, is nonsequential design. By designing information (and the subsequent pages that deliver that information) nonlinearly, the end user is presented with many different choices for navigation. Navigation through a Web site's information must be designed so that it occurs logically, clearly, and con-

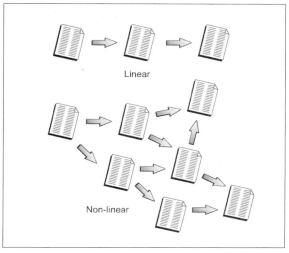

Figure 1.8 Linear versus nonlinear design.

cisely. Figure 1.7 shows a Web site that was designed with effective navigation in mind. You will note that the graphics are effective and the structure on the left promotes interactivity.

Note: *The biggest difficulty people have with developing interactive communication media is breaking out of linear thinking. We are so used to creating linear documents, such as brochures and books (like this one), that it can sometimes be difficult to arrange information nonsequentially. Breaking this habit is probably more difficult than creating the most complex graphical Web page. The design of the information in your site is as important as the graphics and media elements you choose to place in them. Nonsequential thinking is required to produce tools that utilize any nonsequential schemata. Interactive design requires nonlinear thinking.*

The real difference the Web makes in communication is not so much in the ability of using multiple media but in the method of communication and it is really a function of the computer. With today's Web, the real power is not really all the glitzy graphics, animations, or video, although they are pretty cool too. The real advantage of the Web is the ability to nonsequentially access and present information as shown in Figure 1.8.

Nonlinear structure allows the site to be user centered, allowing choice of where to go. This is where interactive design—the design of navigating information—is important. You will find that many of the sites deemed as exceptional will exhibit interactive design that is logical and easy to navigate. In chapter 2, "Raising the Web to the Second Power," you will take a closer look at interactive design and how it can be used to create a more effective Web site.

Multimedia Elements

The last (but not least) attribute found in most successful Web sites is the use of multimedia elements. Most often, these include small animations, sounds, and video clips that contribute to the information being delivered on the Web. However, it must be noted that the Web itself does not support the same capacity of high bandwidth media elements as is found in CD-ROM multimedia products. Often, new designers believe that the Web is a complete multimedia environment that can be used to deliver large portions of video, CD-quality audio, and full screen graphic elements. In reality, nothing could be further from the truth. Although these types of multimedia elements would be nice, the Web cannot support them today due to bandwidth restrictions. In chapter 3, "Designing for Effective Content and Efficient Delivery," we will take a closer look at what your realistic expectations should be concerning multimedia elements on the Web.

Realize at this point that multimedia elements can be used on the Web, but in a limited fashion. Often pages integrate too many multimedia elements, which consequently frustrate the user and cause them to dodge the site. When it comes to integrating animation, video, or audio on your Web pages, conservatism is key. Yet it does not mean you should not incorporate them. You just need to be conscientious about how you do it.

Look at What Makes Great Content

Since much of what is published on the Web extensively utilizes text, it is important that the writing and the writing style support the information being presented at the site or on the page. Undoubtedly you have probably surfed the Web and, like graphics, found pages that were well written and poorly written. It is important that you write well if you plan to create effective pages.

Note: One of the things to keep in mind is that many people acknowledge that reading large segments of text on the computer is quite difficult. In fact, many prefer to print out Web pages before they actually sit down and digest them. You may want to test your pages to ensure they print correctly. Often background colors or extensive graphics may prevent people from printing your pages at all.

One design tip that you can use to increase the readability of your pages is to use short bursts of text. On the computer, breaking information into segments of text makes it easier on the reader. It has been found that people respond to short bursts of information more readily than they do long pages of information.

Breaking up the text-based information you provide can be done in three basic ways. These include balancing the amount of graphics and text you provide, centering the text you provide on the audience through stylizing, and designing a logical flow in your writing. In the next couple of sections, you will take a closer look at these three aspects.

Balance of Content and Graphics

Undoubtedly, graphics play a very important role in Web materials. It is the fact that the Web is a graphical environment that makes it unique and more appealing than other Internet-based information services.

Yet, though graphics are important, the text presented at your site is equally important. Poorly written content

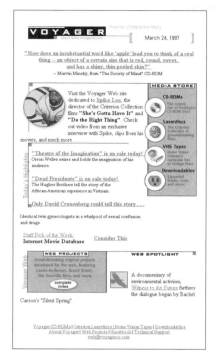

Figure 1.9 Successful sites have a good balance of well-written text and exceptional graphics (http://www.voyagerco.com).

can never be masked. No matter what the design or how many slick graphics, dancing bullets, or animated elements are added, the writing is still poor. It is like dressing up the exterior or interior of a house with a cracked foundation with the intent of selling it. It will not sell because the footing on which everything else rests is unstable.

The same is true of poor writing. Graphics will only carry communication so far. Successful sites, such as the one shown in Figure 1.9, have a good balance of well-written text and exceptional graphics.

Note: *I would like to carry the house analogy a little further. Information communicated via text at your site is the foundation from which communication occurs and to which all supporting elements enhance and clarify. The graphics and other media elements are the anchor bolts that connect foundation with the purpose of communicating. Just as in real life, if the foundation (content) is weak, the structure will fail. If the anchor bolts (graphics and media elements) are weak, then again the structure will fail. In addition, the structure cannot survive at all without a foundation as well as anchor bolts.*

Audience-Centered Writing

One of the most difficult tasks when publishing on the Web is relating content to your audience. To make the text that you present interesting, you have to relate it to your audience. With a worldwide audience on the Web, this is somewhat tricky. Yet, by looking at the people you most want to visit your site, you can develop an idea of who the typical reader is and how to write to them best.

As you are writing text, in addition to breaking ideas into digestible chunks, you can also ensure success by following some simple rules. Many of these are logical and should be obvious, however, seeing some of the pages floating in cyberspace, mentioning them here will not hurt anything.

You can make your pages better written when you:

• Look at your audience to determine age, background, skill level, and language level. This well help you determine what level or style of writing is best used in your Web pages.

• Create a list or outline of the text you want to present. In this outline, bullet the main points you wish to present. Then use it as you are writing to keep yourself on track.

• As you are writing, strive to write with as few words as possible. Avoid lengthy discussions or wordy phrases that add little communicative value to the issue at hand. Remember: short bursts of information, not a digital novel.

• Once you have written your text, read it aloud to yourself, both for spelling and grammatical errors. Avoid

technical or other types of slang. Doing so will help you communicate better. Also analyze the tone in which you are writing. Often we communicate with a sarcastic or offending tone unintentionally. Sometimes, reading a message several hours later shows that we did not communicate as effectively as we had hoped.

• After reading it aloud, use a spell checker as well as a grammar check. This will ensure that your writing is professional and error-free.

The points discussed here are really statements of the obvious, but you will find that successful writers would agree that most problems arise because of errors at this base level.

Task: Analyzing Content, Graphics, and Audience

One of the most difficult things for people to do is to determine the most effective places for graphics in their Web documents. Often a specialized individual called a graphics specialist will work with an information architect to determine the most effective places to use graphics. Nonetheless, this task is accomplished by analyzing the content and audience versus the uses for graphics. Look at the content and determine if a graphic will:

• Enhance, complement, and supplement content that cannot be adequately described or explained with text.

• Present a navigational item such as a button, button bar, or icon to allow the user to navigate your site.

• Aid in creating a visual flow directing the eye through the information by using directional, helper, or "filler" graphics.

Keep in mind that:

• Graphics used for content purposes should always aid in communication. Graphics used this way should always display something that cannot be adequately communicated with text or to add more clarity to the text.

• Graphics should never overshadow or distract the audience from what you are presenting.

• Graphics should contribute to the overall tone of the site. Graphics at a site for business professionals should contribute to a professional tone or look.

• The audience's impression of your graphics will not only be based on what is being shown in the graphic, but also on its size, placement, and orientation.

• Graphics displayed on a page must be designed around the audience's browser, platform, and machine.

Understand Web Design Application Programs

Today's Web has grown to be much more than what Ted Nelson (who defined hypertext and hypermedia) and Tim Berners-Lee (visualist of a Web communication system) could have ever imagined. The Web we have at our fingertips is capable of not only delivering graphics and text, but also video, sound, animation in limited quantities, as well as an entire range of other digital files that impact the communication process.

Currently, we are seeing the emergence of tools that enable almost everyone to publish materials on the World Wide Web. These tools range in complexity, capability, and price. However, they are all designed at making the Web a usable medium for everyone. Some tools require knowledge of HTML while others draw on experience with other applications such as word processors and spreadsheets.

For many, learning HTML is not a desirable task. For those who fit this category, there are many commercial and shareware tools that can be used in creating content for Web delivery. These tools range from simple assistants that allow a digital document to be converted to HTML code, to complete graphical authoring environments designed to create entire Web sites. Applications such as Microsoft's FrontPage, Adobe's PageMill, and Macromedia's Dreamweaver allow individuals to create Web pages and

sites with little knowledge of HTML. Yet, to create specific designs and special effects, knowledge of HTML is still needed. Programs such as these, ones that allow complete site development and implementation, are often called generators.

Note: Many of the HTML tools do not support all of the things that the developer may want to create or that HTML supports. Learn a generator and you learn only what it can create. Learn HTML, and you can create anything the language supports.

It must be acknowledged that the need to learn HTML is decreasing. As the development tools become more sophisticated and support more of the HTML tags and attributes, it becomes easier for the novice to generate pages of information. Today, however, it is still important that the developer have an understanding of how the language works.

Note: One interesting development is the emergence of HTML processors. Some of us may be able to remember the days of having to enter commands within a word processor or the days of programming PostScript code for graphics. Over time, software tools were developed, such as Microsoft Word or Adobe Illustrator, that made word processing and PostScript drawing a visual rather than code process. I suspect that the same will eventually become true of HTML coding. We are beginning to see applications that allow visual development of Web pages, although many are far from being able to support complex graphic designs. Over time I am sure we will see visual HTML drawing/processing programs that will do anything we want, negating the need to know HTML at all. But we are not there yet.

Looking at the wide variety of tools available for creating pages, the three that have the greatest impact are editors, converters, and generators. Editors are stand-alone programs that make creating the ASCII text, HTML files easier. Converters are simple plug-in utilities that convert a digital file from one program to HTML code. Generators, as previously established, allow the developer to create individual pages as well as entire sites using a graphical, rather than a code, environment.

Figure 1.10 The Microsoft Word Assistant adds several HTML-specific menu options, buttons, and templates to the normal Word application (to download Word Assistant access: http://www.microsoft.com/word/internet/ia/).

Editors

Since HTML is a simple ASCII text file, almost any word processor can be used to generate Web documents. However, many of these programs can be made to more easily generate HTML files through the use of styles as well as add-on plug-ins. One such example is the HTML assistant for Microsoft Word. This small add-on program can be easily downloaded and installed from Microsoft's Web site (www.microsoft.com) for a version of Word prior to Office 97.

The Word assistant or the Save as HTML feature of Word 97 allows developers to more quickly create Web pages, albeit you must have knowledge of the language for it to be effective. The Word assistant adds several menus, buttons, and templates to the normal software, allowing the developer to create Web pages within Word as shown in Figure 1.10. By simply typing in the text that you want to appear in the Web page and using styles to set the HTML characteristics, Word is able to generate a viewable HTML document.

Aside from plug-ins and add-ons for common commercial applications, there are also several stand-alone

Figure 1.11 SoftQuad's HoTMetaL Pro HTML editing software.

Figure 1.12 Generator applications such as FrontPage allow the developer to visually create pages.

HTML editors that can be used to create Web pages. If you are even remotely familiar with HTML, you understand that the most time-consuming part of the process is entering the HTML tags and attributes that control the layout of elements on the Web page. This is where stand-alone editors, such as SoftQuad's HoTMetaL Pro (Figure 1.11) and Sausage Software's Hot Dog Pro make creating pages much less time-consuming. These programs are designed to allow quick entry of tags and attributes so that the developer can focus on the content rather than the tags. They also reduce the likelihood of typographical and programming errors.

Most of the stand-alone editors that are frequently used are shareware programs. Many of these can be downloaded directly from the Web. Since they are shareware programs, the developer can try the software before purchasing it. This is advantageous for those who do not want to make a major investment in Web development software, but do want some of the advantages that stand-alone editors can provide. As a courtesy (and a legal responsibility), shareware should be registered and any applicable licensing fees paid for continued use of the product. The licensing fee for most shareware programs is less than $50.

Converters

For those who desire to publish on the Web but do not have the time to expend on learning HTML, there are many converters that will convert standard documents such as Microsoft Word, WordPerfect, Excel, or other files to HTML code for distribution on the Web. Most of these conversion programs do an acceptable job of converting application documents to HTML. Some require the use of intermediate file formats, such as the Rich Text Format (RTF), for the conversion to occur correctly. However, converters often do a very cursory job of creating HTML files. Their capabilities are usually quite limited.

Generators

The most powerful tools available for publishing on the World Wide Web are HTML generators. Programs such as these allow the developer to set up individual pages as well as entire Web sites as shown in Figure 1.12. The advantage to using an HTML generator is that it is graphical in nature. Pages are designed akin to laying

out pages in a word processor. Charts and tables can be drawn very easily, and graphics can be inserted without having to worry about the code behind them. This alone makes the generator not much more than a glorified editor. Yet, note that complex designs are still very difficult to accomplish without knowledge of the code; most generators do not support the ability to drag elements around on the page, a definite limitation to visual design.

The biggest attribute to a generator is that most allow the developer to create an entire Web site visually. Using graphic icons and lines, the application displays the Web site like a chart, which makes managing it much easier as shown in Figure 1.13. By manipulating the site graphically, the developer can create links to and from the pages in the site visually. Changing the page order is equally easy—the user simply drags a page from one location to another. This is a significant improvement over hard coding and using a program like FTP to transfer files.

In addition, many of these programs provide the capability to run an entire Web site from any computer connected to the Internet. Once the software is installed, a Web site, based on the address of the computer, is created. Any user around the world can then access the pages on the computer. These programs also provide a measure of security so that hackers are unable to access the rest of the computer system.

Task: Choosing a Web Design Application

Choosing a Web design application can be a difficult task. Often people ask, "What is the best application on the market for this or that?" This is a loaded question. With so many software products, each designed for a specific task, it really depends on what you want to do. Ultimately, software decisions must be based on what it is you are trying to accomplish. To determine the best application for you:

Figure 1.13 Some generators, like Microsoft FrontPage, show the structure of a Web site using a flowchart.

1 Create a list of the features you plan on creating. Will you need to create pages that include tables? Forms? Multimedia elements? List the features of HTML you wish to utilize in your development tasks.

2 Critically analyze your knowledge of HTML. Understand that the level of your understanding concerning the language will affect whether you should choose an editor, converter, or generator. Also realize that even though you may know the language, a generator may help by allowing you to quickly create laboriously coded elements such as tables.

3 Determine whether you need the ability to manage a Web site from your personal computer. Certain generator applications allow you to establish your personal computer, connected to the Internet, as a Web server. If your institution has a Web server, you probably do not need this capability.

4 Finally, match the application to your list of needs and skills. Your level of proficiency with HTML will determine whether you need a generator, editor, or converter. Your list of needs will help you determine which specific application best suits your needs.

Acquire Necessary Skills and Equipment

Probably one of the most difficult tasks getting started in the Web development arena is acquiring the necessary skills and equipment. This book is aimed at helping you develop in the area of skills. However, determining your software needs may require a little more research than what this book provides. In reality, you may already have enough to get started. But there are many software applications that can be purchased that can be used to aid you in developing sites and pages. In the next couple of sections, you will take a look at the "required" toolset as well as some other application tools that you may find helpful in your development tasks.

A Text Editor and Paint Program

As you begin planning and developing a Web site, you really need nothing more than a simple text editor and a paint application for graphics. However, you will find that there are many tools that have been developed that make Web page creation and maintenance more efficient. If there are several individuals involved as a development team, probably one of them has each of these tools. Note that if you are part of a Web development group, consider discussing the various software applications you have among yourselves.

Some of the most useful tools for Web development include:

• A Web creation tool such as Microsoft FrontPage, Adobe Page Mill, or Macromedia Dreamweaver for quick creation of specific HTML features.

• A raster editor such as Adobe PhotoShop, Fractal Design Painter, or Corel PhotoPaint to edit and create bitmap graphics.

• A vector drawing program such as Macromedia Free-Hand or Adobe Illustrator to create vector graphics. Note that FreeHand can generate vector-based Web graphics that can be transported to Flash for easy distribution on the Web.

Note: *It should be noted that even though generators are not very effective at creating complex page designs, they are very handy for creating tables and some other specific elements. I often use a generator to create the basics of a table. Then I go back and edit the code to fit the bill for what I want to do.*

Other Software Tools

In addition to the basic toolset, you may also need some other specific tools to add special capabilities. For example, if you wanted to add internal multimedia elements, you may want to consider adding other applications to your list of development tools. If you want to deliver a wide range of multimedia elements through your Web site, you may want to also include:

• Authoring software such as Macromedia Director or Macromedia Authorware for Shockwave and Web Player media elements

• Digital video software such as Adobe Premiere or AutoDesk Animator Studio for sampling or editing video

• Animation software such as Discrete Logic's 3D Studio Max or Rio Topas to generate 3D animations

• Audio software such as Sound Forge or Sound Edit Pro to edit and sample audio

Other Platform Specific Tools

If you are working in a group setting, you may find that the various group members are using multiple platforms for Web development. Note that it is common to develop a site on a local hard drive or storage device prior to uploading it to the Web server. Some developers prefer UNIX, others prefer Windows, and still others prefer the Macintosh. Any one will do, but you must be aware of the differences across the various platforms as you begin working.

Due to file format differences across various platforms, you may want to invest in software that performs file format conversions. For example, PC users will probably want to invest in a utility program that will allow them to read Macintosh disks and/or Macintosh files. Macintosh users may want to purchase utilities that convert PC files to Macintosh format. For those who are working across platforms for Web development, you may want to consider purchasing:

• File transfer software such as Pacific Micro's Mac-In-DOS or MacOpener to enable cross-platform capability (PC users) and file transfer.

• A graphic converter such as Hijaak (Windows) or De-bablizer (Macintosh) to convert graphic images and other media elements.

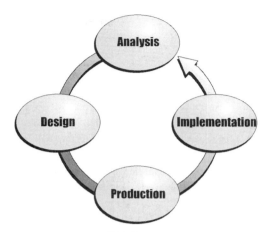

Figure 1.14 *The four major steps in the Web development process.*

Understanding the Process

More than anything else, the Web is a communication medium. Just like the development of any other communication medium, there is a defined process that you can follow to create Web documents that effectively communicate. Whenever a document, book, or other published product is created, the people involved painstakingly follow a living process, most often developed through trial and error.

When creating a document such as a brochure or flyer, look at the audience and what you want to communicate. Then determine how best to fit the content to that audience. If you were writing a book, again, center on the audience and cater your information to that audience. Web-based delivery is no different. However, with hypermedia you have many more options, many more elements, and often, a wider audience. Adapting the wide variety of media elements such as text, graphics, sound, and video, so that they effectively communicate, can be very challenging. Yet, the entire process can be described using four basic development steps as shown in Figure 1.14.

Analysis

The development of a Web site begins with an analysis phase. In most instances, there are five very important aspects that are used to define all of the various variables that constitute the design and delivery of the information. These aspects include the content, the audience, the development system, the delivery system, and the functionality of the site.

CONTENT As they say in the multimedia development field, content is king. Effective Web development is centered on how successfully the content and graphics communicate to the user. There is a precarious balance between these two elements. Poor content can never be dressed up, even with great graphics. The content is still poor. Also, good content can never communicate effectively with poor graphics.

Visual appeal is an important aspect of any communication medium. The first step in developing a good communication tool is analysis of the content you intend to provide. Decide where graphics or other media elements can be used to support your information as well as where text-based information alone is sufficient. Only use

graphics and other media elements where they will complement, supplement, or complete the surrounding information.

AUDIENCE One of the most promising aspects of Web development is the ability to customize your site to your audience through both graphic and interactive design. All good Web sites are audience centered. What does your audience expect to see at your site? What will attract them? What will repel them? The whole point in identifying and analyzing the audience is to custom-tailor the Web site around their needs.

TIP: *Whether you are communicating through a book, a live presentation, or a Web site, it is imperative that you build a profile of your prospective or target users. Target a single population for which you are providing content. What is their age? What is their background? What skills do they have?*

As any good communicator knows, success only occurs when the text, graphics, and any other element transfers a message from sender to receiver in its entirety. To do this requires knowledge about the audience. A measure of whether communication has occurred successfully can be seen in how much of the message the audience receives, and in the accuracy of their interpretation. Many things contribute to the way the audience receives and interprets your message. It is the compilation of graphics, text, and other media elements that contributes to communication. All of these things must be centered around the audience.

DEVELOPMENT SYSTEM To some, the idea of the development system being a variable involved in Web development seems strange. However, I believe it is a very important consideration and here is why. More and more corporations are creating Web development groups, rather than having a single individual create all the Web site information. Often the group will consist of individuals from several departments who may be oblivious to collaborative resources. Of concern in the development system are the applications, platform, tools, and other resources that may be utilized. Looking at these items in a group setting makes everyone aware of the collaborative resources and makes for more efficient and effective development.

DELIVERY SYSTEM Earlier we stressed the importance of the audience, to consider what a visitor would be looking for at your site. In addition, you must also take a look at the hardware that they will be using to access your site. This is the most frequently overlooked part of the development process. The main concerns in the delivery system are what type of network access the user has, what platform they are using, and the typical machine configuration they will be using. In chapter 3, "Designing for Effective Content and Efficient Delivery," you will take a closer look at how the end users configuration can affect the delivery of your pages.

FUNCTION So you have analyzed all the variables, now what? After looking at the content, audience, development, and delivery systems, you must now summarize the information you have. Up to this point, you have been defining the parameters under which communication should occur. At the beginning of this process, you began with a general idea of where you were going. Now you must take that goal and create objectives and an abstract to summarize and describe your site. The objectives and the abstract should give more description to your overall goal. To do a functional analysis, you will need to document your goal, create objectives, and create an abstract that describes the site you will be creating.

Through functional analysis, written documentation of the information found during analysis is vitally important. Therefore, functional analysis is really nothing more than a comprehensive document describing the things that the group has found.

Why is this important? Consider that you, or one of your group members may not always be involved with Web development. Some may move on to other jobs,

Figure 1.15 Graphics and graphic design play a large role in the communicability of a Web site (http://www.discovery.com).

Figure 1.16 Using graphics to set the tone of a site (http://www.usatoday.com).

become ill, or for some other reason be removed from the Web development group. Documenting the parameters for your site helps any newcomers to your group. It also helps keep everyone on track with the original purpose of the site. The document becomes an abbreviated summary that can be used to quickly brief a new member on the focus and purpose of the Web site you are creating. It can also be used to explain to your boss or a client what the Web site is about and what it will communicate.

Design

Graphics and graphic design play a large role in the communicability of a site as shown in Figure 1.15. The graphical layout of the pages, as well as the graphics themselves, will largely contribute to the audience's opinion of your site in addition to the site's communicative value.

Designing appealing, graphical pages is not rocket science. Indeed, the biggest difficulty is in developing an artist's eye. To develop an artist's eye simply requires

training yourself so that you can tell what looks good and what looks bad.

At this point, simply realize that the graphical elements of a page should contribute to the content that is being provided. Do not use graphics to just take up space. Often graphics can be used to set the mood as well as the tone for a site. Graphics play an important role in setting the tone of a site as shown in Figure 1.16. Notice that the professional tone is conveyed through the layout, graphics, and style of the page.

Figure 1.17. Static text becomes much more interesting with related graphics (http://www.warnerbros.com).

Figure 1.18 An example of a digital device metaphor (http://www.mplayer.com).

Graphics also help in the aesthetic dimension by providing visual appeal. Static text becomes much more interesting as you add related graphics to a page as shown in Figure 1.17. The content of the page also becomes clearer because you can visually describe what is being communicated with text. Images communicate much quicker than text and much more vividly as well.

METAPHOR In the multimedia world, a common buzzword commonly creeps up as you begin discussing multimedia and hypermedia. The buzzword is metaphor. A metaphor is a theme, motif, or storyline that attempts to familiarize the audience with something new using association. Metaphors are intended to decrease user apprehension when presented with a new environment by drawing on past knowledge.

One of the most difficult items to tackle when dealing with communication tools is the comfort level of the user. How do you get the user comfortable with navigating or using a new informational environment such as a Web site? How do you get the navigation issues out of the way so they can get to what they really came for (your content)?

This is what a metaphor attempts to do. By drawing on previous experience, a metaphor attempts to link something the user is familiar with to the workings of a new informational environment. For example, you may create a Web site that works like a book—which would be

Figure 1.19 Metaphors can make interacting with information easier and more fun (http://www.iflyswa.com).

Figure 1.20 An interface contains all the navigation controls for a site (http://www.mca.com).

blasé, but nonetheless it is a metaphor. By using a book metaphor for your pages, you would assume that the user could more quickly and easily begin navigating your site. Using the book metaphor means that users do not have to learn how to navigate the site. They use it just like a book—something they already know how to use. This is the primary goal of a metaphor: to get the user past navigational issues and environment control so that they may get to your content quickly and easily.

There are many different metaphors that have been used. Figure 1.18 shows an example of a digital device metaphor. Note that this site uses an interface analogous to a hand-held device. The developers are assuming that you are comfortable and can use such a device. Therefore, using the site draws on your past experience and makes using the site easier with which to become familiar.

As you begin considering how the user will navigate your site, consider using a metaphor to draw on the user's past knowledge. By using a metaphor, sites are more successful, aiding the user in overcoming the new environment (Figure 1.19). If a metaphor is designed with the user's knowledge and skills in mind, they can be fun, both in design and execution.

If you decide to use a metaphor, make sure it is somewhat obvious to your audience. Use something that is rele-

vant to them. If the metaphor you use is too abstract, it will become counterproductive. The best metaphors are the ones with which the audience quickly associates.

INTERFACE DESIGN In addition to the use of a metaphor is the interface itself. The interface that you present to the user is the communication channel between the user and the content of the site. The interface contains all the navigation controls for the site, as shown in Figure 1.20.

An interface is the point of interaction between the computer and the user. It must provide for input and output from both parties. It is also the point of communication and interaction whereby the user interacts with the computer and vice versa.

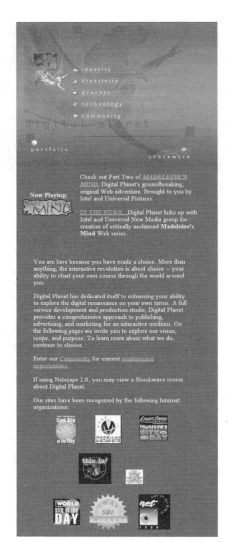

Figure 1.21 Sometimes it is difficult to distinguish between the interface and the metaphor (http://www.digitalplanet.com).

Oftentimes, the interface is part of the metaphor—there can be overlap between the two. The metaphor is the association, the interface is the place of physical interaction. Yet, they can sometimes be difficult to distinguish as shown in Figure 1.21. As you proceed through this book you will invariably see many sites that show good and bad examples of metaphors and interfaces.

Production

As you have already seen, there has been much work and planning put into the site before a single page is ever created. It may seem like a lot of upfront work, and it is. Successful sites do not just happen. There is a tremendous amount of planning involved in creating any good communication medium.

The production phase will be the part where everything seems to come together. If you are working as a freelance Web consultant or as part of a development group, it is here that you will see most of the physical emerge. Time spent planning is not wasted. The planning that goes into Web site development is a long-term investment that will pay off once the site is completed.

Delivery

Once all pages have been completed off-line, the last part of setting up the site is moving it to the server. Some of the software mentioned earlier, such as Microsoft FrontPage, have a very easy way to upload the pages. If you manually upload the pages to your server using FTP, you will undoubtedly have to do some fine-tuning. Regardless, you will again want to rigorously test all the pages and elements to ensure that the site works as intended once it has been uploaded.

Task: Plan a Web Site

One of the most time-intensive portions of developing your Web presence will be in planning what will be delivered and how it will be delivered. Ultimately, planning

can either make or break a Web project. To ensure a better site:

• Begin by looking at your main purpose. Try to state in a single sentence the overall goal or purpose for your site.

• Next, examine your audience. Who are they and what are they looking for?

• Explore what you want to deliver and design the information to be delivered over the Web. Choose the places where your graphics and other media elements should be implemented as well as how the information will be placed on your pages.

• Investigate the resources you have to work with to determine the best method for developing your content for your audience.

• Determine the features of the end user's machine and how it will be connected to the Internet. Can their connection support the media elements you have chosen to include?

• Develop your objectives and abstract to document the analysis phase. Remember to document this information so that you have a clear idea of where you are going and how you will get there.

Individuals Involved with Development

A trend that is occurring within many corporations and businesses is the use of multiple individuals to develop and maintain a company's Web content. With the variety of content and range of media that can be used, as well as given the tremendous size of some corporate Web sites, more than a single individual is normally needed to create and manage a business or corporate Web site.

Often, the creation of a Web development team is a natural outgrowth of the development. Often, a group will consist of a manager, graphics guru, content specialist (usually someone with an education background), an in-

Figure 1.22 Pushing the Web to its limits: Madeleine's Mind (http://www.madmind.com/).

formation architect, and a programmer. As you can see, even the smallest of groups should have these key people. At a minimum, you will find that three predominant areas are represented: graphics, programming, and education or communication. In addition, other specialists may be needed as the content requires. For example, if you are going to include audio or video at your site you may need a digital musician or videographer to assist the Web development group. Regardless of the content-related specialists, the knowledge areas of graphics, programming, and education/communication should be present to create an effective site.

Real World Examples

Probably one of the most impressive ventures on the Web as of late are interactive games. As a message that pushes Web delivery to the extreme, both in files sizes and content, some of the most exciting things are happening in this arena.

Of the games available on the Web, none has captured my attention more than Madeleine's Mind shown in Figure 1.22. As a mix between psychological thriller and animated storytelling, the site utilizes animated graphics and sound in Shockwave format. Although the medium can tax the modem-based user, it works very well with a direct network connection.

Figure 1.23 Animation and sound combined with an excellent story make Madeleine's Mind a very intriguing site.

Undoubtedly, you will want to check out this site, created by Digital Planet with support from Intel and Universal Studios. Make sure to install the Shockwave plug-in prior to visiting the site. Then hold onto your hat for a wild ride (Figure 1.23).

Summary

In this chapter, you have taken a basic look at the current state of Web development and delivery. You have seen many of the current design trends found in Web pages and how the audience judges the effectiveness of a particular site. You have also read about the general qualities that make for pages and sites that communicate effectively. Keep in mind that effective sites are a result of balance between content and graphics, and that you can follow a repeatable process to ensure a more successful site.

Next Steps

Now that you have taken a brief look at the genré of the Web today:

• Check out chapter 2, "Raising the Web to the Second Power," to find out more about multimedia elements and interactivity on the Web.

• Take a look at chapter 3, "Designing for Effective Content and Efficient Delivery," to learn more about network and end user bandwidth limitations.

• Read chapter 4, "Designing for Your Audience," to find out more about designing around your audience's needs.

QUESTIONS

Q *In the chapter, you advised that high bandwidth multimedia elements should not be used on the Web. Does that mean I should not integrate audio, video, and animation?*

A Briefly, no. The major concern with anything you deliver over the Web is how long it will take your audience to download the information. The main thing concerning large media elements is allowing the audience to choose whether or not to download the information. Before you automatically insert audio, video, or animation into your pages, you must look at the target audience to determine how long it will take them to download the information.

Q *If I am going to be delivering rich media elements over the Web, how do I know what is too much to push over the Web?*

A Really to make this determination you must look at two aspects. The first is to ascertain how the user will be connected to the Internet because it is usually the end user's connection that is the weakest link in the delivery chain. The second is to examine the size of the total page that must be downloaded. This requires you to calculate file sizes—all of the elements to be downloaded by the user. In chapter 3, "Designing for Effective Content and Efficient Delivery," you will take a closer look at how this is done.

Q *In the chapter, you talked about various applications that could be used to help generate HTML pages. What are the negative aspects of using a generator? Why should I not ignore learning HTML and just use a generator?*

A Well, besides the fact that generators do not always support all of the available HTML tags, and that they do not allow you to drag things around on the screen, there is one other significant disadvantage. Often generators will add miscellaneous tags to your HTML files that are not part of HTML. When these files are loaded into the browser, they can sometimes cause display problems. In addition, these "generator tags" make it difficult to read through the code, so fixing them is somewhat difficult as well.

Raising the Web to the Second Power

As you look at pages across the Web, one of the most promising features of enterprising pages are multimedia elements. These can range from simple animated GIF graphics or small video segments to scripted elements using VBScript, JavaScript, or another language that extends the functionality of HTML.

It is true that delivering multimedia elements on the Web is limited due to the bandwidth required. In the next chapter, "Designing for Effective Content and Efficient Delivery," we will take a closer look at the limitations of the hardware as it relates to delivery over the Web.

In this chapter, we want to look at the media elements themselves without regard to their size or the current limitations on the Web. Multimedia elements are one of the most promising attributes of today's Web and one that will undoubtedly be found on tomorrow's Web in greater frequency.

Web multimedia, which is becoming a reality due to faster connections and better compression, is often overused and ineffective. When a casual surfer stumbles across a Web page that includes so many animations and other elements that it takes an eternity to download, the site loses its effectiveness. Consequently, this "noise" may cause them to cancel the load and go somewhere else for their information. Figure 2.1 shows an example of a Web page that may put your modem to the test due to the number of multimedia elements included on it.

Nonetheless, Web masters across the world continue to design pages full of multimedia elements that severely tax the standard 28.8, 33.3, or 56 kbps modems. We

Figure 2.1 Pages with many multimedia elements may be greater than your bandwidth (http://www.animagic-media.com/).

must learn that multimedia is only effective when used appropriately. Slamming several animations onto a page—ones that do not contribute to the content or provide some other "value-added" information—wastes time and bandwidth. But again the Web is the place of ultimate experimentation and we are beginning to learn these things through experience.

So how do you decide where multimedia would be advantageous in this interim of change—where we are just beginning to learn to effectively utilize multimedia and where the hardware and software are beginning to support high bandwidth material? Better yet, how do we define this multimedia beast and what works well and what does not work so well?

In this chapter, you are going to take a look at the various multimedia elements that can be integrated into the

Web. In part five of this book, "Multimedia Techniques," we will spend some time looking at how to create those elements. In this chapter, we simply want to look at what is effective multimedia on the Web. In addition, what does the future hold for multimedia on the Web?

Note: Since multimedia is just coming of age on the Web, the real guide to its effective use is based on what we have learned in dealing with CD-ROM media. In fact, one of the more radical approaches to delivering multimedia is through the use of a combination of Web and CD-ROM media. This "hybrid" medium utilizes a CD for high volume items such as video and sound but extracts its text and other information from the Web. Combining the Web and CD-ROM media utilizes the advantages of both. As time progresses and Web connections get faster, you can bet that interactive multimedia products will move away from etched media such as CDs to the fluidity of the Web.

In addition to looking at multimedia, we are also going to spend some time looking at the power of positive interactivity. Interactivity is one of the most powerful capabilities of the Web and the interface of the Web site plays an important role in usability.

Note: As a note, this chapter may stress interactivity, nonsequential, and nonlinear information. But this information will be both helpful and important as you begin striving to create Web sites. As noted in the previous chapter, creating effective nonlinear and nonsequential pages requires the ability to think nonlinearly and nonsequentially.

In designing any interactive work, regardless of whether it is CD or Web-based, you must break the mold of traditional informational delivery. When designing a linear document such as a brochure, a book, or other conventional media, one follows traditional practices to ensure successful communications. Yet on the Web, it is often the unconventional that leads to success. Throughout this chapter this is what we will focus on: breaking the mold of linear, as well as static media, delivery.

OBJECTIVES

In this chapter, you will:

- Understand what multimedia is and how it is different from traditional multiple media presentations.

- Learn where multimedia is best used on the Web and in informational tools.

- Discover the importance of interactivity and how it can be used on the Web.

- Learn the important attributes of effective interface design.

- Learn what it takes to develop nonlinear thinking abilities.

- Discover how to design nonlinear structure as well as a site map to explain the structure.

Understanding What Multimedia Is

Indeed, the efficiency and effectiveness of communication have increased as a result of the computer and the digital elements that can be used in information delivery. CD-ROM and Web media elements enable us to paint a clearer picture of what we are trying to convey because we can utilize more than just static graphics. In addition, interactivity can be added. Figure 2.2 shows an example of a Web site that utilizes multimedia elements effectively. It also has an interactive structure that allows the user to access information quickly. Note that these two attributes make this a worthwhile and effective site.

The ability to utilize multimedia in delivering information is not something new. Many people define multimedia as the use of multiple media to deliver information, no matter the delivery channel: a person, computer, or the Web. Many teachers, professors, and others who have been delivering lectures and presenta-

Figure 2.2 The combination of interactivity and multimedia elements makes for an effective site (http://www.macromedia.com).

tions for years would emphatically exclaim that they have been doing multimedia presentations for a long time. To them, the use of the computer does not make a multimedia presentation.

The real difference that interactive multimedia and hypermedia makes in communication is not so much in the idea of using multiple media, although this makes the information easier and more interesting to digest. The real difference is in the method of communication and it is a function of the computer itself.

With today's multimedia capabilities on the Web and CD-ROM, the real advantage is the ability to nonsequentially access and present information regardless of whether that information is contained within a body of text, a static graphic, or an animation. The media elements are the means to a final product that is interactive, nonsequential, and nonlinear.

Note: Those who believe that multimedia can include a lecture that uses transparencies, films, or tape-recorded audio

combined with a lecturer's voice (text, graphics, "animation," and sound), will inevitably see that this, unfortunately, is not multimedia by the terms of this chapter. Multimedia is not classified as such simply because a presentation uses multiple media. There is one other pervading factor that causes a certain presentation to be classified as multimedia: nonsequential interactivity.

Today, the most widely accepted definition of multimedia is this: multimedia is any informational presentation (designed to inform, educate, persuade, or entertain) that includes text, graphics, sound, animation, or video and is displayed and/or controlled by the computer. In this context, assume that multimedia and interactive multimedia are synonymous. Some classify multimedia as a presentation controlled by the computer and interactive multimedia as a presentation controlled by the user; both are executed on the computer. Nonetheless, today's definition excludes the statement of many individuals who claim to be producing or using multimedia by the default that the presentation "uses multiple media."

The traditional definition of multimedia (the lecturer's voice, text, graphics, etc.) coincides with the modern definition in all but one part: the computer. The only difference between the old paradigm and the new is the computer. The computer clarifies and defines what is multimedia by today's standards.

If we take the interactive multimedia definition one step further you see that hypermedia, information distributed using a variety of resources, is a subset of interactive multimedia. Hypermedia products draw their resources (media elements) from many locations or storage devices. Using this definition you see that hypermedia includes the Web as well as CD and Web-combined products.

Note: Stick with this chapter to better understand why current multimedia is defined this way. You should see that multimedia's advantages are due to the computer and its nonlinear and nonsequential nature, not just digital multimedia media elements that are used.

All That Glitters Is Not Gold

Most discussions in Web development groups surrounding the delivery of content over the Web are focused on performance versus quality issues. It seems that there is a never-ending battle between people in the design/graphics fields and those who are network gurus.

Ultimately, the conversation between these two groups of people focuses on the inverse relationship between quality and performance. As the quality of media elements in pages increases, performance generally decreases. As the quality of media elements in pages decreases, performance increases. Yet there can be a happy medium between performance and quality. The hardest part is finding that perfect mix. Many of the decisions surrounding quality can be determined by looking at the audience and the purpose for delivering the media elements. If the audience is composed of visual people, quality may override performance. Yet, if the goal is to deliver quick information, then performance may be more important.

There is no one answer or solution to this issue. You must decide for yourself, based on your audience and purpose, what mix of quality and performance you need. Again, planning and analysis will help answer which is predominant and how much of each is appropriate.

Note: *One of the related issues concerning multimedia elements is the cross-platform and cross-browser concerns of using multimedia elements. If you decide to use multimedia elements, make sure you pick a format that satisfies your audience's platform or browser.*

Considerations for Using Multimedia

As you look at the wide range of multimedia elements that can be distributed on the Web, you will notice that they can be included in Web pages in a variety of ways. Originally, the browser could only interpret HTML code and plain GIF and JPEG raster graphics. Yet, we have desired to use more complex elements, special capabilities have been added through add-on programs that allow multimedia elements to be embedded directly within

Figure 2.3 Helper application allows files foreign to the browser to be viewed in an external application (http://www.batman-robin.com/).

HTML pages. Additionally, browser manufacturers have endorsed several multimedia data formats—audio-video interleave, QuickTime, Flash, and Shockwave—to name a few.

As you look at the brief history of the Web browser, you will see the beginnings of Web multimedia capabilities found in the use of helper applications. Helper applications are applications that are external to the browser (often created by a separate company) and are executed as certain media elements are encountered or downloaded from the Web.

Note: *Even though the use of helper applications is decreasing, realize that many sites and end users still depend on them for playback of content.*

For example, one of the first ways of utilizing digital video movies such as QuickTime movies was to utilize the QuickTime movie player application. In this scenario, when the browser encountered a page with a QuickTime video file, the user was required to click a hotlink, which would then download the movie. Once the movie was downloaded, the browser would open an external application, Apple's QuickTime Movie Player, and play the movie as shown in Figure 2.3. Any file that was foreign to the browser required an external helper ap-

Figure 2.4 Plug-ins allow multimedia elements to be viewed right within the browser (http://www.zygomedia.com/).

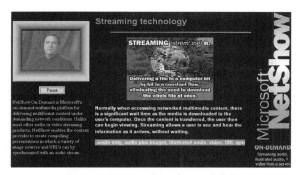

Figure 2.5 Most multimedia capabilities are a result of add-on or external programs (http://amstream.microsoft.com/nsod/default.htm).

plication. The advantage to this approach is that the media is not dependent on its embedded position on the page. You can scroll or even jump to another page and keep the media on the screen.

The browser derives all its application associations, the information that tells it how to view files (based on the three-character file extensions) from an information list called Multipurpose Internet Mail Extensions (MIME). This list must be defined in the browser as well as on the server used for distributing Web files.

The MIME list defines several important pieces of information for the browser concerning any given file type. It includes:

• The application type, such as text or image

• The application subtype, such as plain or JPEG

• The three-letter extension for the file such as .txt or .jpg

• Information on what to do with the file. Options include View in Browser, Save to Disk, Prompt User, and Open Application.

Using the MIME entry information, the browser is able to look at the three-letter extension and then determine whether to try to view the downloaded file in the browser, save it to disk, or open it into another application (a helper application).

Even though helper-based multimedia was the first means of utilizing multimedia elements on the Web,

many companies recognized the need to be able to directly integrate multimedia into the Web page rather than requiring an external application for viewing those elements. This led to the advent of plug-ins that could be installed on the client machine that assist the browser in interpreting multimedia elements. These plug-in-based multimedia elements, such as Shockwave shown in Figure 2.4, allow any range of media elements to be included on Web pages.

Note: *Realize that certain media elements, such as digital video, animations, or digitized sound, can actually utilize either plug-in technologies or helper applications. Depending on how the user machine is configured (i.e., what MIME associations are established) will determine whether a helper or plug-in is used. Because of this, you may want to specify for your audience the "advantageous" method of viewing pages that have such elements.*

Aside from helper applications and plug-in technologies, browsers enable the multimedia technologies themselves. For example, a GIF animation is recognized by most browsers as is the inclusion of sound elements embedded into Web pages using the BGSOUND attribute of the <BODY> tag. Over time more multimedia attributes will be directly supported by browsers, which will make setting up a Web browsing environment easier. But for now most of the complex multimedia capabilities, such as highlighting buttons or multimedia presentations (Figure 2.5), are a result of add-on and external programs more than they are of the browser.

Realize That Interactivity Is Important

The premise that makes the Web unique is its nonlinear and nonsequential nature. These characteristics are a function of the computer connected to the Web. Interactivity is key in communication.

To understand the difference between linear and nonlinear information let us compare two educational settings. The lecture in which all information is given in a progression from beginning to end is an example of linear presentation. Alternatively, a question-and-answer session in which students ask questions based on their immediate interests is an example of a nonlinear presentation. A nonlinear environment is characterized by custom, audience-centered activity. A linear environment displays information from beginning to end, usually simple to complex, with a linear progression in between.

Still, communication is more than a linear process. Communication is a two-way street and Web development and delivery must hinge on this fact. Every element that you integrate into your pages should contribute to communication, design, or navigation. Just pasting elements on a page for no reason at all will distract and confuse your users.

If you look at any page, there are three types of elements that appear on those pages: content elements, design elements, and navigation elements. Figure 2.6 shows a page that exhibits all three types of elements.

The first types of elements you will find in any Web page are those that are used to present or enhance the content. In Figure 2.6, the inline graphics and the text following are designed to present the user with information. The way the elements are arranged as well as the thin line between the two columns of information are focused toward design. Yet, notice the bar to the left of the screen. This is the navigation tool that is used to navigate the site. If you check out this site you will see that this bar appears throughout the site, always allowing the

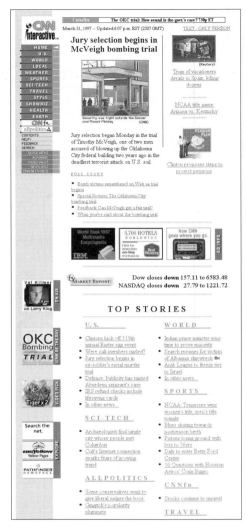

Figure 2.6 The three main types of page elements include content, design, or navigation (http://www.cnn.com/).

audience to navigate the site easily. This is one of the major concerns of development: consistency.

Let us take a look at another Web page to distinguish between content, design, and navigation elements. In Figure 2.7, can you identify which elements are content, design, and navigation related?

*Figure 2.7 Determine whether items in the page
are content, design, or navigation related.*

In Figure 2.7, the center text as well as the logo at the top
are content related—giving information about the insti-
tute. The design elements include the bar on the left of
the screen as well as the "Training Provider Spotlight"
bar. What you really want to look at here are the buttons
that appear over the bar on the left of the screen. These
are navigation items. Through the entire site the pages in-
clude the same buttons, in the same place, on each page.
Navigation items are easy to find and well placed on the
page.

To summarize the primary factors in interface design
you should focus on:

• Consistency, so that the elements that are displayed
on your various pages allow the user to become com-
fortable with the look and the feel of the information
device.

• Efficiency, so that the content, design, and navigation
elements assist the user in efficiently finding the infor-
mation for which they came looking.

• Control, so that the user is in constant control of the
information device.

• Clarity, so that the interface elements themselves, such
as buttons and other metaphorical devices, are clear to the
intended audience.

• Practicality, so that the site's page elements are de-
signed with the limitations of color depth, browsers, and
bandwidth limitations in mind.

• Visual Appeal, so the pages and site are more than a
hypertext-based environment. Pages that have high
amounts of content in text form and few, if any, graphics
require more time to assimilate the information.

Effective interface design requires that you strive to focus
on these factors. All of these attributes can either help or
hinder the user who is trying to access the information at
your site.

More than a Linear Digital Document

Educators and trainers alike have known for a long time
that information is much more readily comprehended
and accepted when it is tailored to the audience. To do
this, a linear progression from simple to complex is usu-
ally used. They also know that information is more read-
ily understood when the audience interacts with it.

However, the traditional media that are used for com-
munication cannot be everything to everyone. Writers
and educators alike must organize and structure infor-
mation cognitively, leading the reader from the simple to
the complex. A book may be too difficult or too basic for
certain individuals; therefore, it may not be adequate for
them. Traditional communication media, due to linear-
ity, cannot be everything to everyone.

A book or any other static and traditional communica-
tion device is linear by default. Therefore, from our
childhood our paradigm of information reception—the
method by which we receive, assimilate, learn, and or-
ganize information—is programmed to occur in a linear
fashion. Most humans have difficulty dealing with non-
sequential information because it contradicts our direct
and programmed way of receiving information.

The Power of Interaction

Previously in this chapter, you have seen that the Web is much more than multimedia elements or a digitized linear document. As you browse the Web you will find that the interactive structure of a document is as important to the site as all of the glitzy graphics or multimedia elements. The people who visit your site want your information, and the interactive structure of your site plays an important role in how quickly and easily they can get to what they came for.

Keep in mind that the levels of interactivity add to the complexity of navigating your information. The deeper a user must go into your information the longer it takes for them to get to what they came for. You should strive to only make them go as deep into your site as is necessary. The structure of your site should be logical and follow the organization of your materials. Keep in mind that there should be an easy way in and an easy way out of the site.

CUSTOMIZED AND AUDIENCE-CENTERED INTERACTIONS
The method of interacting with any device, whether it be a cellular phone, a CD-ROM, or a Web page, occurs through an interface. An interface is the point of interaction between the user and the device as shown in Figure 2.8. In the case of the cellular phone, the interface you use is the device itself. It normally includes the buttons representing numbers as well as other buttons for functions such as memory, recall, and clear. In addition, the cellular phone may have a liquid crystal display (LCD) panel that displays the numbers or functions you enter. The interface on a cellular phone is called a physical interface because you physically interact with it.

When you are dealing with tangible devices that must be manufactured, the arrangement and placement of items on the interface are limited by the confines of manufacturing. Certain designs and arrangements cannot be manufactured either due to feasibility or cost issues. Yet with multimedia and hypermedia interfaces, manufacturability is not an issue, so there are really no physical

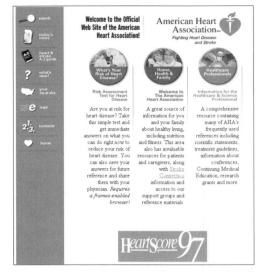

Figure 2.8 Presenting an interface to the user generally includes a menu and informational area (http://www.amhrt.org/).

limits. The only limitations are the amount of screen real estate and the bandwidth limitations of the Web.

On the Web, interfaces can be designed in any fashion. Buttons, graphics, and other elements can be anywhere you want them. Yet, you will notice that effective, established principles are followed to make the interface easier to use and more aesthetically pleasing. For example, study the interfacing used in Figure 2.9. The arrangement of the items on the screen presents a very clear and direct method of accessing the information at the site. As the buttons and other items in an interface become more numerous, they tend to get cluttered and more difficult to use.

With information devices such as interactive CD-ROMs or the Web, keep in mind the basic premise for which the device has been created. The individuals who use your information device are likely not focusing on your buttons, your great artistic talent, or other related visual design issues. Each of these elements contribute to what they do want—your content or information. No matter how good the content or graphics are, if the audience cannot get to your content, or if it is blocked by noise,

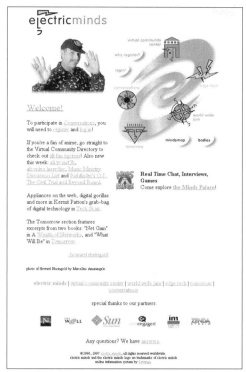

Figure 2.9 Overcrowding the screen with links and buttons can be a hindrance. Moderation is good (http://www.electricminds.com/).

Figure 2.10 Unique nonlinear environments on the Web will always supersede linear environments (http://www.adobe.com/).

they do you little good. This is where the interface, the means by which your audience interacts with your information, is vitally important. The effectiveness of your interface design will determine the speed with which your audience becomes familiar with navigating your environment as well as how comfortable they are using your environment.

Learning to Think Nonlinearly

Effective Web development is more than access to a computer, a knowledge of HTML, or acquiring the latest multimedia software applications. The Web is an interactive communications medium that is rapidly evolving and ever-changing to support what we need it to be.

As has been mentioned before, breaking out of linear thinking due to lifelong linear conditioning is a formidable task. Breaking this pattern is probably more difficult than creating the most complex site or page.

People are slowly seeing that computer multimedia and hypermedia often conflict with linear thinking and the traditional paradigm of communication. Nonsequential thinking is required to produce tools that utilize any nonsequential schemata. Anyone can digitize a traditional document and post it on the Web. But to design a unique, audience centered Web site as shown in Figure 2.10, now that is unique.

Effective Web designers strive to integrate both linear and nonlinear structure into Web pages and the site structure. It is surprising that so many of the video generation can so easily and quickly adapt to the nonsequential environment. Growing up, this "technological advantage" was exhibited in the "VCR phenomena." Parents asked their children to set the clock on the VCR. They were not used to the nature of using the technology.

A look at some of the top companies in the United States and around the world points to the fact that most Web

developers are under the age of 30, predominantly due to a lack of linear conditioning. Conditioned behaviors are a result of conditioned repetitive actions that lead to exhibited, repetitive behaviors. As the nonsequential environment becomes more widely used by subsequent generations, learning, teaching, and information presentation styles will mimic the conditioned behaviors.

Task: Designing Interactive Nonlinear Structure

Designing the interactive structure of your Web page begins by using logical divisions within your content to determine structure.

1 Begin by laying out the logical divisions of your content. What types of relationships exist among information and the way you are presenting it? Does it progress from simple to complex? Problem and then solution? Is it causal in nature?

2 Next, determine what information exists within each area of information. Is each section of information discrete or is there overlap between the sections of information?

3 Once you have determined areas of overlap between your sections of information, realize that these become your intrasite links, or links that go from page to page within your site.

4 Finally, take a summative look at the information you will be delivering in each section. Within each section of information, would it be logical to allow the user to go to any other portion of the site? If you see areas that would logically lead to other parts of the site, include a link to get there.

Use a Site Map

Once you have analyzed the information you will be delivering, it is often appropriate to develop a site map. Keep in mind that a site map is simply a flow chart that shows all the pages at your site as well as the links in be-

Figure 2.11 Overall this site has excessive hotlinks that make the content and information seem disorganized (http://www.qfn.com/).

tween each page. The site map may be a sketch or a drawing created in an illustration package. Nonetheless, the site map is an extension of the previous exercise of establishing the interactive structure. The site map becomes a significant aid when you go to develop the pages at your site. It also reveals the linear or nonlinear nature of your design.

Real World Examples

As you look at Web pages, you find that certain pages will appeal to your taste due to the various elements on the page. In this final section, take a look at the pages presented and notice the things that are highlighted as positives and negatives. I will be providing commentary on what I believe to be the strengths and weaknesses of each page.

• Figure 2.11 shows a Web page that has a typical problem, information overload. Note that when you first look at this page, it takes a while to understand where to start. Often, presenting too much information on a page will cognitively overload your audience.

Figure 2.12 Spreading out the text links and adding more space between the various elements make this page easier to read (http://www.eonline.com/).

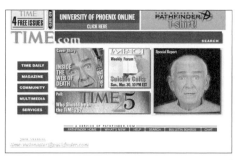

Figure 2.13 Using button items makes navigating a site as well as telling what is there much easier (http://pathfinder.com/@@iQFoTAYALKABQXe6/time/).

Figure 2.14 Even though there are a lot of links on this page (sixteen to be exact) notice that the design is not cluttered and that every nook and cranny is not filled with a graphic or text element (http://www.toshiba.com/).

• Figure 2.12 shows a better use of links and structure. This page contains options that are easier to read and the elements have more space, which makes them more visually appealing. This site has excellent readability.

• Navigating the site shown in Figure 2.13 was fairly easy. The button items along the left side of the screen make it easy to tell what is at the site. In addition, the center images give you an idea of what the current hot topics are.

• The interface for the page shown in Figure 2.14 allows you to get to a lot of varying degrees of information but notice that the screen is not cluttered. There are sixteen different hotlinks on this page. However, the way it has been designed and laid out does not cause information overload on the user.

Summary

In this chapter, you have taken a look at the two most significant attributes of successful sites: multimedia elements and interactivity. You will find that most effective sites exhibit a balance of these two characteristics. Throughout the discussion of multimedia elements, it was stressed that you must be realistic about what can and cannot be effectively and efficiently delivered over the Web. Some more time will be spent focusing on this in the next chapter.

Next Steps

Now that you have looked at the concepts of multimedia and interactivity take a look at:

• The realistic constraints of multimedia on the Web in the next chapter, "Designing for Effective Content and Efficient Delivery."

• Chapter 20, "Using Layered Web Pages and Other Effects," to learn more about multimedia and graphics effects that can be used in Web pages.

• Chapter 21, "Training the Page to Speak," to learn more about integrating digitized audio and Musical Instrument Device Interface (MIDI) files in your Web pages.

• Chapter 22, "Animating Your Web," to discover how to utilize browser and plug-in-based animation.

• Chapter 23, "Integrating Multimedia in Your Pages," to learn more about integrating multimedia elements in your pages.

QUESTIONS

Q *Given all of the various interactive structures, what is the best structure to use in Web sites?*

A Really the best structure is the one that supports your information. Realize that when individuals talk about interactive structure they are simply talking about the overall structure. For example, a site may be predominantly linear or predominantly hierarchical. Design around the information and not the other way around. If you try to fit information to a particular structure you will likely have difficulty designing an effective site. Start with the information. The structure is a function or is derived from the information to be presented.

Q *What is the best way to develop nonlinear thinking skills? Is there anything I can do beyond Web development that will help?*

A One of the best ways to develop a feel for nonlinear thinking is through the use of nonlinear tools. Things such as the Web, interactive multimedia CD-ROMs, even role-playing books are good ways to develop nonlinear thought patterns.

Q *How do plug-in technologies work? I notice that my MIME types automatically change even if I have previously set them to something else. Can this be corrected?*

A One of the most common occurrences with the newer Web plug-ins is that they frequently change the MIME types list when the browser is executed. Most plug-ins consist of .DLL files that are installed in the plug-ins folder of the browser. The .DLLs commonly "reset" the MIME types list on startup. To remove a plug-in requires removing its DLL. If you installed a plug-in and want to use a helper application, you must remove the DLL for the MIME listing to remain constant.

Designing for Effective Content and Efficient Delivery

As you begin developing information for the Web, you will find that one of the most difficult technological parts is to be designing for efficient delivery. It is easy to decide where to integrate multimedia elements, graphics, or video segments, until you find that many audience members who are accessing your pages are using narrow bandwidth modems. Due to the amount of time it takes to download this type of information, their opinion of a site with high bandwidth media elements may be quite low.

On today's Web, the capabilities of a user's machine and connection are often overgeneralized. Developers quickly assume that everyone has a fast Internet connection, often generating pages that include high bandwidth material, pages that consequently post a challenge to even the fastest modems. These generalizations and poor assumptions cause a site to exclude a large potential audience from accessing pages. Therefore, communication, and, ultimately, reception of the message do not occur.

This chapter is dedicated to looking at the technical concerns with delivering various aspects of Web content. In the next chapter, you will take a look at customizing and centering your content on your audience. In this chapter, you will look at the technical concerns with delivering Web pages to the end user.

OBJECTIVES

In this chapter, you will:

• Realize that the speed of the client and server connection to the Internet is vitally important.

• Look at both the server and client side variables that must be dealt with when determining efficient delivery parameters.

• Examine the transfer control protocol/Internet protocol (TCP/IP) to see how data is broken down and routed through the mass of computers that make up the Internet.

• Develop an understanding of the various connections and speeds available for Web connections.

• Learn to develop for effective yet efficient delivery.

Your Connection Is Everything

Connection is probably one of the most important aspects that determines the delivery speed of Web content. How the user gains access to the Internet is vitally important, for it will determine how quickly data flows to his or her computer once it is released from your server. In general, it is the end user's connection than usually limits data transfer on the Web.

However, your server's connection is also important, even if your users have a very fast connection. How are you connecting your server to the Net? The speed of your connection will also contribute to how fast your pages will be served up, and so will the amount of traffic flocking to your site. A site with many users accessing large files with a fast server that has a slow connection will still be hindered from receiving your content.

Although there are many individual hardware and software components that allow the Web to function, the

entire chain includes three major parts and can be viewed at a base level as (Figure 3.1):

• The end user's connection (the client)

• The server's connection (the server)

• The path or connection between the client and server (the channel)

As you might imagine, this chain of delivery is only as strong as its weakest link. This is called "The Law of the Weakest Link." For example, a superfast server connected to a fast cable will still appear slow if the end user is accessing the site using a 28.8 modem. Additionally, a poor cable or server connection yields similar results. Only when the server, client, and cabling (the connection between the two) support the same speed are you assured "fast" delivery.

Note: The connection between the client and the server deserves mentioning. The more points between the client, such as interim servers or connecting points, the longer it takes to receive data from the Web. This is why dial-up access is slower than dial-up connection. Dial-up access requires the use of an interim computer between the client and server, which is an additional link in the delivery chain. The more "middlemen," the longer the delivery chain.

As you begin analyzing your own Web delivery chain, you will find that it is the end user's connection that usually limits Web delivery. In general, there are two types of end user connections to the Web: slow and fast. And as you may have guessed, hardware speed is related to cost. Most end users are household users who cannot financially justify a fast Internet connection. Therefore, they opt for the slow, yet affordable connection via a modem. Those who are fortunate enough to work at a company or university with faster connections, however, receive multimedia-based information more readily.

Note: If you are providing content, examine the audience you will be serving in relationship to the various methods of connection. Put yourself in their situation. Much of what

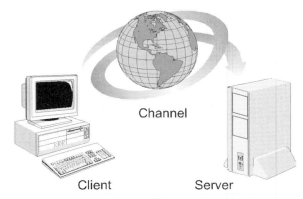

Channel

Client Server

Figure 3.1 The entire delivery path on the Web can be broken into three major components.

you design and provide will hinge on the user's connection. Obviously, the faster the audience's connection, the more graphics and multimedia elements you can provide. However, if you provide a significant number of these elements on your pages, for clients whose connection is through a modem, you will probably lose some of your audience due to significant download times. We will take a closer look at this in chapter 4, "Designing for Your Audience."

When you talk to most people about the issue of fast versus slow connections, fast is defined as those who are using a direct network connection via a network interface card (NIC) as illustrated in Figure 3.2. Generally, the fast connection is part of a local area network (LAN), which is in turn connected to the Internet.

The definition of the slow connection would include most connections that use a modem and the copper-based POTS (Plain Old Telephone System) network. Modem speeds today include a few at 14.4, more at 28.8, and many at 33.6 kbps. All new computers sold within the past 12 months support 56 kbps transfer. You will find that new technologies that are emerging use POTS and allow faster connections, such as Digital Subscriber Lines (DSL) and TV cable connections.

Figure 3.2 The two main types of Internet connections.

Note: *Earlier, you read about The Law of the Weakest Link. This also applies to dial-up connections through an Internet Service Provider (ISP). One of the rave things concerning modems is the new 56 kbps speed. Yet, unless your ISP has a 56 kbps modem (or greater) on the other end of the line, the additional power on your end does little good. Both ends of the connection must have equivalent modem speeds to minimize the weakest link.*

Client and Server-side Variables

Aside from the generalities discussed concerning client and server connections, several other variables can also affect delivery of your content. As with limits on speed, the client's connection can present significant problems. The client-side variables, aside from connection speed, include:

• ISP Software such as PPP or SLIP that must be installed on the end user's machine for access to the Internet. Often this client-side software can inhibit the speed of incoming data.

• Computer hardware parameters such as video card, RAM, hard disk space, and cache. With multimedia elements, the effectiveness of media elements such as video, sound, or animation will be affected by the user's hardware.

• Computer software parameters such as operating system and fonts installed on the system. As you have probably read in other places, the operating system and fonts can be problems when viewing pages created for specific platforms due to differences in operating systems and font characteristics.

• System settings such as screen resolution. One of the biggest problems with designing for the Web is that you must design around a constantly changing page size. You can make assumptions about the size of the screen the user will be viewing, yet often some audience members may be viewing at higher or lower settings. Designing pages for the Web is like designing traditional documents that must work for a range of sizes, which is often difficult.

• The installed browser can affect the way designs, fonts, and page arrangements display for the end user.

• Plug-ins and browser specific add-ons that affect delivery. Often, designing multimedia elements for distribution requires the use of plug-ins or other browser add-ons. Sometimes the user may not have the appropriate plug-in, which can limit communications.

It is quite ironic that many designers who provide content do not think there are any limitations to the server connection. However, there are several things that can cause the server to be the bottleneck in the Web delivery chain. These include:

• Servers that are shared or used for multiple purposes. A dedicated server provides much faster response and delivery than a server that must perform other tasks in addition to serving Web pages.

• Servers that use complex, intertwined firewalls to protect information on the server. Often a firewall can have

so many protective filters or layers that it actually impedes content delivery. Although firewalls are important and valid, they can sometimes create a barrier to content delivery.

• Servers that are burdened by too many connections or connections that are open for long periods of time. More connections or longer connections can post a challenge to even the fastest servers. You must consider the number of people who will want access to your pages and whether it is more than your server can handle.

• Servers that provide large data files. Larger files require clients' connections to remain open for longer periods. This can significantly impede delivery.

Although it is nearly impossible to analyze every variable involved with Web delivery, most bottlenecks in the Web delivery chain occur when these variables are ignored. Understand that both the client and the server have variables that can affect delivery beyond the connection itself. More often than not, you will be able to identify possible delivery problems if you look at each of these variables as it relates to what you are delivering and plan appropriately.

The TCP/IP Variable

The protocol that allows the Web to communicate is the TCP/IP. You may not give it a second thought once you are connected. Nevertheless, it too plays a role in Web delivery.

TCP/IP is the protocol used on the Internet that consists of the Transfer Control Protocol and the Internet Protocol. This is a packet-based protocol in which packets, or chunks, of information are transferred to the client machine from a server machine. The TCP portion controls the dividing of the data and the assembling of the data chunks that are sent over the Net. The IP portion determines and controls how the data chunks are sent from computer to computer, finally arriving at the client connection.

As traffic on the Web increases, more chunks of data are being sent here and there requiring more time to receive

data over the Net, particularly at peak usage hours. Although there is not much you can do about it (except reduce the amount of data you are sending), understanding the way that TCP/IP works, as well as how much traffic is on the Net, can also play a role in efficient delivery.

Understanding Connections and Speeds

Three common terms are used when discussing the delivery of multimedia and hypermedia: data rate, transfer rate, and bandwidth. These terms are often confusing and it would be helpful to understand them better.

Data rate and transfer rate are synonymous and describe the amount of data, in bytes per second, that can be transferred from one device to another. For example, CD-ROM drives, hard drives, removable drives all have a maximum amount of data that can be read off or written to the device. Generally, data rate describes the amount of time required to copy or display a file. Data rate usually refers to the speed of specific hardware devices inside a machine and how long it takes to perform a certain operation, such as displaying a graphic or copying a file.

Frequently, hypermedia developers speak of data rate in terms of the data being passed over their Internet connection. When you are speaking of data coming from the Web, it is generically called bandwidth and is measured in bits rather than bytes. Bandwidth refers to the amount of bits being passed over a network cable in a certain number of seconds.

Often people get confused when talking about bandwidth versus data. To help clear things up, take a look at Table 3.1 to see a comparison of common devices and their respective data rates and bandwidth comparisons.

Note: *Remember that 8 bits equals 1 byte. To calculate between data rate and bandwidth you must either divide or multiply by 8, depending on which way you are calculating.*

Connection	Data Rate	Bandwidth	Time per 100K
modem	1.8 KBs	14.4 kbps	55 seconds
modem	3.6 KBs	28.8 kbps	27 seconds
33.6 modem	4.2 KBs	33.6 kbps	23 seconds
56.6 modem	6.2 KBs	56.6 kbps	18 seconds
ISDN	7–16 KBs	56–128 kbps	14–6 seconds
Frame Relay	7–64 KBs	56–512 kbps	14–1.5 seconds
T1	32–193 KBs	256–1544 kbps	3.1–.5 seconds
1X CD	150 KBs	1.2 mbps	.66 seconds
2X CD	200 KBs	1.6 mbps	.06 seconds
DSL	188 KBs	1.5 mbps	.06 seconds
4X CD	450 KBs	3.6 mbps	.02 seconds
Fast Ethernet	1.25 MBs	10 mbps	.01 seconds
T3	3.52 MBs	44 mbps	.0002 seconds

Table 3.1 Comparison of data rate and bandwidth for common connections.

Task: Understanding Data Rate Versus Bandwidth

When you are attempting to determine the speed of a particular connection or device, ascertain whether the information given you is in terms of data rate or bandwidth. If the figures are given to you as kilobytes per second (KBs) or megabytes per second (MBs), then you are talking about data rate. If the information is given to you in kilobits per second (kbps) or megabits per second (mbps), then you are talking about bandwidth.

Converting Between Data Rate and Bandwidth

Doing the conversion between data rate and bandwidth is straightforward as long as you remember that 1 bit equals 8 bytes. Eight is the important number. To perform the conversion:

• Determine whether you are given a data rate or bandwidth number. If it is KBs, then it is data rate. If it is kbps, then it is bandwidth.

• Next, if you are given a data rate, multiply the number by 8 to obtain the bandwidth in bits per second. If you are given a bandwidth, divide the number by 8 to obtain the data rate.

Finally, if you want to determine the amount of time it will take for a certain amount of data to be downloaded on the device, you must know two things: the amount of data you want to push, and the data rate of the device.

For example, let us say I want to determine the minimum amount of time it will take to download 1.35 megabytes of information using a 14.4 kbps modem. I know that a 14.4 modem has a data rate of 1.8 kilobytes per second (KBs) and that 1.35 megabytes of information is 1350 kilobytes. Dividing 1350 kilobytes by 1.8 kilobytes per second yields a download time of 750 seconds or 12.5 minutes. Realize that this is the shortest amount of time required. Other client or server-side variables may increase this download time.

The Bandwidth Dilemma

All Web developers must realize that size is an issue for effective content developed for and delivered on the Web. Aside from utilizing distributed computing techniques, such as using multiple servers to deliver various types of information, there are really only three ways to increase or to better maximize the Web. Our main options include making more roads on the Web for data to travel on, making the existing roads on the Web wider, and lastly, decreasing the amount of data we push by using compression technologies and streaming.

Since this book is predominantly about design for interactivity, of the three options the one that has the most relevance to us is reducing the amount of data that we are pushing. If you have been around the Web much at all you are aware of compression and streaming technologies available for incorporating audio and video. (Check out RealAudio, RealVideo, and the new MP3 music formulas.) The main effort is to better maximize the existing technology by shrinking the size of Web files using compression and streaming.

COMPRESSION As you have read, one of the biggest problems with Web content is size. To overcome this hurdle, compression schemes have been developed to help reduce file sizes. Almost every computer file has redundant data. For example, an image with many blue

hues in it has redundant data due to the repeated definition of the blue pixels. The same is true of sound, animation, and video files. Compression schemes take the redundant or repeating data and substitute tokens or representative characters for the repeating data, thus reducing the file size as shown in Figure 3.3. Each compression scheme works this way.

Compression schemes use an algorithm, or codec, to compress and decompress the image file. A codec stands for compressor/decompressor, an algorithm used to expand and compress the file. Most compression schemes, such as the ones used in certain graphic files (like GIF and JPG) are transparent to the user. Many times, you do not even know that the compression is occurring, but the compression can significantly reduce the size of the file.

How does compression work? As you have read, it is based on redundant data in the file. However, the compressibility of a file is dependent on how much redundant data exists in the file. An image with many similar colors will compress more than an image with a wide variety of colors.

Compression schemes are judged by the amount that they compress the file or their compression ratio. The compression ratio is the ratio of the uncompressed file's size to the size of the compressed file. However, some of the highest compression ratios are achieved by dropping out some of the data. When the file is decompressed, missing data may be reconstructed poorly, resulting in undesirable artifacts appearing in your image.

It is important to achieve balance in compression. For example, some codecs compress rapidly and decompress slowly. This may be advantageous when you have to compress a volume of images (or sounds), but puts the onus for waiting on the user—just what you do not want!

STREAMING One of the most important advances in Web technology centers on the principle of streaming. Streaming technologies normally utilize compression, yet they have one other significant advantage. Understanding the concept of streaming is easy, yet its implications and application are rapidly evolving.

A streamable digital file, whether it be a graphic, audio, or video file, is one in which the browser can immediately begin its playback even though the entire file has not downloaded. Once a portion of a streamed piece is downloaded, the file can begin playing. In essence, the file is played directly from the Web, within the browser, as it downloads.

Most audio (and video) streaming technologies require that special server software be used. More often than not, a server aimed at delivering audio or video will not be able to provide any other services. The server software that is installed to deliver audio and video often requires that the server be dedicated to only the task of delivering audio and video.

Note: There are a few streaming technologies that do not require a dedicated server or special server software. Nonetheless, all of the streaming technologies require that the client's browser have a plug-in to view the media element. This will probably not change in the coming months. If you decide to utilize streaming technologies, make sure your home page acknowledges that certain plug-ins are required to view the site. Keep your site audience centered in this manner.

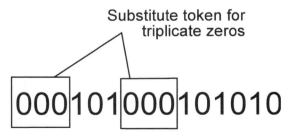

Figure 3.3 *Compression substitutes tokens or representative characters for redundant data.*

Special Lines and Transport Layers

Several new and widely accepted technologies using transport layers are emerging to directly connect companies and institutions. These technologies use the TCP/IP over special, dedicated lines.

ISDN or Integrated Services Digital Network enables a user to access a digital phone line via dial-up using a codec rather than a modem. Much like the codecs for file compression, codecs used for ISDN handle the real-time compression and decompression of the information coming over the digital phone line. ISDN lines can range in speeds from 256 kbps up to 1544 kbps.

A T1 connection is one of the most widely used business and corporation Internet connection. This type of connection supports a bandwidth of 1544 kbps; however, the monthly cost ranges from $1,000 to $3,000 per month, not including the cost of the leased phone line. Often a T1 connection can be leased in portions or increments called fractional T1. Fractional T1 is generally divided into multiples of 256 kbps.

A T3 connection is much wider and faster than the T1. A T3 line is only used to connect major Internet Service Providers. T3 lines can support hundreds of LANs and boasts 44,736 kbps bandwidth. T3 is also what forms the Internet backbone's major network connections.

Other connection services include cable TV, Digital Subscriber Lines (DSL), Asynchronous Mode (ATM), and satellite link-ups. These other connections are rapidly advancing and are currently being tested with Internet-based information services.

Task: Determining Your Best Connection

As you have already seen in this chapter, part of determining effective delivery is determining how fast you can provide data and how fast users can receive data. In general, you can calculate maximum speed for receiving data using the information provided in the section titled, "Understanding Connections and Speeds" and the two tasks that follow it. But as you know you must be able to calculate how much data you will be sending. To do this, add the cumulative sizes of the graphics and other media elements that make up your page. Then you can determine the best or fastest speed. Generally, times will be about 10 to 20 percent longer depending on the amount of traffic on the Web at the time of access.

Take Time to Contemplate Reasonable Delivery

It is critical to consider reasonably acceptable delivery times. If your users have to wait 5 to 10 minutes to download a page, particularly the first page of your site, they will likely go somewhere else for information or resources. Most users assume that worthwhile sites are those that have good content and are designed for efficiency and effectiveness. Knowing how much you are delivering, how long it will take to download, and making that download reasonable are very important. The biggest reason people avoid a site is due to lengthy download times.

Real World Examples

One of the most difficult aspects of developing pages and sites for the Web surrounds networking issues. Likely, you may not want to deal with all of the technical concerns surrounding the setup of servers or the acquisition of hardware and software. In addition, you will undoubtedly want to do research on companies in your area that can help you with networking concerns. Check out the list of networking/consulting companies listed at sites such as Yahoo! for more information. Often companies such as these can provide invaluable advice concerning the specifics of connections available in your area as well as local pricing and availability. The best source of information about the Web? Of course, the Web itself!

Summary

In this chapter, you have read about the various aspects of client and server connections and how they affect the delivery of content over the Web. The list of variables on both sides of the Web delivery chain can be quite complex and difficult to calculate but the first step is to be aware of their existence. Additionally, this chapter has provided information concerning the real issue of the Web: bandwidth and how it relates to data rate and the amount of time it takes to download information from the Web.

Next Steps

Now that you have looked at the technical concerns associated with delivering effective and efficient Web content:

• Check out chapter 4, "Designing for Your Audience," for more information about customizing your content for your audience.

• Examine chapter 5, "Looking at the Curse of the Web Browser," to find out more about browser implications and how various browsers affect the look of Web pages.

• Take a look at chapter 18, "Managing Color Differences," for more information about differences across platforms.

QUESTIONS

Q *What are some of the options for increasing the speed of a server connected to the Internet?*

A To increase the speed of a server connected to the Web, the predominant means is to increase bandwidth. As with the general discussion of speeding up the Web, the same is true with server connections. You can increase the number of connections coming to the individual server, make existing connections better (such as changing from an ISDN line to a faster T1 line), or decrease the amount of information you are delivering. Generally, the best solution is a combination of the three, but the most important is the bandwidth quality of the existing connections. Additionally, there are specific hardware additions, such as adding RAM or processors that can also increase server speed.

Q *You mentioned distributed computing in Web delivery. How is this used?*

A This technique is not new, just new to delivering Web content. In effect, distributed computing for Web content utilizes multiple servers to deliver content for a site's pages. For example, HTML pages are coded so that they draw graphics from one server, video from another, and so on. Distributing the elements to be delivered across multiple servers decreases the load on a single server.

Designing for Your Audience

One of the most promising aspects of Web development is the ability to customize your site to your audience. All good Web sites, as well as other properly designed communication media, are audience centered. What does your audience expect to see at your site? What will attract them? What will repel them? Questions such as these are aimed at identifying and analyzing the audience to custom-tailor the Web site around their needs.

Whether you are communicating through a lecture, a static medium such as a book, or a dynamic Web site, it is imperative to build a profile of your prospective or target users. You must understand what it is that the audience is looking for and what will best facilitate them finding it. To accurately design an audience centered site, you must target a single population for which you are providing content. Although the Web is a worldwide medium, you should still be able to target a specific audience and thus create a tool that appeals to them, while still accommodating the worldwide nature of the Web.

What should you know about your audience? Information may include age, knowledge level, and technical or computer skills. As any effective communicator knows, successful communication only occurs when the text, graphics, and any other media elements transfer a message from sender to receiver in its entirety. To do this requires knowledge about the audience. A measure of whether communication has occurred successfully is in how much of the message the audience receives, and in the accuracy of their interpretation of that message. Many things contribute to the way the audience receives and interprets your message. Age, knowledge level, skill, profession, and experience all contribute to what the audience is looking for, what they expect to see, and how a site should satisfy these expectations. That is what this chapter will examine: meeting the audience's needs.

OBJECTIVES

In this chapter, you will:

• Examine the various attributes of the audience that are important to the development of Web materials.

• Learn how to specify a target audience and understand the implications and assumptions you will make in doing so.

• Examine five specific questions that describe the audience's purpose and task of navigating your site.

• Take a structural look at sites designed to inform, educate, persuade, and entertain.

Surfing a Cyber-Mile in Their Shoes

To develop sites that really attract an audience of intended users requires separating yourself from your personal viewpoint of the site's design, content, and structure and viewing through the eyes of your audience. When it comes to creating anything—a graphic, a book, and even a Web site—the hardest thing to do is to separate yourself from the product. Often criticism of such works is interpreted as a personal rather than product critique. One of the most difficult aspects of graphic artistry is the acceptance of criticism. You must understand that the criticism is focused on the work and not on the creator.

To accurately critique your own work requires gaining the perspective of your audience. Through their eyes, you attempt to analyze a site design from a usability standpoint, looking for things that do not communicate well.

You will note that the first step to this is understanding the viewpoint of the user, which is based on age, knowledge level, skill level, professional level, and expectations.

Age

One of the first things that affect an audience's perspective is age. To take on the mindset of your audience requires an understanding of their general age level. As with other means of communicative tools, age greatly affects how you present your content.

For example, if the age of your audience is less than 20 years, you may want to use something attention-getting. Also keeping this age group's attention requires some ingenuity, as shown in Figure 4.1. Often this is accomplished through not only the information but also the graphics, design, typography, media elements, and colors used on the site.

However, if your audience is older than 20 years of age, something attention-getting may repel, if not offend, the audience. For example, notice the difference in the way the site in Figure 4.2 is presented compared to Figure 4.1. Attention-getting materials often push away a more mature or refined crowd. The tone, graphics, design, and other aspects are somewhat age-dependent. Akin to a live presentation, age plays a large role in how you present your information.

Knowledge Level

A second means of developing an understanding of the audience's perspective is knowing their knowledge level. Particularly when a site is aimed at informing or educating the audience, it is important to acknowledge what prerequisite information they should know to be able to comprehend or use the information you are presenting.

For example, a technical discussion of some complex concept may be appropriate for some of your audience members. But ask yourself, "Am I excluding those who do not have the background needed to assimilate the information I am presenting?" Does the audience need to

Figure 4.1 A site designed for the younger generation, which has that teenage flair (http://www.mtv.com).

Figure 4.2 A more mature or refined audience may require a professional approach to design and presentation (http://www.allencomm.com).

have some prerequisite knowledge before your content makes sense? If so, you may want to either provide links to sites on the Web where your audience can get the prerequisite knowledge, or start your content at a lower level.

Skill Level

Another consideration is the skill level of your audience. For example, if you are planning to create content that requires a specific plug-in or helper application, will your audience have the skills necessary to find the plug-in or helper and install it? Will the audience need to know how to download files or understand compression programs like Pkware's PKZIP or Aladdin's Stuffit Expander? As a developer these may seem like simple things, but to an audience member, they can be significant hurdles. Consider the skill level of your audience. If needed, provide links to get plug-ins and helpers and even instructions for installation if you believe your audience needs them. To overcome skill limitations in your audience, use a customer service approach. Provide the audience everything they need to be able to efficiently and effectively use your site.

Professional Level

In addition to age, knowledge, and skill level, you must also consider the professional level of the individuals who will be visiting your site. This concerns the tone of your site but it can also be related to age. Do business professionals make up the majority of your audience? If so, you will definitely want to take a reserved approach to both navigability and content presentation. When determining the professional level of Web communications, it is always better to err on the side of conservatism than on the avant garde. Even in cutting edge sites (far out, techno-punk, artsy, flamboyant, etc.) you should still convey a professional tone.

For example, let us contrast two sites that are aimed at different professional levels. Figure 4.3 shows an example of a site that is somewhat fun and is designed to inform

Figure 4.3 A fun site that is aimed at a relaxed audience (http://www.thepalace.com).

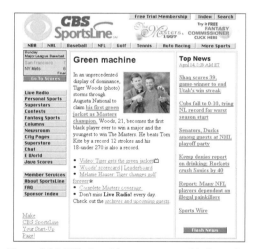

Figure 4.4 A Web site with more structured information (http://www.sportsline.com).

the audience. This page is designed for a more relaxed audience and the material is not necessarily time dependent.

To contrast with Figure 4.3, take a look at Figure 4.4. This site is designed for professionals seeking specific technical information. The sophistication level of individuals accessing the site in Figure 4.4 is higher than that of Figure 4.3. The site in Figure 4.4 is more mission critical and more serious. Analyze the importance and seriousness of the information at your site and tailor it for your audience.

Expectations

The last characteristic that contributes to a viewer's perspective is what they expect, based on previous background and training. The issue is to determine what it will take to impress, engage, and attract your audience's attention. Once you have done this, chances are they will stay around to look at the content.

For example, people in the graphics field generally expect high-quality graphics. Yet attracting those who are outside the graphics field may be a little easier and require less graphical flair. You should strive to meet your audience's expectations. If they will expect high-quality, impressive graphics, do not provide anything less. If the audience is used to something lower on the graphical scale, simply meet their expectations.

Note: Meeting the audience's expectations may be better than trying to exceed them. For example, throwing high-quality graphics onto a page where the audience is looking for quick information is probably not a good choice. Often the user's connection, hardware, and skills are proportional to their experience, skills, and professional level. Generally, household surfers are using a modem. Therefore, high-quality graphics will probably push them away due to download times. People in the graphics or other professional field probably have better connections, better hardware, and higher expectations.

Task: Determining Your Audience

Determining your audience differs little from preparing for a presentation or other information delivery project. Find out as much as you can about the intended audience. You may even want to look through corporate information, personal information, or reviews of intended customers or average users who access such sites. Doing so will help you establish the tone, design, and breadth and depth of the information that you provide at your site.

Questions to Ask Yourself

As you work, beyond simply looking at the user's attributes, there are several questions that you can ask yourself to help ensure a better Web site. To many it seems awkward to spend so much time looking at the audience, and although this chapter is devoted to audience analysis, most of these suggestions are more a thought process than a written analysis.

Mentally understanding the audience information is like a strategic plan for a business. The strategic plan is a written document that describes the missions and goals of a department or institution. Once a business plan is established, day-to-day decisions can be based on the plan. Without a plan, day-to-day decisions are difficult and can often lead a business astray, often far from their overall goal.

Thus, an in-depth understanding of your audience promotes making better decisions about your site. Without a plan and an understanding of your audience, day-to-day decisions concerning site development often lead the site away from its main mission: communication.

What Is the User's Perspective?

Once you have taken a look at age, knowledge level, skill level, professional level, and expectations you should have a pretty good feel for your target audience. Therefore, you are ready to begin assembling your content and designing your pages.

Realize that for most individuals the Web is a new experience. Even those people who are using it on a daily basis no doubt find new methods, new techniques, and new effects every day. More than likely, most potential visitors do not want to spend time searching for information or waiting for it to download. It is really no different from going to the library. It is not the searching or finding of a book that is important—it is the information.

Many sources state that the amount of available information is multiplying exponentially. It is likely that many items of information may take time to find, assimilate, and act on. However, the more difficult to access that information or find the information, the more likely we are to ignore it. The chief responsibility of Web developers is to make information easily accessible, easily digestible, and clearly interpretable. If any of these variables is lacking, more than likely your message will be misinterpreted or ignored outright.

Keep in mind the main mission of your site. There are four areas of communication around which your site will ultimately revolve: informing, educating, persuading, or entertaining. Each of these main missions may require a different approach but it is easy to get off track in any of these communicative missions. Frequently, developers think, "Let's throw in some Java or GIF animations" or "How 'bout sound, wouldn't that be cool?" Yet unless those elements support your main mission of communicating, they do nothing but take up bandwidth.

What Is the User Looking For?

Ultimately, visitors are looking for something. It may be information or it may be resources, it may be entertainment or education. Nonetheless, they are looking for something.

Specific objectives of your site should meet the needs and expectations of potential users. Take a marketing approach. Make sure that there is always some benefit to the audience when they access a page at your site. Find a way to create value-added features that will attract and hold your audience.

Can They Find It?

Once you determine what the user is looking for, how do you place it into your site so that it is easy to find? Often it is amazing to find that sites lose their purpose and make it difficult for users to find what they are looking for.

Have you ever looked for something, such as a driver or software update at a company's Web site only to get lost in the mass of pages? If you go to a site to find a driver update or information on a product and find no link on the first page, you will be discouraged from looking further. This is a prime example of losing a site's purpose.

Whatever it is that is attracting your users, make sure that it is clear in your page's interface how to get to it. Many users will quickly get frustrated when a 2-minute operation takes more than 2 minutes. Clearly put the things that the user is looking for in the first page of your site. Structuring a site so that the pages are deep is fine, yet make sure it is apparent to the user how to get what they need.

Can They Get to It?

To complement finding information efficiently also make sure that the interface you use is clear. As you read in chapter 2, "Raising the Web to the Second Power," clarity is an important interface attribute. With sites that have well over 1,000 pages, how to get here and there often becomes unclear.

One of the most effective methods of ensuring interface clarity is to design with your purpose in mind. Often when companies begin creating their Web presence, they have a good idea at the inception what they want to accomplish. Yet one thing that is true about interface design is that as sites change, so must the interface. Often a site outgrows the original interface. The Web is inundated with sites that have outgrown the original interface. After a year or two of growth, it is sometimes a good idea to revamp the interface to better accommodate and represent the information at the site.

How Long Does It Take?

The last question that you can ask yourself concerning your site and its ease-of-use is, "How long does it take to get to what the audience wants?" Frequently as sites grow, the path to get from point A (the home page) to

point B (whatever it is you are looking for) gets longer and more convoluted. Consequently, if you are surfing from a modem, it can seem like an eternity.

As a Web site developer, you should conscientiously examine your site as you begin adding on new sections and more pages. If a user has to funnel through three or four pages to get to what they want, the likelihood they reach it will undoubtedly decrease. Present the user with an easy path to get from A to B. If the page is quite lengthy, the audience may decide to leave rather than wait.

Task: Designing Around the Audience

Designing for an audience requires a significant amount of planning and research about their needs and desires. You can:

• Begin by determining the audience's age, knowledge level, skill level, professional level, and expectations. Ask yourself, what is the user's perspective?

• Determine the main things for which people will be coming to your site. Ask yourself, what are the users looking for?

• Ask yourself the remaining questions listed in the preceding section: can they find it, can they get to it, and how long does it take?

• Design an interactive structure that supports what the audience needs. Provide a path of least resistance for the user to get what they need. Use a site map to aid in developing this structure.

• Finally, as your site grows do not think that you can continually add to your original site and its interface without making the site more difficult to use. In the life of every site there comes a time when major revisions to structure and interface will be required. The 20-pound bag you originally designed will only hold 20 pounds. You may have to design a bigger bag to better support your growing Web presence!

Real World Examples

For this chapter's real world examples, get on the Web and examine various sites that are designed to inform, educate, entertain, and persuade. Look at these sites from the audience's perspective and determine if the site has "lost its focus." As you are surfing, look for elements that are effective, value-added features for the audience. In addition, look for design features that inhibit navigation, such as nonexistent links on the first page. A good place to start is Yahoo! at (www.yahoo.com).

Summary

In this chapter, you have read about the importance of looking at the audience in Web design. Effective communication depends on a message being conveyed from sender to receiver. For the sender to send an interpretable message, he or she must know the audience and how to tailor the message for the receiver. This requires knowledge of the user, which includes age, knowledge level, skill level, professional level, and expectations. In this chapter, you have also been presented with several questions that can be used to help to make sure your site is audience centered.

Next Steps

Now that you have taken an in-depth look at the audience and how to design a site that is audience centered, revisit the first two chapters:

• Take a look at chapter 1, "Taking Web Page Design to the Next Level," to look more closely at the design process.

• Examine chapter 2, "Raising the Web to the Second Power," for more information concerning multimedia and interactivity in your Web pages.

QUESTIONS

Q *When I develop my site structure, which is more important—breadth or depth?*

A Really the best sites have a combination of breadth and depth. For example, a site that has a numerous amount of links from the first page often makes the interface difficult to use. On the other hand, sites with a very deep structure often require several clicks to get from here to there. The optimal site structure will include a balance between breadth and depth.

Q *What are some value-added features that can be used at a site to attract the audience?*

A Although the features that will attract users depend on the user, in general the best way is to use little freebies or other personal utilities to attract your users. For example, some sites give away free phone cards, T-shirts, and so on, to get people to their sites. Other sites give away (actually distribute is a better word) shareware utilities or freeware utilities that will benefit the user. Really anything that gives the user added benefits for visiting your site will help.

Q *Is it a good idea to include a site overview or site map on a Web page?*

A The inclusion of a site map or overview to your site is good as long as it is up-to-date. Frequently, Web information changes and as long as you keep your site map up-to-date it is a handy item. Yet many sites that include a map allow the map to become outdated, which makes it both frustrating to the users and really quite useless. Decisions concerning a site map will depend on how frequently your site changes and whether you have time to keep it up-to-date.

CHAPTER 5

Looking at the Curse of the Web Browser

The vision for the Web we now enjoy was brought to fruition by Timothy Berners-Lee (and others) from the late 80s to today. The original idea, spawned by the ideas of Ted Nelson in the mid-sixties, was a computer communication system that was platform independent, universal, and multiprotocol capable. Over time and with commercialization, the Web and the Web browser have evolved into a tool that can be used to browse the mass of pages that include a wide range of media elements.

Yet, one of the biggest advantages of the Web is also seen as one of its greatest liabilities. Because Web documents are designed to be platform and machine independent, a certain amount of control over the visual aspects of a page must be sacrificed. For browsers on various platforms to understand HTML documents, some variability must exist. Thus, specific control over element positioning and layout is sacrificed for universal interpretation.

Probably one of the biggest arguments that exists in the Web world is that of two contrasting opinions about what HTML should be and what it should include. One side encourages more tags that control the design attributes of Web pages, such as the placement and arrangement of graphics, text, and multimedia elements. Designers of Web documents desire more tags that allow control over how page elements mingle. Their biggest hopes for HTML is that it becomes more of a page layout language like PostScript or Adobe Acrobat's PDF format.

However, the opposing side to appearance control are those who purport that HTML should remain a semantic structure language. By remaining a structure-based language, not getting into the specifics of visual appearance, HTML can continue to support universal, platform-independent page interpretation and further remain true to its SGML origin.

HTML is actually evolving into something in between these two opposing camps. As more tags are added to the language, many new visual controls are being added, with little loss of interpretive power. However, it does take time for browsers to begin supporting new tags. It seems that browsers will forever be a step behind the most recent tags and attributes simply due to logistics in the development cycle.

For example, Netscape Navigator and Microsoft Explorer currently support most of the 3.2 tags, as well as some browser specific ones to boot. Full support of HTML 4.0 features, such as layering and dynamic vector graphics, remains incomplete.

Because of the release cycle of the most recent HTML version, it seems that we will consistently and constantly need to deal with backward compatibility in Web pages. With version 3.2 of the language as well as many of the browser specific tags, using some tags or capabilities can be a curse for the developer as well as the surfer. Just as program developers must make programs that are backward compatible, Web developers must assure compatability of their Web pages.

Because there are factors that affect how pages are displayed in various browsers as well as on various platforms, this chapter is focused at looking at the sometimes tricky, often apparent differences of HTML

interpretation across browsers and platforms. As you will see, much of this surrounds font and color differences. In addition, you will be presented with some new features, such as dynamic fonts, that will give developers more control over some of yesterday's design problems.

OBJECTIVES

In this chapter, you will:

• Take a look at the cycle of HTML version ratification and how it relates to browser integration.

• Examine those "special browser" tags supported by various browsers and generator applications.

• Understand why the appearance of pages varies across platforms and browsers.

• Look at how fonts and colors are displayed across browsers and platforms.

• Explore various browsers and their features, functions, and quirks.

HTML Version What?

One of the most frustrating issues that you will deal with in Web page development is cross-platform and cross-browser compatibility. There are natural differences that occur between platforms and browsers, such as colors and fonts. But the most frustrating occurrence is designing a Web page that is "backward" or multibrowser capable.

Realize that due to the cycle of development—the relationship between HTML version whatever and browser X—most browsers are usually a step behind the latest HTML tags. You must be cautious about using the newest tags in HTML in your designs because using

them often excludes part of your audience—those who are using older browsers. Note when I say older that older means browsers that are only about a year old.

In addition, using the latest special plug-ins or scripting languages can cause ill effects because most are "working" type programs. This means that they have not been tested extensively or used inclusively on different platforms. The best case scenario is to stay with current and standard HTML tags and browser plug-ins so that you do not exclude a portion of your audience. In general, acknowledge that:

• Different browsers as well as different platform versions of browsers may vary in the length to which they support various HTML specifications or standards.

• Many browsers support their own custom extensions (tags and attributes) such as the FRAMES capability introduced by Netscape, which has been quickly supported by most other browsers and the HTML standard.

• The HTML standard is constantly changing. The HTML specification is a living set of standards.

• Knowledge of what is supported by various browsers is necessary to create pages that are effective on many browsers and platforms.

Dealing with Design Constraints

Designing for the Web is not like designing in a page layout or illustration program. One of the reasons designers have become comfortable with computer layout and illustration programs is due to these programs providing a familiar metaphor for design.

Becoming comfortable with the HTML "design atmosphere" requires an understanding of the constraints concerning design elements, inline images, and the method of defining the arrangement of elements on the page and how those items vary from platform to platform and

from browser to browser. Unfortunately, this process does not match many designers' paradigm of design.

With mainstream browsers (Netscape and Explorer) and version 3.2 of HTML (although not all the 3.2 features are supported by every version of the browsers), you can summarize, with caution, today's Web design constraints. Of course, they will probably change slightly within the next month:

• There are really only two functional layers in an HTML page: the tiling background (defined by the BACKGROUND attribute of the <BODY> tag) and the foreground items defined between the <BODY>...</BODY> containers. Note that this statement ignores frames documents and the layering capability of Cascading Style Sheets (CSS). See chapter 20, "Using Layered Web Pages and Other Effects," for additional information on page layering.

• Unique or custom fonts are best created as images and inserted as inline graphics, because you cannot depend on the font definition being on the user's computer (unless it is a system font, which are poor for design anyway!). As a side note, Netscape has included a feature called dynamic fonts, which allows specific fonts to be specified in Web pages.

• Inline images cannot overlap or be layered in the browser, but they can be interchanged (such as in a GIF or JAVA animation) and border one another with no noticeable gap (see Adobe's home page at www.adobe.com).

• Graphical items, whose rectilinear outlines overlap horizontally or vertically, must be contained in the same raster image.

• The only non-bitmap graphic you can define in a page using HTML, aside from text, is a horizontal rule (<HR>).

• Background tiles integrated into a Web page repeat infinitely in both the X and Y directions. Changes in audience screen settings can drastically affect the look of a page with a tile that is too small.

• You must design around a constantly changing canvas (screen) size and have some idea as to the lowest audience screen size.

• The more pixels that have to be downloaded, the longer the user must wait to view a page (unless the pixels are transparent). Generally, download times range from 4 to 7 seconds for 10 K over a 28.8 modem.

• The file size, and therefore the download time, of a page is based on the cumulative sizes of the elements that appear in the page.

It is ironic that if you had to follow such a constrictive set of design parameters to use products like Adobe Page-Maker, Quark Express, or Adobe Illustrator, you would likely go back to traditional paste-up. Yet, it is possible to understand the main variables that affect the layout of a Web page as well as design around them. You must understand the two main considerations, fonts and colors, and how they vary across platforms.

Browser Considerations

As you work with Web documents, keep in mind that HTML is a semantic language. This means that the HTML code loosely defines the way in which the elements on the screen, such as text and graphics, should be laid out. However, it is the browser which actually does the composing of the text and graphics after the elements are downloaded. This means that each browser may present the contents of a Web page a little differently, as shown in Figure 5.1 and Figure 5.2 (next page).

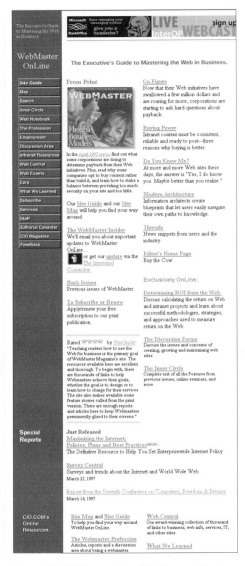

Figure 5.1 A Web page viewed in Netscape Navigator (http://www.cio.com/WebMaster/).

Figure 5.2 The same Web page viewed in Microsoft Internet Explorer (http://www.cio.com/WebMaster/).

Due to differences in the way the HTML coding is interpreted by the browser, differences in the operating systems, and differences in the features each browser supports, creating a page that is exactly the same on every browser or system is impossible. Note that the predominant differences, as far as layout is concerned, are related to the browser and platform on which the browser is running.

Because every Web page is composed on the fly, the browser can be thought of as a real-time HTML interpreter. It works much like interpreters that execute programming code a line at a time. The code itself, unlike a compiled executable application, is read and executed

Figure 5.3 HTML code is nothing more than a plain text file and can be opened into any ASCII text editor.

<div style="text-align:center">

ARIAL
Helvetica
Times

</div>

Figure 5.4 Various typefonts have various characteristics that make them look different.

on the fly. Problems or bugs do not appear when the user is entering code. Errors appear when the code is interpreted. HTML errors, in the case of undesirable formatting, appear once the HTML code is loaded into the browser.

Another similarity between interpreted code and HTML is that both files are nothing more than ASCII text as shown in Figure 5.3. HTML code can be created in any text editor, so long as it saves the recorded file as simple or plain text. You can use a simple text editor such as WordPad (Windows 95) or Simple Text (Macintosh) to create HTML files.

Once the HTML code is entered into a simple text file, the code can then be loaded into the interpreter (browser) to actually see how the file works and how it is displayed. Because there are differences in the way different browsers interpret HTML code, and since you can only see the differences in the browser, it is always a good idea to test your HTML code on various browsers to get a feel for how it displays when the user loads it.

Note: I cannot overemphasize how important it is to test your pages in at least Navigator and Explorer. Test your pages on multiple browsers to make sure your page loads as intended. Note that you can install multiple browsers on your machine without much trouble.

Although browsers are a big part of the entire process that makes the Web function, to many, browsers are a trou-

blesome foe with which to work. Because of the variety of browsers used on the Net, it is difficult to code a Web page so that it looks exactly the same from every browser. It is nearly impossible to make a page look exactly the same across all browsers.

For the most part the differences from browser to browser are subtle but noticeable, particularly if you are trying to get the same design every time. In many instances, it is important to get a relatively standard look across browsers. For now, realize that there are differences in the way HTML code is interpreted from browser to browser, which shows up when a page is displayed within the browser.

In addition to browser differences, the operating system or platform can also affect the way in which the browser combines text and graphics. The operating system affects Web pages in two specific ways: font and color issues.

Fonts

One of the main operating system attributes that can influence the way a page is displayed are the typefonts. A typefont or font is a set of characters with similar attributes, such as similar heights, widths, and spacing. Examples of various typefonts include Arial, Helvetica, and Times as shown in Figure 5.4.

Figure 5.5 Text differences across platforms can be seen when pages are compared: a page in Netscape on the PC (http://www.chrysler.com/approach/).

Figure 5.6 Text differences across platforms can be seen when pages are compared: a page in Netscape on the Macintosh (http://www.chrysler.com/approach/).

Due to differences in the styles, widths, and heights of various typefaces, the text displayed on a given Web page can shift significantly from platform to platform. This presents a problem if you are trying to tightly align text and graphics on a Web page. On one platform, the page may look good, but on another, the text may give you an undesirable appearance as it flows around graphics.

Simply enough, as you look at a typeface, the actual differences in size and spacing can be imperceptible, but it is the additive differences in various versions of a particular font that cause the text and graphics to shift. A font called Helvetica on a Macintosh has different size and spacing attributes than does the font called Helvetica on the Windows platform. Note that these differences are almost imperceptible in a comparison of individual letters, yet when several paragraphs of text from each platform are compared, one will likely require more visual space than the other.

Let us take a look at an example to show this in application. Assume the difference between text heights across platforms is approximately ⅛ of an inch and you have 64 lines of text flowing around some graphics as shown in Figure 5.5 and Figure 5.6. Multiplying the ⅛ inch by 64 lines would cause the text to shift by 1 inch at the end of the page—definitely a noticeable shift. Yet, the actual font that is used looks the same.

As you create Web pages, many of these font characteristics are the very things that cause problems on Web pages across platforms. This is something you cannot directly control because it is dependent on the user's machine and not the way you code or lay out your HTML code. There will always be some variability from browser to browser and from platform to platform. If you need precise placement of text elements, particularly for a page composed of graphics and text elements, use a bitmap of the font and integrate it using the tag.

Note: *One of the newest features predominantly supported by Netscape Communicator is the use of dynamic fonts within a Web page. Dynamic fonts allow the developer to embed a font description file, based on BitStream's True-Doc font technology, directly into a Web page. Dynamic fonts not only allow you to specify specific fonts but also alleviate the problem of a font not existing on the user's machine. In addition, dynamic fonts appear anti-aliased in the browser, which makes them look better to boot!*

Figure 5.7 In general, bitmap fonts appear much smoother than vector fonts; however, they take longer to download (http://www.harley-davidson.com/hd-95/).

Outline fonts must deal with the variability that occurs from machine to machine as the outlines are created on the fly. In addition, you are limited to the fonts that the user has on his or her machine. So what happens if you want to use a font that the user's machine does not have or you do not want to deal with the variability associated with vector font? In this case, you create a graphic of the font. Using an image editor, create a graphic of the font and insert the image as an inline image using the tag.

There are advantages and disadvantages in using both outline and raster fonts. Raster fonts refer to a raster image and not a fixed-size bitmap font. Font bitmaps allow you to incorporate any type of font into a Web page with accurate control over placement. However, bitmaps take longer to download because they are graphics rather than code. You will also notice that bitmap fonts, if they are anti-aliased, appear smoother than vector fonts as shown in Figure 5.7.

Vector fonts on the other hand are limited in that you can only use fonts that are resident on the user's machine and are also characterized by aliased (jaggy) edges.

Yet, because vector text is defined using the HTML code, it can be quickly downloaded.

Task: Comparing Fonts Across Platforms

As you begin developing Web pages or even multimedia for cross-platform delivery, you will quickly see the differences that are a result of the small inconsistencies of fonts across platforms. In general, Macintosh fonts are approximately 2 points smaller than PC fonts, which will cause your page elements to shift slightly as you design your pages. Again, the best scenario is to test, test, and test again to make sure your pages display as intended.

Note: *Note that you can directly compare fonts on Macintosh and PC platforms, or with any other platform for that matter, by doing a screen capture of the page in the browser. Then, use a raster editor like PhotoShop to overlay the pages for a direct comparison of the layout.*

Colors

If you could set two computers with different operating systems side by side and view the same graphic image, you would notice a perceivable difference in the colors between the two computers. Some of this can be attributed to variability in the display monitor's manufacturing processes. However, when you compare machines that use different operating systems, the majority of color differences occur because each operating system uses a different method of defining colors for the system. In addition, some computer hardware configurations allow for more colors to be displayed than another. Before you can understand how they differ, you must understand the three primary attributes of color.

COLOR ATTRIBUTES All colors that you can see can be described and defined by three primary characteristics. In your everyday speech you probably describe colors by

using terms such as a dark blue, a fluorescent blue, a light blue, a bright blue, and so on. Every color has three dimensions. These are hue, value, and saturation. When you see a color, your interpretation depends on these three characteristics.

The first of these characteristics is hue. Often you refer to a color by its name, such as red, green, blue, and so on. The word *color* is synonymous with hue. The names you use—red, green, and so on—are the hues. Hue is a property of the wavelengths of light.

The second characteristic is the value of the color. This refers to the amount of white or black in the color. The difference between pink and red is an issue of value. To create pink from red you add white to the hue. This creates a tint of the red, pink. Alternatively, compare a dark red to the same red value. You arrive at the dark red by adding black to the red hue. This creates a shade of the red hue, a dark red. When you think of the value of a color, tints and shades are created by adding achromatic colors (white, black, or gray).

When dealing with the value of a color, a common term that is used is contrast. Contrast is predominantly perceived due to changes in value; however, saturation, which you will read about next, also contributes to contrast.

Contrast is a term used to describe the value differences between two or more adjacent colors. The higher the contrast, the greater the difference in values. The lower the contrast, the smaller the difference in values. One of the key characteristics of good graphics is the use of contrasting values or colors. Often poor graphics have very little contrast and appear flat. Figure 5.8 shows three images side by side. The one in the middle has proper contrast. The one at the top has too much contrast, resulting in a very dark and sometimes intense image. The one on the bottom has too little contrast, making the image appear underdeveloped and light. Good graphics have good contrast.

Figure 5.8 Examples of good and poor contrast.

The final characteristic of color is saturation. The saturation of a color describes the purity of a hue. For example, red is more saturated than pink because pink has white added to red. Slate blue is less saturated than primary blue because it also has black added to the hue. Saturation is affected by not only the amount of black and white in a hue but also in how much of another hue is intermingled with it.

Each color or hue can be thought of as a mixture of a particular hue with either other hues or achromatic colors. The portion of the pure hue determines the saturation level. For example, to determine the level of saturation for

PC **Macintosh**

Figure 5.9 A printed simulation of the differences between PC and Macintosh displays.

a particular pink, you would determine how much red is in the hue. The pink may have a saturation of 45 percent, meaning that 45 percent of it is red while the remaining 55 percent is white.

Every color can be measured or defined by its hue, value, and saturation. However, the same method will not work for every device such as a computer monitor, application, or television screen. For every device, you must be able to define the number of colors that it can use. This is called the gamut or range of colors for the particular device. In the case of a computer monitor, as well as a particular operating system, there are specific differences in the colors that can be displayed and how they are displayed.

COLOR DIFFERENCES Colors from one platform to another appear different in value and saturation as shown in Figure 5.9. The value of a color is the lightness or darkness of the particular color such as a light blue versus a dark blue. The saturation of a color is the pureness of the color such as a fluorescent blue compared to a subdued blue.

Setting a PC and Mac side by side, you will notice that the colors on the Macintosh are desaturated (not as pure) and lighter in value than the colors on a PC. The colors on the PC will appear more saturated (more fluorescent) and somewhat darker in value. Moreover, if you throw UNIX in, it could be anywhere in between.

Real World Examples

In the real world, testing every page on every browser and in every operating system is somewhat absurd. In reality, doing so would take an unacceptable amount of time for developing a single set of pages. Yet knowing that the biggest discrepancy lies in fonts and colors will help. I suggest testing pages in the two main browsers, Navigator and Explorer, and possibly on the Mac and PC. This gives you a broad enough base to see if there will be major problems when you deliver your pages.

Summary

In this chapter, you have read about the major considerations concerning the platform independent nature of the Web browser. As you have seen, there are many variables associated with Web pages, predominantly due to differences in the operating system as well as individual differences in the browsers themselves. Trying to microscopically track these differences is nearly impossible. But acknowledging the major hurdles involved with development will help you produce better pages for cross-platform and cross-browser delivery.

Next Steps

Now that you have taken a look at the browser and how it affects what is displayed as you are surfing:

• Examine chapter 17, "Utilizing Bitmap Graphics," to find out more about bitmap graphics in Web pages.

• Take a look at chapter 18, "Managing Color Differences," to find out more about cross-platform color issues.

• Read chapter 20, "Using Layered Web Pages and Other Effects," to find out more about dynamic fonts and other new features.

QUESTIONS

Q *Where can I find out more information about Netscape and Explorer specific extensions to HTML?*

A Unfortunately, it can be somewhat difficult to dig up this information mainly because it is constantly changing. Because the information is transient in nature, the best place to find out about it is at either Netscape's site (www.netscape.com) or Microsoft's site (www.microsoft.com). With the preview release of Communicator as well as the upcoming release of Explorer 4.0, putting the assumed extensions for these browsers in this book is somewhat absurd because they will undoubtedly change by the time this book is printed. The best place to look for information that frequently changes (transient information) is the Web.

Q *Where can I find out more specific information about the specifications of HTML 3.2?*

A All of the specifications are housed at the World Wide Web Consortium's Web site at www.w3.org. This is the ratifying body composed of various organizations and institutions that decide what will and will not be included in the various HTML versions. You can find out the complete details about what is and what is not part of the "official" HTML 3.2 language.

Q *I like using my HTML generator (PageMill, Front-Page, etc.) but I notice it sticks extra tags and attributes into my Web page. What are these for?*

A One of the things that generator applications are notorious for is inserting unneeded tags and attributes into a Web page. Often, creating a page in these programs is frustrating when you go back and try to manually edit the page. Even for someone who knows the language, editing an HTML page generated from these programs is a bother. Unfortunately, there is no easy way around this—these programs automatically add the extra tags and attributes.

Q *Where can I find out more information on dynamic fonts? Will it be supported in other browsers?*

A You can find out more about dynamic fonts from Netscape's site as well as Bitstream's site at http://www.bitstream.com/. As far as support by other browsers, such as Internet Explorer, well, that remains to be seen.

HTML Primer: Tags and Formatting

In the preceding chapters, you started to look at the global issues that surround Web design. As you have read, Web design entails a wide variety of elements with which you must contend: from making your pages interesting to developing around the audience, your connection and browser. There is much to understand besides just HTML.

The essence of what makes the Web work is the Hypertext Markup Language, or HTML. Designed for simplicity, it is this language that will allow you to format your documents in all kinds of ways. Although as a beginner it may seem to have endless capabilities, realize that there are limits to what you can do with HTML.

Throughout the remainder of this book, you will look at the variety of interactive designs you accomplish with HTML. As you have probably noticed, much of this book focuses on tables, frames, graphics, and multimedia elements. The reason is that these are the main elements you will probably want to use when building interactive pages. Tables give you more control over the layout of the elements on your pages. As you will quickly see through the examples in this chapter, HTML is not very precise when compared to layout programs such as Word, PageMaker, or Quark. It is difficult to get the same look over and over without the use of tables.

Frames, on the other hand, allow you to divide up the screen into multiple windows. Again, the main purpose is to give you more control over the layout of your pages on the screen. Frames also give you some other benefits. You will review these other benefits in the chapters devoted to frames that appear later in this book.

As for the multimedia and graphics chapters, they are the crux of what is so special about the Web. Undoubtedly, these are the elements that draw so many people to the Web.

Yet, before you can dive into the real focus of this book—the cool stuff—we have to start at the beginning. This chapter is aimed at getting you started with HTML. If you have prior experience with basic HTML, you may be able to skip right to the next chapter. However, even if you have had some experience with HTML coding, it may be beneficial to at least browse this chapter. In this chapter, we introduce a little history, look at the structure of the language, as well as some of the common formatting it offers.

OBJECTIVES

In this chapter, you will:

• Look at the origin of HTML and how it ties into other languages such as SGML.

• Examine the four basic parts of an HTML document.

• Learn about tags, attributes, comments, and the HTML code structure.

• Acknowledge the difference between block- and text-level tags.

• Learn how to use lists, paragraphs, and other block-level formatting.

• Understand the use of the line break and the horizontal rule.

• Learn how to integrate images with HTML.

• Learn how to use anchors for extrasite links, intrasite links, and targets in documents.

Origins of HTML

The Hypertext Markup Language (HTML) is a subset of the Standard Generalized Markup Language (SGML). Created by Tim Berners-Lee in 1989, HTML was, and still is, based on SGML. SGML is a system for defining structured documents that can be ported from one machine to another without having to deal with extraneous hardware and software issues. Like its big brother, HTML performs this same function.

The idea behind SGML was to use embedded tags to describe all the elements of a particular document or program. The tags do not make specific references to elements that are inherent to any machine or platform. Due to this, the file can be transferred to any machine, read, and displayed. SGML was designed to create portable, independent documents and programs that could outlast any particular machine, operating system, or application.

Note: Although SGML is often overshadowed by HTML, it still is in wide use today. It often is used in documents that utilize complex search engines and text manipulation schemes. Often it is associated with large catalogs, digital dictionaries, and encyclopedias in which the capability to utilize the text of the document is extremely important. SGML also can be used in high-end multimedia programs and applications. For a comprehensive description of SGML, refer to the International Standard ISO 8879 or check the World Wide Web Consortium's Web site at http://www.w3.org.

HTML does not include all elements of SGML. It is actually much simpler. It also includes one other significant feature: the capability to utilize hypertext, or the ability to jump from one document to another via a hotlink. Basic hypertext environments such as the Windows Help menu are not new; most people use them on a day-to-day basis. However, the ability to create your own individualized hypertext environment is powerful and unique.

When HTML was first introduced, it had relatively few tags; the first version had as few as 30 tags that could be used to define a document. When version 2.0 of HTML was adopted and introduced, it provided many more tags and attributes that could be used to define and create a viewable document.

Today we are at version 4.0 of HTML. This book introduces most of the features related to visual formatting, all of which existed in version 3.2. The biggest difference between versions 3.2 and 4.0 is the addition of special tags for nonvisual browsers such as text readers for the blind. Currently, Netscape and Explorer 4.0 support all of the HTML tags we will discuss.

Note: If you are interested in checking out the latest developments in HTML, check out Yahoo!'s information at http://dir.yahoo.com/Computers_and_Internet/Information_and_Documentation/Data_Formats/HTML/ or go directly to the World Wide Web Consortium at http://www.w3.org/MarkUp/. You may also wish to review the Web Accessibility Initiatives at http://www.w3.org/WAI/, which is focused on making pages more usable for individuals with disabilities.

As you begin to learn the basics of HTML, keep in mind that you are creating a semantic definition of a document; it is not a fixed layout. The actual compositing (rendering) of text, graphics, and multimedia elements is as much a result of the browser and platform as it is of the HTML code itself. As was discussed in the previous chapter, platform and browser can drastically affect what is rendered and displayed on a computer screen.

Cranking HTML Pages

There are several ways to create HTML documents. Because HTML files are simple ASCII text, you can use any ASCII text editor to generate HTML files. There are several commercial tools available that enable you to create Web-based documents quickly and easily.

Programs such as Microsoft FrontPage, Adobe PageMill, and Macromedia Dreamweaver are available and can speed your page creation time. Yet, an effective Web developer must have a firm knowledge of HTML. Over the past couple of years, many applications have been created to enable a person with little knowledge of HTML to

Figure 6.1 A very simple Web page.

Listing 6.1 HTML for Figure 6.1

```
<!DOCTYPE "HTML 4.0//EN">
<HTML>
<HEAD>
   <TITLE>A Very Simple Web Page</TITLE>
</HEAD>
<BODY>
   <H1 ALIGN=CENTER>Hello to all my friends</H1>
</BODY>
</HTML>
```

create HTML pages and Web sites. For example, Microsoft FrontPage makes managing and creating a Web site a visual rather than code process. With each of these tools, knowledge of HTML programming is still required. Often you will want to do something that you have seen on the Web, but cannot get your generator to do it. Maybe it is a special frame setup or form and your generator cannot create it.

You should make learning HTML a prerequisite to buying a code generator. After you understand how to generate hard code (by typing it from scratch in a text editor), generators can be handy. But you must first understand the code that the generator creates. The problem with learning HTML from a generator is that generators often add browser-specific HTML tags or "junk" code that are not defined in the HTML specification. This makes it difficult even for experienced HTML writers to decipher HTML code from a generator.

In addition, many code generators still have problems creating specific items. Ultimately, you will have to learn the language because there are still things that you cannot effectively or efficiently accomplish with these programs. Learn the language and you can do anything the language supports. Learn a generator and all you can do is what the generator supports. This does not mean you have to learn every style tag or attribute by heart, but you should know the basics of HTML code so that you can fix any problems that arise as well as create code structures that some generators do not support.

One of the best ways to learn HTML is by using a simple text editor. By forcing yourself to enter code manually, you learn much more about the programming style than through the use of an automated HTML application. It may be preferable to use a text editor over a generator because a text editor offers more control.

Learning to Speak HTML

HTML uses primary code words to define different elements within a document. These primary code words are called tags. In addition, each tag can have its own settings or parameters, which are called attributes. You can identify tags in HTML code by looking for the carets (< >) that surround them. HTML tags almost always appear in pairs such as <H3>Some Text</H3>. The first tag is called the "opening tag." The second tag adds the forward slash (/) making it the "closing tag." Some tags, such as the <P>, or paragraph tag, do not require a closing tag. In Figure 6.1 you see an example of a very simple Web page. Listing 6.1 shows the code used to generate this page.

You can use the heading tag, <H1>, to create a line of text that says, "Hello to all my friends" as shown in the listing. The tag is <H1>. However, notice the words ALIGN= CENTER inserted into the opening tag. In addition to simply placing the text on the page, the line of text can be aligned left, right, or center using the heading tag's ALIGN attribute. This, like all attributes, is something

you can define at will. If you do not define a value for an attribute, a default value is assumed. The default for alignment in the paragraph tag is left justification.

Note: *Tags and attributes are not case sensitive. It does not matter whether you enter tags in uppercase or lowercase, but you should be consistent. Either use all caps (as in the examples), or all lowercase to make it easier to read. If you use all caps for tags and attributes, you can easily scan a page of code and distinguish content text from formatting tags.*

As you read, the attribute ALIGN=CENTER is an attribute for the tag <H1>. Attributes are always inserted directly into the tag and most attributes have a value. Every tag will use its default value for an attribute if you do not include the attribute in the tag. Even though the preceding example was rudimentary, this is how all tags and attributes are used. Tags are the main or primary HTML code words, whereas attributes are settings or optional parameters for those tags.

There are many tags or code words in HTML. You will find that for many of the HTML tags, there are more attributes than what are presented in the chapters of this text. Each code word (tag) has its own options, or attributes.

Syntax

As with any formatting language, there are basic rules of speech for HTML that you must learn and follow. As an HTML programmer, one of the most frustrating things is to program a page and have errors appear because you typed the wrong character. Searching a page for a single typographical error is a bother, but it is necessary.

As you learned earlier, each tag can be identified by the carets that surround it, such as <H1> or <P>. Each tag has attributes and values, such as the ALIGN=CENTER option you saw previously, as well as external values such as <H1> Hello to all my friends </H1>, where Hello to all my friends is the external attribute. You must be sure that each tag you enter begins properly and ends properly. Note that the line starts with <H1> and ends with </H1>. Usually the ending tag causes problems—if you forget to add it and it is required—but misspellings and

unintentional characters will also cause problems. When a page does not appear correctly in a browser, check for typographical errors and tags that are left open.

Note: *Several tags in HTML do not need a closing tag. The <P> or paragraph tag is an example of this exception. However, you will find that most require a closing tag. Get in the habit of closing every tag. Remembering those that need to be closed and those that can remain open is difficult, so close them all.*

Leaving closing tags off may be confusing later when you try to figure out why the page is not working.

In addition to spelling and unintentional characters, HTML does not recognize concurrent spaces. A double space (concurrent space) in a line of text will appear in a displayed document as a single space. The same is true of extraneous spacing in a document. The browser will ignore all extraneous spaces in a Web document. In the previous example (Figure 6.1), the browser ignored the indenting at the beginning of the lines as well as between lines of code. They are shown this way in the examples to make them easier to read; however, the browser will ignore the indenting.

Comments

In any programming language, it is customary and recommended to add internal documentation to the code that you crank out. Often, you can use internal documentation to help find certain lines of code as well as insert special comments or information for people who might be reviewing your HTML code.

HTML includes a special tag that enables you to insert comment lines within the HTML files you create. A comment line is a line that is ignored by the browser or other interpreting program. Comment lines are used to insert programmer comments or descriptions of what certain portions of the code do. A comment line begins with <!— and ends with —>. A comment line looks like the following:

<!— Created by J.L. Mohler 5-25-99 —>

It is always a good idea to include a comment line such as this so that you know the last date the file was modified as well as who created it. You might want to use comment lines throughout the document to help you remember what does what in the code.

Resources

There are many different resources on the Web that provide information on HTML programming. If you would like more information, exercises, and examples on HTML coding beyond what is covered in this book, you might want to check out the sites listed at Yahoo! or do a search on the Web for HTML.

Note: Do not forget that you have one of the best HTML resources connected right to your computer. If you are having trouble coding a page and you know how you want it to look, surf the Web and find a page that looks like what you are trying to generate. Most browsers allow you to view the source code using the Document Source or Source option. One of the best ways to learn good programming skills is to look at code that has already been created by an experienced programmer.

The Basics of a Document

Every HTML document has the same general structure. This includes pages that use complex scripts and multimedia elements. Over time there have been tag and attribute additions to the language, but the overall structure is still the same. The primary parts of an HTML document are denoted by the <DOCTYPE>, <HTML>, <HEAD>, and <BODY> tags. The latter three are required elements, whereas the <DOCTYPE> tag is optional (but always suggested).

Each of these tags is known as document structure tags. Document structure tags are HTML tags that define and delimit the major portions or sections of the HTML document. They are the tags necessary for a viewing program (browser) to properly interpret the HTML file.

Note: Although each new version of HTML provides new tags and attributes, keep in mind that the browsers many people are currently using might not support every new or existing feature. Just because HTML enables a tag to be used does not mean that all browsers support the new tags. This does not mean that you cannot use these tags, but it does mean that the new tags and attributes will not have any effect (or may have adverse effects) when viewed in older browsers. Therefore, it is vital to test your pages in as many browsers as possible, at least in a version of Netscape and a version of Internet Explorer.

TIP: *You can install multiple browsers on your machine for testing purposes. With Netscape, you can install as many versions as you want. For example, I have six different versions on my machine for testing. One caveat, however, is that you can only have one version of IE installed—due to the way it works. Yet, you can have both Internet Explorer and Netscape Communicator or Navigator installed on the same machine. If you have enough RAM and a decent connection, you can even run them both at the same time.*

The <DOCTYPE> Element

The first line that should be included in any HTML document is the <DOCTYPE> tag. The <DOCTYPE> tag specifies what version of HTML is being used and to what governing body and specification the document conforms.

For example, the simplest <DOCTYPE> line can look like

<!DOCTYPE "HTML 4.0//EN">

This line simply says that the file is an HTML 4.0 file.

Another <DOCTYPE> line might look like

<!DOCTYPE HTML PUBLIC "-//W3C//DTD HTML 4.0//EN">

This line says that the document uses the HTML 4.0 document type definition (DTD) developed by the World Wide Web Consortium (W3C).

Most code generators will automatically add this tag and its associated attributes. However, you will find that many

people do not use the <DOCTYPE> tag when manually coding their HTML pages. In fact, you do not have to use it for the page to load properly. Yet, it is recommended and even specified as mandatory by the W3C.

The <HTML> Elements

In order for the browser to open the HTML file, it must be told that the file actually is an HTML file. You can do this within the document by marking the beginning of the file with the <HTML> tag and the end of the file with the </HTML> closing tag. The <HTML> tag marks the beginning of the file, and the </HTML> closing tag marks the end of the file. All HTML files must have these tags to work properly. All other tags, excluding the <DOCTYPE> tag, must reside within the <HTML>...</HTML> tags.

The <HTML>...</HTML> section of the document is divided into two different sections. Like most digital files, the first part is called the header or head. This section is marked by the opening and closing <HEAD>...</HEAD> tags. The second part of the HTML section is the body, which holds the actual description of the elements to be shown in the browser work area. The body is marked by the <BODY>...</BODY> tags.

The <HEAD> Elements

The head section of an HTML document describes the various characteristics of the document itself. Much like the items on the cover of a book or the heading of a letter, the header section describes several specific attributes of the HTML document.

Probably the most widely used tag in the <HEAD>...</HEAD> section is the <TITLE> tag. This particular tag is required for the document to load properly and is the only one that is actually displayed in the browser interface. All other tags specified in the <HEAD>...</HEAD> section are not displayed in the browser's work area.

TIP: *Two things must be noted about the <TITLE> tag. Make sure the length of your title does not exceed 60 characters. As with any application, the number of characters that can be displayed in the title bar is limited. Excess characters will cause the title to be truncated.*

You also want to make sure that the title line is descriptive of your page. Many Web site search engines use the data contained in the title to conduct searches. Using a title such as My Homepage will mean very little to a search engine that operates this way. Use descriptive titles to describe your pages. Bookmarks also use the title.

Warning: The <TITLE> tag, as well as the other tags that can be used in the header section, must be completely contained within the <HEAD>...</HEAD> tags. Misplaced tags can cause unexpected results.

In addition to the <TITLE> tag, the other tags that can be used in the header section are:

<ISINDEX> - Used for simple keyword searches.

<BASE> - Defines an absolute URL to use for relative URL links.

<STYLE> - Established for use with style sheets.

<SCRIPT> - Reserved for use with scripting languages.

<META> - Used to supply information that cannot be supplied anywhere else in the document.

<LINK> - Used to define the independent relationships of the current page with other documents in the Web structure.

The <BODY> Elements

Finally, you come to the most fundamental part of the HTML document. The second part of the HTML file, which is contained within the <HTML>...</HTML> delimiters and right after the </HEAD> tag, is the <BODY>...</BODY> tags. This section contains all of the instructions for laying out the HTML document. The <BODY>...</BODY> section defines the actual instructions for laying out graphics, text, multimedia, and other content elements in the browser's work area.

The <BODY> tag has several attributes, or settings, for the various items that occur within the body. You use attributes within the <BODY> tag to set the background color, to establish a tiling background image, or to set the color of various text elements. The attributes that can be used within the <BODY> tag itself include the following:

BGCOLOR="color" - Defines a background color for your Web document where color is replaced with a hexadecimal color value.

TEXT="color" - Defines the color of your document's normal text where color is replaced with a hexadecimal color value.

LINK="color" - Defines the color to be used for links you have not visited where color is replaced with a hexadecimal color value.

VLINK="color" - Defines the color to be used for links you have visited where color is replaced with a hexadecimal color value.

ALINK="color" - Defines the highlight color used when you click on a link where color is replaced with a hexadecimal color value.

Figure 6.2 A basic HTML file showing the document structure tags.

BACKGROUND="myimage.gif" - Defines an image to be tiled across your document's background.

Note: *An exception to the basic HTML file structure is the use of frames in the Web page. Whenever you use frames in a Web document, the <FRAMESET> tag will replace the body section of the document. You will read more about this in the chapters devoted to frames.*

Now that you have examined the basic structure of a Web document, look at an example showing them in use. In Figure 6.2 and Listing 6.2, compare the code

Listing 6.2

```
<!DOCTYPE "HTML 4.0//EN">
<HTML>
<HEAD>
  <TITLE>Viewing Document Structure</TITLE>
</HEAD>
<BODY TEXT="#000000" BGCOLOR="#FFFFFF" LINK="#CC9900" VLINK="#CC9900" ALINK="#EE1111">
  <H1 ALIGN=CENTER>Hello to all my friends</H1>
  <H3 ALIGN=CENTER>These are my links!</H3>
  <UL>
    <LI><A HREF="http://www.tech.purdue.edu">My School</A></LI>
    <LI><A HREF="http://www.tech.purdue.edu/cg/">My Department</A></LI>
    <LI><A HREF="http://www.tech.purdue.edu/cg/facstaff/jlmohler/">My Home
          Page</A></LI>
  </UL>
</BODY>
</HTML>
```

sample to what is displayed in the browser. Note the first line, which identifies the version of HTML that is being used. The definition of the start and end of the HTML document uses the <HTML>...</HTML> tags. The HTML section is divided into the header and body sections. The header section, marked by <HEAD>... </HEAD>, contains a title shown in the title bar of the browser, and the body section contains two headings and a link list (which we will discuss in a moment). In the body, we have also modified some of the characteristics of the document by using some of the body attributes. All HTML documents will conform to this basic structure.

Block- Versus Text-Level Tags

Most tags you will use will be contained within the <BODY> section of your documents. This makes sense because all of the data in this section composes what you see in the browser's work area. All of the body elements can be further subdivided based on what they actually enable you to define in the HTML file.

The two types of tags that occur within the body of the HTML file are block tags and text tags. A single document usually will contain an intermixed number of block and text tags. Both can be used simultaneously. The biggest distinguishing characteristic is that block tags cause paragraph breaks to occur around the tagged block of text, whereas text tags do not. Block tags are designed to enable you to create blocks of information on your pages. Text tags are designed to format or stylize individual characters, words, or paragraphs.

Let us begin by looking at the block tags. As a note, no matter whether you are manually coding or using a code generator it is usually best to begin formatting your document using block tags first. Then you can come back and apply text-level tags to individual elements.

There are many block tags that you can use in a document. Block tags include the following:

Headings, which are defined by <HX>...</HX>, where X can range from 1 (the largest heading size) to 6

Paragraphs, which are defined by <P>...</P>

Divisions of text (a special tag used with style sheets), which are defined by <DIV>...</DIV> or <CENTER>...</CENTER>

Unordered lists, which are defined by ...

Ordered lists, which are defined by ...

Definition lists, which are defined by <DL>...</DL>

Preformatted text blocks, which are defined by <PRE>...</PRE>

Quotations, which are defined by <BLOCKQUOTE> ...</BLOCKQUOTE>

Addresses, which are defined by <ADDRESS>... </ADDRESS>

Horizontal rules, which are defined by <HR>

Line breaks, which are defined by

Interactive forms, which are defined by <FORM>... </FORM>

Tables, which are defined by <TABLE>...</TABLE>

To understand how these work, let us look at some of them. We will not cover all of the block-level tags. But from the ones we do examine, you should get a good idea of their use.

Headings

The <HX> tag is one of the most commonly used block tags. This tag is used to represent titles, subtitles, and other headings by providing a single opening and closing tag that can be used rather than having to style the text using multiple text-level tags. The heading tags are often sought out by Web search engines and software robots that automatically compile lists of Web sites and their respective content.

The <HX> tag defines the headings for the HTML document, where X can equal a value of 1 to 6. Headings defined by <H1> are rendered in a larger font and are deemed the most important head. As the value of X increases, the font size and importance decreases as shown in Figure 6.3 (see also Listing 6.3).

*Figure 6.3 The use of various headings
to represent titles and subtitles.*

Figure 6.4 A basic heading with a paragraph.

Listing 6.3

```
<!DOCTYPE "HTML 4.0//EN">
<HTML>
<HEAD>
  <TITLE>Headings</TITLE>
</HEAD>
<BODY>
  <H1 ALIGN=CENTER>Heading Level 1</H1>
  <H2 ALIGN=CENTER>Heading Level 2</H2>
  <H3 ALIGN=CENTER>Heading Level 3</H3>
  <H4 ALIGN=CENTER>Heading Level 4</H4>
  <H5 ALIGN=CENTER>Heading Level 5</H5>
  <H6 ALIGN=CENTER>Heading Level 6</H6>
</BODY>
</HTML>
```

Listing 6.4

```
<!DOCTYPE "HTML 4.0//EN">
<HTML>
<HEAD>
  <TITLE>School of Technology</TITLE>
</HEAD>
<BODY>
  <H3 ALIGN=CENTER>School of Technology at
Purdue University</H3>
  <P>A hands-on, minds-on approach to
preparing students for business and
industry has skyrocketed the school to
national prominence with renowned faculty,
state-of-the-art laboratories, and highly
recruited graduates.
</BODY>
</HTML>
```

Paragraphs, Center, and Divisions

Text paragraphs in a Web document are the simplest type of block tag that can be used. There are three different tags that can be used to format paragraphs of text: the paragraph <P>, the center tag <CENTER>, and the division <DIV>. Which one you use is up to you but they all perform the same general thing—a paragraph of text followed by a blank space. The only differences are:

• The paragraph tag does not have to be closed.

• The center tag is automatically center justified.

• The division tag must be closed.

• Both the paragraph and division tags have an ALIGN attribute that can be set to LEFT, CENTER, or RIGHT.

Let us take a look at an example using the <P> tag (paragraph) and a heading. Figure 6.4 and its accompanying code shown in Listing 6.4 show a simple heading with a paragraph. Note that when no ALIGN attribute is defined in either tag, the default justification is left.

Using Lists

Another important block format is the list. HTML supports three types of lists. You have the choice of creating unordered lists (bulleted lists), ordered lists (numbered lists), or definition lists. Definition lists are special in that they allow you to present a term, and then indent the term's definition below the term.

Each uses a different tag and has its own set of attributes but they are somewhat similar. The following list shows the various types of lists and their tags:

• Unordered lists, which use the ... tags.

• Ordered lists, which use the ... tags.

• Definition lists, which use the <DL>...</DL> tags.

In combination with these list tags, you must also define the items that are to appear in the list called list items. You do this using the tag. This is a closed tag so you must make sure you also use the tag.

Since these three work similarly, let us add a list to our previous document. In Figure 6.5 a list has been added to the page. Listing 6.5 shows the code for the page. Notice how the list is delineated by the and tags with the list items ... appearing between them.

Note: You can create nested lists by defining a second list within the first. When you create nested lists, the sublist is indented and the bullets change to show the hierarchical structure.

Figure 6.5 Adding a list to the previous example.

Listing 6.5

```
<!DOCTYPE "HTML 4.0//EN">

<HTML>

<HEAD>

   <TITLE>School of Technology</TITLE>

</HEAD>

<BODY>

   <H3 ALIGN=CENTER>School of Technology at Purdue University</H3>

   <P>A hands-on, minds-on approach to preparing students for business and industry has
skyrocketed the school to national prominence with renowned faculty, state-of-the-art
laboratories, and highly recruited graduates.

   <UL>

      <LI><A HREF="http://www.tech.purdue.edu">My School</A></LI>

      <LI><A HREF="http://www.tech.purdue.edu/cg/">My Department</A></LI>

      <LI><A HREF="http://www.tech.purdue.edu/cg/facstaff/jlmohler/">My Home
            Page</A></LI>

   </UL>

</BODY>

</HTML>
```

Important Block Elements

Aside from formatting text blocks, you often want visual flow as well as formatting control beyond what the heading and paragraph tags can offer. The horizontal rule tag provides visual flow and the line break tag provides the ability to create a break within a body of text. Here we will take a look at these two very important block tags.

Horizontal Rules

One of the things that will help organize the information on your page into readable sections are horizontal rules, set off by the <HR> tag. A horizontal rule or <HR> tag automatically creates a horizontal line or divider between block elements.

The horizontal rule or <HR> tag is probably one of the most widely used elements on Web pages. The <HR> tag has many attributes or controls that you can use to define it. These include the following:

SIZE=X - where X specifies a thickness in pixels. The default is SIZE=2.

WIDTH=X - where X specifies the horizontal width in pixels (WIDTH=20) or as a percentage of the screen (WIDTH=50%). The default is WIDTH=100%.

ALIGN=X - where X is LEFT, RIGHT, or CENTER. This setting determines the alignment of the horizontal rule. The default is ALIGN=CENTER.

NOSHADE - Turns off the embossed look of the rule. By default, shading is turned on.

Figure 6.6 shows multiple, consecutive <HR> tags. Listing 6.6 shows the code used to define the page. Although you would not normally create a page like this, notice how the attributes affect the rules that are displayed.

The default width (thickness) of horizontal rules is 2, the default length (width) is 100%, and the default alignment is center justified. Adjusting the size changes

Figure 6.6 Multiple horizontal rules.

Listing 6.6

```
<!DOCTYPE HTML 4.0//EN>
<HTML>
  <HEAD>
    <TITLE>Horizontal rules</TITLE>
  </HEAD>
  <BODY>
    <HR SIZE=1>
    <HR SIZE=2>
    <HR SIZE=4>
    <HR SIZE=8>
    <HR WIDTH=200>
    <HR WIDTH=200 ALIGN=LEFT>
    <HR WIDTH=50%>
    <HR WIDTH=50% ALIGN=LEFT>
    <HR SIZE 8>
    <HR SIZE 8 NOSHADE>
  </BODY>
</HTML>
```

the thickness of the rule. Changing the width changes the length of the rule, which also shows that the default for the ALIGN attribute defaults to ALIGN=CENTER, or center justification.

As you work with rules, keep in mind that the color of the highlight and shadow colors of the rule will be determined by the background color of the document. This is set with the BGCOLOR attribute in the <BODY> tag. In addition, if you specify a length using the WIDTH attribute, the width will be dependent on the user's current display setting. It is better to use percentages than specific pixels settings.

Note: If the user's display is set to a small screen resolution and you define an <HR> length longer than his or her screen, the user will have to horizontally scroll to see all your page. As most will agree, this is not preferred. You must design your pages for the lowest common denominator. Assuming that everyone browsing your page has an 800 x 600 display or a 1024 x 768 display is not safe. Today most users surf the Net at a 640 x 480 resolution. It is recommended that you do not design pages that extend beyond 640 pixels.

Line Break

As you are writing HTML code, you will often define a paragraph or other block element and want the text to be separated a certain way. The
 tag enables you to insert a line break or "carriage return-line feed" into block elements so that you can force a line break within tags.

You can use the
 tag to insert line breaks into documents where you want the elements to resume at the next line. For example in Figure 6.7, notice the continuous string of the name, title, and institution. This does not really look very good. It would look better if the three items followed one another. We could use a list but we do not want bullets. We could use successive <P> tags but there would be a blank line after each element. This is a perfect example of a place to use the
 tag.

Figure 6.7 A continuous line of text that does not look very good.

Listing 6.7

```
<!DOCTYPE HTML 4.0//EN>
<HTML>
 <HEAD>
   <TITLE>Need to break a line?</TITLE>
 </HEAD>
<BODY>
 <H3>James L. Mohler
 <BR>Assistant Professor
 <BR>Purdue University
 </BODY>
</HTML>
```

*Figure 6.8 Adding
 tags causes the text to jump to the next line.*

To make the text appear correctly (or in a more visually pleasing way) let us use
 tags. As shown in Listing 6.7,
 tags are inserted right into the other block tags. This causes the text to jump to the next line and continue, as shown in Figure 6.8. Any time you want a line of text to be forced to the next line, you can insert a line break with the
 tag.

Text-Level Tags

As you have seen, block tags are effective for formatting blocks of text information. Yet, with only block tags you have nothing more than static pages with no links, graphics, or visual appeal. Text-level tags enable a developer to provide many of the stylized effects found in Web pages, such as links, graphics, and multimedia elements.

Text-level tags are different from block tags in that they do not add a blank line before and after an element. When you use a text-level element, it does not change the formatting or how the element is arranged. These tags do not cause paragraph breaks to occur. Text-level tags that affect text elements are generally nested inside a block tag or even within another text-level element. Sometimes, text-level tags may stand alone.

Physical and Logical Text Styles

To begin, let us look at the most basic text-level tags— those used for formatting words, phrases, or paragraphs. These tags can actually be divided into two groups: physical and logical styles. Although the difference may seem like splitting hairs, for accuracy we will describe them as defined by the W3C.

A physical style is probably the most frequently used type of these two styles (physical and logical). For example, you may want to italicize a string of text. By using the logical <I> tag style to italicize it, the text will be italicized when viewed in the browser. No matter where you view it, or on what platform, the text will be italic. The italicized text draws attention to only the text itself. However, the idea behind logical style is that the style not only draws attention to the font but it also communicates something else. For example, maybe you want to not only draw attention but also have the text communicate something such as a caution or other notable attribute. In this case you could use a logical style such as for emphasis. When you use a logical style, the rendering of the item is determined by the browser. On one browser it may appear as italic, on another it may appear bold, and on another it may appear as both italic and bold. Logical styles are fluent styles that are rendered based on the browser and platform. A physical style is a fixed style that will always appear bold, italic, and so on.

Physical Styles

A physical style affects a font style to simply draw attention to the font itself. It communicates no other information through the formatting of the text. Physical styles are straightforward. They require both a beginning and ending tag. The following are physical styles:

<TT> - Creates teletype or monospaced text

<I> - Creates italic style text

 - Creates bold style text

<U> - Creates underline style text

<STRIKE> - Creates strikethrough style text

<BIG> - Renders the text larger than the surrounding text

<SMALL> - Renders the text smaller than the surrounding text

<SUB> - Attempts to place the text in subscript style

<SUP> - Attempts to place the text in superscript style

Figure 6.9 shows an example of the various physical style tags. Listing 6.8 shows the code for the page. Note in the code for this page the intermixing of block tags (and) and text-level tags <I>. This is how you combine these two major types of tags to create Web pages.

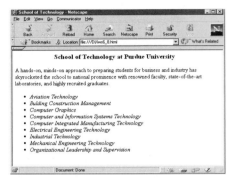

Figure 6.9 Intermixing block- and text-level tags to create a page.

Logical Styles

Logical styles are coded exactly like physical styles, but they are different because they also convey meaning behind the way they are formatted. Note that the main difference is the logical style's formatting changes depend on the browser that is defining it.

Again, using logical styles in your code is much like using physical styles. The following are the logical style tags:

 - Renders the font with emphasis

 - Renders the font with strong emphasis

<DFN> - Specifies a defining instance of the stylized text

Listing 6.8

```
<!DOCTYPE "HTML 4.0//EN">
<HTML>
<HEAD>
  <TITLE>School of Technology</TITLE>
</HEAD>
<BODY>
  <H3 ALIGN=CENTER>School of Technology at Purdue University</H3>
  <P>A hands-on, minds-on approach to preparing students for business and industry has
skyrocketed the school to national prominence with renowned faculty, state-of-the-art
laboratories, and highly recruited graduates.</P>
  <UL>
    <LI><I>Aviation Technology</I></LI>
    <LI><I>Bulding Construction Management</I></LI>
    <LI><I>Computer Graphics</I></LI>
    <LI><I>Computer and Information Systems Technology</I></LI>
    <LI><I>Computer Integrated Manufacturing Technology</I></LI>
    <LI><I>Electrical Engineering Technology</I></LI>
    <LI><I>Industrial Technology</I></LI>
    <LI><I>Mechanical Engineering Technology</I></LI>
    <LI><I>Organizational Leadership and Supervision</I></LI>
  </UL>
</BODY>
</HTML>
```

<CODE> - Renders the font as representing extracted code

<SAMP> - Renders the font as representing output from a program or application

<KBD> - Renders the font as representing text that the reader should enter

<VAR> - Renders the font as representing variables, arguments, commands, or instructions

<CITE> - Renders the font as a citation or reference to another source of information

Working with Images

The wonderful thing about the Web is that you can do almost anything you want with images. However, as you have learned, you must cautiously integrate graphics so that you do not tax the user's hardware or their patience. Inline images are images that are directly integrated within the document or Web page. The primary tag for integrating all graphics is the tag.

The tag

The tag is used to reference a graphic image file to be included in the display of a Web page. When you are using graphics on your Web pages, you have several options for how you want the graphic to be displayed. Whether you want it aligned left, want a border around it, or if you want a specific amount of space around it, all of these characteristics can be controlled using the tag's attributes. They include the following:

SRC - Defines the image filename and path to be included in the Web page. This is a required attribute for the tag.

ALT - Specifies alternative text that should be displayed in nongraphical Web browsers. It also displays the asso-ciated text as the graphic being downloaded. Although the ALT attribute is not mandatory, it should be.

ALIGN - Controls the alignment of the image in relationship to the text surrounding the image. Valid options are TOP, MIDDLE, BOTTOM, LEFT, RIGHT.

WIDTH - Specifies the intended width of the image in pixels. When this attribute is combined with the HEIGHT attribute, the browser shows a blank box for the image in the browser as the image is loading. If the ALT attribute is also used, the text will display in the blank box.

HEIGHT - Specifies the intended height of the image in pixels. When this attribute is combined with the WIDTH attribute, the browser shows a blank box for the image in the browser as the image is loading. If the ALT attribute is also used, the text will display in the blank box.

BORDER - Specifies the size of the border for the image. The default is BORDER=2. With BORDER=0 the border is suppressed.

HSPACE - Specifies, in pixels, a specific amount of white or negative space to be left on the left and right of the image. The default is a small, non-zero number less than 1.

VSPACE - Specifies, in pixels, a specific amount of white or negative space to be left on the top and bottom of the image. The default is a small, non-zero number.

USEMAP - Specifies that the image be mappable by a client-side image map. This attribute is used in conjunction with the <MAP> tag.

ISMAP - Specifies that the image is an image map. Regions of the image are defined as hypertext links.

LOWSRC - Specifies a low-resolution image to display while the higher, true source image is being downloaded.

Inserting Images

Throughout the rest of this book we will use the tag frequently, but before you move on, take a quick look at the tag in action. Figure 6.10 shows a series of images that have been inserted using the tag. Listing 6.8 demonstrates that specific sizes have been set using the WIDTH and HEIGHT attributes and that the spacing around the images has been set using the HSPACE and VSPACE attributes. In addition, there are borders around the images.

Note: *In Listing 6.9, note the use of , which inserts a nonbreaking space. HTML provides for special (as in these spaces) and non-English language characters through the use of ASCII codes.*

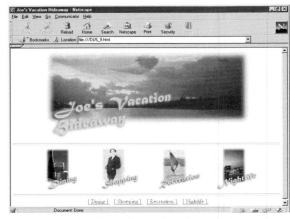

***Figure 6.10** Using the tag to insert images.*

Listing 6.9

```
<!DOCTYPE "HTML 4.0//EN">
<HTML>
  <HEAD>
    <TITLE>Joe's Vacation Hideaway</TITLE>
  </HEAD>
  <BODY BGCOLOR="#FFFFFF" TEXT="#FFFFFF" LINK="#334557">
    <CENTER>
        <IMG SRC="9a.gif" BORDER=0 WIDTH=569 HEIGHT=254>
    </CENTER>
    <HR SIZE=4>
    <CENTER>
        <A HREF="dine.html"><IMG SRC="9b.gif" BORDER=0 HSPACE=30></A>
        <A HREF="shop.html"><IMG SRC="9c.gif" BORDER=0 HSPACE=30></A>
        <A HREF="rec.html"><IMG SRC="9d.gif" BORDER=0 HSPACE=20></A>
        <A HREF="night.html"><IMG SRC="9e.gif" BORDER=0 HSPACE=20></A>
    </CENTER>
    <HR SIZE=4>
    <CENTER>
        <A HREF="dine.html"> [ Dining ] </A>    
        <A HREF="shop.html"> [ Shopping ] </A>   
        <A HREF="rec.html"> [ Recreation ] </A>   
        <A HREF="night.html"> [ Nightlife ] </A>   
    </CENTER>
  </BODY>
</HTML>
```

Working with Anchors

Images that appear in Web pages would not be possible if the tag did not exist. Similarly, hypertext capability would not be possible without the anchor tag, <A>. The <A> tag enables you to make almost anything a hotlink to the outside world or to another page at your site. The <A> tag can be used with graphics, text, and multimedia elements.

To make the various elements hyperlinks you must use the attributes of the <A> tag. The following attributes can be used with this tag:

NAME - Used for targeting specific portions of a Web document. Valid entries for the NAME attribute are strings such as part1, part2, and part3.

HREF - Used to specify a URL address that links the item with the site. Clicking the item sends the browser to the URL address specified in the HREF attribute.

REL - Defines the forward relationship of the current page. This is the next page in the site's structure.

REV - Used to define the backward relationship of the current page.

TITLE - Used as a title for the linked resource.

Next, let us take a look at a few examples using some of the <A> tag's attributes. All links inside a document can be considered either internal (that is, links within a single site) or external links (links to other sites on the Web), in relationship to the current page. The most common type of link is the external link—the link to another Web site's page.

Creating Links

When the <A> tag (anchor) uses the HREF attribute to define Web address, the link is considered an external link. This means that when the user clicks the link it will take him to another site or page.

Figure 6.11 shows the most common use of the <A> tag. Listing 6.10 shows the code for the page. In Listing 6.10, notice the <A> tag used within the list items. The HREF attribute in each anchor defines the site or page to which the link points. When the user clicks, this is where he or she will be sent. Presenting a list in this way can be effective, but it is quite simple. Notice that, again, we are combining text-level tags with block tags to create the pages, nesting the text-level tags into the block tags.

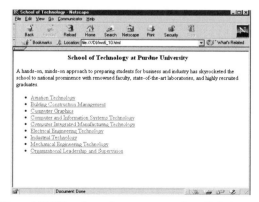

Figure 6.11 Using the anchor tag to create hyperlinks in a page.

Listing 6.10

```
<!DOCTYPE "HTML 4.0//EN">
<HTML>
<HEAD>
   <TITLE>School of Technology</TITLE>
</HEAD>
<BODY>
   <H3 ALIGN=CENTER>School of Technology at Purdue University</H3>
   <P>A hands-on, minds-on approach to preparing students for business and industry has
skyrocketed the school to national prominence with renowned faculty, state-of-the-art
laboratories, and highly recruited graduates.</P>
   <UL>
   <LI><A HREF="http://www.tech.purdue.edu/at/">Aviation Technology</A></LI>
```

```
    <LI><A HREF="http://www.tech.purdue.edu/bcm/">Building Construction
Management</A></LI>
    <LI><A HREF="http://www.tech.purdue.edu/cg/">Computer Graphics</A></LI>
    <LI><A HREF="http://www.tech.purdue.edu/cpt/">Computer and Information Systems
Technology</A></LI>
    <LI><A HREF="http://www.tech.purdue.edu/cimt/">Computer Integrated Manufacturing
Technology</A></LI>
    <LI><A HREF="http://www.tech.purdue.edu/eet/">Electrical Engineering
Technology</A></LI>
    <LI><A HREF="http://www.tech.purdue.edu/it/">Industrial Technology</A></LI>
    <LI><A HREF="http://www.tech.purdue.edu/met/">Mechanical Engineering
Technology</A></LI>
    <LI><A HREF="http://www.tech.purdue.edu/ols/">Organizational Leadership and
Supervision</A></LI>
  </UL>
</BODY>
</HTML>
```

As you create external links, keep in mind that the HREF attribute can be used to link to sites, specific pages, and e-mail addresses. In previous examples, you have seen the scenario used to link to an external site such as the following:

 Purdue's School of Technology

When you use the <A> tag in this way, the browser will look for a page called INDEX.HTML at the root level of the Web server. Whenever you specify a Web address with no page specification, the browser will look for a page called INDEX.HTML.

As you develop sites and pages, keep this tidbit concerning pages named INDEX in the back of your mind. Every major directory of your site should have a page named INDEX.HTML to make your site surfer-friendly. Because the name of Web pages at almost every site changes constantly, it often can be difficult when you go to use a specific Web address that has a page name as part of its destination. Often you will find that the page has been renamed, making the Web address incorrect (when it ends with a page destination).

For example, suppose you enter a Web address such as http://www.site.com/notsmart/webpage.html into a browser's Web address field. When your browser tries to access it, it says, "Page not available or not found." Unknown to you, the developer at this site changed the name of webpage.html to Webpage.html. The page is there, but your address is not correct because the page name has changed. Remember that Web site addresses are case-sensitive! If the developer has named all pages in all directories using custom names, you have a problem. You cannot access any of the pages at this site unless you know the starting page's name.

In another example, the developer of a site is aware of the INDEX.HTML rule. Suppose the address of the site is http://www.site.com/verysmart/index.html. In this scenario, you can enter the site address and your browser will find it. In addition, because the browser automatically looks for INDEX.HTML, you could enter http://www.site.com/verysmart/ and still find the page. Assuming that every directory on this server has an INDEX page, you could enter all of the following and be able to get onto their site:

http://www.site.com/verysmart/index.html

http://www.site.com/verysmart/

http://www.site.com/

Indeed, using the default page INDEX.HTML is very smart and makes your site surfer-friendly.

TIP: *Web anchors also can be used to insert e-mail addresses into Web pages. This gives the audience a direct route for sending you e-mail rather than having to write down or digitally copy the address to their mail program. Clicking on an e-mail link will automatically open your e-mail program.*

To integrate an e-mail address as a link on your page, enter code similar to the following:

* Email Professor Mohler. *

Creating Targets

In addition to creating external links, you also can create links within a single page using targets. Pages that have links to other sections in the same document are called internal links.

For example, suppose you have a very long page and the document has several defined sections that are identified by heading tags. To see the entire document, the user must scroll down, very far down your page. It is possible to create a list at the top of the page with the items linked to other sections of the long page. Clicking an item in the list at the top of the page automatically jumps you down the page.

To create an internal link you must create two things. First, you must establish a jump-to point in your document. You do this by using the <A> tag with the NAME attribute. For example, somewhere in your document you would create a tag that says

 This is the text that appears at the jump to point.<A>

The second item you must create is the actual link. More than likely at the top to the page you would create a list of link items, one of which would represent the link to your jump-to point. The list item that is linked to your jump-to point would look like the following:

 Go to jumpto point

When the document is viewed in the browser, the line would look like any other hypertext link. However, when a user clicks it, the link would jump further down the document.

Internal links often are placed at the beginning of major sections of a document. Suppose a document has five major sections that include an abstract, introduction, description, conclusion, and references. You could embed jump-to links in the headings for these elements by using code that looks like this:

...

<H3> Abstract </H3>

...

<H3> Introduction </H3>

...

<H3> Description </H3>

...

<H3> Conclusion </H3>

...

<H3> References </H3>

...

Then at the top of the document you could create a list of elements that would enable your readers to quickly jump to the various sections of your document. The code for the list might look like this:

<OL TYPE="I">

 <LH> Table of Contents


```
<LI><A HREF="#abstract"> Abstract </A></LI>

<LI><A HREF="#intro"> Introduction </A></LI>

<LI><A HREF="#descript"> Description </A></LI>

<LI><A HREF="#conclude"> Conclusion </A></LI>

<LI><A HREF="#references"> References </A></LI>

</OL>
```

Using internal links can be effective for pages that are quite long; however, do not overuse them. Many times, it becomes difficult for the audience to differentiate between internal and external links because they appear exactly the same in the browser. Use these types of links only when the document is very lengthy.

Summary

In this chapter, we have focused on defining the basic parts of HTML. You have seen that the entire language is composed of tags, the main code words, and attributes—the optional settings for those code words. HTML can be divided into block tags and text tags. Block tags enable you to format your documents into blocks of information. Yet, with only block tags you have no graphics, no links, and very little style or visual appeal.

Text-level tags provide the necessary means for inserting graphics, stylizing text, and providing hyperlinks. You have also taken a look at physical and logical styles and become familiar with the two most powerful tags, the and <A> tags. In the chapters that follow, we will continue to examine HTML through an extensive view of tables and frames. Then we will examine ways in which you can extend the capabilities of HTML through animation, video, sound, and multimedia.

Next Steps

Now that you have taken a look some of the basic HTML tags:

• Check out chapter 22, "Animating Your Web," for more information on utilizing animations at your Web site.

• Read chapter 23, "Integrating Multimedia in Your Pages," to find out more about HTML related to Web multimedia elements.

• Examine chapter 24, "Utilizing Plug-in Capabilities," for information on other Web media plug-ins.

QUESTIONS

Q *What is a code generator? What is the disadvantage of only learning how to use a generator versus learning the HTML code?*

A A code generator is a visual HTML layout program in which you can create Web pages and sites visually rather than through hard coding a page or site in a text editor. It is like the difference between creating cookies from scratch (which I am no good at) versus using slice and bake cookies (a godsend for me).

The disadvantage to learning a generator rather than the language is that many generators do not fully support all the features of the language. When I create slice and bake cookies I am limited to the variations that the cookie dough company makes; I never learn to make my own unique variations. However, if I learn to bake cookies from scratch, I can create more unique or elaborate creations. The same is true with generators versus hard coding a page. You will often have difficulty creating things

like image maps, frames, or tables—items fundamentally important in Web development. Learn a generator and you learn only that which the generator can do. Learn HTML and you can do anything the language supports.

Q *How does a Web browser treat extraneous spaces within a Web document? What about missing spaces?*

A A Web browser will generally ignore extraneous spaces in a document. Spaces that are used to help the programmer read the code, such as indents at the beginning of lines, are ignored outright by the browser. However, missing spaces, such as between attributes or tags, can cause problems when the file is viewed in a browser.

Q *What is the difference between a physical and logical text style?*

A A physical style affects a font style to simply draw attention to the font itself. It communicates no other information through the formatting of the text. A logical style affects a font style to draw attention to the font as well as communicate some information to the reader.

Q *Can a text-level tag be nested inside another text-level tag? Give an example.*

A Yes. An example is an tag nested within an <A> tag to create a hyperlinked graphic on the Web page, such as:

This example would make "logo.gif" a hotlink to http://www.tech.purdue.edu/. Additionally, there would be no unsightly blue border around the image.

PART TWO

WEB PAGE DESIGN WITH TABLES

Using the HTML <TABLE> Structure

In chapter 5, "Looking at the Curse of the Web Browser," you learned that browsers often recognize special tags—tags that may limit the potential audience for your Web pages. When you use special tags that apply to tables, you limit control over your pages, something that as a designer is very frustrating. Why spend all that time designing how text, images, and graphic elements interact on a Web page only to see the elements all jumbled around? The solution is to use your creativity, and not special tags, to implement your design.

This chapter is like a table training camp. You will learn all the moves, the plays, and get into condition so that in the next chapters you will be a finely tuned table animal.

You may wonder why we do not simply use a product such as FrontPage or Page Mill to create our tables. Examples of these products will be shown from time to time but not as the primary means of creating tables. These products have simplified and automated the process to quite a degree but by using them, you do not learn anything about how HTML structures tables or the data within them. In fact, without fundamental table knowledge, you would be unable to tweak the HTML code so that the tables better represent your designs. In addition, these editors add application-specific

tags that may be incompatible with a target browser. If you do not know how the tags work, you will never know which ones to strip out. Here is my suggestion: learn tables the old way first. Then, use an editor and tweak the code.

OBJECTIVES

In this chapter, you will:

• Understand how tables are used to organize textual and numeric information.

• Become familiar with how tables are used as the underlying page design grid.

• Gain knowledge as to the various table structuring tags available in the current release of HTML.

• Understand the potential and limitations of using WYSIWYG table editors.

• Develop a designer's eye for how colors and text can enhance table design.

• Apply table design and structure to create your own structured pages.

Overview of Table Structure

No other HTML structure impacts both the look and function of a Web page quite like the <TABLE> structure. Originally conceived as a way of presenting tabular information, tables have developed as the primary means of organizing pages and in doing so, overcoming many of the fundamental limitations of HTML structuring.

Tables are both flexible and powerful. Tables can contain HTML text, graphics, animation, sound, video, and links to other Web resources. The HTML block and text tags presented in the previous chapter are all valid within tables. Tables can be allowed to resize as a user changes the size of the browser window or be constrained so that the page's dimensions are fixed.

Note: Many designers choose to fix the size of a table rather than let the table resize as a percentage of the browser window. While this may result in portions of the page being outside the extent of the browser window, the spatial relationships of elements on the page remain constant. The larger the table, the more important this is. A small table may never be impacted by reducing the size of the browser's window.

As an overview, tables can:

• Appear anywhere on a Web page

• Have a visible or invisible border

• Include or omit interior division lines

• Have entire tables nested within table cells

• Include text, graphics, video, animation, and sound as table data

HTML tables are described as a matrix of rows and columns, with columns containing table data for each of the rows. An HTML table and its structural components are described in Figure 7.1. When row contains a single box (called a cell), that element functions as the heading for the entire table. Several data cells can be combined into spanned rows or columns.

The best way to understand tables is to compare a table and the tags required to make that table work. We will spend more time later in this chapter with each structural tag. Simply put, an HTML table is a collection of rows of data cells. The way you choose to set the rules for how data within each of the cells will appear makes the difference between a successful and unsuccessful table. The simplistic table shown in Figure 7.1 is created by Listing 7.1.

Note that by indenting the HTML code, it becomes easier to visualize which structural elements are subordinate to others.

Note: Do not be afraid to sit down with pencil and paper to plan a table. By sketching out the structure, you will quickly be able to see which HTML tags and attributes will most efficiently accomplish the task.

Understand Browser Differences

Browsers may interpret HTML table code differently and may even include table extensions not available with other browsers. Be careful that in using browser-specific tags, you do not limit your potential audience. For example, Figure 7.2 shows a table that includes a border, cell spacing, and cell padding, as well as a graphic with no padding or spacing. Each of these table characteristics may be interpreted differently by different browsers.

Interactive Web page editors such as FrontPage and Page Mill contain native browsers that you can use to see what your pages will look like over the Web. These browsers, however, are less flexible and more dependent on proprietary tags than are Navigator and Explorer. Be very careful! Do not assume that just because a table looks great in Page Mill that it will be interpreted the same way in a browser.

The American Electric Power example used in this chapter was not commissioned nor endorsed by the company. It is strictly used for illustrative purposes.

Table Caption

Table Heading				
Table Heading	Table Data	Spanned Table Data		
Table Heading	Table Data			
Table Heading	Table Data	Table Data	Table Data	

Figure 7.1 The components of an HTML table.

Listing 7.1 The basic structure of an HTML table.

```
<HTML>
 <TITLE>Page Design with Tables</TITLE>
 <BODY  BGCOLOR=#FFFFFF TEXT=#000000>
 <TABLE BORDER=3>
  <CAPTION>Table Caption</CAPTION>
    <TR><TH COLSPAN=5>Table Heading</TH></TR>
    <TR>
      <TD><TH>Table Heading</TH>
      <TD>Table Data</TD>
      <TD COLSPAN=2 ROWSPAN=2>Spanned Table Data</TD>
    </TR>
    <TR>
      <TD><TH>Table Heading</TH></TD>
      <TD>Table Data</TD>
    </TR>
    <TR>
      <TH>Table Heading</TH>
      <TD>Table Data</TD>
      <TD>Table Data</TD>
      <TD>Table Data</TD>
    </TR>
  </TABLE>
 </BODY>
</HTML>
```

Figure 7.2 A page designed with a table. The table border has been turned on so that the grid can be seen.

Tables for Designers

Because this is not a book strictly on the current HTML standard, the approach is decidedly on the side of a designer. Not every HTML tag and attribute is documented, but the ones you will probably want to use in designing your Web pages are covered in detail, with hints for effective design use.

Note: The bulk of discussion on how designers use tables in Web page development is covered in Chapter 11, "Using Tables to Structure Pages."

Designers use tables for much more than the presentation of textual, numeric, and visual data. Most Web page designers use tables to structure and organize the entire page. This technique will be used in detail in Chapter 10. In the sections that follow are HTML table tags and attributes that you will use for both tabular information and as a fundamental design tool.

Knowing the HTML Table Tags

Tables are specified by tags. Tags set out the major structural components of the table. These tags are modified by attributes. As you might imagine, not all attributes are valid for all tags. Before we look at table tags, let us become familiar with the attributes that will be used by those tags.

Looking at Table Attributes

For any HTML listing to be meaningful, one needs a wealth of information…usually, right now! Attributes have been presented here first, before the tags that use them, so you can see their specific effect. Unfortunately, in order to make the tables work, these attributes are buried in the code and tags. The examples have purposely been kept simplistic so you can see the individual effect.

Left Alignment	Center Alignment	Right Alignment

Figure 7.3 Horizontal alignment of column data.

$56.76
$123.56
$1,005.32
$.18

Figure 7.4 Horizontal alignment using a specific character.

ALIGN

Data within a table cell can be aligned left and right (horizontally) using the ALIGN tag. An example of horizontal alignment is shown in Figure 7.3 and its code in Listing 7.2. The options for horizontal alignment are:

ALIGN=LEFT

ALIGN=RIGHT

ALIGN=CENTER

ALIGN=JUSTIFY

ALIGN=CHAR

Default alignment for headings is ALIGN=CENTER while table data is default aligned as ALIGN=LEFT. By using ALIGN=JUSTIFY, text that would normally push out the width of a cell will wrap to the next line.

In tables with numerical entries, you will want to use the ALIGN=CHAR attribute to align the data on a specific character. For example, say you have the following values:

15%	5%
2%	75%

By using ALIGN=CHAR CHAROFF=%, the data will appear formatted as in Figure 7.4. See also the discussion below on the CHAROFF attribute to specify where within the cell the alignment character will be placed. The HTML code for Figure 7.4 is shown in Listing 7.3.

Listing 7.2 Horizontal alignment within a table.

```
<HTML>
<HEAD>
<TITLE> Horizontal Alignment in Table Cell</TITLE>
</HEAD>
 <BODY BGCOLOR=#FFFFFF >
  <TABLE BORDER=1>
   <TR BGCOLOR="YELLOW">
     <TD ALIGN=LEFT WIDTH=100><FONT SIZE=5> Left Alignment</TD>
     <TD ALIGN=CENTER WIDTH=100><FONT SIZE=5> Center Alignment</TD>
     <TD ALIGN=RIGHT WIDTH=100><FONT SIZE=5>Right Alignment</TD>
   </TR>
  </TABLE>
 </BODY>
</HTML>
```

Listing 7.3 Alignment by character within table cells.

```
<HTML>
<HEAD>
<TITLE> Character Alignment in Table Cell</TITLE>
</HEAD>
 <BODY BGCOLOR=#FFFFFF >
  <TABLE BORDER=1 BGCOLOR="YELLOW">
     <COL ALIGN=CHAR CHAR=. OFFSET=75>
       <TR>
         <TD WIDTH=100><FONT SIZE=5>$56.76</TD>
       </TR>
       <TR>
         <TD WIDTH=100><FONT SIZE=5>$123.56</TD>
       </TR>
       <TR>
         <TD WIDTH=100><FONT SIZE=5>$1,005.32</TD>
       </TR>
       <TR>
         <TD WIDTH=100><FONT SIZE=5>$.18</TD>
       </TR>
  </TABLE>
 </BODY>
</HTML>
```

VALIGN

Where ALIGN controlled the horizontal alignment of table data, the VALIGN attribute lets you align data vertically within cells (Figure 7.5). See Listing 7.4 for the code to accomplish this. The options for vertical alignment are:

VALIGN=TOP

VALIGN=MIDDLE

VALIGN=BOTTOM

VALIGN=BASELINE

Figure 7.5 Vertical alignment of column data within a table.

Default vertical alignment is VALIGN=MIDDLE. To vertically align all the data entries in a row to a common baseline, use the ALIGN=BASELINE attribute.

BORDER

A table's border provides a visual boundary to separate a table from the page. The border's default value is the same as BORDER=0, meaning no border is shown. The value in the BORDER attribute is in current units. See the UNITS tag described later in this chapter. Increasing the border value creates a beveled picture frame effect. Figure 7.6 displays a table with no border above the same table with its border turned on. To selectively display border elements, see the FRAME attribute. Personally, I think that HTML table borders are pretty ugly. I leave them off or create my own as horizontal and vertical graphic elements. See the HTML code in Listing 7.5.

Listing 7.4 Vertical alignment of table data.

```
<HTML>
<HEAD>
<TITLE> Vertical Alignment in Table Cell</TITLE>
</HEAD>
 <BODY BGCOLOR=#FFFFFF>
  <TABLE BORDER=1>
   <TR BGCOLOR="YELLOW">
     <TD ALIGN=CENTER VALIGN=TOP WIDTH=100 HEIGHT=100>
        <FONT SIZE=5> Top Alignment</TD>
     <TD ALIGN=CENTER VALIGN=CENTER WIDTH=100 HEIGHT=100>
        <FONT SIZE=5> Middle Alignment</TD>
     <TD ALIGN=CENTER VALIGN=BOTTOM WIDTH=100 HEIGHT=100>
        <FONT SIZE=5>Bottom Alignment</TD>
   </TR>
  </TABLE>
 </BODY>
</HTML>
```

Figure 7.6 Displaying a border around a table.

Note: *When you are designing pages, toggle between BOR-DER=0 and BORDER=1 to keep an idea as to where the table structure is. That is why my tables have an attribute BORDER=0 even when no border is shown.*

CHAROFF

This attribute can be used to position the special character specified in the CHAR= attribute left and right within a data cell. This value is expressed as a percentage or cell width (without the %) and can range from 0 (left justified) to 100 (right justified). A value of 50 places the special character in the middle of the data cell. Refer back to Figure 7.4 and Listing 7.3 for an example of character offset.

Listing 7.5 Display of border around a table.

```
<HTML>
 <HEAD>
  <TITLE>Table Borders</TITLE>
 </HEAD>
<BODY BGCOLOR=#FFFFFF >
 <TABLE BORDER=0>
  <TR>
   <TD WIDTH=125 HEIGHT=88><IMG SRC="man.gif"></TD>
   <TD WIDTH=45 HEIGHT=88 ROWSPAN=6><FONT COLOR="WHITE">2</TD>
   <TD WIDTH=200 HEIGHT=88><IMG SRC="logo.gif" WIDTH=300 HEIGHT=50></TD>
  </TR>
  <TR>
   <TD WIDTH=96 HEIGHT=70 ALIGN=RIGHT><FONT SIZE=7>
     Border Width in Pixels</TD>
   <TD WIDTH=300 HEIGHT=70 ROWSPAN=4><IMG SRC="papers.jpg"></TD>
  </TR>
 </TABLE>
</BODY>
</HTML>
```

CELLPADDING

To keep data within table cells from running into each other, an amount of spacing or padding can be added inside each cell. The attribute CELLPADDING uses the current units (usually pixels) and builds a buffer so that data within cells does not run into the lines dividing the cells. In Figure 7.7, pictures in the top table have been displayed in cells without any padding. The same data is shown in the second table with CELLPADDING set to a value of 15. (A gray border is displayed so you can see the effect of the padding.) See Listing 7.6 for a description of the second table.

CELLSPACING

By default, cells in a table are separated by a 1-pixel dividing line. This can result in cell contents running into each other. Rather than adding additional padding to the inside of a data cell, you may choose to add space between cells by using CELLSPACING. By setting CELLSPACING=0, you can ensure that no extra space separates adjacent table cells. This is very important when two adjacent cells contain graphics that you want to view as a single image. Figure 7.8 displays a table using CELLSPACING=15. This separates the data, adding to reading efficiency. Representative code is shown in Listing 7.7.

Note: CELLSPACING adds space between rows and columns, revealing the background color. If you want the contents of data cells to be contiguous, make sure you use CELLSPACING=0.

COLS

For your browser to incrementally display table data, rather than wait for the entire table to download, specify the number of columns as an attribute of the TABLE tag. The number of columns may not be readily apparent as cells are combined and tables are nested within other tables. For example, in Figure 7.9 a table is shown that can be specified as <TABLE COLS=6>. The first view of the table is without borders. It actually comprises three rows and six columns even though it may be difficult at first to determine this. The second view turns the border on. Look at the code in Listing 7.8 to determine how many columns are actually in the table.

Note: Do not confuse COLS and COL. COLS is an attribute of the TABLE tag, used for instructing the browser how to display the table. COL is a tag that allows column formatting.

Figure 7.7 Data in cells without padding and with padding set to 15 pixels.

Listing 7.6 Use of padding within data cells.

```
<HTML>
 <HEAD>
 <TITLE>Cell Padding in Tables</TITLE>
 </HEAD>
  <BODY BGCOLOR=#FFFFFF >
   <TABLE BORDER=1 BGCOLOR="BLUE" CELLPADDING=15>
    <TR>
     <TD><IMG SRC="linemen.jpg"></TD>
     <TD><IMG SRC="linemen.jpg"></TD>
    </TR>
   </TABLE>
  </BODY>
</HTML>
```

Listing 7.7 The use of cell spacing to separate data.

```
<HTML>
 <HEAD>
  <TITLE>Cell Padding in Tables</TITLE>
 </HEAD>
 <BODY BGCOLOR="YELLOW">
  <TABLE BORDER=1 BGCOLOR="YELLOW" CELLPADDING=15 CELLSPACING=0>
    <TR>
     <TD><IMG SRC="linemen.jpg"></TD>
     <TD><IMG SRC="linemen.jpg"></TD>
    </TR>
  </TABLE>
 </BODY>
</HTML>
```

Figure 7.8 Cell spacing set to 15 pixels.

Listing 7.8 Use of <COLS> to set rules for table columns.

```
<HTML>
 <HEAD>
  <TITLE>Columns in Tables</TITLE>
 </HEAD>
  <BODY BGCOLOR="WHITE">
   <TABLE COLS=6 BORDER=0 BGCOLOR="BLACK" WIDTH=280>
    <TR>
     <TD ALIGN=CENTER><IMG SRC="aep.gif" HEIGHT=30 WIDTH=30></TD>
     <TD ROWSPAN=2 COLSPAN=3 ALIGN=CENTER>
      <IMG SRC="linemen.jpg" HEIGHT=100 WIDTH=150></TD>
     <TD>3</TD>
     <TD>4</TD>
    </TR>
    <TR>
     <TD>7</TD>
     <TD>8</TD>
     <TD>9</TD>
    </TR>
    <TR>
     <TD COLSPAN=6><IMG SRC="name.gif"></TD>
    </TR>
   </TABLE>
  </BODY>
</HTML>
```

*Figure 7.9 A table with six columns
with borders off and on.*

FRAME

Where BORDER puts a full picture frame around a table, FRAME allows you to customize how this border will appear. The options for displaying the frame include:

FRAME=VOID No frame is placed around the table.

FRAME=ABOVE Frame only on top of table.

FRAME=BELOW Frame only on bottom of table.

FRAME=HSIDES Frame on top and bottom of table.

FRAME=VSIDES Frame on left and right sides of table.

FRAME=LHS Frame on left hand side of table.

FRAME=RHS Frame on right hand side of table.

FRAME=BOX Frame on all sides of table.

FRAME=BORDER Frame on all sides of table.

Note: While FRAME may allow you to customize how the border is applied to a table, this HTML feature is not widely implemented in today's browsers.

Listing 7.9 Table text allowed to wrap and suspended with NOWRAP.

```
<HTML>
  <HEAD>
    <TITLE>Table Frames</TITLE>
  </HEAD>
  <BODY BGCOLOR="WHITE">
    <TABLE BORDER=1 WIDTH=280>
      <TR>
        <TD ROWSPAN=2><FONT SIZE=5>1</TD>
        <TD>Lots and lots of text, surely enough to cause the text to wrap.
        </TD>
      </TR>
      <TR>
        <TD>Not enough text to wrap.</TD>
      </TR>
    </TABLE>
    <TABLE BORDER=1 WIDTH=280>
      <TR>
        <TD ROWSPAN=2><FONT SIZE=5>2</TD>
        <TD NOWRAP>The same amount of text but with wrap off, pushing the table cell.
        </TD>
      </TR>
      <TR>
        <TD>Not enough text to wrap.</TD>
      </TR>
    </TABLE>
  </BODY>
</HTML>
```

Figure 7.10 Using NOWRAP prevents the browser from wrapping text to the next line.

NOWRAP

There may be times when you do not want the browser to push text that bumps into the end of a cell onto the next line. To do this, use the NOWRAP attribute with the <TD> table data or <TH> table heading tags. However, because this can cause a cell to be widened greatly, it can cause the balance and formatting of your table to be altered—usually for the worse. Use this feature carefully. An example of this is shown in Figure 7.10. The top table shows text allowed to wrap. The second table implements the NOWRAP attribute. See Listing 7.9.

RULES

If you think of a table as a window frame, BORDER, FRAME, and RULES control which frame elements are displayed. BORDER forms the window frame. FRAME allows individual elements of the border to be displayed. RULES divides the cells into individual panes.

Tables by default have no interior rules. The options for the RULE attribute are:

RULES=NONE

RULES=GROUPS

RULES=ROWS

RULES=COLS

RULES=ALL

Note: The RULES attribute controls how interior rules are displayed for the entire table. For more creative rules, try the <HR> horizontal rule in spanned rows or columns.

Using RULES=NONE produces the same effect as leaving out the RULES attribute all together—no horizontal or vertical rules appear. RULES=GROUPS separates the table header, body, and footer elements with a horizontal rule. RULES=ROWS places a horizontal rule between rows. RULES=COLS separates columns with vertical rules and adds horizontal rules between header, body, and footer. Finally, RULES=ALL separates all elements and cells in a table with horizontal and vertical rules.

Figure 7.11 shows two tables, the first with no rules and the second with horizontal rules.

SPAN

If you find that several columns share the same attributes, you can use the SPAN attribute to apply the current <COL> specification to a number of successive columns. In Figure 7.12, a table of four columns only requires two <COL> tags when the second spans three columns. See the code in Listing 7.10 (next page).

Figure 7.11 The options for displaying rules within tables.

Figure 7.12 Use SPAN to apply attributes to more than one COL tag.

Listing 7.10 Use of SPAN attribute to apply rules to more than one column.

```
<HTML>
 <HEAD>
  <TITLE>Table Rules</TITLE>
 </HEAD>
 <BODY BGCOLOR="WHITE">
   <TABLE BORDER=1 WIDTH=280>
    <COL ALIGN=CENTER>
    <COL ALIGN=RIGHT SPAN=3>
     <TR>
      <TD ROWSPAN=3>Rounds/Person</TD>
      <TD>12,345</TD>
      <TD>15,289</TD>
      <TD>345,031</TD>
     </TR>
     <TR>
      <TD>53,493</TD>
      <TD>16,492</TD>
      <TD>21,345</TD>
     </TR>
     <TR>
      <TD>12,294</TD>
      <TD>9,738</TD>
      <TD>3,481</TD>
     </TR>
   </TABLE>
 </BODY>
</HTML>
```

WIDTH

The width of a table can be controlled by the WIDTH attribute. By default (and by not using the WIDTH attribute at all), tables resize to fit the current browser window. To set a table to a specific size use WIDTH=XXX, where XXX is a value as specified in current UNITS. You can also specify WIDTH=XX%, where XX% is a percentage of the current browser's window width.

Note: Units are by default in pixels. It is important to know the expected maximum browser window width for your target audience. Every browser will have a different width for a given monitor dimension (640 x 480, for example) because of unique interface elements. You can, of course, just let the table resize to the browser or use a percentage. But then, you will never know what your page will look like. It is better to redesign your table so that the data can be displayed in a typical browser window.

There are two schools of thought when it comes to using absolute or relative table widths. Figure 7.13 (Listing 7.11) shows a table under the attribute condition where the table is allowed to resize because no specific width is set for either the table or the data cells.

There may be times where you will not know ahead of time how much information will fill a given cell of a table. This might occur when a Web page is built from a script from changing as opposed to static data. But in most cases, you will know how much text or how large an image will fill a table cell. When you set a table to a specific width as is done in Figure 7.14 (Listing 7.12), a browser window too small will not force the table to resize (page 98).

Figure 7.13 A table allowed to resize to fit the browser window.

Listing 7.11 A table without size constraint.

```
<HTML>
 <HEAD>
  <TITLE>Table Rules</TITLE>
 </HEAD>
  <BODY BGCOLOR="WHITE">
   <TABLE BORDER=0 BGCOLOR=#D0D0D0 CELLPADDING=5 CELLSPACING=2>
    <TR>
     <TD ROWSPAN=2 ALIGN=RIGHT><FONT SIZE=5>
                   <B>SIDEBAR</B>
     </TD>
     <TD><FONT SIZE=5>Text in a Title
     </TD>
    </TR>
    <TR>
     <TD><Font SIZE=3>Body text in the second cell of the table. This text is less
noticeable when it is forced to resize than is a title. A title that is forced onto a
second line throws your entire design off.
     </TD>
    </TR>
   </TABLE>
 </BODY>
</HTML>
```

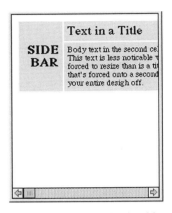

Figure 7.14 A table of fixed width in a resized browser window.

The <TABLE> Tag

An HTML table is defined by a strict framework. The opening <TABLE> tag and the closing </TABLE> tag define the limits of data and formatting associated with the table. Between these two tags will be all of the text and graphics in the table, as well as additional structure defining rows and columns.

The most helpful <TABLE> attributes are:

UNITS	BORDER
CELLPADDING	CELLSPACING
COLS	FRAME
RULES	WIDTH

Listing 7.12 A table with fixed widths.

```
<HTML>
 <HEAD>
  <TITLE>Table Rules</TITLE>
 </HEAD>
 <BODY BGCOLOR="WHITE">
  <TABLE BORDER=0 BGCOLOR=#D0D0D0 CELLPADDING=5 CELLSPACING=2 WIDTH=270>
   <TR>
    <TD ROWSPAN=2 ALIGN=RIGHT><FONT SIZE=5>
                   <B>SIDEBAR</B>
    </TD>
    <TD><FONT SIZE=5>Text in a Title
    </TD>
   </TR>
   <TR>
    <TD><FONT SIZE=3>Body text in the second cell of the table. This text is less
noticeable when it is forced to resize than is a title. A title that is forced onto a
second line throws your entire design off.
    </TD>
   </TR>
  </TABLE>
 </BODY>
</HTML>
```

Figure 7.15 (Listing 7.13) shows how tables can be nested inside tables. Note that each table structure has its own opening and closing tags.

Figure 7.15 The structure of nested tables.

Listing 7.13 Nesting of table structures.

```
<HTML>
 <HEAD>
  <TITLE>Table Rules</TITLE>
 </HEAD>
 <BODY BGCOLOR="WHITE">
  <TABLE BORDER=1 WIDTH=280 BGCOLOR=#D0D0D0>
    <CAPTION><B>The Overrall Table</CAPTION>
    <TR>
     <TD><B>1.1</TD>
     <TD COLSPAN=2 ROWSPAN=2>
        <TABLE BORDER=1 WIDTH=244 BGCOLOR=#E8EBEB>
        <CAPTION> <B>A Nested Table</CAPTION>
         <TR ALIGN=CENTER>
            <TD WIDTH=122><B>2.1</TD>
            <TD WIDTH=122><B>2.2</TD>
         </TR>
         <TR ALIGN=CENTER>
            <TD WIDTH=122><B>2.3</TD>
            <TD WIDTH=122><B>2.4</TD>
         </TR>
        </TABLE>
     </TD>
     <TD><B>1.2</TD>
    </TR>
    <TR>
     <TD><B>1.3</TD>
     <TD><B>1.4</TD>
    </TR>
  </TABLE>
 </BODY>
</HTML>
```

Table Sections

It may be helpful to organize a table into logical divisions, and HTML has provided three structures to accomplish this. The tags <THEAD>, <TBODY>, and<TFOOT> allow rules to be applied to areas of a table. A table can have only one header and footer, but multiple body sections. By having multiple body sections, rows and columns can have different rules and attributes, making the table highly customizable. Listing 7.14 shows the overall structure of a table using header, body, and footer sections.

The <CAPTION> Tag

A caption is part of a table but with the unique attribute of being outside the table's border. You might use a caption to add a title or footnote to a table. All text tags can be applied to caption text. The attributes ALIGN=TOP, ALIGN=BOTTOM, ALIGN=RIGHT, and ALIGN= LEFT can be used with CAPTION.

Note: Try using a graphic as a caption for interesting effects. This can be a banner graphic or a logo that although outside the table's border, is still influenced by table alignment. In other words, it follows the table around.

For example, assume a table (Figure 7.16) is to have the title at the top, "The Working Lineman." The basic code would be similar to that in Listing 7.15.

Or, a table might have a footnote at the bottom, such as "Lineman Responsibilities." The only change in the code would be:

```
<CAPTION ALIGN=LEFT
VALIGN=BOTTOM>Lineman
Responsibilities</CAPTION>
```

UNITS

In most cases you will want to work in pixels (the default) since a 15″ 640 x 480 monitor will usually display 72 pixels per inch. You can use UNITS=EN if you know

Listing 7.14 The structure of table sections.

The most helpful table section attributes are:

```
UNITS
ALIGN
VALIGN
CHAR
CHAROFF
<HTML>
  <TITLE>Table Sections</TITLE>
  <BODY>
   <TABLE>
     <THEAD>
       .
       . Header information
       .
     </THEAD>
     <TBODY>
       .
       . Data for the first body section
       .
     </TBODY>
     <TBODY>
       .
       . Data for the second body section
       .
     </TBODY>
     <TFOOT>
       .
       . Data for the footer section
       .
     </TFOOT>
   </TABLE>
  </BODY>
</HTML>
```

Figure 7.16 A table with a title caption at the top.

Listing 7.15 Use of a table caption.

```
<HTML>
 <TITLE>Table Caption</TITLE>
 <BODY BGCOLOR=#FFFFFF LINK=#FF000000 VLINK=#FF000000>
  <TABLE BORDER=1 ALIGN=CENTER>
    <CAPTION ALIGN=CENTER VALIGN=TOP>
    <FONT SIZE=7>The Working Lineman</CAPTION>
    <TR>
     <TD><IMG SRC="linemen.jpg"></TD>
    </TR>
  </TABLE>
 </BODY>
</HTML>
```

enough about printing to know what an en measure is. If it is important, a en is equal to the type size in points. An en of 36 point type is 36 points or about one-half inch. Stick with points.

The <COL> Column Tag

The key to any successful table is in planning. It is relatively easy to execute a table from a detailed sketch. It is relatively difficult to create a table on the fly, not know-

ing ahead how many rows or columns you might need. Plan, plan, plan!

The <COL> tag allows you to impact formatting rules for all data in a given column. There may be instances in which you may want to change formatting for specific data cells, and in those cases, you will want to override <COL> rules with attributes in either <TR> rows or <TD> column tags. Figure 7.17 (Listing 7.16) shows a table that makes use of the <COL> tag (next page).

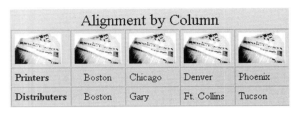 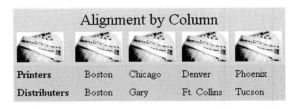

Figure 7.17 A table using the <COL> tag to format columns.

Listing 7.16 Formatting columns using the <COL> tag.

```
<HTML>
 <TITLE>Alignment by Columns</TITLE>
 <BODY BGCOLOR=#FFFFFF LINK=#FF000000 VLINK=#FF000000>
  <TABLE BORDER=1 ALIGN=CENTER CELLSPACING=5>
    <COL ALIGN=LEFT VALIGN=MIDDLE>
    <COL ALIGN=CENTER SPAN=4>
    <CAPTION> <FONT SIZE=5>Alignment by Column</CAPTION>
    <TR>
     <TD><IMG SRC="news.jpg"></TD>
     <TD><IMG SRC="news.jpg"></TD>
     <TD><IMG SRC="news.jpg"></TD>
     <TD><IMG SRC="news.jpg"></TD>
     <TD><IMG SRC="news.jpg"></TD>
    </TR>
    <TR>
     <TD><B>Printers</TD>
     <TD>Boston</TD>
     <TD>Chicago</TD>
     <TD>Denver</TD>
     <TD>Phoenix</TD>
    </TR>
    <TR>
     <TD><B>Distributers</TD>
     <TD>Boston</TD>
     <TD>Gary</TD>
     <TD>Ft. Collins</TD>
     <TD>Tucson</TD>
    </TR>
  </TABLE>
 </BODY>
</HTML>
```

If your table has five columns (as in the example), your table will have five <COL> tags, unless you use the SPAN attribute as was done in Listing 7.16. The first tag and its rules will be associated with the first column, the second tag with the second column, and so on.

The following attributes can be used to establish rules for columns as specified by the <COL> tag:

CHAR

CHAROFF

ALIGN

VALIGN

WIDTH

SPAN

The <TR> Row Tag

In discussing table rows, you have to be aware of the data that goes into the rows. The concept of data will be covered in the next topic when the table data <TD> tag is presented. They go hand in hand. Rows can appear in header, body, or footer sections of a table and are defined as follows:

```
<TABLE>
 <THEAD>
        <TR> ...
  </TR>...
 <TBODY>
  <TR> ...
  </TR>...
 </TBODY>
 <TFOOT>
  <TR> ...
  </TR>...
 </TFOOT>
</TABLE>
```

Table rows contain one or more data cells—either a header or data. Several attributes can be used within the <TR> tag to set rules for all data in that row. Using any of the following within the <TR> tag overrides attributes made in <COL>, <THEAD>, <TBODY>, or <TFOOT> tags:

ALIGN

VALIGN

CHAR

CHAROFF

UNITS

Note: Many HTML tags can get away with only an opening tag and not a closing tag. If you spend a lot of time analyzing HTML code, it is much easier to pick out structural groups by bracketing code between opening and closing tags. Use opening and closing tags not for the browser but for your benefit.

The <TD> Cell Data Tag

Earlier you were shown two ways of using columns in HTML tables. The first was using the COLS attribute in the <TABLE> tag to inform the browser as to the number of expected columns. The second was the <COL> tag that set up rules for treating data in the table's columns. But the real work of columns in tables is left to the <TD> tag.

The default alignment of data within <TD> cells is VALIGN=MIDDLE and ALIGN=LEFT. Additionally, rules for data cells can be set by using the following attributes:

ALIGN

VALIGN

CHAR

CHAROFF

UNITS

A special case of the <TD> tag is the <TH> or table heading tag. Table headings apply special formatting to make them set off from normal table data, removing the need to apply special text formatting tags to text that

will appear in the first row or column of a table. The same attributes can be applied to <TH> tags as are applied to <TD> tags. Figure 7.18 shows a table of rows and columns with headings. Note the use of an empty data cell in the first row that positions H1 over the first data column. Listing 7.17 shows the HTML code that drives this table.

Listing 7.17. Table headings and data.

```
<HTML>
 <TITLE>A Table of Headings, Row, and
Columns</TITLE>
 <BODY BGCOLOR=#FFFFFF LINK=#FF000000 VLINK=#FF000000>
  <TABLE BORDER=1 ALIGN=CENTER WIDTH=300 HEIGHT=200>
   <CAPTION ALIGN=LEFT VALIGN=TOP>
   <FONT SIZE=5>A Table of Heads and Columns</CAPTION>
    <TR>
     <TD></TD>
     <TH>H1</TH>
     <TH>H2</TH>
     <TH>H3</TH>
    </TR>
    <TR>
     <TH>H5</TH>
     <TD ALIGN=CENTER>D1</TD>
     <TD ALIGN=CENTER>D2</TD>
     <TD ALIGN=CENTER>D3</TD>
    </TR>
    <TR>
     <TH>H6</TH>
     <TD ALIGN=CENTER>D4</TD>
     <TD ALIGN=CENTER>D5</TD>
     <TD ALIGN=CENTER>D6</TD></TR>
    <TR>
     <TH>H7</TH>
     <TD ALIGN=CENTER>D7</TD>
     <TD ALIGN=CENTER>D8</TD>
     <TD ALIGN=CENTER>D9</TD>
    </TR>
  </TABLE>
 </BODY>
</HTML>
```

A Table of Heads and Columns

	H1	H2	H3
H5	D1	D2	D3
H6	D4	D5	D6
H7	D7	D8	D9

Figure 7.18. A table with rows, columns, and headings.

Rows That Span Columns

It is common when designing tables to need to group several tables together. The structure for doing this is the COLSPAN attribute of the <TD> and <TH> tags. Figure 7.19 shows a table where data cells span columns. The HTML code for generating this table is shown in Listing 7.18. See the accompanying note.

Note: I have seen many page designers get lost when spanning data cells across rows and columns and there is a simple reason for this. When you span cells, you do not automatically delete any of them. If you start with sixteen cells and span four together, three unneeded cells are pushed

out the back of the table. The best way to keep track of this is to set up a dummy table with sequential numbers in the cells and delete the lines of code that generate the bogus cells. This is illustrated in the final task in this chapter.

A Table with Data Spanning Columns

	H1	H2	H3
H5	D1		
H6	D4		
H7	D7		

Figure 7.19 A table with data cells that span columns.

Listing 7.18 The use of COLSPAN to group <TD> cells in three columns.

```
<HTML>
 <TITLE>Spanning Columns</TITLE>
 <BODY BGCOLOR=#FFFFFF LINK=#FF000000 VLINK=#FF000000>
  <TABLE BORDER=1 ALIGN=CENTER WIDTH=300 HEIGHT=200>
   <CAPTION ALIGN=LEFT VALIGN=TOP>
   <FONT SIZE=5>A Table with Data Spanning Columns</CAPTION>
    <TR>
     <TD></TD>
     <TH>H1</TH>
     <TH>H2</TH>
     <TH>H3</TH>
    </TR>
    <TR>
     <TH>H5</TH>
     <TD ALIGN=CENTER COLSPAN=3>D1</TD>
    </TR>
    <TR>
     <TH>H6</TH>
     <TD ALIGN=CENTER COLSPAN=3>D4</TD>
     <TR>
     <TH>H7</TH>
     <TD ALIGN=CENTER COLSPAN=3>D7</TD>
    </TR>
   </TABLE>
  </BODY>
</HTML>
```

Data Cells That Span Rows

Identical to the function of COLSPAN, use ROWSPAN (Figure 7.20) when you want to group data cells across rows. In practice, the combination of COLSPAN and ROWSPAN provides you with the design tools to create almost any table design.

Task: Designing Table Background Colors

In the battle of browser wars, almost monthly developments add features that impact tables. For example, both

Netscape Navigator and Internet Explorer offer the feature to add color to the entire table or individual cells. To add color to the entire table, include the BGCOLOR= attribute in the <TABLE> tab either using your browser's standard color words, or their hexadecimal equivalents as shown below.

<TABLE BGCOLOR=GRAY>

<TABLE BGCOLOR=#CCCCCC>

To add color to sections, use BGCOLOR in the section tags: <THEAD>, <TBODY>, or <TFOOT>. Color can be added to individual data cells by including BGCOLOR in the <TR>, <TD>, or <TH> tags.

Listing 7.19 The use of ROWSPAN to group <TD> cells in three rows.

```
<HTML>
 <TITLE>Spanning Rows</TITLE>
 <BODY BGCOLOR=#FFFFFF LINK=#FF000000 VLINK=#FF000000>
  <TABLE BORDER=1 ALIGN=CENTER WIDTH=300 HEIGHT=200>
   <CAPTION ALIGN=LEFT VALIGN=TOP>
   <FONT SIZE=5>A Table with Data Spanning Rows</CAPTION>
    <TR>
     <TD></TD>
     <TH>H1</TH>
     <TH>H2</TH>
     <TH>H3</TH>
    </TR>
    <TR>
     <TH>H5</TH>
     <TD ALIGN=CENTER ROWSPAN=3>D1</TD>
     <TD ALIGN=CENTER ROWSPAN=3>D2</TD>
     <TD ALIGN=CENTER ROWSPAN=3>D3</TD>
    </TR>
    <TR>
     <TH>H6</TH>
    <TR>
     <TH>H7</TH>
    </TR>
   </TABLE>
 </BODY>
</HTML>
```

A Table with Data Spanning Rows

Figure 7.20 A table with data cells that span rows.

Care should be exercised in specifying colors on top of which text will be displayed. Readability is directly related to contrast—both in terms of value (light and dark) and in terms of color (hue). Colors that are opposite each other on a color wheel (like red and green) have the greatest color contrast. Colors beside each other (like blue and green) have less contrast. Avoid low contrast relationships between text and background colors.

Follow these steps to add color to your table:

1 Determine if contrasting header and data areas best show the information. In Figure 7.21 we have decided that black and white <TH> text will contrast nicely.

2 Pick a general table data color. We have chosen an off-white, slightly yellow color, whose hexadecimal value is #F5D87A.

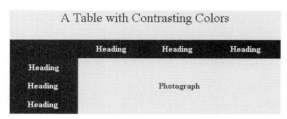

Figure 7.21 Use of contrast in tables.

Listing 7.20 Background color in tables.

```
<HTML>
 <TITLE>Colored Tables</TITLE>
 <BODY BGCOLOR=#FFFFFF LINK=#FF000000 VLINK=#FF000000>
  <TABLE BORDER=0 ALIGN=CENTER WIDTH=300 HEIGHT=200 BGCOLOR=#F5D87A CELLSPACING=0>
   <CAPTION ALIGN=LEFT VALIGN=TOP>
   <FONT SIZE=5>Using Color in Data Cells</CAPTION>
    <TR>
     <TD BGCOLOR=#000000>*</TD>
     <TH BGCOLOR=#000000><FONT COLOR="WHITE">H1</TH>
     <TH BGCOLOR=#000000><FONT COLOR="WHITE">H2</TH>
     <TH BGCOLOR=#000000><FONT COLOR="WHITE">H3</TH>
    </TR>
    <TR>
     <TH BGCOLOR=#000000><FONT COLOR="WHITE">H5</TH>
     <TD ALIGN=CENTER ROWSPAN=3 COLSPAN=3>D1</TD>
    </TR>
    <TR>
     <TH BGCOLOR=#000000><FONT COLOR="WHITE">H6</TH>
    <TR>
     <TH BGCOLOR=#000000><FONT COLOR="WHITE">H7</TH>
    </TR>
  </TABLE>
 </BODY>
</HTML>
```

3 Color the entire table by adding BGCOLOR=#F5D87A to the <TABLE> tag.

4 Selectively color the <TH> headings with BGCOL-OR=#000000 where #000000 is the hexidecimal specification for black.

5 Selectively change heading font color to white using FONT COLOR="WHITE" inside the <TH> heading tag.

6 The empty first data cell will not accept black as a color without a data character. The first data cell is <TD BGCOLOR=#000000>*</TD>, where the asterisk and the cell body color are both black.

Figure 7.21 showed the table with colored backgrounds that maintain contrast. Listing 7.20 shows the HTML code defining that table (previous page).

Internet Explorer and Netscape Communicator provide the added feature of allowing an image to be used as a table background using the following structure:

<TABLE BACKGROUND="table.gif">

<TD BACKGROUND="cell.gif">

<TH BACKGROUND="header.gif">

If caution should be exercised in using color, extreme caution should be exercised in using a background image. Remember readability!

Note: If you really want to qualify for someone's Internet Hall of Shame, combine a page background with a table background... even better, make the table background an animated GIF. Just do not let anyone know you read this book!

Task: Designing a Simple Table

The key in designing any effective table lies in analyzing and planning the table before starting its technical implementation, whether you are hard-coding the table (like I do) or using an editor.

Let us assume you have the following data concerning tornadoes:

Kansas
 average/year 129 deaths/year 4.7

Oklahoma
 average/year 92 deaths/year 2.3

Missouri
 average/year 34 deaths/year .6

Illinois
 average/year 87 deaths/year 4.9

Indiana
 average/year 56 deaths/year 1.5

Ohio
 average/year 41 deaths/year .8

Follow these steps in order to create a table displaying the tornado data:

1 Complete a number of sketches of possible table solutions. The greater the number of sketches, the better the chance you will come up with an effective solution. Figure 7.22 shows the sketch we will be using as the basis of our table.

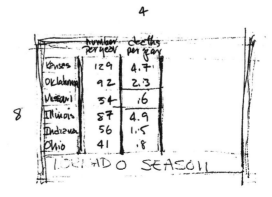

Figure 7.22 A sketch of a table displaying tornado information.

Figure 7.23 Spanning rows and columns causes unneeded cells to be pushed out the back of the table.

Figure 7.24 The basic translation of our sketch.

2 Translate that sketch into a basic table using place holder text for eventual cell data. Seed this table with incremental data (1,2,3 or a,b,c). This is where you can interactively adjust the dimensions of the table, going back and forth between your text editor and your browser.

3 When you span data cells over rows or columns, you will push unwanted cells out the back of the table. This is shown in Figure 7.23. If you have seeded the cells with incremental data, it is an easy task to go back and strip out the unneeded lines of code.

The final basic table is shown in Figure 7.24 and Listing 7.21.

Listing 7.21 The finished translation of our table sketch.

```
<HTML>
 <TITLE>Table with Color</TITLE>
 <BODY BGCOLOR=#FFFFFF>
  <TABLE BORDER=0 BGCOLOR=#F5D87A BORDER=0 CELLPADDING=4 CELLSPACING=0>
   <TR>
    <TH BGCOLOR=#FFFFFF COLSPAN=4 WIDTH=300><FONT COLOR="WHITE">-</TD>
   </TR>
   <TR>
    <TD BGCOLOR=#000000>-</TD>
    <TD BGCOLOR=#000000 ALIGN=CENTER><FONT COLOR="WHITE">H1</TD>
    <TD BGCOLOR=#000000 ALIGN=CENTER><FONT COLOR="WHITE">H2</TD>
    <TD BGCOLOR=#000000>-</TD>
   </TR>
    <TD ALIGN=CENTER>D1</TD>
    <TD ALIGN=CENTER>D2</TD>
    <TD ALIGN=CENTER>D3</TD>
    <TD ALIGN=CENTER ROWSPAN=6>D4</TD>
<!-causes 4 cells to be deleted>
   </TR>
   <TR>
    <TD ALIGN=CENTER>D5</TD>
    <TD ALIGN=CENTER>D6</TD>
```

```
  <TD ALIGN=CENTER>D7</TD>
 </TR>
 <TR>
  <TD ALIGN=CENTER>D9</TD>
  <TD ALIGN=CENTER>D10</TD>
  <TD ALIGN=CENTER>D11</TD>
 </TR>
 <TR>
  <TD ALIGN=CENTER>D13</TD>
  <TD ALIGN=CENTER>D14</TD>
  <TD ALIGN=CENTER>D15</TD>
 </TR>
 <TR>
  <TD ALIGN=CENTER>D17</TD>
  <TD ALIGN=CENTER>D18</TD>
  <TD ALIGN=CENTER>D19</TD>
 </TR>
 <TR>
  <TD ALIGN=CENTER>D21</TD>
  <TD ALIGN=CENTER>D22</TD>
  <TD ALIGN=CENTER>D23</TD>
 </TR>
 <TR>
  <TH COLSPAN=4 BGCOLOR=#000000 HEIGHT=30 ALIGN=LEFT><FONT
       COLOR="WHITE">H3</TH>
 </TR>
 </TABLE>
 </BODY>
</HTML>
```

4 Substitute the real data for the place holder data and make any final adjustments to CELLPADDING and CELLSPACING to enhance readability. The final table is shown in Figure 7.25 with its HTML code in Listing 7.22. Illinois's high death rate is highlighted by a change in cell color.

	number per year	deaths per year
Kansas	129	4.7
Oklahoma	92	2.3
Missouri	34	0.6
Illinois	87	4.9
Indiana	56	1.5
Ohio	41	.8
TORNADO SEASON		

Figure 7.25 The final tornado table.

Listing 7.22 The code for the finished table in Figure 7.25.

```
<HTML>
 <TITLE>Table with Color</TITLE>
 <BODY BGCOLOR=#FFFFFF>
   <TABLE BORDER=0 BGCOLOR=#F5D87A BORDER=0 CELLPADDING=4 CELLSPACING=0>
    <TR>
     <TH BGCOLOR=#FFFFFF COLSPAN=4 WIDTH=250><FONT COLOR="WHITE">-</TD>
    </TR>
    <TR>
     <TD BGCOLOR=#7D342D>-</TD>
     <TD BGCOLOR=#7D342D ALIGN=CENTER><FONT COLOR="WHITE">number<BR>per
         year</TD>
     <TD BGCOLOR=#7D342D ALIGN=CENTER><FONT COLOR="WHITE">deaths<BR>per
         year</TD>
     <TD BGCOLOR=#7D342D>-</TD>
    </TR>
     <TD ALIGN=RIGHT>Kansas</TD>
     <TD ALIGN=RIGHT>129</TD>
     <TD ALIGN=CENTER CHAR=.>4.7</TD>
     <TD ALIGN=CENTER ROWSPAN=6 WIDTH=50><FONT COLOR=#F5D87A>-</TD>
    </TR>
    <TR>
     <TD ALIGN=RIGHT>Oklahoma</TD>
     <TD ALIGN=RIGHT>92</TD>
     <TD ALIGN=CENTER>2.3</TD>
    </TR>
    <TR>
     <TD ALIGN=RIGHT>Missouri</TD>
     <TD ALIGN=RIGHT>34</TD>
     <TD ALIGN=CENTER>0.6</TD>
    </TR>
    <TR>
     <TD ALIGN=RIGHT>Illinois</TD>
     <TD ALIGN=RIGHT>87</TD>
     <TD ALIGN=CENTER BGCOLOR=#F27DB3>4.9</TD>
    </TR>
    <TR>
     <TD ALIGN=RIGHT>Indiana</TD>
     <TD ALIGN=RIGHT>56</TD>
     <TD ALIGN=CENTER>1.5</TD>
    </TR>
```

```
<TR>
  <TD ALIGN=RIGHT>Ohio</TD>
  <TD ALIGN=RIGHT>41</TD>
  <TD ALIGN=CENTER>.8</TD>
  </TR>
  <TR>
  <TD ALIGN=LEFT COLSPAN=4 BGCOLOR=#7D342D>
      <FONT COLOR="WHITE"><H2>TORNADO SEASON</H2></TD>
  </TR>
  </TABLE>
 </BODY>
</HTML>
```

Real World Examples

The best way to see how text is handled both on pages and within tables is to go to the Web and see what people are doing. The ones chosen here show a range of techniques. You are encouraged to visit these sites and study the pages with an eye for how tables and text are used.

Once you have accessed the site, choose "View Document Source." If you have associated .html extensions with a particular application program, that program will launch and you will get to see the code that drives the page. If your browser cannot find an application, save the file and open it in a text editor or word processor.

Figure	Web URL Address
7.26(A)	http://www.harley-davidson.com/what/
7.26(B)	http://www.carnegiehall.org/
7.26(C)	http://www.blades.co.za/

(B)

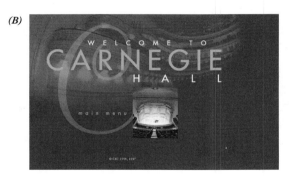

(A)

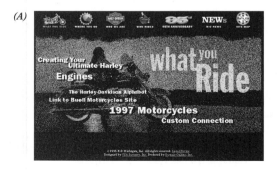

(C)

Figure 7.26 Examples of current table use in Web pages.

Summary

In this chapter, you became aware of how tables are defined, how tags are used, and the attributes that modify those tags. You were shown several examples that stressed analyzing table structure, creating a simple, basic table that satisfies the structure, and seeding the table with temporary text.

Some HTML table features are not implemented in every browser. Some browsers include custom tags and attributes not generally available. The only way to know how your tables will respond is to preview them in as many browsers as practicable.

In the next chapter, "Using Text in Tables," you will see how HTML text can be formatted to achieve a variety of designs.

QUESTIONS

Q *How can I keep from getting lost when I am designing a table with a large number of cells?*

A It is important to seed the table with incremental text. That way, when you want to combine or add additional cells, you can see exactly where they are going. Another way is to color any cells that you add a unique color using BGCOLOR= inside the <TD> or <TH> tags.

Q *I want to create a table that will perfectly fill a browser window when it is fully open. How do I do this?*

A This is more problematic than you might think. First, not all browser brands have the same dimensional overhead—that is, they vary in how much space they take up for their interface. In addition, it may be impossible to predict the monitor size of potential customers. My suggestion is to aim your page at the minimum screen dimensions you anticipate using. If you have a multiple resolution monitor, set it to 640 x 480 and fully open your browser. Do a screen grab and open this raster file in Photoshop or some similar program. Crop the canvas

down to the browser window and check the image's dimensions. This is the largest table you can make that will not scroll the browser window.

Q *Several HTML table tags or attributes do not seem to work with my browser. Why?*

A You may be trying to use HTML commands that are unique to a particular browser (unfortunately, not yours). Each browser implements its own HTML parser, an engine that looks at the HTML code and separates it into commands and data. This parsed text is then compared to a dictionary of HTML commands that came with your browser. Not all browsers implement all commands. This is not uncommon.

Q *I cannot seem to keep my table columns and rows fixed in size, even when I use commands like WIDTH=100 to set the cell to 100 pixels.*

A This is frustrating. When this happens, I load a transparent GIF file of the desired size into a small cell at the top of the column. All cells in the column are then fixed to that size.

Q *My browser will not allow a colored background or image in a table. Is there any way I can get around this limitation?*

A The immediate answer is to upgrade your browser, but that is not always feasible. Try this: Create a background image that has the design you want. Make this large enough to the right and bottom that it does not tile. Design a table with cells that coincide with the background and it will appear that you can use colors and images.

Q *I have tried all combinations of BORDER, FRAME, and RULES and cannot seem to get what I want.*

A Try designing horizontal rows (using COLSPAN) and columns (using ROWSPAN) that you fill with your own graphic rules. To do this effectively, this needs to be done at the beginning of your design. It is tough to do this after a table is essentially finished.

Using Text in Tables

In chapter 7, "Using the HTML <TABLE> Structure," you became familiar with available table formatting options. I would not be honest if I told you that you can achieve any design of tabular information using this HTML structure. Add to the inherent limitations of HTML tables the differences between browsers, and limitations become vagaries. But with a little creativity, you can create very readable and visually pleasing table designs.

Your goal, after reading this chapter, is to be able to look at a tabular presentation of information, see the underlying text structure, and easily pick out the HTML text structuring tags appropriate for making the design work.

OBJECTIVES

In this chapter, you will:

• Understand how text can be formatted within tables.

• Know when logical and physical text styles are appropriate and how to implement them.

• Learn how and when to use style sheets.

• Link table text to internal and external resources.

• Create a table of financial information similar to those found in print publications.

HTML Text Formatting for Tables

In chapter 9, "Using Graphics in Tables," you will learn how to combine HTML text, graphic images, and graphic text (text done in a raster editor like Photoshop). In this chapter, you will learn how text can be styled and formatted directly, using HTML tags and attributes. Admittedly, it is difficult to get just the right results by using HTML text alone. But with the addition of cas-

cading style sheets (CSS) covered later in this chapter, you will find new control over HTML text.

Note: A word of caution concerning style sheets. The greater the variability of people who might visit your Web page, the less effective will the style sheets be. If a customer's browser does not recognize the CSS, the typical browser and HTML defaults will take over. The only problem is, you may have spent hours getting your pages to look just so, only to have the styles ignored. Style sheets for intranets, where equipment may be identical, makes more sense.

Text does not have to be included in tables. It can be thrown directly on the page using the <P> paragraph structure. Indeed, all of the formatting commands explained in this chapter can be applied to text not contained in tables. But you will soon see that combining table structures to organize a page with text formatting will result in greater control over the design of the page than by using text formatting alone.

To begin, let us review the standard HTML text formatting tags and attributes.

HTML Text-Level Tags

The Tag

FONT SIZE=1 Approximately 6 point type.

FONT SIZE=2 Approximately 8 point type.

FONT SIZE=3 Approximately 10 point type.

FONT SIZE=4 Approximately 14 point type.

FONT SIZE=5 Approximately 18 point type.

FONT SIZE=6 Approximately 24 point type.

FONT SIZE=7 Approximately 28 point type.

You can increase the font size from the current value (if you can remember it!) by using + and - integers. Figure

8.1 (Listing 8.1) shows a line of standard text and subsequent lines of text enlarged and reduced. Notice that by reducing text size -2, the base size remains the default (FONT SIZE=3). Bumping up does not change the current attribute setting, either explicit or default.

The Tag

Using the tag, you can selectively add color to HTML text. There are sixteen standard colors you can specify by color name:

Aqua	Black
Blue	Fuschia
Gray	Green
Lime	Maroon
Navy	Olive
Purple	Red
Silver	Teal
White	Yellow

Some of the more popular colors and their hexadecimal values are:

Black 000000	Blue 0000FF
Brown 996633	Cream FFFBF0
Cyan 00FFFF	Dark Blue 000080
Dark Gray 808080	Dark Green 008000
Dark Purple 800080	Dark Red 800000
Dark Yellow 808000	Grass Green C0DCC0
Green 00FF00	Light Gray C0C0C0
Medium Gray A0A0A4	Purple FF00FF
Red FF0000	Sky Blue A6CAF0
White FFFFFF	Yellow 00FFFF

Note: Do not be afraid to try different colors and text designs. Almost all computers will have a monospaced font specified (usually Courier). Combining monospaced with Times can make for interesting results. Try a background color and font color very close in hexadecimal specification (C0C0C0 and C0C0D0, for example).

The <PRE> Preformatted Text Tag

I am sure most of you have seen the cute character graphics adorning the bottom of many people's e-mail messages. I honestly did not know that you could make ASCII text characters look like a person riding a bicycle…but you can! I would not spend much time doing this, but you can, with the <PRE> tag, use the mono-

Figure 8.1 Bumping font size from current attribute setting.

Listing 8.1 Incremental text sizing.

```
<HTML>
 <TITLE>Use of Incremental Text Sizing</TITLE>
 <BODY BGCOLOR=#FFFFFF TEXT=#000000>
 <P>This text is in standard TEXTSIZE=3 size</P>
 <P><FONT SIZE=+4>This text is bumped up to TEXT SIZE=7<FONT></P>
 <P><FONT SIZE=-2>This text is bumped down to TEXT SIZE=1<FONT></P>
 </BODY>
</HTML>
```

spaced font in the browser's font preferences to do something you cannot normally do in HTML—add spacebar characters to text strings. Listing 8.2 shows how a table might be coded without any table tags, just using spaces. Figure 8.2 shows the result.

Note: Preformatted text uses the monospaced font and size set up in a browser's preferences. As a designer, you have no control over this. Monospaced characters all use the same horizontal space—that used by the widest character, usually a capital M or W. Your preformatted table will be much wider than one set with table tags.

A Preformatted Table

```
COPYRIGHT CONSIDERATIONS
- - - - - - - - - - - - - - - - - - - - - - - - -
|                                   |         |
|   The Ownership Stage             |         |
|      * Who did the work, Work for Hire |    |
|                                   |         |
|   The Copyright Stage             |         |
|      * Copyrightable, Copyrighted |         |
|                                   |         |
|   The Permission Stage            |         |
|      * Written Permission, Fee Paid |       |
|                                   |         |
|   The Attribution Stage           |         |
|      * Attribution Statement, Fidelity |    |
|                                   |         |
- - - - - - - - - - - - - - - - - - - - - - - - -
                 U.S Copyright Office, Washington, D.C.
```

Figure 8.2 Preformatted text in a table.

Listing 8.2 Preformatted text.

```
<HTML>
 <TITLE>Use of Preformatted Text in a Table</TITLE>
 <BODY BGCOLOR=#FFFFFF TEXT=#000000>
 <H1>A Preformatted Table</H1>
 <PRE>
COPYRIGHT CONSIDERATIONS

- - - - - - - - - - - - - - - - - - - - - - - - - - - - - - - - -

|                                       |           |
|    The Ownership Stage                |           |
|        * Who did the work, Work for Hire |        |
|                                       |           |
|    The Copyright Stage                |           |
|        * Copyrightable, Copyrighted   |           |
|                                       |           |
|    The Permission Stage               |           |
|        * Written Permission, Fee Paid |           |
|                                       |           |
|    The Attribution Stage              |           |
|        * Attribution Statement, Fidelity |        |
|                                       |           |
- - - - - - - - - - - - - - - - - - - - - - - - - - - - - - - - -
                  U.S. Copyright Office, Washington, D.C.
 </PRE>
</BODY>
</HTML>
```

The Bold Tag

To quickly render text in boldface use the boldface tag. This is done inline in the middle of any text string. The size, font, and color attributes currently in effect are not changed, only the weight of the characters between the tags. Make sure you close the tag with a to signal the browser to continue with current text formatting. This is shown in Figure 8.3 and coded in Listing 8.3.

The <Big> Enlarge Tag

The <BIG> tag bumps the enclosed text up a default increment. It does not make the text bold, however. To do this, combine and <BIG> tags. This is shown in Figure 8.4 and coded in Listing 8.4.

The <Blink> Blinking Tag

Like many things in life, a little bit of something goes a long way—especially blinking text. Use this feature selectively, and only when blinking text is needed to draw attention to something. Blinking text is difficult to read as the browser inverses the video. Reserve blinking text, if you can, for single words or phrases. An example of blinking text is shown in Figure 8.5 and coded in Listing 8.5.

Boldface in a Text String

Make sure you have all permissions on file **before** manuscript is released for publication.

Figure 8.3 Use of boldface to add emphasis.

Bigger and Bolder in a Text String

You can make selected text bigger if you want to.

You can make selected text **bigger and bolder** if you want to.

Figure 8.4 Use of <BIG> to enlarge selected text.

Listing 8.3 Boldface.

```
<HTML>
 <TITLE>Boldface Text</TITLE>
 <BODY BGCOLOR=#FFFFFF TEXT=#000000>
 <H1>Boldface in a Text String</H1>
   <P>Make sure you have all permissions on file <B>before</B> manuscript is released
for publication.</P>
 </BODY>
</HTML>
```

Listing 8.4 Bigger text.

```
<HTML>
 <TITLE>Making Selected Text Larger</TITLE>
 <BODY BGCOLOR=#FFFFFF TEXT=#000000>
  <H1>Bigger and Bolder in a Text String</H1>
    <P>You can make selected text <BIG>bigger</BIG> if you want to.</P>
    <P>You can make selected text <B><BIG>bigger and bolder</BIG></B> if you want to.</P>
 </BODY>
</HTML>
```

The Emphasis Tag

This tag provides emphasis to enclosed text and is browser dependent, usually rendering in italic font. Unless you are directing your pages to a browser that renders uniquely (and that is the effect you want) stick with the <I> italic tag.

The <STRIKE> Strike Through Tag

Strike through text is specialized. I have not had need to use this other than as a way of showing edits on HTML documents posted on the Web. Someone out there probably knows of a creative use. Drop us an e-mail at jl-mohler@tech.purdue.edu or jmduff@asu.edu and let us know! See Figure 8.6 and Listing 8.6.

Figure 8.5 Blinking text should be used selectively.

Figure 8.6 Using strike through text.

Listing 8.5 Blinking text.

```
<HTML>
 <TITLE>Blinking Text</TITLE>
 <BODY BGCOLOR=#FFFFFF TEXT=#000000>
  <H1>A Little Bit of Blinking Text</H1>
   <FONT COLOR="RED">
   <P><B><BLINK>WARNING</BLINK></B></P>
   <FONT COLOR="BLACK">
   <P>Assure that grounding strap is attached before removing case.</P>
 </BODY>
</HTML>
```

Listing 8.6 Strike through text.

```
<HTML>
 <TITLE>Showing Strike Throughs</TITLE>
 <BODY BGCOLOR=#FFFFFF TEXT=#000000>
  <H1>Striking Through Text</H1>
   <P><STRIKE>Strike through text is pretty specialized. I have not had need to use this
other than as a way of showing edits on HTML documents posted on the Web</STRIKE>
Someone out there probably knows of a creative use. Drop me an e-mail and let me
know!</P>
 </BODY>
</HTML>
```

The Bolding Tag

Figure 8.7 (Listing 8.7) shows two lines of text, one with strong emphasis and one with bold emphasis. Because browsers may choose to render these tags differently, you should preview their effects. If they are the same, use because it is shorter.

The <SUB> Subscript Tag

A subscript differs from <SMALL> text in that its baseline is adjusted downward as the text is reduced. You can nest the <SUB> tag inside other formatting instructions (like <BIG>, <SMALL>, and) to fine-tune the appearance of the subscripted text. Several subscripting options are shown in Figure 8.8 and Listing 8.8.

The <SUP> Superscript Tag

The same considerations can be made for superscripted text as was just shown for subscripted text. See the previous discussion.

The <U> Underline Tag

Underlined text is commonly used as a substitute for italicized text. HTML has the <I> tag so do not use the <U> tag for this purpose. Also, linked text usually is displayed with an underline (a carryover from when people had nongraphical browsers and could not move a cursor around the screen to click on elements like image maps.

Emphasizing Text Strong and Bold

This text has been made **strong**

This text has been made **bold**

Figure 8.7 Using for emphasis.

Listing 8.7 Emphasis in text using and tags.

```
<HTML>
 <TITLE>Using Strong Emphasis</TITLE>
 <BODY BGCOLOR=#FFFFFF TEXT=#000000>
  <H1>Striking Through Text</H1>
    <P>This text has been made <STRONG>strong</STRONG></P>
    <P>This text has been made <B>bold</B></P>
 </BODY>
</HTML>
```

Using Subscripts

Text can be ₛᵤᵦₛcᵣᵢₚₜₑd as needed.

Text can be **ₛᵤᵦₛcᵣᵢₚₜₑd** as needed.

Text can be **subscripted** as needed.

Figure 8.8 Using subscripted text.

Listing 8.8 Subscripted text.

```
<HTML>
 <TITLE>Using Subscripts</TITLE>
 <BODY BGCOLOR=#FFFFFF TEXT=#000000>
  <H1>Using Subscripts</H1>
    <P>Text can be <SUB>subscripted</SUB> as needed.</P>
    <P>Text can be <B><SUB>subscripted</SUB></B> as needed.</P>
    <P>Text can be <BIG><B><SUB>subscripted</SUB></B></BIG> as needed.</P>
 </BODY>
</HTML>
```

Additionally, HTML has the <HR> horizontal rule tag that can be sized to display under a line of text if you want the effect of a horizontal rule. All of these reasons point to limited applicability of the <U> tag.

The Ordered List Tag

Ordered lists automatically place letters or numerals beside the entries of a list. This is great when you have a list that changes order or a list to which you have to add entries—especially if those new entries do not always fall at the end of the existing list. Using keeps you from having to renumber the list. Figure 8.9 (Listing 8.9) shows an ordered list.

A number of attributes of the ordered list are available to customize how the list is displayed. If no attribute is used, the list will generally display with numerals.

TYPE=A Upper case letters; A, B, C...

TTPE=a Lower case letters; a, b, c...

TYPE=I Large Roman Numerals; I, II, III...

TYPE=i Small Roman numerals; i, ii, iii...

TYPE=1 The default setting; 1, 2, 3...

Figure 8.9 Using ordered lists.

Listing 8.9 Ordered lists.

```
<HTML>
 <TITLE>Ordered Lists.</TITLE>
 <BODY BGCOLOR=#FFFFFF TEXT=#000000>
  <H1>Showing Ordered Lists</H1>
      <P>An ordered list with no list attributes.</P>
   <OL>
    <LI>List Item
    <LI>List Item
    <LI>List Item
    <LI>List Item
   </OL>
   <P>An ordered list with small Roman numerals.</P>
   <OL TYPE=i>
    <LI>List Item
    <LI>List Item
    <LI>List Item
    <LI>List Item
   </OL>
 </BODY>
</HTML>
```

The Unordered List Tag

Use an unordered list when the order of entries is not important or when the target browser supports custom bullets. The default is usually a solid meatball bullet. When supported, possible unordered list attributes include:

TYPE=disc A solid circular bullet in current TYPE COLOR

TTPE=circle An open circular bullet in current TYPE COLOR showing background color

TYPE=square An open square bullet in current TYPE COLOR showing background color

An example of an unordered list is shown in Figure 8.10 and its HTML code is represented in Listing 8.10.

Figure 8.10 Using unordered lists.

Listing 8.10 Unordered lists.

```
<HTML>
 <TITLE>Unordered Lists.</TITLE>
 <BODY BGCOLOR=#FFFFFF TEXT=#000000>
  <H1>Showing Unordered Lists</H1>
      <P>An unordered list with no list attributes.</P>
   <UL>
    <LI>List Item
    <LI>List Item
    <LI>List Item
    <LI>List Item
   </UL>
   <P>An unordered list with a square bullet.</P>
   <UL TYPE=SQUARE>
    <LI>List Item
    <LI>List Item
    <LI>List Item
    <LI>List Item
   </UL>
 </BODY>
</HTML>
```

Figure 8.11 A page design to be put on a Web page.

Figure 8.12 The basic table structure for the table in Figure 8.11.

Listing 8.11 Code for the basic table structure.

```
<HTML>
 <TITLE>Page Design with Tables.</TITLE>
 <BODY  BGCOLOR=#FFFFFF TEXT=#000000>
  <TABLE BORDER=1>
    <TR VALIGN=TOP BGCOLOR=GRAY>
      <TD WIDTH=100 HEIGHT=300><FONT
          SIZE=5>Margin</TD>
      <TD WIDTH=300 HEIGHT=300><FONT
          SIZE=5>Body Copy</TD>
    </TR>
  </TABLE>
 </BODY>
</HTML>
```

Task: Formatting Text with HTML Text-Level Tags

Now that you have seen examples of how HTML text can be formatted, let us see how this can be applied to table text on a Web page. We will use the break
 tag to bump text down on the page. In the next chapters, you will learn how to use additional table structure and graphic spacers to do this more efficiently. Figure 8.11 shows a sketch of a page design that you would like to implement on the Web.

1 Analyze the table for its structure and develop a basic table structure in HTML like you did in the previous chapter. Our page is actually contained in a table of one row and two columns. This is probably the most important step because if you do not build a workable structure, you will never get a representative table. This is shown in Listing 8.11 and Figure 8.12.

2 Use dummy text to seed the table. This can be text you have previously used in a document or Lorem Ipsum dummy text used in publications.

3 Establish the base text parameters at the beginning of the table code. This usually reflects the formatting of the majority of the text.

4 In the individual table cells (<TD> and <TH>), override the general text rules with the exceptions. This may include text size, emphasis, and alignment. Make sure you close the tags or you will affect all text following the tag.

5 Adjust CELLSPACING and CELLPADDING to increase readability.

6 Replace the dummy text with the real text.

The finished table is displayed in Figure 8.13. Although it does not exactly match the example, it does a credible job of communicating the data…and is visually pleasing to boot! The HTML code to produce this table is shown in Listing 8.12.

Figure 8.13 The finished Web page text table.

Listing 8.12 Code for the finished Web page text table.

```
<HTML>
<TITLE>Page Design with Tables.</TITLE>
 <BODY BGCOLOR=#FFFFFF TEXT=#000000>
  <TABLE BORDER=0>
    <TR>
      <TD><B><BR><BR><BR><BR><BR>
              dignissim qui blandit<BR>
              praesent luptatum zzril
              <BR><BR><BR><BR><BR><BR><BR><BR><BR><BR><BR>
              Consectetuer adipiscing <BR>
              elit molestie consequat<BR>
              vel illum
              <BR><BR><BR><BR><BR><BR>
              Diam nonummy nibh velit<BR>
              esse molestie consequat
              <BR><BR><BR><BR><BR>
              Euismod tincidunt ut <BR>
              laoreet dolore eu feugiat <BR>
              nulla facilisis
              <BR><BR>
      </TD>
      <TD><B>Lorem ipsum dolor</B>
          <BR><BR>
```

```
Sit amet, consectetuer adipiscing elit, sed diam nonummy nibh euismod tincidunt ut
laoreet dolore magna aliquam erat volutpat. Duis autem vel eum iriure dolor in hendrerit
in vulputate velit esse molestie consequat, vel illum dolore eu feugiat nulla facilisis
at vero eros et accumsan et iusto odio dignissim qui. Blandit praesent luptatum zzril
delenit augue duis dolore te feugait nulla facilisi.
            <BR><BR>
        <B>Dolor sit amet</B>
            <BR><BR>
<!—Body Copy—>
Consectetuer adipiscing elit, sed diam nonummy nibh euismod tincidunt ut
......
facilisi.
            <BR><BR>
        <B>Lorem ipsum dolor sit amet</B>
            <BR><BR>
<!—Body Copy—>
Consectetuer adipiscing elit, sed diam nonummy nibh euismod tincidunt ut
......
consequat.
        </TD>
      </TR>
    </TABLE>
  </BODY>
</HTML>
```

Understanding Logical and Physical Styles

Physical styles specify the precise format for the display of text. These include , <I>, <U>, and <TT> (monospaced teletype font). Logical styles do not specify strict formats and leave the rendering of the style up to the browser, either in its default or configurable settings. Logical styles include , , <CITE> (italicized citations), <CODE> (monospaced computer code), <KBD> (monospaced keyboard font), <SAM> (sample text displayed in monospaced font), and <VAR> (usually displayed in italics).

Using Style Sheets with Tables

Cascading style sheets are a way of applying style declarations to HTML documents in a way that preserves style decisions established at the document level. Style sheet rules are biased toward the page author first, and then the reader. This means that a reader can implement a style sheet for all documents entering their browser that will impact all elements not explicitly styled by the page author.

Style sheets offer unbelievable power to page designers with a couple of caveats. First, you have to have a style sheet capable browser in order to make use of this feature.

If you do not, all of the style declarations in the <STYLE> section will be passed over and normal default HTML formatting will take over. This usually results in disaster because when using styles, the designer abandoned traditional physical and logical styles, so very little of the design will be displayed in a noncompliant browser. Probably all browsers will eventually support style sheets to some degree, and HTML itself now incorporates elements of styles in its latest release.

Second, not everyone will want a style sheet capable browser. If you have taken a look at the size of Internet Explorer and Netscape Communicator, you will see that they are not for the casual consumer. There will be plenty of Web customers for years to come out there with basic graphical browsers. Your job is to deliver pages to them (and the style sheet crowd) that are effective, well-designed, download rapidly, and viewable by the largest possible market.

Note: *In the changing landscape of internets, intranets, and extranets it becomes all the more important to match the level of technology to both the task and the potential customer. The best source of information is to go to http://www.w3org/pub/WWW/TR/WD-css1-960911.html for the current state of style sheet development.*

Lastly, as a designer you want to be able to guarantee that your pages will be delivered to a customer's computer in the form you envisioned. If you cannot guarantee this, why bother at all? Just throw the pages together and 100 customers see 100 different pages.

Let us assume you have a style sheet capable browser. How would you go about setting up a table that uses one? First, understand that style declarations can be used in combination of four methods:

First Method. The style declarations can be included in the HTML document that will use them. This is simple enough. Listing 8.13 shows how this is done.

Second Method. Create an ASCII text document specifically for holding style declarations. This will cascade, adding style declarations to the current document but not replacing explicit declarations in the HTML document itself. For example, in Listing 8.14, any style in the file "stylesheet" will be used unless it is explicitly declared between <STYLE> and </STYLE>. If "stylesheet" contains a font declaraction other than New Century Schoolbook, it will be ignored.

Third Method. Link to an external style sheet using the HREF structure as shown in Listing 8.15.

Fourth Method. Add style declarations inline in the HTML code directly where they will be implemented. This makes for a local style, overriding any global, imported, or linked style sheet declarations. Inline styles are shown in Listing 8.16.

Listing 8.13 A basic style sheet.

```
<HTML>
 <HEAD>
  <TITLE>Style Sheet Declaration</TITLE>
  <STYLE>
    H1 {font:45pt Times; color:blue}
    P  {font:11pt Helvetica; line height: 18pt; color:black}
  </STYLE>
 </HEAD>
 <BODY BGCOLOR=#FFFFFF TEXT=#000000>
  ...
 </BODY>
</HTML>
```

Listing 8.14 An imported style sheet.

```
<STYLE>
    H1 {font:45pt Times; color:blue}
    P  {font:11pt Helvetica; line height: 18pt; color:black}
</STYLE>
<!-Then import that style into the current HTML document->
<HTML>
 <HEAD>
  <TITLE>Style Sheet Declaration</TITLE>
  <STYLE>
    P   {font: New Century Schoolbook;}
    @import url(http://www.location.ext/stylesheet);
  </STYLE>
 </HEAD>
 <BODY BGCOLOR=#FFFFFF TEXT=#000000>
  . . .
 </BODY>
</HTML>
```

Listing 8.15 Linking to an external style sheet.

```
<HTML>
 <HEAD>
  <TITLE>Style Sheet Declaration</TITLE>
  <LINK REL=STYLESHEET HREF="http://www.location.ext/Stylesheet">
 </HEAD>
 <BODY BGCOLOR=#FFFFFF TEXT=#000000>
  . . .
 </BODY>
</HTML>
```

Listing 8.16 Adding style declarations inline.

```
<HTML>
 <HEAD>
  <TITLE>Style Sheet Declaration</TITLE>
 </HEAD>
   <P STYLE="font: 14pt Helvetica; color: red"> This is the text that will be impacted
by the inline style specification.</P>
 </BODY>
</HTML>
```

Linking Table Text

It is fine when you are able to create a table that effectively presents information. If you have carefully followed the suggestions in this and the last chapters, you should have a good knowledge of what makes a table work. But the real power of the Web is to create tables that are the entry into even more information. To do that, we create links between data and other HTML resources. When these links allow someone to be in control of what information they get to see and in what order (as opposed to a strict linear structure), we call them hyperlinks.

Many visual aspects of links can be browser- or user-specific. For example, text that is linked can be displayed with an underline, in a special color before visited and a different color after visitation, and identified with a cursor that changes to a finger-pointer when over the text. Including all three indications is probably overkill. Underlined text unfortunately gives the impression of italicized text for which you did not have the correct font. Turning all of the linked text a special color only works when links are the exception. When every cell of a table is linked, what is the point? Some may find visited links being a different color helpful, I have not. Most Web users are used to moving the cursor across a page, noting when the cursor changes to a finger-pointer. This may ultimately be enough.

For you to be able to distinguish linked text in this book, the text will be underlined.

The HTML structure that creates hyperlinks is not called a link, rather it is called an anchor and is defined by the <A> tag.

A number of attributes can be added to the <A> tag:

HREF – The document or Internet address you want to go to.

METHODS – Browser-specific HTTP methods for the link.

NAME – A unique text string in the referenced document to jump to.

TARGET – Name of frame into which linked document will appear.

TITLE – Provides header bar title information.

The basic structure of a text link is:

<A "where you want to go">the text you click on to go there

More specifically, if you wanted to go to a document called linkdoc.html, the structure might be:

Go to Linkdoc

This HREF structure can appear anywhere text is placed in a table. This includes inside <TH> table headings and <TD> table data. Figure 8.14 (Listing 8.17) shows a table with linked headings. Figure 8.15 (Listing 8.18) shows a table with linked data.

Directory Conventions Using HREF

In order to make the HREF structure work, you need to know precisely where the target file is located. This involves entering the path to that file in terms that the host computer can understand. Paths can be specified either in absolute terms (using specific drive and directory names, working your way up) or in relative terms (using directory levels up and down). In most cases you will want to use relative directory structure. Then, if you change the location of the files, you will not have to go back and change your path names (as long as the relative position of the files and directories did not change).

If the target file is located in the same directory as the current HTML file, enclose the filename in quotes. The structure would look like:

If the target file is located in directory 1, inside the current directory:

Table Heading Text Linked

NEW FILE			
DATA 1	DATA 2	DATA 3	DATA 4

Figure 8.14 Linked text in a table.

Table Cell Data Text Linked

TABLE HEADING			
DATA 1	DATA 2	DATA 3	DATA 4

Figure 8.15 Linked data text in a table.

Listing 8.17 Linked heading text.

```
<HTML>
 <TITLE>Table Heading Text Linked</TITLE>
 <BODY BGCOLOR=#FFFFFF TEXT=#000000>
  <TABLE BORDER=1 CELLPADDING=4>
  <CAPTION> Table Heading Text Linked </CAPTION>
   <TR>
    <TH COLSPAN=4><A HREF="newfile.html">NEW FILE</TH>
   </TR>
   <TR ALIGN=CENTER>
    <TD>DATA 1</TD><TD>DATA 2</TD><TD>DATA 3</TD><TD>DATA 4</TD>
   </TR>
  </TABLE>
 </BODY>
</HTML>
```

Listing 8.18 Linked table data.

```
<HTML>
 <TITLE>Table Heading Text Linked</TITLE>
 <BODY BGCOLOR=#FFFFFF>
  <TABLE BORDER=1 CELLPADDING=4>
   <CAPTION> Table Cell Data Text Linked </CAPTION>
   <TR>
    <TH COLSPAN=4>TABLE HEADING</TH>
   </TR>
   <TR ALIGN=CENTER>
    <TD><A HREF="data_1.html">DATA 1</A></TD>
    <TD><A HREF="data_2.html">DATA 2</A></TD>
    <TD><A HREF="data_3.html">DATA 3</A></TD>
    <TD><A HREF="data_4.html">DATA 4</A></TD>
   </TR>
  </TABLE>
 </BODY>
</HTML>
```

If the target file is located in directory 2, inside directory 1, inside the current directory:

If the target file is located one directory level closer to the root level of the disk (back one directory):

If the target file is located in another Web site:

Linking to a Spot in the Same HTML Document

Although one should try to avoid lengthy Web pages that require extensive scrolling, sometimes you will want to jump around on a single page. To accomplish this you create an anchor or marker using the NAME attribute at the location you want to jump to:

The text that will appear at the top of the screen

Then, at the location that will trigger the jump, create a link to the anchor with:

The text to click on

Listing 8.19 shows how this can be done. Down in the document are two anchors, the first jump and the second jump. The first jump is triggered by clicking on the linked text at the top of the file, "Go to Part One." The text associated with the first anchor, "Part One," will be scrolled to the top of the browser window. Clicking on "Go to Part Two" causes "Part Two" to appear at the top of the browser window.

Linking to Target Text in a Local Document

You can do the same kind of jump between the current document and one in the current site by making use of the directory structure you previously learned. You will have to go to the target file and create your anchor, and then in the file that triggers the jump, enter:

Listing 8.19 Jumps inside a document.

```
<HTML>
 <TITLE>Anchor in Same Document</TITLE>
 <BODY BGCOLOR=#FFFFFF TEXT=#000000>
  <H1>Jump Around in Same Document</H1>
     <P><A HREF="#first jump">Go to Part One</A></P>
     <P><A HREF="#second jump">Go to Part Two</A></P>
     .
     .
     .
     .
     <A NAME="first jump">Part One</A>
     .
     .
     .
     .
     <A NAME="second jump">Part Two</A>
 </BODY>
</HTML>
```

Jump Text

When you click on "Jump Text" in the current file, control will be transferred to the file "filename.html" located in dir_2 that is inside dir_1 that is inside the current directory, and the text "anchor," wherever it appears, will appear at the top of the browser window.

Linking to Target Text in a Remote Document

Here is where the limitations of anchors become evident. Say you do not just want to link to the National Root Beer Association Web Page at http://www.rootbeer.com, you want to go to a specific spot on one of the pages. You certainly can go to any of their pages, but because no anchors exist in the target document, there is no #anchor to refer to. Some Web pages have anchors placed on long pages by their authors for their own use. If so, you can ref-erence them from your own pages. Otherwise, the best you can do is jump to the top of the target document.

Task: Creating Drop Caps

By combining text formatting tags and a table structure, you can create publication-style results. Take for example, initial drop caps shown in Figure 8.16 (Listing 8.20). One way of creating this effect is to create a style declaration:

<STYLE>

P:first-character {font: 36pt Arial; float: right contour}

</STYLE>

But we know that not everyone will be able to use style sheet technology, so how can we make drop caps with a more simple approach? Follow these steps to create the Web table shown in Figure 8.16 and Listing 8.20.

Listing 8.20 An initial drop cap.

```
<HTML>
 <TITLE>Drop Caps in HTML</TITLE>
<BODY BGCOLOR=#FFFFFF TEXT=#000000>
  <H1>Initial Drop Caps</H1>
    <TABLE BORDER=0 CELLPADDING=0 CELLSPACING=0>
      <TH></TH>
      <TR>
      <TD><FONT SIZE=7 ALIGN=LEFT><B>D</B></TD>
      <TD VALIGN=TOP ALIGN=LEFT>rop caps can be used to draw interest to the beginning
of an article. The difficult part is to get the text to continue flowing around the cap.
This requires some trial and error but after several attempts, you can get what you see
here. This text continues from this cell</TD>
      </TR>
      <TR>
      <TD COLSPAN=2>to this cell. This text is actually in the next table row,
continuing the text from the left margin.
      </TD>
      </TR>
    </TABLE>
</BODY>
</HTML>
```

Initial Drop Caps

Drop caps can be used to draw interest to the beginning of an article. The difficult part is to get the text to continue flowing around the cap. This requires some trial and error but after several attempts, you can get what you see here. This text continues from this cell to this cell. This text is actually in the next table row, continuing the text from the left margin.

Figure 8.16 An initial drop cap used to set off the start of a passage.

		November 30, 1996		December 2, 1995
LIABILITIES				
Current Liabilities				
Short-term debt (Note 4)		$	74	$ 40
Current portion of long-term debt (Note 4)			1	2
Trade accounts payable			50	71
Income taxes payable (Note 8)			21	13
Accrued compensation			58	62
Other liabilities (Note 12)			116	113
Total current liabilities			320	301
Long-Term Debt (Note 4)			204	206
Other Long-Term Liabilities (Notes 5 and 12)			74	79
Deferred Income Taxes (Notes 1 and 8)			13	15

See Notes to Consolidated Financial Statements.

Figure 8.17 A traditional financial chart.

1 Create a two-row, two-column table. Set padding and spacing to 0 and turn the border on so you can see what you are doing. Put the drop cap in table cell 1 and the first part of the paragraph text in cell 2.

2 Span table cell 3 across cells 3 and 4. Put the continuation of the paragraph text in this spanned cell.

3 Style the drop cap, and align it to the left. Style the paragraph text as desired.

4 Load the table into your browser and see where the text breaks at the end of table cell 2. Adjust this to achieve a contiguous flow from cell 2 to cell 3. Turn the border off. The code for making a drop cap is shown in Listing 8.20.

Task: Creating a Financial Data Chart

A good way to test your text formatting and table skills is to reproduce a table of financial data for publication on a Web page. Figure 8.17 shows a traditional financial chart. It includes text of different size, weight, and alignment. It also includes selective horizontal rules. Here is one way of reproducing this table design:

1 Analyze the structure of the table. On first look, our table in Figure 8.17 has three columns and 13 rows. But to get a little more control over the columns of numeric data, let us assume that a blank column is between the columns of numbers.

2 Create a basic table with place holder text that satisfies a 4 column x 13 row design.

3 Insert horizontal rule rows by adding <TR><TD COLSPAN=4><HR></TD></TR> in the appropriate places.

4 Add alignment, text size, and text weight attributes to the appropriate <TD> data cells.

5 Fine-tune alignment. For example, the dollar signs are left justified while the numbers are right justified in the same data cell. HTML cannot do this directly. Instead, FONT COLOR is changed to the background (white) and padding characters added to bump the dollar sign to the left.

The final financial chart is shown in Figure 8.18 with its corresponding HTML code in Listing 8.21.

Financial Table

LIABILITIES	November 30, 1996		December 2, 1995
Current Liabilities			
Short-term debt (Note 4)	$ 74	$	40
Current portion of long-term debt (Note 4)	1		2
Trade accounts payable	50		71
Income taxes payable (Note 8)	21		13
Accrued compensation	58		62
Other liabilities (Note 12)	116		113
Total current liabilities	320		301
Long-Term Debt (Note 4)	204		206
Other Long-term Liabilities (Notes 5 and 12)	74		79
Deferred Income Taxes (Notes 1 and 8)	3		15

See Notes to Consolidated Financial Statement

Figure 8.18 The Web page financial chart.

Listing 8.21 A financial chart translation in HTML code.

```
<HTML>
 <TITLE>Financial Table</TITLE>
 <BODY BGCOLOR=#FFFFFF TEXT=#000000>
  <H1> Financial Table</H1>
    <TABLE BORDER=0 CELLPADDING=0 CELLSPACING=0>
        <TR><TD COLSPAN=4><HR></TD></TR>
        <TR><TD WIDTH=500></TD><TD WIDTH=70></TD><TD WIDTH=70></TD></TR>
        <TR><TD><B><BIG>LIABILITIES</BIG></B></TD>
            <TD ALIGN=CENTER>November 30,<BR>1996</TD>
            <TD></TD>
            <TD ALIGN=CENTER>December 2,<BR>1995</TD></TR>
        <TR><TD COLSPAN=4><HR></TD></TR>
        <TR><TD><B>Current Liabilities<B></TD>
            <TD></TD>
            <TD></TD>
            <TD></TD></TR>
        <TR><TD>Short-term debt (Note 4)</TD>
            <TD ALIGN=RIGHT>
              <B>$<FONT COLOR=#FFFFFF>————<FONT
                  COLOR=#000000>74</B></TD>
            <TD></TD>
            <TD ALIGN=RIGHT>
              $<FONT COLOR=#FFFFFF>————-<FONT
                  COLOR=#000000>40
            </TD></TR>
        <TR><TD>Current portion of long-term debt (Note 4)</TD>
            <TD ALIGN=RIGHT><B>1</B></TD>
            <TD></TD>
            <TD ALIGN=RIGHT>2</TD></TR>
        <TR><TD>Trade accounts payable</TD>
```

```
            <TD ALIGN=RIGHT><B>50</B></TD>
            <TD></TD>
            <TD ALIGN=RIGHT>71</TD></TR>
        <TR><TD>Income taxes payable (Note 8)</TD>
            <TD ALIGN=RIGHT><B>21</B></TD>
            <TD></TD>
            <TD ALIGN=RIGHT>13</TD></TR>
        <TR><TD>Accrued compensation</TD>
            <TD ALIGN=RIGHT><B>58</B></TD>
            <TD></TD>
            <TD ALIGN=RIGHT>62</TD></TR>
        <TR><TD>Other liabilities (Note 12)</TD>
            <TD ALIGN=RIGHT><B>116</B></TD>
            <TD></TD>
            <TD ALIGN=RIGHT>113</TD></TR>
        <TR><TD COLSPAN=4><HR></TD></TR>
        <TR><TD>Total current liabilities</TD>
            <TD ALIGN=RIGHT><B>320</B></TD>
            <TD></TD>
            <TD ALIGN=RIGHT>301</TD></TR>
        <TR><TD COLSPAN=4><HR></TD></TR>
        <TR><TD><B>Long-Term Debt (Note 4)</B></TD>
            <TD ALIGN=RIGHT><B>204</B></TD>
            <TD></TD>
            <TD ALIGN=RIGHT>206</TD></TR>
        <TR><TD COLSPAN=4><HR></TD></TR>
        <TR><TD><B>Other Long-term Liabilities (Notes 5 and 12)</B></TD>
            <TD ALIGN=RIGHT><B>74</B></TD>
            <TD></TD>
            <TD ALIGN=RIGHT>79</TD></TR>
        <TR><TD COLSPAN=4><HR></TD></TR>
        <TR><TD><B>Deferred Income Taxes (Notes 1 and 8)</B></TD>
            <TD ALIGN=RIGHT><B>3</B></TD>
            <TD></TD>
            <TD ALIGN=RIGHT>15</TD></TR>
        <TR><TD COLSPAN=4><HR></TD></TR>
        <TR ALIGN=LEFT>
            <TD><FONT SIZE=1>
                <I>See Notes to Consolidated Financial Statement</I>
            </TD></TR>
    </TABLE>
  </BODY>
</HTML>
```

Real World Examples

The best way to see how text is handled both on pages and within tables is to go to the Web and see what people are doing. The ones chosen here show a range of techniques. You are encouraged to visit these sites and study the pages with an eye for how tables and text are used.

Once you have accessed the site, choose "View Document Source" from the Edit menu of your browser. If you have associated .html extensions with a particular application program, that program will launch and you will get to see the code that drives the page. If your browser cannot find an application, save the file and open it in a text editor or word processor.

Figure Web URL Address

8.19 http://www.jennair.com/design/forum/index.asp

8.20 http://www.honda.com

8.21 http://www.ippa.org/essays.html

8.22 http://www.retroactive.com/sfmuseums.html

Summary

As you have seen from the examples in this chapter, a world of possibilities are available for displaying text in interesting and effective ways if you have command of the text formatting capabilities of HTML tags and their attributes.

But still, there are compelling reasons to use system-level text on your Web pages. Text downloads and displays rapidly. Textual information is generally easier to edit and update. And pages based on text, although they are more difficult to design, are readable by more browsers and, thereby, accessible by more potential customers.

In the next chapter, "Using Graphics in Tables," you will see how images enhance text. You will see that in some cases, images can eliminate your use of traditional text for page design altogether.

Figures 8.19–8.22 Real world examples of text formatting.

QUESTIONS

Q *I use a lot of images for text above 24 points because it looks so much better. Some of my customers use the "Find" command in their browser to locate key words, but of course, the graphic words do not show up. What can I do?*

A Put the keyword in a place that the color can be set the same as the background, making it invisible. Do this as close to the graphic text as possible. The search will not be perfect, but it will get your customer to the right place on the page.

Q *I like the look of multicolumn pages. How do I make HTML flow into multiple columns?*

A The easiest way to do this is by structuring your page with a table that defines the columns. If you plan for margins and alleys (the space between columns) as table columns, you can have precise control over how the page looks. Another way is to capture the page as a Portable Document File (pdf) from a page layout program like PageMaker or Quark. Your customers will have to have a pdf plug-in installed in their browser.

Q *I used a script font in a style sheet specification and it looks great on my development workstation. How can I ensure that a potential browser will have access to this font?*

A Your customer (the User Agent [UA], in style sheet parlance), tries to match your font declaration with locally installed fonts or fonts that have been downloaded over the Web. If there is no match, alternative font families may be entertained. Finally, if no match is found, the best match of the default browser font (monospaced or proportional) will be made. This said, you can see that if the unique font is not on your customer's computer, you have no control over what will be used.

Note: *True Type fonts are copyrighted font outlines and may not be freely transported across the Web. PostScript screen fonts are of common industrial utility and may be distributed.*

Q *I want to do other things with blinking text. What is available?*

A If you want more control over blinking text (color, rate, sound) substitute a small animated GIF, AVI, or QuickTime movie. Be careful! Unless you want the look of an arcade game, use flashing page elements wisely.

Q *I want selective padding and spacing in my table but the attributes affect the entire table. What can I do?*

A You can break your table into a series of contiguous tables, or nest tables inside tables. That way you can make padding and spacing values impact selected parts of a table. Another approach is to use transparent GIF graphics inside table cells. Scale the images horizontally and vertically to get just the right spacing.

Using Graphics in Tables

If you spend any time with HTML, you will quickly realize that few structures exist for controlling the exact placement of images on a Web page. Enter the HTML table. By creating a table structure, you can easily control where images and text appear on a page. You can place text above, below, beside, or around a picture. Images can be grouped, aligned, and displayed in patterns that would be impossible without the table structure.

By using place-holding or dummy graphics, you can preview how successful a table will be. Then, with a couple of edits, you can substitute your finished images for an efficient and effective design.

OBJECTIVES

In this chapter, you will:

• Review the HTML tags that control the placement of graphic elements within table cells.

• Learn how to create and scale small graphic files to help you design tables.

• Use padding to make tables more readable.

• Link images in a table to both internal and external graphics.

• Combine text and graphics in the same table.

GIF Design Files in Black, White, Gray, and Clear

In order to create the structure for a Web page, you will have to carefully analyze the design and come up with a table structure that allows the elements (both graphical and textual) to be placed in the correct position. This

sounds like a formidable task but once you get the hang of it, you will find it to be quite straightforward.

Note: *Most designers are big believers in creating swipe files. They are always on the lookout for interesting designs—on Web pages, on television and in the movies, in traditional print media, and multimedia. A quick sketch, photocopy, or tear sheet should be kept in a notebook for reference.*

Most effective page designs are based on eyeflow and the relationship of elements spatially. In chapter 7, the importance of not letting a table resize as a browser's window is changed was stressed. The easiest way to force table cells into specific unvarying sizes is to load a graphic exactly the size you want.

It would be impossible to anticipate all of the sizes of graphic blocks you might need. HTML solves this problem by allowing you to scale a graphic to the page using:

HEIGHT=height in current units

WIDTH=width in current units

Because UNITS is normally allowed to default to pixels, it is easy to scale a graphic if you know its original size. For example, if you have a graphic that is 1.5″ x 1.5″, its original size in pixels is 109 x 109 (72 x 1.5 = 109). To get your graphic 2″ x 2″, your scale would be (72 x 2 = 144):

HEIGHT=144

WIDTH=144

This is fine for images but what we want to do is size spacers that form the structure of the table itself. To do this, we use small 1 pixel square spacers that can be easily scaled.

Call these files trans.gif, white.gif, black.gif, and gray.gif. These files are 1 pixel by 1 pixel, 1 bit deep for black, white, and transparent spacers, and 2–3 bits deep for the

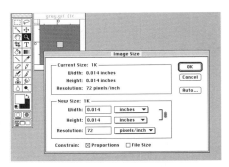

Figure 9.1 Create transparent, white, black, and gray spacer graphics.

gray spacer file (depending on the level of gray you want). Figure 9.1 shows a 1 x 1 canvas and the Image Size dialogue box in Photoshop. The transparent GIF file can be exported right out of your raster application (as a GIF89) or converted with a stand-alone utility. Because many areas of a page are negative space—they hold no text or graphics and allow the background to show through—the transparent GIF file is very important.

Note: Use black.gif, white.gif, and gray.gif to create page rules as well as horizontal and vertical bars that separate page elements.

By using unitary spacer files, you can design a table structure to match almost any page design. An added benefit of using a single tiny file over and over is that it has almost no download penalty and used once, is cached to the browser's computer where it is instantaneously used after that.

Task: Integrating Graphics with the Tag

In order to bring a graphic spacer into your table you will use the tag. This tag has several attributes that you will want to be aware of.

BORDER – A solid border is displayed around a linked graphic as specified in current units.

HEIGHT – Height of graphic in current units.

WIDTH – Width of graphic in current units.

HSPACE – Space on left and right of graphic in current units.

VSPACE – Space above and below graphic in current units.

LOWSRC – Loads a low resolution image before the image associated with SRC=.

ALT – Substitutes a text string for display in nongraphical browsers, or browsers for which graphics display has been toggled off.

Rather than spread these GIF spacers around your Web site structure you probably will create a directory specifically for them. (Each takes up about 2 k so there may be room to debate whether it really matters but no one likes messy site structure.) For example, assume that we want to bring in a transparent spacer that is 216 pixels (3.0″) wide and 360 pixels (5.0″) tall:

would load the 1 x 1 transparent GIF file from the current directory and scale it to 216 pixels wide and 360 pixels tall.

would load the 1 x 1 transparent GIF file from a directory called "spacers" that is one level closer to the root directory and scale it to 216 pixels wide and 360 pixels tall. If this were the second time the file and path were called, the cached file would be used and scaled.

HTML deals with a graphic in a table much as it handled text with a couple of exceptions.

You can buffer a graphic using HSPACE and VSPACE. This has the same effect as adding trans.gif spacers but can be used only after a graphic has been loaded. For example, assume that you want five 1″ square table cells. You could do this using Listing 9.1.

An alternative method is to load the transparent GIF file and use HSPACE and VSPACE to form the cell size (Listing 9.2). HSPACE and VSPACE are applied to both sides of the graphic. This takes a little calculation and may not arrive at the same results. In our case, a 1-pixel wide spacer with HSPACE of 35 applied on each

Listing 9.1 Using a transparent GIF file to size table cells.

```
<HTML>
<TITLE>Table Design Using Trans.GIF </TITLE>
 <BODY  BGCOLOR=#FFFFFF TEXT=#000000>
  <TABLE BORDER=2>
   <CAPTION><FONT SIZE=5>Transparent Spacers</CAPTION>
    <TR>
     <TD><IMG SRC="trans.gif" HEIGHT=72 WIDTH=72></TD>
     <TD><IMG SRC="trans.gif" HEIGHT=72 WIDTH=72></TD>
     <TD><IMG SRC="trans.gif" HEIGHT=72 WIDTH=72></TD>
     <TD><IMG SRC="trans.gif" HEIGHT=72 WIDTH=72></TD>
     <TD><IMG SRC="trans.gif" HEIGHT=72 WIDTH=72></TD>
    </TR>
  </TABLE>
 </BODY>
</HTML>
```

Listing 9.2 Using a transparent GIF file to size table cells.

```
<HTML>
<TITLE>Table Design Using HSPACE and VSPACE </TITLE>
 <BODY  BGCOLOR=#FFFFFF TEXT=#000000>
  <TABLE BORDER=2>
  <CAPTION><FONT SIZE=5>HTML H and V Space</CAPTION>
    <TR>
     <TD><IMG SRC="trans.gif" HSPACE=35 VSPACE=35></TD>
     <TD><IMG SRC="trans.gif" HSPACE=35></TD>
     <TD><IMG SRC="trans.gif" HSPACE=35></TD>
     <TD><IMG SRC="trans.gif" HSPACE=35></TD>
     <TD><IMG SRC="trans.gif" HSPACE=35></TD>
    </TR>
  </TABLE>
 </BODY>
</HTML>
```

Transparent Spacers

HTML H and V Space

side results in a 71-pixel cell (35 + 1 + 35 = 71). Since pixels are integers, HTML cannot create a 35.5 pixel space. Do this over the range of cells and you can see the result in Figure 9.2. The first VSPACE establishes the height of the row, making additional VSPACE in subsequent cells unnecessary.

Figure 9.2 Comparison of using HEIGHT/WIDTH and HSPACE/VSPACE to size table cells.

Padding In and Padding Out

Whether you have CELLPADDING or CELLSPACING added in the <TABLE> tag dramatically impacts how you are able to control the exact size of the page structure. For example, look at Figure 9.3. We want the buttons to be contiguous, that is, to butt up against each other and the gray margin to the left. The page and table have different BGCOLOR assignments to emphasize the results. Figure 9.4 shows what happens with CELLPADDING set to 5. Figure 9.5 adds 5 pixels of CELLSPACING to the table. Not only has the design been altered, the size of the entire page has been enlarged—both horizontally and vertically. Unless you want table background, table color, or the image to show around each cell, set CELLSPACING and CELLPADDING to zero so all cells fit tightly together.

Linking Table Graphics

Up to now, we have just placed images into a table to get a certain look. But what you will probably want to do is link certain images to other Web pages, Web sites, or media such as sounds, video, or animations.

Note: *The only time to display a BORDER around a linked image is during the design of the page. It can be helpful to quickly see where your links are. But almost all page designs are destroyed by unsightly borders around linked images. Leave anchor BORDERS off.*

It is advisable to get the page looking the way you want it and then establish the links. Because the linking process is so simple, you can concentrate first on how the page looks. The tasks at the end of this chapter will show you how to create linked table structures.

To link a graphic in a table cell to another Web page you add an anchor. A line that displays a logo in a table cell such as

<TD>

</TD>

Figure 9.3 What is desired with no CELLPADDING or CELLSPACING.

Figure 9.4 Adding CELLPADDING to the table.

Figure 9.5 Adding CELLSPACING to the CELLPADDING.

could be easily linked to the company whose logo you are displaying by changing the line to

<TD>

</TD>

Your browser will interpret this as: Go to the images directory, which is one level up from the current directory and get the file logo.gif. Display that graphic 100 pixels high and 80 pixels wide in this table cell, using the currently active alignment attributes. When the user positions the cursor over the graphic, change the cursor from an arrow to a finger-pointer. If the mouse is clicked, transfer control to the file intro.html at company.com.

Task: Create a Graphical Table

Using a table to bring graphic images to your Web pages accomplishes three important goals. First, it breaks the download into several smaller files. Additionally, these files can be called on subsequent pages from cache and not from the server. Second, these smaller files are easier to update. Rather than having to edit a single large graphic every time one minor component changes, the individual component graphic can be changed. And lastly, by using a table, you have ultimate control over where the text and graphics will appear.

In this task, we will be creating a graphical table that will serve as the splash page for an online magazine called Intestellar. Design notes: The banner art, issue information, and lead-in feature article will change each month. The navigation bar will be constant.

To create a graphical page that has individual linkable components, follow these steps:

1 Create your page in a raster editor like Photoshop (Figure 9.6).

Figure 9.6 The graphical page in Photoshop.

Figure 9.7 The grid in the raster editor that describes the page.

2 On another layer in the raster editor, construct a table grid that describes your layout (Figure 9.7). In the case of Intestellar, the table is 5 columns by 5 rows,

Figure 9.8 A display of the files that are the contents of the table.

although there will be several spanned cells. The white lines represent the planned table structure.

3 Carefully capture the cells (by cutting or cropping) as GIF or JPG images (Figure 9.8). Do this for all of the cells and replace empty cells later with scaled trans.gif files.

4 Create a basic <TABLE> structure to match your design. This is shown in Listing 9.3. The basic table is shown in Figure 9.9 in two versions: an unedited 5 x 5 table with cell identification numerals in place, and a table edited to reflect spanned cells. Compare this final basic table to the structure in Figure 9.7.

5 Bring the images into the table using the tag.

6 If you have empty cells, replace them with scaled spacer files. We do not have any in this case. The final page is shown in Figure 9.10. The HTML code for a final table is shown in Listing 9.4.

Listing 9.3 Basic table structure for the layout in Figure 9.7.

```
<HTML>
<HEAD>
<TITLE>Table for Figure 9.7</TITLE>
</HEAD>
  <BODY BGCOLOR="WHITE">
    <TABLE BORDER=1>
     <TR>
      <TD COLSPAN=5><FONT SIZE=5>1</TD>
     </TR>
     <TR>
      <TD COLSPAN=5><FONT SIZE=5>6</TD></TD>
     </TR>
     <TR>
      <TD COLSPAN=5><FONT SIZE=5>11</TD>
     </TR>
     <TR>
      <TD><FONT SIZE=5>16</TD>
      <TD COLSPAN=4><FONT SIZE=5>17</TD>
     </TR>
     <TR>
      <TD><FONT SIZE=5>21</TD>
      <TD><FONT SIZE=5>22</TD>
      <TD><FONT SIZE=5>23</TD>
      <TD><FONT SIZE=5>24</TD>
      <TD><FONT SIZE=5>25</TD>
     </TR>
    </TABLE>
  </BODY>
</HTML>
```

1	2	3	4	5
6	7	8	9	10
11	12	13	14	15
16	17	18	19	20
21	22	23	24	25

1				
6				
11				
16	17			
21	22	23	24	25

Figure 9.9 The basic table structure
that corresponds with Figure 9.7.

Listing 9.4 Final listing for the graphical Web page.

```
<HTML>
<HEAD>
<TITLE>Table for Figure 9.10</TITLE>
</HEAD>
 <BODY BGCOLOR="BLACK">
   <TABLE BORDER=0>
    <TR>
     <TD COLSPAN=5><IMG SRC="banner.gif"></TD>
    </TR>
    <TR>
     <TD COLSPAN=5><IMG SRC="name.gif"></TD>
    </TR>
    <TR>
     <TD COLSPAN=5><IMG SRC="issue.gif"></TD>
    </TR>
    <TR>
     <TD><IMG SRC="feature.gif"></TD>
     <TD COLSPAN=4><IMG SRC="text.gif"></TD>
    </TR>
    <TR>
     <TD><IMG SRC="j1.gif"></TD>
     <TD><IMG SRC="j2.gif"></TD>
     <TD><IMG SRC="j3.gif"></TD>
     <TD><IMG SRC="j4.gif"></TD>
     <TD><IMG SRC="j5.gif"></TD>
    </TR>
   </TABLE>
 </BODY>
</HTML>
```

Figure 9.10 The final page based on table structure.

Task: Combining Graphics and Text

To tie this and the previous two chapters together, let us substitute HTML text for cell 17 of Figure 9.9. The reason we want to do this is to be able to easily change the feature each month without creating a graphic each time. The original code from cell 17 was

<TD COLSPAN=4></TD>

Follow these steps to combine HTML text in our graphical table page:

1 Copy the text out of your text editor.

Note: What? You forgot to create a text file? Try this: Go back to the Photoshop (.psd) file and make the text layer active. If this text passage is the last text you entered, it is still in the text dialogue box. (Each layer keeps track of all text parameters separately.) Copy out of Photoshop and paste into your HTML file.

2 In cell 17, substitute the real text for text.gif by pasting. It should look something like the following:

<TD COLSPAN=4>

On July 14, 1947, on a small ranch outside Big Timber, Montana

.

.

.

Old Ralph Twondsay was a sharp old coot, and if he said he saw something, he saw it."

</TD>

3 Style the text appropriately. Use a style sheet only if you anticipate browser support for this feature. In our case, the text should use

<TD COLSPAN=4 ALIGN=RIGHT>

4 Finally, introduce a new graphic (the little green sphere and arrow captured out of Photoshop) with its anchor to jump to the rest of the feature article. By clicking on jump.gif you are sent to feature.html.

<TD COLSPAN=4 ALIGN=RIGHT>

On July 14, 1947, on a small ranch outside Big Timber, Montana

.

.

.

Old Ralph Twondsay was a sharp old coot, and if he said he saw something, he saw it."

</TD>

Summary

This chapter should have increased your interest in using <TABLE> to structure graphical Web pages. You discovered how white, black, gray, and clear GIF spacers can be scaled to create solid, unchanging page structure. You also discovered how padding and spacing of table cells impact the display. Finally, you saw how to develop pages based on table structure—pages that contain both raster images and HTML text.

In the next chapter, you will add sound, animation, and video to text and graphics, making truly rich interactive Web pages.

QUESTIONS

Q *I created the GIF spacer files you suggested but they do not show up when I go to load them with the tag. What am I doing wrong?*

A There are several things that might be going wrong. First (and this happens to me) is that I save the GIF file to somewhere else than the path specified in the tag. Check this first. Then ensure that the spacer is in GIF format.

Q *I get lost when I start editing my basic table. How can I keep track of which cells are where?*

A Always seed the cell with successive numbers. Then, when you use ROWSPAN or COLSPAN, the unneeded cells are pushed out the back of the table. Check the cell labels and delete these from the HTML code.

Q *I want to separate my table cells but I do not want the page's background color showing through when I use CELLSPACING. How do I do this?*

A You may be able to set BGCOLOR in the <TABLE> tag to the same color as the color of the data cells. If not, see if you can use CELLPADDING. As a last resort, you may have to introduce rows and columns into which you scale GIF spacers to get the results you want.

Q *I have noticed that some browsers do not support a background raster image across an entire table or individual cells. How can I get around this?*

A First ask yourself "do I really want a background image?" Do not use it unless it adds to the communication ability of your table. If you want everyone to see the background, try using the image as the background for the page, placed so that it appears on the right place on the page. (Make the image large enough so that it does not tile.) Design your table to appear over the page background.

CHAPTER 10

Using Multimedia in Tables

Few developments have changed the presentation of information more than has computer-based multimedia. The temptation to deliver the same level of interactivity and media richness found on CD-ROM is more than many can stand—even with the inherent limitations of the Internet's client-server design. You can, with limitations and restrictions, deliver sound, video, animations, and interactivity just like a CD multimedia title via Web pages.

This chapter is an overview of multimedia—focused on using the <TABLE> structure to control the placement of images, video, and sound on your Web page. Do not hesitate to read the chapters in Part Five: Multimedia Techniques, and then jump back here to see how tables and multimedia are combined.

Note: Multimedia *is the combining of multiple sensory content into an integrated product. Multimedia can have any combination of visual, auditory, and tactile activities. This can include still art, animations, video, sound, and interaction. Multimedia can be as simple as a slide show or as involved as a virtual reality role-playing game.*

Multimedia for general consumption on the Web will probably always be less than satisfying when compared to traditional computer-based multimedia because of the need to design for the lowest common hardware configuration and bandwidth limitation. In order to make multimedia work on the Web, you always have to think reduced—reduced sample rate for audio, reduced frame rate for video, reduced color palettes for images—all necessary so that your pages will download and play with acceptable response.

Multimedia elements can add interest to your Web pages and set them apart from the thousands of other pages vying for customer attention. It is certainly worth the effort to learn how to incorporate multimedia into HTML's table structure. Later in this book, several chapters are devoted to planning and executing multimedia on the Web.

OBJECTIVES

In this chapter, you will:

• Understand multimedia and the process of analyzing Web pages for its inclusion.

• Know which multimedia to avoid on Web pages.

• Understand how audio can be played as part of a Web page table.

• Become familiar with audio, video, and animation file types.

• Know where to find plug-ins so that you can use multimedia as part of your Web pages.

Understanding Nonsupported File Types in Tables

Multimedia—sound, video, animation, and interactivity—are not natural to the Web. That is, you cannot view the most common media or multimedia formats without

considerable help. See chapter 24, "Utilizing Plug-in Capabilities," for additional help on nonsupported file types. True, you can force multimedia onto the Web, but the level of responsiveness and interactivity is not comparable to that of other computer-based multimedia. If you try to deliver serious multimedia via the Web, you will probably be disappointed. This is due to several factors that are explained in detail in chapters 21 through 24. But suffice to say, you really have three choices:

1 Forget about multimedia. Unless you decide that the effectiveness of your Web page depends on a particular sound, video, or animation, leave such multimedia out. Create Web pages that extol the strengths of the medium. Forcing multimedia on the Web is a little like driving in a screw with a hammer. It can be done but it is not pretty.

2 Emphasize the natural interactivity of hyperlinked text and graphics. The Web is a naturally interactive medium and interactivity is an important part of multimedia. If you ignore video and sound, HTML can deliver interactivity, animation, and visual media quite easily. This is like nailing two boards together when you really wanted to use screws.

3 Deliver multimedia using specialized plug-ins. True multimedia (Director, Toolbook, Authorware, Oracle Media Objects) is developed off the Web and delivered to the browser by specialized plug-ins. This is a little like gluing a screwdriver blade to a hammer to drive the screw.

The file types that are naturally supported in browsers are changing almost monthly, but as a general overview, consider the following when planning media-rich pages:

Still Images GIF, JPG

GIF images are limited to 256 colors

JPG images can contain 16.7 million colors but must be dithered to the screen on 8- or 16-bit systems Video AVI, MOV

AVI video is directly supported by Internet Explorer

MOV quicktime requires a plug-in or helper application Audio AVI, AIF, WAV, MP3

AVI video can hold audio

AIF audio requires a plug-in or helper application

WAV audio requires a plug-in or helper application

MP3 requires a plug-in or helper application Animation GIF, MOV, AVI, MPG

GIF animations are naturally supported

AVI requires a plug-in or helper application

MOV requires a plug-in or helper application

MPG requires a hardware or software decompressor

Additionally, the server you use to deliver nonsupported file types must be configured to handle the format's MIME types. If a number of multimedia sites are already being delivered by your server, there is a good chance that most of the common MIME types are already active.

Incorporating Media with HTML Tables

In the previous chapter, you were shown various examples of the tag, the tag that is used to include GIF and JPG images inline on a page or in the cells of a table. Both Internet Explorer and Netscape Navigator provide ways to incorporate media directly onto your page (as opposed to opening a separate browser window) and both can be used with the TABLE structure. Explorer uses the tag.

While Navigator uses the <EMBED SRC=> tag, as in

<EMBED SRC="movie.mov" WIDTH=160 HEIGHT=120>.

The <DYNSRC> tag signals to Explorer that a dynamic source is being downloaded, and because Explorer has support for AVI files, loads and runs the video without any help.

The <EMBED> tag is more flexible but requires that a plug-in or helper application be identified in the browser's preferences that will run the media type. Plug-ins maintain the integrity of your page layout, that is, they play the media inline. Helper apps (unless they load directly on the page as with Explorer) open a new browser window.

Both browsers allow you to use the link and load feature. This requires that an appropriate application be identified in Navigator's General Preferences or Explorer's Windows Associations. See chapter 23, "Integrating Multimedia in Your Pages."

Using Audio in Tables

Internet Explorer provides a ready-made solution for adding a background sound to a table, BGSOUND. See chapter 21, "Training the Page to Speak," for an in-depth discussion of planning Web audio. Listing 10.1 shows how a barnyard sound might be incorporated into a table containing a picture of animals.

Task: Integrating Audio with HTML

In this task we will be creating a children's game in which common animals are displayed in a table and sounds are linked to table cells containing the pictures of the animals. Click on the animal, and sounds will play, it is really straightforward. (We could also make this a lesson in which a sound is played, then the correct animal would have to be selected.)

Listing 10.1 Using a background sound to play while a table is displayed.

```
<TITLE>Table Design Using Trans.GIF</TITLE>
 <BODY  BGCOLOR=#FFFFFF TEXT=#000000>
  <TABLE BORDER=2>
   <CAPTION><FONT SIZE=5>Table Sounds</CAPTION>
    <TR>
     <TD><BGSOUND SRC="barnyard.wav"></TD>
     <TD><IMG SRC="animals.gif" HEIGHT=72 WIDTH=72></TD>
    </TR>
   </TABLE>
  </BODY>
</HTML>
```

To create our little animal game, we would:

1 Design a table to hold the animals. In our case we have a table with a caption and five data cells (Listing 10.2).

2 Link the appropriate animal cells with sounds (Listing 10.3).

Our little animal sound game is shown in Figure 10.1.

Using Video in Tables

A table is a natural structure for organizing a video clip on your Web page because supporting textual and graph-

ical information can be formatted and presented along with the video. If the clip is embedded into the page, the video will run in the space provided in the table. If the video is not embedded (as with <A HREF>), a separate window will be opened and the video run by a plug-in or helper app.

There is an advantage to the separate video window. If the Web page requires scrolling, you may end up scrolling the video clip out of the browser's window. Then, when you want to refer to the video, you have to scroll back. Opening a separate video window and positioning it outside the browser solves this problem. Figure 10.2 shows a Web page and a video running in a separate window.

Listing 10.2 Table setup for the children's animal game.

```
<TITLE>Animal Sounds Children's Game </TITLE>
 <BODY  BGCOLOR=#FFFFFF TEXT=#000000>
  <TABLE BORDER=2>
   <CAPTION><FONT SIZE=5>
     Click on the Animal to Hear it Say Hello!
   </CAPTION>
    <TR>
     <TD><IMG SRC="dog.gif"></TD>
     <TD><IMG SRC="cat.gif"></TD>
     <TD><IMG SRC="pig.gif"></TD>
     <TD><IMG SRC="cow.gif"></TD>
     <TD><IMG SRC="horse.gif"></TD>
    </TR>
   </TABLE>
  </BODY>
</HTML>
```

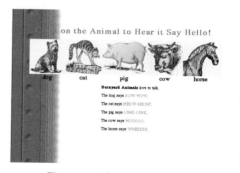

Figure 10.1 The animal sound game.

Listing 10.3 Linking table images with different sounds.

```
<TR>
      <TD><A HREF="sounds/dog.wav"><IMG SRC="dog.gif"></A></TD>
      <TD><A HREF="sounds/cat.wav"><IMG SRC="cat.gif"></A></TD>
      <TD><A HREF="sounds/pig.wav"><IMG SRC="pig.gif"></A></TD>
      <TD><A HREF="sounds/cow.wav"><IMG SRC="cow.gif"></A></TD>
      <TD><A HREF="sounds/horse.wav"><IMG SRC="horse.gif"></A></TD>
</TR>
```

Figure 10.2 Web page and video running in separate windows.

Note: *If your Web page metaphor is that of a print publication, it may be more honest to open a separate video window than to embed a video to actually run in a table cell.*

Task: Integrating Video with HTML

Let us add a video clip to our barnyard table. The table is redesigned so that a video of the animal is displayed in a separate window (Listing 10.4). Because sound can be part of the video, it is combined with the image in a single file. Now when you click on the picture of the animal,

Listing 10.4 Video resource called from a table cell.

```
<TITLE>Animal Sounds Children's Game with Video </TITLE>
 <BODY   BGCOLOR=#FFFFFF TEXT=#000000>
  <TABLE BORDER=2>
    <CAPTION><FONT SIZE=5>
     Click on the Animal to Hear it Say Hello!
    </CAPTION>
    <TR>
    <TD><A HREF="video/cat.avi"><IMG SRC="cat.gif"></A></TD>
    <TD><A HREF="video/cat.avi"><IMG SRC="cat.gif"></A></TD>
    <TD><A HREF="video/pig.avi"><IMG SRC="pig.gif"></A></TD>
    <TD><A HREF="video/cow.avi"><IMG SRC="cow.gif"></A></TD>
    <TD><A HREF="video/horse.avi"><IMG SRC="horse.gif"></A></TD>
    </TR>
    <TR>
    <TD>dog</TD><TD>cat</TD><TD>pig </TD><TD>cow</TD><TD>horse</TD>
    </TR>
  </TABLE>
 </BODY>
</HTML>
```

a video of the animal (with sound) is displayed as shown in Figure 10.3.

Embedding Multimedia in Tables

Probably the easiest way to add multimedia to your Web page is to embed a multimedia product that has been prepared specially for the Web environment. Macromedia has one approach to doing this. First, use Macromedia's Director or Authorware to create the multimedia product. Then, postprocess the multimedia file (using Shockwave for Director and Web Player for Authorware) so that it can be delivered as an embedded source with a line similar to the following:

<EMBED SRC="shockwave/movie.dcr">

To provide content for browsers that are not Shockwave enabled, you will want to include an alternative. You do this by using the <NOEMBED> tag:

<NOEMBED>

. Alternate content for the Shockwave Impaired

</NOEMBED>

Task: Embedding Multimedia in a Table

To demonstrate how a multimedia resource can be added to a table structure, let us add a small Macromedia Authorware piece to a Web page. To do this you would:

Figure 10.3 Adding video to our animal table.

1 Create the multimedia product. In this case, we have made a little publications calculator that converts decimal inch, fractional inch, and millimeters to points and picas.

2 Postprocess the multimedia file using Macromedia's Authorware Afterburner compressor. This generates a .aam map file and a number of .aas program modules. These .aas modules are served to the browser only when the application needs them—very much like streaming.

3 Embed the resource in your table and provide an alternative if the Web Player plug-in is not available. The code for this is shown in Listing 10.5 and the resulting Web page is in Figure 10.4.

Real World Examples

The best source of information about multimedia resources are the sites maintained by suppliers of those products. For up-to-the-minute developments in Quick-Time movies for the Web, visit Apple's QuickTime site (Figure 10.5). Information about Shockwave, Flash, and

Listing 10.5 An Authorware multimedia piece in a table.

```
<TITLE>Table Design Using Trans.GIF </TITLE>
 <BODY  BGCOLOR=#FFFFFF TEXT=#000000>
  <TABLE BORDER=2>
   <CAPTION><FONT SIZE=5>Transparent Spacers</CAPTION>
    <TR>
     <TD>A Publications Calculator</TD>
     <TD><EMBED SRC="web_player/calc.aam">
       <NOEMBED>You need the shockwave plug-in to view this page. Go
         to <A HREF=""http://www.macromedia.com>Macromedia's Home
         Page</A> to download.</NOEMBED>
     </TD>
    </TR>
  </TABLE>
 </BODY>
</HTML>
```

Figure 10.4 Authorware multimedia delivered using the TABLE structure.

Figure 10.5 A source for sites using QuickTime movies (http://www.quicktime.apple.com).

Web Player is provided on Macromedia's Web site (Figure 10.6). To locate Web sites using audio as well as suppliers of audio utilities and files, visit the Pro Audio site shown in Figure 10.7.

Summary

Tables provide the structure for inline multimedia and are used to hold the links to sound, video, animation, and multimedia. Much of this is still very much browser dependent, so delivering sophisticated multimedia for general consumption is probably unrealistic. However, delivering multimedia-enhanced pages on an intranet (where user profile is much easier to predict) is very realistic.

Because the Web is naturally interactive, it is a logical platform for multimedia. The challenge is to deliver interactivity and appropriate media-rich content within its current limitations.

QUESTIONS

Q *I want to deliver embedded video that uses a helper application but my UNIX and Mac clients get a separate window. Can I fix this?*

A Unfortunately, Mac and UNIX will not run the helper application in the current window. See if a plug-in is available for this file type.

Q *What is the difference between the EMBED and OBJECT tags?*

A EMBED is Netscape's way of bringing almost any resource to a Web page. OBJECT does the same thing and is being considered by the World Wide Web Consortium for the next revision of the HTML standard. Browsers that do not understand EMBED will simply disregard it. Netscape will continue to support EMBED. Both can be used in the HTML TABLE structure.

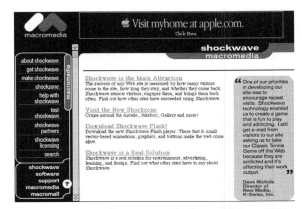

Figure 10.6 A source for sites using Shockwave, Flash, and Web Player (http://www.macromedia.com/).

Figure 10.7 A source for sites using streaming audio (http://proaudio-web.com/home.html).

Q *I have made an interactive button in Shockwave but it only appears once in my button bar. I thought I could save download time by calling it once and using it multiple times from cache.*

A A Shockwave file can be loaded only once per HTML page. You can get around this by renaming each button (but1.dcr, but2.dcr), or by loading the file into separate frames that call their own HTML pages.

Using Tables to Structure Pages

The previous three chapters discussed many of the features available for incorporating text, graphics, and multimedia into tables. In this chapter, we will start planning the design of actual Web pages—pages based on table structure.

Tables were not available in the early releases of Navigator or Explorer, so you can imagine the HTML tricks that had to be used to get text and graphics in anything other than a strictly linear design. The great thing about tables is that the practice of dividing a page into structural areas (header, footer, sidebar, marginalia, body text, and illustrations) fits the traditional design paradigm most information designers have used for years. The trick is to make HTML tables respond like a blue line grid. A Web site whose pages are designed around consistent table structure has the best chance of success—in being attractive and effectively communicating content.

By the next chapter, "Designing with Tables," you will be able to use whatever graphic tools are available to create table-based, graphical Web pages.

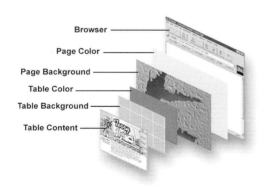

Figure 11.1 The Web page stacking order.

OBJECTIVES

In this chapter, you will:

• Combine tables with background images, both in the table and on the page.

• Learn how to create custom borders and rules.

• Use resizing tables to your advantage.

• Use set size tables to control page dimensions.

• Nest tables within tables to easily design highly complex structure.

• Understand the table structure behind the most popular page designs.

• Be able to analyze existing page design to implement on the Web.

Combining Tables and Background Images

Background images can be displayed behind a table if your browser has this feature. This was not a tag in the implementation of the HTML 3.2 standard so it is not available with all browsers, or on all platforms.

But before addressing tables with background images, let us look at the depth of visual information that can be built up on a Web page.

Figure 11.1 shows the stacking order of visual elements on a typical Web page. Notice that I purposely avoid using the term *layer* in this case. The final page is what you see looking through the page stack. At the back of the stack is the BGCOLOR hexadecimal page color.

Next, a BACKGROUND wallpaper GIF or JPG raster image is displayed. This will tile (repeat) if it is smaller than the browser window and if a transparent color is identified, the page color will show through. The BG-COLOR table color assigned in the TABLE tag will cover up the wallpaper and page color. A background table image is a raster image that displays in front of the table color. This means that if the table image contains a transparent color, the table color will show through. Into individual table cells images, text, and multimedia can be loaded. Table 11.1 further defines how this Web page stack works. Even without real layers, you have five positions in the stack to use in your design.

First, let us see how we can put a background behind a table using a browser that does not support background images in tables themselves.

Figure 11.2 shows a table with what appears to be a background image. On closer inspection, what we really have is a page background image whose dimensions are so large that tiling is defeated. A page table is designed to overlay the background such that the image appears behind the main table structure (Figure 11.3). If you want the inner table to have borders and rules, but you want the rest of the table to be clean (without a border), nest the inner table with BORDER=3 inside the page table with BORDER=0. Nested tables are covered in more detail later in this chapter.

For Internet Explorer, use the BACKGROUND= attribute in the TABLE tag to display a GIF or JPG raster image in front of page color or table color.

Realizing When Table Borders and Frames Are Appropriate

By now you probably know that we are not fans of table borders. Unless you are "just presenting the facts," we cannot imagine displaying table borders or frames.

Top	<...SRC>	<TD><TH>	HTML text, graphic, media
	BACKGROUND	<TABLE>	GIF, JPG raster graphic
	BGCOLOR	<TABLE>	Hexadecimal or color name
	BACKGROUND	<HEAD>	GIF, JPG raster graphic
Bottom	BGCOLOR	<HEAD>	Hexadecimal or color name

Table 11.1 The Web page stacking order.

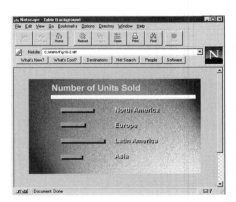

Figure 11.2 Page background image functioning as a table background.

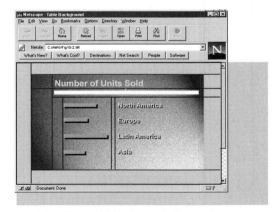

Figure 11.3 Position of background relative to the table borders.

Note: *Do not confuse plain and boring with ineffective. If you want to see very effective tabular data, pick up a couple of annual reports from any of the top corporations. None of the data in the reports will look like straight HTML tables but with a little creativity, the TABLE structure can easily be used to produce annual report results.*

The major use of table borders rests in the design of the Web page. It is nearly impossible to tell where a particular data cell is falling on the page unless you turn the border on. On the code listings in this book, the BORDER attribute has been included even when it is always BORDER=0. Before the pages were finished, borders were toggled on and off hundreds of times.

Almost every Web page that displays content in a table with the default borders and rules literally shouts, "Hey, look at me, I just discovered HTML!" Do not do it! Study Figure 11.4. The first data use a default HTML table with borders. The second table turns off the borders and introduces scaled black.gif graphic spacers for rules—much better!

Task: Using Tables That Resize Automatically

HTML provides attributes of the <TABLE>, <TD>, and <TH> tags that impact how the table reacts to changes in browser window dimensions. The attributes WIDTH and HEIGHT can be left out entirely, set as a percentage of the browser window's dimensions, or set to specific pixel dimensions. But when a graphic is brought into a table cell, that cell will not resize smaller than the graphic's dimensions. However, if a cell only contains HTML text, both free and percentage resizing become problematic. HTML text cells will resize only to a point, and at some time, further shrinking of the browser window does not have an effect on the table's dimensions.

Let us allow a table to first resize freely, and then resize as a percentage of the open browser window. The page in Figure 11.5 shows the results of letting the page table resize as the browser window is made smaller.

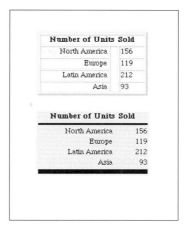

Figure 11.4 Standard table borders and the use of black.gif to create table rules.

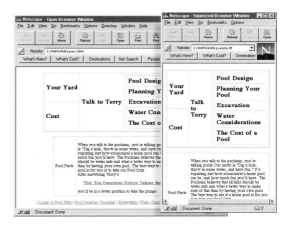

Figure 11.5 Table resized by browser window dimensions.

1 Create a page using HTML text like that shown in Figure 11.5. Leave out any reference to WIDTH or HEIGHT.

2 Open the browser window fully. Notice the impact on your page design. Resize the window to be tall and skinny. Notice how the page design has been altered.

3 Do some quick X and Y calculations for your table and enter HEIGHT=Y% and WIDTH=X% into your <TD> tags. See Listing 11.1. Open the browser fully and then shrink it dramatically.

Notice that the browser attempts to maintain table proportions sometimes with tragic results on content. This demonstrates that for most page design, allowing a table to resize freely or as a percentage of browser dimensions does not enhance either the visual design or efficiency of information transfer.

Task: Using Tables That Are a Set Size

By expressing table dimensions explicitly in terms of pixels, you can thwart the page redesign previously de-

Listing 11.1 Table resized as percentage of browser window.

```
<TABLE BORDER="3" CELLSPACING="0" CELLPADDING="5" WIDTH=100%>
 <TR>
  <TD WIDTH=30%><H2>Your Yard</TD>
  <TD ROWSPAN=3 WIDTH=30%><H2>Talk to Terry</TD>
  <TD ROWSPAN=2 VALIGN=TOP WIDTH=40%>
     <TABLE BORDER="1" CELLSPACING="0" CELLPADDING="5" WIDTH=40%>
       <TR>
        <TD WIDTH=35%><H2>Pool Design</TD>
       </TR>
       <TR>
        <TD WIDTH=35%><H2>Planning Your Pool</TD>
       </TR>
       <TR>
        <TD WIDTH=35%><H2>Excavation</TD>
       </TR>
       <TR>
        <TD WIDTH=35%><H2>Water Considerations</TD>
       </TR>
       <TR><TD WIDTH=35%><H2>The Cost of a Pool</TD>
       </TR>
     </TABLE>
  </TD>
 </TR>
 <TR>
  <TD WIDTH=30%><H2>Cost</TD>
 </TR>
</TABLE>
```

scribed. By introducing HEIGHT=Y and WIDTH=X (where X and Y are pixels at 72 pixels per inch on a 640 x 480, 15″ diagonal display), a resized browser window will have no impact on your design.

Note: *The key to life is flexibility, and life with computers is no exception. There may be times where expressing HEIGHT and WIDTH in pixels will not constrain resizing. I have seen this anomaly between files on the same browser and between browsers with the same file. You can always force a table to exact size by loading a transparent graphic into a column or row's first cell. It is crude, but it always works.*

Let us take the same page we used in Figure 11.5 and force it to a specific size. When the table's width or height is greater than that of the browser window, scroll bars will automatically appear. To create a table that does not resize you would:

1 Edit the code in Listing 11.1 so that the values following HEIGHT and WIDTH are expressed in terms of absolute pixel values. See Listing 11.2.

2 Open your browser's window fully. Notice that the page is not allowed to stretch.

Listing 11.2 Explicit pixel values used in HEIGHT and WIDTH attributes.

```
<TABLE BORDER="3" CELLSPACING="0" CELLPADDING="5" WIDTH=850>
    <TR>
      <TD WIDTH=255><H2>Your Yard</TD>
      <TD ROWSPAN=3 WIDTH=255><H2>Talk to Terry</TD>
      <TD ROWSPAN=2 VALIGN=TOP WIDTH=340>
          <TABLE BORDER="1" CELLSPACING="0" CELLPADDING="5" WIDTH=340>
            <TR>
             <TD WIDTH=298><H2>Pool Design</TD>
            </TR>
            <TR>
             <TD WIDTH=298><H2>Planning Your Pool</TD>
            </TR>
            <TR>
             <TD WIDTH=298><H2>Excavation</TD>
            </TR>
            <TR>
             <TD WIDTH=298><H2>Water Considerations</TD>
            </TR>
            <TR><TD WIDTH=298><H2>The Cost of a Pool</TD>
            </TR>
          </TABLE>
      </TD>
    </TR>
    <TR>
     <TD WIDTH=255><H2>Cost</TD>
    </TR>
  </TABLE>
```

3 Shrink the browser's window so that it is tall and skinny. Notice that the page is not squeezed (Figure 11.6).

Task: Using Nested Tables

Simply put, nested tables are tables within tables. Any TD or TH tag can contain an entire TABLE structure; usually it is the TD tag that is used. I have already mentioned several advantages of doing this: background image stacking, color, and border changes. But there is another benefit. Using nested tables reduces the necessity of spanning rows and columns. This makes the overall page design more simple. Additionally, because the nested table is a valid and complete table in its own right, its HTML code can be easily repurposed with little or no editing.

Look at the tables in Figure 11.7. On first glance the first table might appear to be 6 columns by 4 rows. As such, one TD must span 3 rows while another must span 5 columns. Instead, let us do this to create the second table:

1 Design an outside table that is 2 rows by 2 columns (cells 1–4).

2 As the data in cell 4 (the second TD of the second TR), place a 3-row by 5-column table (data cells 5–19).

3 You are done! See Listing 11.3.

Popular Page Structures

In order to design effective Web pages, you will need to assemble an arsenal of page structures that can be ap-

Figure 11.6 WIDTH and HEIGHT expressed in absolute pixels forces the table not to resize.

Figure 11.7 Using nested tables to simplify page structure.

plied to different jobs. The more designs you can choose from, the better chance a successful design can be found. There are, of course, an infinite number of page designs possible, and by combining elements of various pages, you can arrive at a different solution with little effort. Figures 11.8 through 11.14 show a number of page designs. Table borders have been left on so the structure can be

Listing 11.3 Nested tables simplify table structure.

```
<CENTER>
   <TABLE BORDER="1" CELLSPACING="0" CELLPADDING="0" WIDTH=300
      HEIGHT=300>
      <TR>
         <TD WIDTH=50 HEIGHT=50 ALIGN=CENTER
          BGCOLOR="RED">1</TD>
         <TD ALIGN=CENTER BGCOLOR="RED">2</TD>
      </TR>
      <TR>
         <TD ALIGN=CENTER BGCOLOR="RED">3</TD>
         <TD ALIGN=CENTER BGCOLOR="YELLOW">
<!—Nested Table—>
            <TABLE BORDER="1" CELLSPACING="0"
               CELLPADDING="0"
               WIDTH=200 HEIGHT=200 BGCOLOR="WHITE">
            <TR>
               <TD ALIGN=CENTER WIDTH=40>5</TD>
               <TD ALIGN=CENTER WIDTH=40>6</TD>
               <TD ALIGN=CENTER WIDTH=40>7</TD>
               <TD ALIGN=CENTER WIDTH=40>8</TD>
               <TD ALIGN=CENTER WIDTH=40>9</TD>
            </TR>
            <TR>
               <TD ALIGN=CENTER>10</TD>
               <TD ALIGN=CENTER>11</TD>
               <TD ALIGN=CENTER>12</TD>
               <TD ALIGN=CENTER>13</TD>
               <TD ALIGN=CENTER>14</TD>
            </TR>
            <TR>
               <TD ALIGN=CENTER>15</TD>
               <TD ALIGN=CENTER>16</TD>
               <TD ALIGN=CENTER>17</TD>
               <TD ALIGN=CENTER>18</TD>
               <TD ALIGN=CENTER>19</TD>
            </TR>
            </TABLE>
         </TD>
      </TR>
   </TABLE>
```

matched with the HTML code. The text passages in the listings have been shortened for the sake of brevity.

Single Column, Banner at Top, Unequal Margins

Figure 11.8 shows an example of this type of page, one that is good for opening pages. However, realize that the optimum column width for 12-point text is 5 inches, much narrower that an open browser window on a 640 x 480 display. See Figure 11.8 and Listing 11.4.

Figure 11.8 Single column design with banner at top.

Listing 11.4 Single column with banner and unequal margins.

```
<HTML>
<HEAD>
<TITLE>Banner and Single Column</TITLE>
</HEAD>
<BODY BGCOLOR=#FFFFFF>
<CENTER>
   <TABLE BORDER="1" CELLSPACING="0" CELLPADDING="0">
      <TR>
          <TD><IMG SRC="banner.jpg"></TD>
      </TR>
      <TR>
          <TD><IMG SRC="trans.gif" WIDTH=500 HEIGHT=25></TD>
      </TR>
      <TR>
          <TD WIDTH=700 ALIGN=LEFT><FONT SIZE=4>
            <IMG SRC="trans.gif" WIDTH=20 HEIGHT=10>
               Lorem ipsum dolor...
            <P>
            <IMG SRC="trans.gif" WIDTH=20 HEIGHT=10>
               Lorem ipsum dolor...
            <P>
            <IMG SRC="trans.gif" WIDTH=20 HEIGHT=10>
               Duis autem vel...
          </TD>
      </TR>
   </TABLE>
</BODY>
</HTML>
```

Equal Columns, Banner at Top

Page structure that uses multiple columns provides for the greatest flexibility. Many designers begin with a 7- or 9-column page and group columns together (COLSPAN) as necessary. See Figure 11.9 and Listing 11.5.

Figure 11.9 Page design with three equal columns and banner at top.

Listing 11.5 Equal columns, banner at top.

```
<HTML>
<HEAD>
<TITLE>Banner and Equal Columns</TITLE>
</HEAD>
<BODY BGCOLOR=#FFFFFF>
  <TABLE BORDER="1" CELLSPACING="0" CELLPADDING="5">
    <TR>
      <TD COLSPAN=3><IMG SRC="banner.jpg"></TD>
    </TR>
    <TR>
      <TD COLSPAN=3>
        <IMG SRC="trans.gif" WIDTH=500 HEIGHT=25></TD>
    </TR>
    <TR>
      <TD VALIGN=TOP>
        <IMG SRC="trans.gif" WIDTH=20 HEIGHT=10>
          Lorem ipsum dolor...
      </TD>
      <TD VALIGN=TOP>
        <IMG SRC="trans.gif" WIDTH=20 HEIGHT=10>
          Lorem ipsum dolor...
      </TD>
      <TD VALIGN=TOP>
        <IMG SRC="trans.gif" WIDTH=20 HEIGHT=10>
          Lorem ipsum dolor...
      </TD>
    </TR>
  </TABLE>
</BODY>
</HTML>
```

Unequal Columns with Marginalia

Body text can be put into an optimum column and re-mainder of the page used as a smaller column for marginalia, heads, or illustrations. See Figure 11.10 and Listing 11.6.

Figure 11.10 A page with unequal columns with marginalia.

Listing 11.6 Unequal columns with marginalia.

```
<HTML>
<HEAD>
<TITLE>Banner and Unequal Marginalia Column</TITLE>
</HEAD>
<BODY BGCOLOR=#FFFFFF>
   <TABLE BORDER="1" CELLSPACING="0" CELLPADDING="5">
      <TR>
         <TD COLSPAN=3><IMG SRC="banner.jpg"></TD>
      </TR>
      <TR>
         <TD COLSPAN=3>
           <IMG SRC="trans.gif" WIDTH=500 HEIGHT=25></TD>
      </TR>
      <TR>
         <TD WIDTH=100 HEIGHT=300 ALIGN=RIGHT>
           <FONT SIZE=4><B>Marginalia, Notes, and Other Stuff
         </TD>
         <TD VALIGN=TOP>
           <IMG SRC="trans.gif" WIDTH=20 HEIGHT=10>
             Lorem ipsum dolor ...
           <P>
           <IMG SRC="trans.gif" WIDTH=20 HEIGHT=10>
             Duis autem vel...
           <P>
           <IMG SRC="trans.gif" WIDTH=20 HEIGHT=10>
             Laoreet dolore magna...
         </TD>
      </TR>
  </TABLE>
</BODY>
</HTML>
```

Illustration Intensive with Supporting Text

In this case, an illustration is the main focus of the page and text takes on a supporting role. Notice that a separate data cell is created for the figure legend. Because of the narrower text column, 10-point text is used to get more words per line. See Figure 11.11 and Listing 11.7.

Figure 11.11 An illustration-intensive page design.

Listing 11.7 Illustration intensive with supporting text.

```
<HTML>
<HEAD>
<TITLE>Illustration and Supporting Text</TITLE>
</HEAD>
<BODY BGCOLOR=#FFFFFF>
   <TABLE BORDER="1" CELLSPACING="0" CELLPADDING="5">
      <TR>
         <TD ALIGN=RIGHT>
            <IMG SRC="cracked.jpg">
         </TD>
         <TD VALIGN=TOP><FONT SIZE=4>
         <P>Lorem ipsum dolor...
         </TD>
      </TR>
      <TR>
         <TD ALIGN=RIGHT><B>Figure Number</B><BR> Figure explanation goes here below the
illustration.</TD>
         <TD></TD>
      </TR>
   </TABLE>
</BODY>
</HTML>
```

Graphic Link Bar and Text

In order for the link images to touch in a seamless bar, set both CELLPADDING and CELLSPACING to zero. Introduce row and column spacing by using trans.gif or nesting either the link bar or the text in a separate table. See Figure 11.12 and Listing 11.8.

Text with Sidebar

A sidebar presents supplementary information not all readers may be interested in. Or, it may display information of a highly changing nature. Use CELLPADDING to buffer the sidebar. See Figure 11.13 and Listing 11.9.

Figure 11.12 A page with a linked graphics bar and supporting text.

Listing 11.8 Link bar and text.

```
<HTML>
<HEAD>
<TITLE>Grapohic Link Bar and Text</TITLE>
</HEAD>
<BODY BGCOLOR=#FFFFFF>
  <TABLE BORDER="1" CELLSPACING="0" CELLPADDING="5">
    <TR>
      <TD ALIGN=TOP>
        <TABLE BORDER="0" CELLSPACING="0"
            CELLPADDING="0">
          <TR>
            <TD><A HREF="1.html"><IMG SRC="1.gif"BORDER=0></A>
            </TD>
          </TR>
          <TR>
            <TD><A HREF="2.html"><IMG SRC="2.gif" BORDER=0></A>
            </TD>
          </TR>
          <TR>
            <TD><A HREF="3.html"><IMG SRC="3.gif"BORDER=0></A>
            </TD>
          </TR>
          <TR>
            <TD><A HREF="4.html"><IMG SRC="4.gif" BORDER=0></A>
            </TD>
          </TR>
          <TR>
            <TD><A HREF="5.html"><IMG SRC="5.gif" BORDER=0></A>
            </TD>
```

```
            </TR>
          </TABLE>
        </TD>
        <TD VALIGN=TOP WIDTH =100 HEIGHT=300>
            <IMG SRC="trans.gif" WIDTH=20 HEIGHT=300>
        </TD>
        <TD VALIGN=TOP><FONT SIZE=4>
            <IMG SRC="trans.gif" WIDTH=20 HEIGHT=10>
              Lorem ipsum dolor...
          <P>
            <IMG SRC="trans.gif" WIDTH=20 HEIGHT=10>
              Lorem ipsum dolor...
          <P>
            <IMG SRC="trans.gif" WIDTH=20 HEIGHT=10>
              Lorem ipsum dolor...
        </TD>
      </TR>
    </TABLE>
</BODY>
</HTML>
```

Figure 11.13 A page design utilizing a side bar for supporting information.

Listing 11.9 Text with sidebar.

```
<HTML>
<HEAD>
<TITLE>Sidebar and Text</TITLE>
</HEAD>
<BODY BGCOLOR=#FFFFFF>
  <TABLE BORDER="1" CELLSPACING="0" CELLPADDING="5">
    <TR>
     <TD ALIGN=RIGHT>
       <TABLE BORDER="1" CELLSPACING="0" CELLPADDING="5">
        <TR>
         <TD WIDTH=300 HEIGHT=20 BGCOLOR="BLACK">
          <FONT COLOR="WHITE"><FONT SIZE=4><B>Sidebar Heading
          </TD>
        </TR>
        <TR>
         <TD WIDTH=300 HEIGHT=200 BGCOLOR="TAN" VALIGN=TOP>
         <FONT SIZE=4>Lorem ipsum dolor...
         </<TD>
        </TR>
       </TABLE>
     </TD>
     <TD VALIGN=TOP WIDTH=300 Height=400><FONT SIZE=4>
       Lorem ipsum dolor...
```

```
    <P>
      Lorem ipsum dolor...
    <P>
      Lorem ipsum dolor...
    </TD>
   </TR>
  </TABLE>
</BODY>
</HTML>
```

Text with Pull Quote

A pull quote can be created as an inline graphic with the table structure. If you use an inline graphic, you have the advantage of text wrap—based on the alignment of the graphic. However, without the table structure you have little control over what the page will look like. Listing 11.10 combines a table and an inline graphic to achieve the results shown in Figure 11.14.

Figure 11.14 Page design using a pull quote and wrapped text.

Listing 11.10 Text and pull quote.

```
<HTML>
<HEAD>
<TITLE>Sidebar and Text</TITLE>
</HEAD>
<BODY BGCOLOR=#FFFFFF>
   <TABLE BORDER="1" CELLSPACING="0" CELLPADDING="5">
    <TR>
     <TD><IMG SRC="trans.gif" WIDTH=50 HEIGHT=400>
     </TD>
     <TD COLSPAN=2 WIDTH=500 HEIGHT=100>
     <FONT SIZE=4 VALIGN=TOP>
     <B>Lorem ipsum dolor </B>sit amet..
     <IMG SRC="pull.gif" ALIGN=LEFT>
        vero eros et...
     </TD>
    </TR>
   </TABLE>
</BODY>
</HTML>
```

Task: Analysis of Existing Page Design Structure

The best way to hone your page layout skills using tables is using a traditional publication such as a magazine, and translate existing page structure into an HTML Web page.

Note: *Probably the easiest way to maintain existing paper document structure is to scan the document into Portable Document Format (PDF). This requires a PDF plug-in or helper application. On the Web, the document will look just like the original. You can zoom and inspect, and link words (regions) to other Web resources or documents. However, it is difficult to modify a PDF document created from paper. Distilled from an electronic document, it is easier to go back and change the original file, but it still must be distilled into PDF format before posting on the Web.*

Figure 11.15 shows a magazine page that has been translated to the Web. You may have seen the page (from a networking company) in any of several mainstream computer publications. On first glance, it might appear difficult to put into HTML, but with a systematic approach, it is fairly easy. Let us see how to do it.

1 Analyze the content elements on the page. Which are text and which are graphic? Which text would be easier to control as graphic text? Are there background images, either in the page, or within a possible table?

2 On a tracing overlay, develop a grid that describes the page's structure (Figure 11.16). This may take several attempts because the page may have a structure that is difficult to discern. Do not forget to add rows or columns for margins, gutters, or alleys between columns of text; add empty column or row headers to control the size of the table.

3 Working from the inside out, determine whether the structure can be defined as nested tables. This is particularly appropriate when a region of the page has a different background color or image.

Figure 11.15 A magazine advertisement page on the Web.

Figure 11.16 The page and its structural grid.

4 Notate the number of rows and columns within the table structure. You may eventually use ROWSPAN or COLSPAN to group data cells, but that will only work if you define the table first as if the cells were not going to be spanned.

5 Seed the cells with successive numbers or letters. Create an HTML table with BORDER=1 that corresponds to your tracing, using these seed values. When you look at this basic table in your browser, it will not look much like your page, but do not worry! Just check to make sure that the structure is the same. Compare the basic table in Figure 11.17 with the layout in Figure 11.16. Some of the cells will have to be spanned. If you look at the fundamental structure, you will see that the page is really described by a 5-column by 8-row table, resulting in 40 total cells.

6 Analyze the structure and apply COLSPAN and ROWSPAN to group data cells. The unneeded cells will be pushed out the right side of the table. Because you seeded the data cells with values, you can easily find the lines of code to eliminate. For best success, do this in steps, rather than for the entire page.

7 Use trans.gif to size empty rows or columns. Now when you look at the page in your browser (Figure 11.18), it will probably look much like the original magazine page, just without content.

8 Create the text and graphic content. Then, place your seed data with HTML text and calls to images. After tweaking and fine-tuning text size, impact, and alignment—plus image size—your finished page should look like Figure 11.15. The final code is in Listing 11.11.

Figure 11.17 The basic table.

Figure 11.18 The page with empty cells sized.

Listing 11.11 HTML code for magazine page shown in Figure 11.15.

```
<HTML>
<HEAD>
<TITLE>Advertising Example</TITLE>
</HEAD>
<BODY BGCOLOR=#FFFFFF BACKGROUND="background.jpg">
    <TABLE BORDER="1" CELLPADDING="0" CELLSPACING="0">
    <TR>
        <TD HEIGHT=42 WIDTH=162>
        <IMG SRC="clear.gif" WIDTH=162 HEIGHT=42></TD>
        <TD ROWSPAN=8 WIDTH=6>
        <IMG SRC="clear.gif" WIDTH=6 HEIGHT=42></TD>
        <TD HEIGHT=42 WIDTH=168>
        <IMG SRC="clear.gif" WIDTH=168 HEIGHT=42></TD>
        <TD HEIGHT=42 WIDTH=12>
        <IMG SRC="clear.gif" WIDTH=12 HEIGHT=42></TD>
        <TD HEIGHT=42 WIDTH=168>
        <IMG SRC="clear.gif" WIDTH=168 HEIGHT=42></TD>
    </TR>
    <TR>
        <TD HEIGHT=30 WIDTH=162></TD>
        <TD ALIGN=CENTER COLSPAN=3>
            <TABLE BORDER="0" CELLPADDING="0" CELLSPACING="20">
                <TR>
                    <TD VALIGN=BOTTOM ALIGN=CENTER>
                    <FONT SIZE=5><B>ADVERTISING TITLE HEADLINE.
                    </FONT SIZE=5></B></TD>
                </TR>
                    <TD VALIGN=TOP ALIGN=CENTER>
                    <IMG SRC="black.gif" WIDTH=363 HEIGHT=1></TD>
            </TABLE>
        </TD>
    </TR>
    <TR>
```

```
      <TD HEIGHT=168 WIDTH=162></TD>
      <TD HEIGHT=168 WIDTH=162>Lorem ipsum dolor...</TD>
      <TD HEIGHT=168></TD>
      <TD HEIGHT=168 WIDTH=162>Lorem ipsum dolor...</TD>
    </TR>
    <TR>
      <TD HEIGHT=54 WIDTH=162 ALIGN=RIGHT>
       <IMG SRC="gray.gif" WIDTH=60 HEIGHT=40>
      </TD>
      <TD HEIGHT=354 COLSPAN=3 ROWSPAN=2 ALIGN=CENTER>
       <IMG SRC="gray.gif" WIDTH=252 HEIGHT=312>
      </TD>
    </TR>
    <TR>
      <TD HEIGHT=300 WIDTH=162 ALIGN=RIGHT VALIGN=TOP>
          Lorem ipsum dolor<BR><BR>

          .

          .

          .

          Esse molestie consequat</TD>
    </TR>
    <TR>
      <TD HEIGHT=48 WIDTH=162></TD>
      <TD COLSPAN=3 ALIGN=CENTER>
       Lorem ipsum dolor sit amet,consectetuer adipiscing
       elit sed diam 000-000-0000</TD>
    </TR>
    <TR>
      <TD HEIGHT=78 WIDTH=162></TD>
      <TD COLSPAN=3 ALIGN=CENTER>
        <IMG SRC="gray.gif" WIDTH=65 HEIGHT=72></TD>
    </TR>
    <TR>
      <TD HEIGHT=42 WIDTH=162></TD>
      <TD COLSPAN=3 ALIGN=CENTER>
       <FONT SIZE=1>autem vel eum iriure dolor in
       hendrerit<BR>
        <FONT SIZE=3><B>Lorem ipsum dolor sit amet</B></TD>
    </TR>
    </TABLE>
</BODY>
</HTML>
```

Real World Examples

Figure 11.19 shows an example of a commercial Web page based on table structure. The HTML code is shown along with the page. It is often difficult to reproduce the design of the structure without the original content resources.

Here is a hint if you really want to dig into a page structure: First, download the HTML source. Then, download the individual graphic elements. You can do this in Navigator by clicking and holding on an image (right clicking in Internet Explorer). When the pop-up menu appears, choose "Save Image." Then, put the images and HTML code in the same directory, simplify directory paths in all tags, turn your border on and see if you get the page. If not, go back to the HTML code and strip out any lines that do not deal specifically with the table structure. These may be browser, editor, or server specific. Normally, two or three edits gives you the page.

Summary

Tables are the lifeblood of Web page design. Without table structure, it would be impossible to make pages with anything other than linear designs. Additional design tools such as layers will certainly become available in future releases of the HTML standard. Until then, designers will have to be satisfied with the stacking order of background color, images, table color, images, and content.

Default table borders are invaluable when designing a page, but are of limited value as actual design elements. It is much better to design your own borders as graphic elements.

As a designer, you will want to deliver consistent pages to your clients. To do this, constrain page tables to specific sizes. That way, when a client switches from a 13″ 640 x 480 monitor to a 17″ 800 x 600 monitor, your page will look the same.

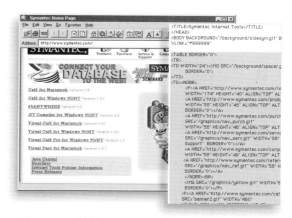

Figure 11.19 Table structure at http://www.symantec.com.

Nested tables give you the flexibility to combine independent designs with the minimum of code editing. For example, including a traditional thumbnail of one page on another is a relatively easy task with nested tables.

You will want to keep a library of different page designs and in this chapter, you were shown a number of basic designs with which to start. With this information, and that in the next chapters, you should be designing Web pages in no time, which will cause others to say, "How did they do that?"

QUESTIONS

Q *Every now and then I get one graphic on top of another, like they were layered. Can I control this?*

A If you force a graphic into a smaller cell that will not resize, you can get overlap. If you played with this enough you could probably get to the place where you could predict the results. I just do not think it would be worth it.

Q *How can I easily edit a table that already has been finished? I cannot tell where to start adding TR and TD tags.*

A It is a lot easier to do this by adding nested tables. You may have to resize existing graphic spacers so you can get enough size in the nested cells.

Q *Most browsers I design for do not recognize table backgrounds. I want to show a light screened photograph behind some numerical data. Do I have to make the whole thing into a graphic?*

A No, if you do you will have to edit the graphic if the numeric data changes. Use a page background that does not tile and adjust its size so it corresponds to the table.

Q *How can I make a custom table border that has another table inside? I do not want to piece partial table borders together.*

A This is an example of the classic nested table. Create a single cell table (<TR><TD></TD></TR>) with a background graphic of your table border. Then, introduce a table as the object of the <TD> tag.

Q *Where did you get the lorem ipsum text you use for page templates?*

A This text has been kicking around for some time but PageMaker made it available in electronic form. You can create your own by using English text that is rearranged into nonsensical patterns.

Q *Are page designs copyrighted? Is it OK for me to copy how someone arranges text and graphics?*

A An idea cannot be copyrighted, only the tangible expression of that idea. The design of a page is an idea.

Designing with Tables

If you have not gotten the message about how important tables are in the design of Web pages, you had better go back and revisit chapters 7 through 11. But of course, you are now a TableMeister and cannot wait to put your newfound knowledge to work!

In this chapter, we will present additional information to help you become even more productive using tables to structure your pages. It is really amazing, once you adopt this structured table approach to Web page design, you can begin to immediately see the underlying table that describes any Web page you visit. (The danger is in seeing structure where there is none—Tableosis—a condition that is difficult to treat as long as you have an Internet connection.)

OBJECTIVES

In this chapter, you will:

• Better understand the table planning process.

• Come to appreciate the beauty of using grids (and from the grids, tables) to plan your pages.

• Be able to break a design into its grid.

• Match the right graphics tool to the Web task.

• Know the benefits of replacing HTML text with graphic text.

• Understand the steps in using a raster editor to plan your pages.

Understanding the Page Design Planning Process

Web pages that are designed around TABLE structure give you control over the placement of text and graphics that is otherwise impossible. Tables are best designed by first having an idea as to what the end result will be. It is not impossible to design a page without making design decisions first, it is just not as efficient, and the results are almost always amateurish. We authors have probably seen several hundred Web designers at work, and they generally create pages in one (or a hybrid) of four ways:

1 They start with an existing page description in HTML, either one they have previously created or one that has drawn their attention on the Web and whose source code they have downloaded. Using source code that comes from the Web requires good HTML knowledge because there will be an amount of code in there that is not needed. You have to strip it out. The HTML is usually jumbled, run-on, and unformatted (no intelligent indents), making its structure fairly obscure. **Warning: This method requires a devotion to HTML few designers are willing to develop.**

2 They use a page design from an existing traditional print publication and determine the underlying grid. This is what we did in Figures 11.15 through 11.17. To do this, you will need sharp observation and analysis skills to see through page content to the underlying structure. **Warning: This method requires a good understanding of TABLE structure.**

Note: Always be on the lookout for interesting publication designs. Here is a suggestion: Start a notebook where you keep interesting pages, from the Web, books, magazines, annual reports—anything you can find. Then, when you want to increase the voltage in your designs, leaf through this swipe file for inspiration. You may actually use one of the designs or merge features of several into a new layout.

3 They sketch their conceptions roughly in pencil, then more tightly, until they can create a sample page in a raster or vector drawing program. From this page the underlying structure is derived and an HTML table coded to match the structure. The content of each cell is captured (screen captured or copied into a new file) and introduced into the table using tag. **Warning: This method requires sophisticated knowledge of a raster or vector graphic application.**

4 They begin a page in a text or HTML editor without any preconception as to what the page will look like. Working back and forth between editor and browser, they fiddle around until the page looks sort of like they want. **Warning: This method usually results in ineffective pages that have a beginner's look to them.**

Working from Grid to Design

Sometimes it is best to think about the design of a page from an information standpoint. That is, if you start dealing with content right away, your design decisions will be influenced by how you want something to look, rather than by how you want something to function. Figure 12.1 shows the designs for several Web pages based on blocks of information and not on the actual content. Notice how you can easily make decisions about eyeflow and balance when the details are abstracted.

Working from Design to Grid

Sometimes there are designs that are so compelling that their underlying structure literally leaps off the page. In these cases, the elegance of the design is independent of

Figure 12.1 Web page design based on information flow.

Figure 12.2 Web page design based on existing publication pages.

the content. This is where the swipe file mentioned in the previous note comes into play. The greater number of great designs you have access to, the greater the chance that one of them can satisfy your needs. Figure 12.2 shows a collection of pages and their structure overlayed. This structure will become the basis for the TABLE that will describe the page.

Matching the Tool to the Job

There are many tools available to do the job, and to answer your immediate and obvious question, there is no perfect tool for every job. If you did not have the opportunity, review the suggested equipment and software discussed in the preface. You have probably found your favorite tools and we would not want you to relearn other applications. This would probably reduce your productivity to the point where you would be a liability to your boss, or working for $.50 an hour for yourself.

What you will probably do is settle on one tool and supplement it with others as needed.

Note on Raster Tools: *We do not mean to leave out your favorite product. We know artists who use the most bizarre raster tools and get great results. (There is no substitute for talent.) Hey, whatever works for you!*

Designing in Photoshop 5.0

http://www.adobe.com/prodindex/photoshop/

The granddaddy of them all, Photoshop remains a strong choice when creating graphical pages. Release 5 adds several useful features to an already feature-laden product, and once the interface changes are overcome, forms the basis for anyone's graphics studio. Of particular interest to Web artists are the following:

- Digital watermarking using PictureMaker™ technology

- Batch processing with the Actions feature

- GIF89a support of transparent and interlaced 8-bit images

- Support for PNG, PDF, and progressive JPG formats

- Direct link to Adobe home page

Designing in Fractal Painter 5

http://www.fractal.com/products/painter/

The other raster heavyweight, Painter, provides a different, more painterly approach to raster editing. It contains several filters and tools that would require greater artistic skill in Photoshop. Its strong points are:

- Filters specific for Web page features such as bevels, shadows, and wet text

- Animated GIFs supported right in the product

- GIF89a support of transparent and interlaced 8-bit images as well as JPG output

- Ability to take QuickTime or AVI vi... GIF animation

- Browser-safe and platform-specific color pa...

Note on Vector Tools: *PostScript illustration tools ar... at their core, designed to make graphics for the Web. They a... designed to create resolution independent images, just the opposite of raster display. You can display EPS art on Web pages but the vectors have to be rasterized at display time, something you have no control over. Surprise! your PostScript art does not look like you thought it would.*

Designing in Illustrator 8.0

http://www.adobe/prodindex/illustrator/

This new release of an industry standard brings the Macintosh and Windows products closer in functionality. You can composite vector and raster images. Illustrator has seamless hooks to Photoshop so the two work well together. Illustrator's Web features include:

- An RGB color picker and browser-safe palettes

- Export in GIF89a, JPG, and TIF raster formats

- GIF89a support of transparent and interlaced 8-bit images

- Ability to embed URLs for client- and server-side image maps

Designing in Freehand 8.0

http://www.macromedia.com/software/freehand/

Macromedia's PostScript drawing tool includes several new features that make this a logical choice for planning and making raster graphics for the Web and with their Flash addition, great support for including vector graphics on you pages also. Freehand supports:

- Browser-safe RGB palettes

- Flash technology for creating vector graphics, animations, and raster to vector conversions

Shockwave technology for delivering high-quality, res-olution-independent vector images on your Web pages

- Embedded anti-aliased fonts
- Attached URLs for image maps
- Graphic export in GIF89a, JPG, PNG, and PDF

Designing in CorelDRAW 8.0

http://corel.com/products/graphicsandpublishing/draw8

This mainstay of PC graphics is a serious player in the Web graphics arena. In fact, Corel has a suite of products specifically aimed at Web graphics, including a capable raster editor (CorelPAINT). But here are the Web fea-tures of their main graphics application:

- Digimarc™ digital watermarking technology
- Palettes specifically for the Web
- Embedded client-side image maps
- Support for GIF89a and JPG raster formats

Task: Building a Table Page from Scratch

Let us use our knowledge of page design and the TABLE structure to design an interactive page from scratch. As-sume the following requirements:

1 Links to major sections need to be prominently dis-played, preferably at the top of the page.

2 These links should be tied to the company logo.

3 Features should run in a column down the left side.

4 The remainder of the page can be used for text that will change weekly.

To create a page that satisfies these requirements, follow these steps:

1 Create a number of sketches that explore possible de-sign solutions. Figure 12.3 shows a final sketch that translates this description into a visual form. Note that

Figure 12.3 Sketch for our table page.

Figure 12.4 Dummy page in Photoshop.

Figure 12.5 The grid that represents the page.

Figure 12.6 Individual files representing table cells.

this sketch does not have to be super-refined, just a fair representation of how the page is divided into text and graphic regions.

Note: Students always ask, "How many rough sketches do I need to make?" The answer is, of course, as many as are necessary. It would be difficult to arrive at a truly effective design in one or two tries. Certainly 5–10 ideations, possibly as many as 20.

2 Pick your favorite tool (ours is Photoshop). Using a canvas the size of the maximum browser window you anticipate, begin laying out your page layer. You may want to use Lorem Ipsum dummy text at this point because you may not even know what the real content will be. A finished dummy page that translates the sketch is shown in Figure 12.4.

3 Determine the underlying table structure by dragging guides out from the rulers. You will want to do this first without regard to spanned rows or columns, or nested tables (Figure 12.5).

Do not worry about making this layer pretty because you are not going to use it for anything other than a guide.

4 Using the rectangular selection marquee, copy the contents of each cell and paste into a new file. We need 10 separate images to describe the page. Open a new file (it will be the same size as the selection on the clipboard), paste, and save as GIF or JPG (Figure 12.6).

5 Create the HTML <TABLE> description that matches the grid layer. Review Figures 11.15–11.17 for this technique. Our "Wind Feather" page is described by 6 columns and 10 rows. Upon closer inspection, we have a 1-column by 8-row nested table along the left side, and several cells that span rows and columns. Refer again to Figures 11.15 through 11.17 if you want to see additional examples.

6 Bring in the cell graphics with tags.

7 Now, substitute HTML text for cell images where the text will change (you do not want to be going back to the graphics program every time you want to change the copy). Note that we have added a little feather icon to tie the logo into the feature list. We will save changing the graphic body text into HTML for the next task.

8 The final page is shown in Figure 12.7.

Task: Replacing a Graphic with HTML Text

In Figure 12.7, the text on the main part of the page will frequently change, so we do not want graphic text. This is where we put the knowledge gained in chapter 8, "Using Text in Tables," to work. To replace the graphic text, follow these steps:

1 Carefully analyze the text passage for structure. Our passage has heads and inset paragraphs. Because our page is intended for a broad Internet audience, we cannot make use of cascading style sheets (yet!), so we have to be creative with text in our table.

2 In the table cell containing the body text, design a nested table that matches the design of the text. This is shown in Figure 12.8. The table is a 2-row by 6-column design. The A Head rows span two columns.

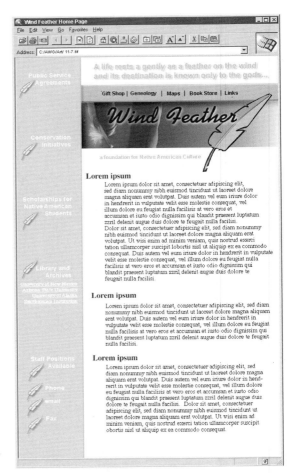

Figure 12.7 Finished table page in browser.

3 Code this table in HTML and get it working independently of the main page. Because this nested table needs to be a specific horizontal size, a two-cell row at the top is filled with trans.gif, scaled to correct widths. The nested table is shown in Figure 12.9. (Since this page was created as an example, we still use mostly dummy

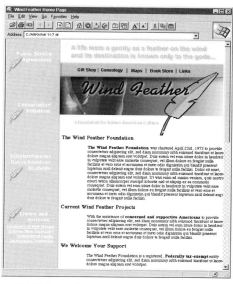

Figure 12.10 The graphic page table with nested HTML text.

text. Of course, if there really was a Wind Feather Foundation, they would supply you with the content.) With BORDER=0, you can make out the row at the top of the table filled with the transparent GIF that sizes the table.

4 Introduce the nested table into your page (copy the code and paste). If everything went according to plan, your finished page should look like Figure 12.10.

Figure 12.8 The nested table that matches the text design.

Figure 12.9 The completed nested table.

Real World Examples

It is always great to look at commercial Web pages for inspiration. The Internet Shopping Network's home page (Figure 12.11) uses a highly structured, newspaper insert design. With your knowledge you should be able to visualize overall page as well as nested table structures.

Summary

In this chapter, you became familiar with the four methods Web designers employ to plan and execute their pages. Efficient designers reuse elements of their own page structure and add to that elements from other designs they find on the Web. Some of the best page designs on the Web can be traced back to traditional print publications. Being able to analyze and translate these print designs into Web pages is an important tool.

It is good that several approaches exist, and that everyone is not forced into the same design process. Some designers like to work from a general grid to the actual design.

It is difficult to create great interactive pages without great tools, and we discussed the advantages of several of the most powerful applications currently on the market.

Figure 12.11 Commercial page at http://www.internet.net that makes extensive use of table structure.

Review the suggested workshop equipment in the preface of this book.

Finally, this method of basing a page on table structure was demonstrated with a specific example, including replacing dummy graphic text used to design the page with actual HTML text that can be easily edited.

In the next part, "Page Design with Frames," you will learn how to bring even greater flexibility to your page design by subdividing it into regions into which individual HTML content can be displayed.

QUESTIONS

Q *I use a non-PostScript vector graphics program to make my Web graphics but the graphics look really coarse. What am I doing wrong?*

A Your program is not doing a very good job of rasterizing the vectors. There may be an option where you can specify the resolution of the bitmap. If you can, make this as large as possible and scale the image to the Web page. If you cannot adjust the coarseness of the bitmap, export the vectors in EPS format and let a raster program like Photoshop do the rasterizing. You can specify the resolution in Photoshop.

Q *When I "borrow" someone else's HTML code, I can never get it to work. Any suggestions?*

A When you do this, go in and strip out any HTML code you do not recognize. If you do not know what it does, it probably does not do what you want anyway. Assemble your trans.gif, white.gif, black.gif, and gray.gif spacer files and replace any IMG SRC= calls to these scaled spacer files. At this point, the page should start looking like the example, just without specific content.

Q *What is digital watermarking? Should I learn more about it?*

A Digital watermarking is a technology that embeds an identification into a raster image that survives cropping, rescaling, or resampling. Because copying is so easy on the Web, this technology has the promise to at least discourage image piracy.

Q *My graphic text is not smooth. What can I do?*

A If your graphic text is not smooth, you are not using Adobe Type Manager or True Type fonts. Raster fonts are created from mathematical outlines. If you do not have outline fonts, you will have smooth text only at the fixed sizes of the screen fonts. Hint: if it looks rough in your raster editor, it will look rough on your page. You can smooth the text somewhat by setting large and rescaling in RGB mode. The edges will anti-alias. Or, you can apply a light blur to the edges. Neither will produce the quality of outline fonts.

Q *I cannot get HTML text to look exactly like my design.*

A You may never get perfect results, especially with the limited font rendering of operating systems. If you carefully plan the table structure that defines the text design, you should get very credible results. Remember, only you know what the original design looked like!

PART THREE

PAGE DESIGN WITH FRAMES

Using the HTML <FRAMESET> Structure

One of the most powerful features in Web design is the support of framed documents. Prior to the <FRAME-SET> tag, all documents were known as body documents—documents that had a body section. The actual definition of the elements to be laid out on the screen were contained between the <BODY>...</BODY> containers.

In the non-framed world each browser window contained only one Web page. Today, however, the framing convention invented by Netscape and now supported by Explorer and the HTML standard, has added a new twist to documents that can be viewed inside a browser. Frames allow a single browser to contain multiple pages that can be linked to the outside world as well as within a single site structure.

As you saw in the previous chapters, you can create Web documents that are formatted using tables with various block- and text-level tags occurring within the table's individual data cells. But as you know, the table must be designed around the audience's display size. If your audience views a table that was designed for a screen larger than their current setting, they must horizontally scroll to view all of the table.

However, frames can help you overcome this if you create them correctly. What is worse than horizontally scrolling to see an entire page? Having to horizontally scroll three windows in a document to see each of the items displayed in those windows.

In this chapter you are going to take a look at how you can use frames in your Web pages. From how they work to creating the programming for them, you will see that frames can be a good addition to your Web site, but there are some design considerations you must ponder before cranking out a framed page.

Note: Some browsers do not support frames. The big two, Netscape and Explorer, both support frames. Explorer actually gives you a few more options than does Netscape. If your audience assumably uses one of these two browsers, then you do not necessarily have to be concerned. However, later in this chapter you will read about accommodating browsers that do not support frames.

OBJECTIVES

In this chapter, you will:

• Examine the frame structure and how it can be used in your Web pages.

• Understand the differences between browsers and how they utilize frames.

• Discover that almost all of the other HTML tags are valid within the document or documents in a frame.

• Examine the differences between frames across browsers.

• Look at the basic frames structure and tags as well as create a basic frames document.

Figure 13.1 Dividing the browser work area into multiple windows, using browser frames (http://www.kewl.se/kustas/).

Overview of Frame Structure

So what is the whole point to using frames in your Web pages? Frames can be predominantly used to divide your screen into various windows as shown in Figure 13.1. The header in this example is in a non-scrolling frame while the body of the page is in a scrolling frame. By using a frames layout, you can divide your screen into separate windows. The windows each contain a single Web page and sometimes a single frame can contain another frames document, which is called a nested frame.

As you can see in Figure 13.1, sometimes it is difficult to tell whether the document you are viewing is a frames document because the frame borders are not always noticeable. Yet, most frames documents have noticeable borders around them as shown in Figure 13.2. Note also that frames may or may not have scroll bars.

Windows, or frames, can actually be any size you want. You must still work within the limitations of your audience's screen size. If you specify a frames page that is too big for the current display, the browser will scale the windows to fit them into the browser work area. Conse-

Figure 13.2 Most of the time frame borders reveal the use of frames (http://www.phoenix.net/~shuttle/).

quently, the user will more than likely have to scroll horizontally to see the pages within the frames when this occurs. This is bad form.

In reality, being able to open multiple pages into a browser is not new. By now you have probably been to a site that has automatically opened a new browser window

Figure 13.3 Opening multiple browser windows and documents.

Figure 13.4 The Web page as it was designed to be (http://www.bravegp.com.au/).

Figure 13.5 Frames can be designed so that the user can size them by dragging on the frame border.

to load a document (Figure 13.3). In operating systems, you can open multiple browser windows that can each contain a different document. For the few who have (and can afford) fast Internet connections, you can even be downloading multiple pages at a time or surfing in two windows at once. Consider it as TV-in-a-window (PIP) for the Web!

Frames give you two distinct advantages. First, a Web page that is divided into frames gives the audience the ability to size the frames. Figure 13.4 shows a page as it was downloaded from the server. Within the circle in Figure 13.5 you can see the "resize frame" icon as the frame border is being moved. As a developer, you can allow (or disallow) the audience from sizing the frames at their will. Note that once a page is laid out using frames, simply dragging the frames border resizes the window, assuming you allow the audience to do it. This works much that same way as dragging the edges of any window in the Windows, Macintosh, or other Graphical User Interface (GUI) environment.

The second advantage that frames provide is the ability to have one window control contents that are displayed in another window. For example, you can create a frame

that houses a menu for the contents of your site as shown in another frame.

Many of the examples on the Web that have one window controlling another are graphics related. In most instances they are trying to convey certain combinations of graphics and text at the same time. For example, a site

Figure 13.6 Using a menu in a frame to control the contents of another frame (http://www.ProductNet.com/).

designed to distribute commercial products may use a menu down one side of the screen to control what is seen in another window as shown in Figure 13.6.

Note: Even though frames are a cool way to present a site, keep in mind that the more windows or frames you have, the more HTML files you will have also. When using frames, it is vital that you stringently manage the files via naming conventions and logical directory structures so that maintenance of your site does not become a memory task.

What Is Legal HTML in Frames

Since each window of a framed Web page houses a separate HTML file, the frames can actually contain anything. Each window is linked to a different Web document that can contain any of the HTML tags that you have at your disposal. Figure 13.7 shows an example of a graphics-intense Web page that uses frames. Even though the user can size the frames, keep in mind that the pages you link to the various windows must be designed around the size of the frame.

In Figure 13.7, the page developer had to design all of the graphics for the window pages so that they would fit

Figure 13.7 Any tags can be included in the Web documents that appear in the windows (http://www.meat.com/netscape_hos.html).

into the windows without the audience having to horizontally scroll. Just as with other pages, you will have to design your graphics and text elements around the size of the area in which the page is displayed.

Looking at Browser Differences

One of the important aspects about frames is the differences between frame documents designed and displayed for one browser versus another.

The basic <FRAMESET> tag itself is really standard across browsers. There are no browser-specific attributes that belong to the tag. The only attributes for the <FRAMESET> tag are the ROWS and COLS attributes.

However, with the <FRAME> tag, which is used to define the pages that appear inside the frame windows, there are some attributes that only work in one browser or another. For example, some attributes such as the FRAMEBORDER and FRAMESPACING attributes, are only recognizable by Microsoft Explorer. Netscape will consequently ignore these tags. In the next chapter, "Using Frames to Structure Your Pages," we will devote more time to looking at the <FRAME> tag and its various attributes.

TIP: *If you are designing using specific tags and attributes that you know are supported by certain browsers, let your audience know. Use a note or other method to tell them that the page is best viewed by Netscape or Explorer. It will save them much frustration when they are surfing your pages.*

Note: *One of the other little tidbits that you must be aware of is that depending on the browser as well as the platform, varying amounts of foreground and background offset may occur relative to the left edge of the frame or browser window. For instance, images that are adjusted to align perfectly in a frame in Netscape for Windows will exhibit a slight misalignment in Netscape for Macintosh due to the variable distance between the edge of the foreground elements and the edge of the window. In instances where this may occur, make sure you design around your primary audience as well as note to your audience the best viewing parameters.*

Frames for Designers

Similar to tables, frames allow any range of designs to be created. Probably the hardest part, however, is keeping track of what pages go with what windows, as well as how those pages are arranged on the developer's server. Designing with frames will require much planning before you start writing code. Look at what you want to create and then decide if frames are actually the best way to implement the design.

Keep in mind that any frames document you create can be displayed with borders or without borders. Often a borderless frames document, much like a borderless

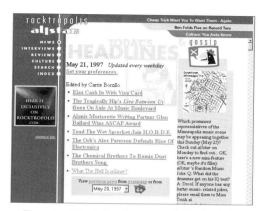

Figure 13.8 Borderless frames, much like borderless tables, can be used to create unique designs with HTML (http://allstarmag.telebase.com/news/).

table, can be used to create very unique designs, such as the one shown in Figure 13.8. Note that the designer of this page has almost seamlessly integrated the lower right frame with the upper frame.

Understanding HTML Frame Tags

Up to this point you have probably realized that all HTML documents contain a body section. Well, this is partially true. In documents that use frames, the frames section replaces the body of the document. Therefore, a frames document contains no <BODY>...</BODY> structure at all. The body for a frames document is actually contained within the documents that go into the window, rather than in the frames document itself.

As the browser loads a frames document, the frames document contains only the information on how to set up the frames and then what pages go into those frames. The body for a frames document is actually contained within the pages that are inserted into the frames, not in the frames document itself. If you load a Web page that has frames defined, without loading the pages that go into the frames, you have a bunch of blank frames that are not worth a lot. However, keep in mind that the

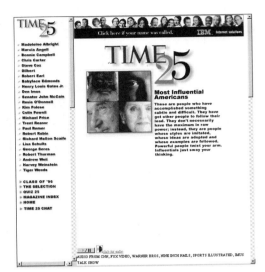

Figure 13.9 *The simple frames document shown here requires three different HTML files for display (http://time25.pathfinder.com/frame.html).*

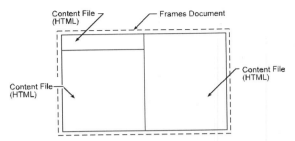

Figure 13.10 *Any tag can be included in a Web document that appears in the body of a frame.*

body of a Web page that uses frames is contained in the pages that are loaded in the frames, not in the page that defines or lays out the frames. This will become clearer as you begin looking at and entering the code for a frames document.

To show you what this means examine Figure 13.9. Note that a frames document is displayed in the browser. Yet, to deliver this page requires a total of three documents. The first required file is the master frames document that defines the windows and defines the pages that should be inserted into the left and right frames. The other two files are the pages that are displayed or inserted within the frames defined by the master document as shown in the following example:

Master HTML Frame Document

Left Frame

 Left HTML Page

Right Frame

 Right HTML Page

Frames documents provide a cool means of delivering pages, but they require the creation of more individual pages than do non-frames documents.

Note: One of the special features of a frames document is the ability to open another browser window, which makes two instances or copies of the browser run simultaneously. Using this feature keeps the current document where it is. Normally, choosing a new link replaces the items shown in the browser's work area. Opening a new window leaves the current window where it is—the new window jumps to the specified Universal Resource Locator (URL).

Looking at Frame Attributes

The primary tag that is used to create a frame document is the <FRAMESET> tag. As you read previously, this tag replaces the normal <BODY>...</BODY> tags found in the HTML document. The document that uses the <FRAMESET> tag is the one that defines the layout of the windows and it only contains information relevant to the actual windows or frames. The <FRAMESET> document not only contains information on how to divide the screen into individual frames but it also contains the references to the pages that should be placed in the defined frames. Note that the actual content, or "body," for the frames is defined in any number of other HTML files and is stored externally as shown in Figure 13.10.

As you read earlier the <FRAMESET> tag contains only information about how the screen should be subdivided into windows. Valid attributes for the <FRAMESET> tag include:

• ROWS—which defines the number and size of row frames that should be created in the browser work area. Valid entries include absolute (pixels), relative (wild card characters), and percentages of the screen.

• COLS—which defines the number and size of column frames that should be created in the browser work area. Valid entries include absolute (pixels), relative (wild card characters), and percentages of the screen.

COLS and ROWS Attributes

As you use the <FRAMESET> tag, the ROWS and COLS attributes can use absolute dimensions, relative dimensions, or percentages to define the sizes of the windows that appear in the document. For, example you can specify that a series of frames be created by setting the COLS attribute to 150,150,150,150. These are absolute dimensions.

TIP: *It can be detrimental if you specify absolute dimensions and a user accesses your page at a screen size smaller than you anticipated.*

In our example, the user's browser must have 600 pixels to be able to display your frames as you created them. If they have less than 600 pixels, the browser will automatically scale the windows to fit in the user's screen, which can cause problems—horizontal scrolling.

A better way of defining frames is by using either the relative or percentage specification. No matter how you define your frames you have to allow enough variability in the pages shown in the frames for the variability in the frame sizes.

The percentage specification is easy to understand. To create a page that defines a series of column frames each occupying 25% of the screen, you would enter COLS=25%,25%,25%,25%. This allows the browser to show the frames no matter what the display setting. However, as noted, the pages that are shown in these frames must allow enough variability so that the user will *never* have to horizontally scroll. As you begin designing some pages with frames, you will look at this a little closer.

If you choose to use the relative dimensioning, understand that it works the same way as percentages. A relative dimension may look like COLS=1*,3*,6*, which is the same as saying 10%,30%,60%.

TIP: *You will find that percentages are most commonly used to define the sizes of columns and rows in a frames document.*

Note: *When you are creating frames documents, the order in which you define your columns and rows is important. Depending on which you define first (with the <FRAMESET> tag) will determine the way your screen looks. For example, if you have a column that spans the entire screen, you will use the COLS attribute first. If you have a row that spans the entire screen, you will use the ROWS attribute first. In the next chapter, "Using Frames to Structure Your Pages," you take a closer look at this issue.*

Using the <FRAME> Tag

Once you have defined the containers for the overall page design, define the contents and other attributes of the frames themselves. This is done using the <FRAME> tag. The <FRAME> tag defines the document that goes into one frame or window in a frames document. For each "frame cell" (similar to a table) that is created as a result of intersecting rows and columns, a <FRAMES> line must be established. Note that the order in which columns and rows are created with the <FRAMESET> tag is the same order in which you place the <FRAMES> tag.

Creating Basic Frames

To begin working with frames, you will start with a very simple example by dividing the screen into two columns and inserting two very simple pages into them. To do this example will require three HTML files. The first is the frames document, which defines how the screen will be laid out. The other two files are the actual documents that are inserted into the frames as shown in Figure 13.11.

Figure 13.11 shows an example of your frames document. Notice the source code for this file shown in Listing 13.1. The <FRAMESET> tag contains the definitions for the frames. We have used the COLS attribute to define two frames that each take up 50% of the screen.

The code for the content of Frame A and Frame B looks like Listing 13.2 and Listing 13.3 respectively.

Figure 13.11 A simple frames document.

Listing 13.1 The code for the simple frames document.

```
<!DOCTYPE "HTML 3.2 //EN">
<HTML>
  <HEAD>
    <TITLE>Creating a Simple Frames Document</TITLE>
  </HEAD>
  <FRAMESET COLS=50%,50%>
    <FRAME SRC="frame_a.htm">
    <FRAME SRC="frame_b.htm">
  </FRAMESET>
</HTML>
```

Listing 13.2 The code for frame A.

```
<!DOCTYPE "HTML 3.2 //EN">
<HTML>
  <HEAD>
    <TITLE>Page A </TITLE>
  </HEAD>
  <BODY>
    <H3> Frame A </H3>
    <P> A 50% Column </P>
  </BODY>
</HTML>
```

Listing 13.3 The code for frame B.

```
<!DOCTYPE "HTML 3.2 //EN">
<HTML>
  <HEAD>
    <TITLE>Page B</TITLE>
  </HEAD>
  <BODY>
    <H3> Frame B </H3>
    <P> A 50% Column </P>
  </BODY>
</HTML>
```

From this example you can see that any frame setup includes the frames document, and an HTML file for each window. Every frame window in a frames document will be referenced to some separate HTML file. If no HTML is referenced, the window will appear blank and contain the default browser background color.

To get a better idea of how frames work, let us divide the two columns that you have created into two rows as shown in Figure 13.12. The resulting document will contain four equal windows. The code for this frames document is shown in Listing 13.4, while the code for HTML files in Frame C and Frame D are presented in Listings 13.5 and 13.6 respectively (next page).

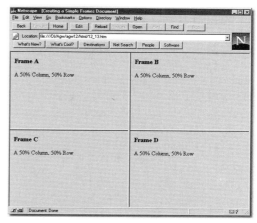

Figure 13.12 Dividing the two columns into rows.

Listing 13.4 The code for Figure 13.12.

```
<!DOCTYPE "HTML 3.2 //EN">
<HTML>
  <HEAD>
    <TITLE>Creating a Simple Frames Document</TITLE>
  </HEAD>
  <FRAMESET COLS=50%,50%>
    <FRAMESET ROWS=50%,50%>
      <FRAME SRC="frame_a.htm">
      <FRAME SRC="frame_c.htm">
    </FRAMESET>
    <FRAMESET ROWS=50%,50%>
      <FRAME SRC="frame_b.htm">
      <FRAME SRC="frame_d.htm">
    </FRAMESET>
  </FRAMESET>
</HTML>
```

In this particular example (see Listing 13.4), you will notice that the <FRAME> tags have defined the content files for the frames in a seemingly strange order. This document is creating two columns first, and then dividing the two columns into two rows. Therefore, with the <FRAMES> tag, Frame A and Frame C are defined (for the first column) and then Frame B and Frame D are defined for the second column. Note that since there are no columns or rows that span the entire screen, either columns or rows could be defined first. The coding for this frames page could also be defined as shown in Listing 13.5.

Listing 13.6 shows the document coding for each of the four frames.

Listing 13.5 Alternate coding of the 4 x 4 frame design.

```
<!DOCTYPE "HTML 3.2 //EN">
<HTML>
  <HEAD>
    <TITLE>Creating a Simple Frames Document</TITLE>
  </HEAD>
  <FRAMESET ROWS=50%,50%>
    <FRAMESET COLS=50%,50%>
      <FRAME SRC="frame_a.htm">
      <FRAME SRC="frame_b.htm">
    </FRAMESET>
    <FRAMESET COLS=50%,50%>
      <FRAME SRC="frame_c.htm">
      <FRAME SRC="frame_d.htm">
    </FRAMESET>
  </FRAMESET>
</HTML>
```

Listing 13.6 The code for frame C.

```
<!DOCTYPE "HTML 3.2 //EN">
<HTML>
  <HEAD>
    <TITLE>Page C</TITLE>
  </HEAD>
  <BODY>
    <H3> Frame C </H3>
    <P> A 50% Column, 50% Row</p>
  </BODY>
</HTML>
```

As you can see from this example, the <FRAMESET> container can be nested within itself to create multiple windows. In the example, the first <FRAMESET> tag defines two columns that are 50% of the screen. The second <FRAMESET> tag defines the divisions for the first column—two 50% rows. The third <FRAMESET> tag defines the divisions within the second column—again two 50% rows.

TIP: *If you decide that you want to use frames in your pages, make sure that you lay them out on grid paper before you create the pages that go inside the frames. You must create the inserted pages at the size of the frame. Elements that are larger than the frame will require scrolling.*

Using the <NOFRAME> Tag

To deal with non-frame capable browsers one must be aware of the <NOFRAMES> tag. The <NOFRAMES> tag allows a developer to specify an alternative body section within a frames document for browsers that cannot utilize frames.

In the previous example (Figure 13.11), had you used the <NOFRAMES> tag, it would be inserted into the frames document. To include this in the previous frames document, the code would look like Listing 13.7.

Listing 13.7 Using the <NOFRAMES> tag to allow non-frames browsers to view the page.

```
<!DOCTYPE "HTML 3.2 //EN">
<HTML>
  <HEAD>
    <TITLE>Creating a Frames Document</TITLE>
  </HEAD>
  <FRAMESET COLS=50%,50%>
    <FRAMESET ROWS=50%,50%>
      <FRAME SRC="frame_a.htm">
      <FRAME SRC="frame_c.htm">
    </FRAMESET>
    <FRAMESET ROWS=50%,50%>
      <FRAME SRC="frame_b.html">
      <FRAME SRC="frame_d.html">
    </FRAMESET>
  </FRAMESET>
  <NOFRAMES>
   <BODY>
      ...
      Insert alternative body content here for non-frames browsers.
      ...
   </BODY>
  </NOFRAMES>
</HTML>
```

Task: Create a Simple Frames Page

To create a frames page:

1 Begin by sketching out the layout you wish to use. Remember that you can use grid paper to help you establish the working size of your frames. This way when you create the pages to be inserted into them, they will fit.

2 Next, examine your layout to determine if any rows or columns span the screen. If either one does, you will have to use the <FRAMESET> tag to define the appropriate one (either ROWS or COLS) first.

3 Next, assign the proper HTML files to the appropriate frame. The grid paper you used will help you determine the size the HTML files should be designed around.

Summary

In this chapter, you have begun looking at simple frames documents and how they work. The biggest point to remember about frames is that they are a browser convention and can only be guaranteed to work in Netscape 2.0 or higher or Explorer 3.0 or higher. Make sure that if you decide to use frames that you either give the user the option to view a non-frames page or use the <NOFRAMES> tag. This way you can ensure that the non-frame end users are not excluded from using your site.

Next Steps

Now that you have begun looking at frames document:

• Refer to chapter 7, "Using the HTML <TABLE> Structure," to compare the frames structure to the table structure.

• Take a look at chapter 14, "Using Frames to Structure Your Pages," for more information on the documents that actually appear in the frames document.

• Examine chapter 15, "Designing with Frames," for information on more complex frames designs.

QUESTIONS

Q *When I am designing frames documents, is it better to use the <NONFRAMES> tag or to present the user with the option to view non-frames pages in the Web page?*

A It is my opinion that anything you can do to automate pages for the end user works better. Although there are some who may disagree, it is better that you not count on the user knowing what they need to view your pages. Always use the <NOFRAMES> tag!

Using Frames to Structure Your Pages

In the last chapter, "Using the HTML <FRAMESET> Structure," you began by looking at the basic <FRAME-SET> tag and how it is used to create frames documents. But the <FRAMESET> tag itself is only part of creating frames documents. The other important piece of information is the FRAME tag and defining the options for any given frame within the main document.

In addition, to be able to effectively use frames documents at your site, you must also understand how to get the individual frames to communicate with one another. Simply creating a page divided into windows is, by itself, pointless. It is important that you understand how to get the various frames to communicate with one another as well as control one another. This capability and more are explained in detail in this chapter.

OBJECTIVES

In this chapter, you will:

• Acknowledge that there is an etiquette to using frames at your site.

• Discover the attributes of the <FRAME> tag and how they are used to define the pages for your frames.

• Learn about the TARGET attribute of the <A> tag and how it can be used to point to predefined and developer-defined items.

• Examine navigation, status, and data frames and the settings that are generally associated with each.

• Examine frame hierarchy and see how links within frames can be used to access extrasite and intrasite documents.

Acknowledge Frame Etiquette

By now you have seen both good and bad examples of frames documents on the Web. Indeed, there is an etiquette to creating effective frames-based pages, particularly when you begin creating links to the outside world (extrasite links) and even links within your own site (intrasite links).

Be cautious when you begin designing frames documents because the same concerns that arise with conventional documents and horizontal scrolling also exist with frames documents. Any document you create must be designed at the right size so that it will fit properly into the particular frame of the document. As already noted, nothing is worse than having a frames document in which you have to horizontally scroll in two or more frames to see the document inserted into it. Not only should you design for the appropriate document size, you should also give the user the option for a non-frames version of the document as well (see Figure 14.1).

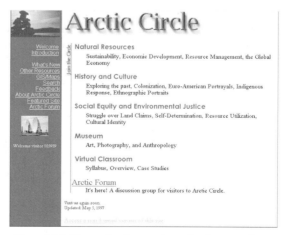

Figure 14.1 Always give the user the option for a non-frames version (ht;://www.lib.uconn.edu/articcircle/).

TIP: *Because the size of the Web canvas can vary, from 640 x 480 to 800 x 600 and beyond, it is always a good idea to present the user with the size at which the frames document will display properly. Many Web users surf at 800 x 600; however, some are still limited to 640 x 480. Tell the user what he or she needs to effectively view the site.*

Attributes of the <FRAME> Tag

Once the frames layout for a particular document has been defined using the <FRAMESET> tag, use the <FRAME> tag to actually assign the HTML documents that go into those frames. You have many options (attributes) that you can use to set the parameters for a particular frame using the <FRAME> tag. As you have seen, frames that you create can or cannot have borders, scroll bars, as well as movable frame borders. Use the following attributes to control how a particular frame behaves:

• SRC - Defines the Web page that will appear in the frame.

• NAME - Defines a unique name for the individual frame. This attribute is used to allow one frame to control another through a TARGET specification in the <A> (anchor) tag.

• SCROLLING - Defines whether the frame should have scroll bars or not. Valid entries for this attribute are SCROLLING=YES, SCROLLING=NO, and SCROLLING=AUTO. The default is AUTO.

• MARGINWIDTH - Defines the left and right margins for the frame in pixels. Note that this attribute cannot be zero and the smallest value varies slightly across browsers and platforms.

• MARGINHEIGHT - Defines the top and bottom margins for the frame in pixels. Note that this attribute cannot be zero and the smallest value varies slightly across browsers and platforms.

• NORESIZE - Disables the ability of the user to be able to size the frame.

• FRAMEBORDER - Specifies if a border should be displayed around the frame. Valid settings include either YES or NO. Note that this feature is not "official" and is only supported by Microsoft Internet Explorer.

• FRAMESPACING - Specifies the spacing between frames in pixels (that is, FRAMESPACING=10, which is 10 pixels). Note that this feature is not "official" and is only supported by Microsoft Internet Explorer.

• ALIGN - Specifies the default alignment for the page in the frame window. Note that this is not an official tag but is supported by both Netscape and Microsoft browsers.

Note: *In addition to the standard <FRAME> tag, Microsoft Internet Explorer supports an additional tag for frames called <IFRAME>. This tag allows you to create floating frame windows in front of the browser window.*

Using Predefined Targets with the <A> Tag

In the previous chapter, you began looking at a simple example that divided the screen into four frames. Each frame contained a document labeled Frame A through Frame D. In this section, you will continue with this example (shown again in Figure 14.2) and look at the structure for adding links to pages within the frames. In addition, you will see how to target specific links and documents at several predefined objects.

One important aspect about frames documents is that any links to other pages that appear in the windows (that is, links in page A, B, C, or D) will cause the page to be loaded into the respective frame. In Figure 14.3, we have added a link to Netscape's Home Page into page A. Listing 14.1 shows the code for Frame A before the link was added and Listing 14.2 shows the code after the link was added. Yet using the standard anchor (<A>) for the link creates a fundamental problem when it is used in conjunction with a frames document.

Figure 14.2 The simple example of dividing the
screen into four windows using a frames document.

Figure 14.3 Putting a clickable link into
Page A using the standard anchor (<A>) tag.

Listing 14.1 The original code for Frame A.

```
<!DOCTYPE "HTML 3.2 //EN">
<HTML>
  <HEAD>
    <TITLE> Page A </TITLE>
  </HEAD>
  <BODY>
    <H3> Frame A </H3>
    <P> A 50% Column, 50% Row </P>
  </BODY>
</HTML>
```

Listing 14.2 The code for Frame A with the anchor added.

```
<!DOCTYPE "HTML 3.2 //EN">
<HTML>
  <HEAD>
    <TITLE>Page A </TITLE>
  </HEAD>
  <BODY>
    <H3> Frame A </H3>
    <P> A 50% Column, 50% Row </P>
    <P><A HREF="http://www.netscape.com"> Netscape's Home Page </A></p>
  </BODY>
</HTML>
```

Figure 14.4 The page is forced to load into a missized frame.

If you have a clickable link in page A, when the user clicks on that link, the linked page will automatically load into that window as shown in Figure 14.4. If no other attributes are used for the anchor, the frame will load the page into itself by default. The problem is that links that occur within your framed pages may not be designed to fit in your frame size (as dramatically demonstrated in Figure 14.4). What you really want is to load the externally linked page into a new window rather than into the frame.

TIP: *Whenever you create an extrasite link that is a link to an external site, you should always force it to load into a new browser window. You can never be assured that the page is designed for a particular size, unless you were the one who created it.*

To make a new window open, you need to recognize the TARGET attribute for the <A> tag. Note that the TARGET attribute is usually only used with frames documents; however with the _blank option, you can also use it in normal body documents.

The TARGET attribute is predominantly used to allow one frame to update the contents of another frame. You will see this in the next section. However, with the TARGET attribute, there are also several implicit, or predefined, names that you can use. These implicit names are simply predefined objects that you can reference when using frames documents. Implicit names for targets begin with an underscore and include:

• _self - which makes the browser update the frame that the page occurs in.

• _parent - which makes the browser update the parent of the current frame, assuming one exists.

Listing 14.3 Adding the TARGET attribute so that the page loads into a new browser window.

```
<!DOCTYPE "HTML 3.2 //EN">
<HTML>
  <HEAD>
    <TITLE> Page A </TITLE>
  </HEAD>
  <BODY>
    <H3> Frame A </H3>
    <P> A 50% Column, 50% Row </P>
    <P><A HREF="http://www.netscape.com" TARGET="_blank"> Netscape's Home Page </A></p>
  </BODY>
</HTML>
```

Figure 14.5 Using the TARGET="_blank" attribute causes a new window to be opened.

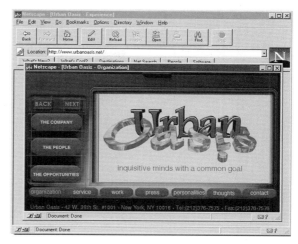

Figure 14.6 Opening a new window allows for a customized environment in the browser (http://www.urbanoasis.net/).

- _top - which makes the browser update the entire browser work area.

- _blank - which makes the browser open a new window to display the page in.

As you can see, there are several predetermined references that you can use as targets for your links. Right now the one you are concerned with is the _blank setting. You will look at the other options a little later.

To get our Netscape link to load into a new browser window you simply need to add a target statement for the page in the referring anchor (<A> tag). From the earlier code (see Listing 14.2), change the code for Page A so that it includes a target specification, as shown in Listing 14.3.

Now when the user clicks on the link in Frame A, a new browser window is opened for the document as shown in Figure 14.5.

Now you may be asking, "Why would I want to open a new browser window for my users?" Some sites are doing some interesting things, such as creating a customized browser window that contains nothing but an interface for the site. With some of the new features supported by Netscape Communicator (Figure 14.6), as well as the upcoming release of Microsoft Internet Explorer, these new features are allowing the Web to develop a genré all its own.

Note: Keep in mind that you can use the TARGET="_blank" attribute in both frames and body documents. However, having every link set this way may frustrate your users. Use it cautiously and only when there is a real need to open a new browser window. Normally, it is most appropriate for extrasite links in frames documents.

Types of Frames

As you begin working with frames, you must ultimately determine the purpose for any given frame and then use the <FRAME> tag attributes to set the options for the frame. In general, there are three different types or categories of frames: navigation, status, and data frames.

Figure 14.7 Navigation frames usually present the user with a list of links that can be used to open a new browser window or update another frame window (http://www.intra-net.de/marco/mr.htm).

Figure 14.8 Depending on your site's content and structure, you may need more than one frame for navigation (http://www.co.richland.sc.us/).

Of the types of frames, navigation frames are probably the most common (Figure 14.7). The frames provide the user a list of options or other pages within the site that can either be jumped to by opening another browser window, or by updating another frame in the current document. Often, a navigation frame will require a scroll bar if the available options exceed those that can fit into the window. You may also need more than one frame for navigation, as shown in Figure 14.8. This site has one horizontal frame and two vertical frames.

The second type of frame is the status frame. Often status frames are static frames that contain a logo, a site locator, or an advertisement. Most often status frames have no scroll bars and simply present a piece of information—most often an advertisement as shown in Figure 14.9. One of the most common "techniques" used in a status frame is to allow the frame to automatically update itself using client pull techniques. Note that any of the standard HTML techniques, including client-pull, can be performed in any frame.

The last type of frame, the data frame, has the most relevance to the end user. This type of frame can utilize any combination of attributes. Most often data frames are where the content of the site is presented and typically includes scroll bars. If you are designing, this is the frame that will typically be the largest, shown in Figure 14.10.

TIP: *No matter what type of frame you are creating, keep in mind that you must design the document that goes into the frame around the size of the frame. If the frame has a vertical scroll bar, the scroll bar itself will require 16 pixels for display. The horizontal size of your HTML document must fit into the frame minus 16 pixels.*

Understanding Frame Hierarchy

You have seen how the basics of the frames document works but let us do some things that are a little more complicated. What if you want to have one window controlling another? For example, clicking a link in one page and the content of another window is changed. To be able to have one page update another requires the use of frame names (a function of the <FRAME> tag) and target specifications (a function of the <A> tag). If each

Figure 14.9 Using a status frame to present an advertisement.

Figure 14.10 The data frame is used to present content and is generally the largest frame in the document (http://www.ozemail.com.au/~thecoast/).

Figure 14.11 Creating a frames document that contains a navigation, status, and content frame.

frame is named, then you can target that frame for update based on links in other frames.

Grasping Linear Organization

Let us begin an example in which you want to create a frames document that contains a navigation, status, and content frame. The navigation frame will consist of a menu on the left side of the screen, which controls images that are displayed in a content frame on the right side of the screen. You will also have a status frame that contains a graphic banner at the top of the page. In this example, the contents will be static with no scroll bars and non-movable frames. Figure 14.11 shows an example of what you will be creating.

To begin setting up this page, first create the frames document itself. You do this using the <FRAMESET> tag and its ROWS and COLS attributes. However, first look at the document and see how the screen should be divided. You can easily define rows and columns, but the order in which you define them in the code is what determines how the frames will be subdivided.

To determine how to divide the screen up, look at what you want to create and determine whether the columns or rows extend over the entire screen. This will show you whether you need to define the rows or the columns first using the <FRAMESET> tag.

In Figure 14.12, you see two different sets of frames. The code for each of these frame configurations is a little different. In (A), the columns extend over the entire screen. These columns are then divided into smaller segments (rows). In (B), the rows extend over the entire screen and are then divided into smaller segments (columns).

In Figure (A) you would first define the columns and then the rows using the <FRAMESET> tag shown in Listing 14.4.

To achieve a column that spans the entire browser, you must first divide the screen into two 50% columns. Then the columns are divided into appropriate rows. The first column is divided into two rows. One is 10% while the other is 90%. The second column is defined by the remaining <FRAME> tag at 100%, achieving a column that spans the entire browser work area.

To create the code for (B), you would need to define the rows first and then the columns. The code for (B) would look like Listing 14.5.

The code in Listing 14.5 defines two 50% columns. The first 50% column is assigned to 100%, achieving a row that spans the entire screen. The remaining 50% column is then divided into a 10% column and a 90% column using the last <FRAME> tag in the code. So you can see that the way you define your frames using the COLS and ROWS attributes determines how the final frames document is created.

Figure 14.12 Determining whether to define rows or columns first.

Looking back at Figure 14.11, you see that the rows extend over the entire screen so you will define the rows and then the columns. The code for this page you will create looks like Listing 14.6.

In this code, rows were assigned first because they extend over the entirety of the screen. The 20% row is assigned to the HTML file called banner.htm. It is a 100% row. The second row, which is 80%, is further divided into two columns. The 25% column is assigned to the HTML file called menu.htm, while the 75% column is assigned to the HTML file called screen.htm.

The function of this interactive page is to choose items in the menu frame and update the screen frame. To do this you have to give the screen frame a name as you can see denoted in the code by the NAME attribute. Giving a frame a name allows documents in other frames the ability to target and update the named frame.

Listing 14.4 If the columns span the entire browser area, use the COLS attribute first.

```
<HTML>
<HEAD>
  <TITLE> Defining Columns, Then Rows </TITLE>
</HEAD>
<FRAMESET COLS 50%, 50%>
  <FRAMESET ROWS 10%, 90%>
    <FRAME SRC="URL">
  </FRAMESET>
  <FRAME SRC="URL">
</FRAMESET>
</HTML>
```

Listing 14.5 If a row spans the entire browser area, use the ROWS attribute first.

```
<HTML>
<HEAD>
  <TITLE> Defining Rows, Then Columns </TITLE>
<FRAMESET ROWS 10%, 90%>
  <FRAMESET COLS 50%, 50%>
    <FRAME SRC="URL">
  </FRAMESET>
  <FRAME SRC="URL">
</FRAMESET>
</HTML>
```

Listing 14.6 The code for the frames layout shown in Figure 14.11.

```
<!DOCTYPE "HTML 3.2 //EN">
<HTML>
  <HEAD>
    <TITLE>Controlling One Frame with Another</TITLE>
  </HEAD>
  <FRAMESET ROWS=20%,80%>
    <FRAME SRC="banner.htm" SCROLLING="no">
    <FRAMESET COLS=25%,75%>
      <FRAME SRC="menu.htm">
      <FRAME SRC="screen.htm" NAME="screen">
    </FRAMESET>
  </FRAMESET>
</HTML>
```

To see how the menu frame targets the frame named screen, let us look at the code for menu.htm. This file shows you how to target frames using anchors. The code for this page looks like Listing 14.7.

In the anchor tags of the code in Listing 14.7, targets have been specified for the anchors using the TARGET attribute. Any time the user clicks on a link, the respective document will be updated in the frame called screen. Figure 14.13 shows a new screen displayed in the data frame. This is how you get one frame to update another frame using the TARGET and NAME attributes. Keep in mind that the TARGET attribute belongs to the <A> tag, and NAME belongs to the <FRAME> tag.

TIP: *If you use a menu structure as shown in the previous example, make sure you provide a means for the user to get back to the "Main Screen" or "Main Menu" inside the menu itself. In Figure 14.13, you will note that Main Menu is one of the menu options.*

Figure 14.13 One frame updates another using the TARGET attribute for the anchor tag.

Listing 14.7 The code for the menu, which contains targets specifications in its anchors.

```
<!DOCTYPE "HTML 3.2 //EN">
<HTML>
  <HEAD>
    <TITLE>Bird Menu</TITLE>
  </HEAD>
  <BODY BGCOLOR="#FFFFFF">
    <UL>
      <LH><H3> Menu of Birds </H3>
      <LI><A HREF="bird1.htm" TARGET="screen"> Red-Headed Woodpecker</A></LI>
      <LI><A HREF="bird2.htm" TARGET="screen"> Spotted Barn Owl </A></LI>
      <LI><A HREF="bird3.htm" TARGET="screen"> Blue Heron </A></LI>
      <LI><A HREF="bird4.htm" TARGET="screen"> Speckled Grouse </A></LI>
      <LI><A HREF="bird5.htm" TARGET="screen"> Sparrow Hawk </A></LI>
      <LI><A HREF="screen.htm" TARGET="screen"> Main Menu </A></LI>
    </UL>
  </BODY>
</HTML>
```

Summary

In this chapter, you have taken a closer look at the frame structure and how you can use a frames document to control a single frame as well as multiple frames. When you first begin utilizing frames, it can be somewhat difficult to figure out the relationship between the frames. If you get into the habit of naming your frames and designing frame layouts using sketching paper, you will find actually implementing frames documents becomes easier. Several automated tools are becoming available, such as Microsoft FrontPage, that are making frames easier to work with and create. Yet, you will still need to be aware of how the frame structure works and how to program the code in many instances.

Next Steps

Now that you have taken a look at controlling individual frames:

• Check out Chapter 12, "Designing with Tables," for more information about designing pages with tables.

• Check out Chapter 15, "Designing with Frames," for a closer look at designing pages with frames.

QUESTIONS

Q *How can I make sure that my pages will fit into the frame I have designed?*

A The best way to ensure your pages will fit into the frames is to plan them out using grid paper. Understand that you must also take into account two other variables: the scroll bar and the variable width between the first element and the left side of the screen. First, understand that the scroll bar itself requires approximately 16 pixels. If your page is longer than the frame, you must accommodate the loss of 16 pixels in width due to the scroll bar. Second, the amount of space between the left edge of the browser and the first element varies across platforms and browsers. Planning your pages on grid paper will help you stay within the actual working area that you have within your frames, but you must also test early and test often. And you must do it with a variety of Web browsers.

Q *Several of the frames pages I have seen on the Web use horizontal scrolling. Is that not bad?*

A In general, horizontal scrolling is bad. Yet some of the pages that are floating on the Net have been designed with purposeful horizontal scrolling. If there is a reason to do it, do it. Overall, however, horizontal scrolling is frowned on by the surfing community.

CHAPTER 15

Designing with Frames

In the last chapter, "Using Frames to Structure Your Pages," you took a look at the <FRAMES> tag and its various attributes. You read about attributes, such as SRC, NAME, SCROLLING, and NORESIZE, that could be used to customize the frames on your pages.

As you saw you can easily create pages that utilize frames that update other frames. But what happens if you want to update multiple frames based on an interaction with a single frame? Can two frames have the same name? Or can you specify two different targets?

In short, multiple frames cannot have the same name, nor can anchors have multiple targets. Therefore, another technique must be employed when you want to update multiple frames based on a single frame. In this chapter, you will spend some time looking at a technique called nested frames and how they can be used to update multiple frames in your documents. In addition, to round out your experience with frames documents, you will conclude this chapter by taking a brief look at frames pages from all across the Web with various purposes and audiences to develop a better understanding of how frames are being used throughout cyberspace.

OBJECTIVES

In this chapter you will:

• Develop an understanding of what indirectly nested frames are and how they are used.

• Understand how to create a frames page that updates multiple frames based on another frame.

• Browse the world of frames Web pages and see how this browser convention is being used in the real world.

Grasping Nested Frames

Now that you have seen how to control individual frames using the TARGET and NAME attributes, let us look at a way of updating two or more frames based on the interaction with the contents of another frame.

Continuing the "North American Birds" example from the last chapter, imagine that you want to create a page that contains a menu frame, a status frame, as well as two content frames as shown in Figure 15.1. Your goal is to allow the menu to update both content frames simultaneously. Yet you understand that you cannot have two windows with the same name or an anchor with multiple targets.

In Figure 15.1 you see the page that you are going to be creating. To accomplish this, modify the code so that the menu now controls both the image screen and the text about the particular bird (both frames in the right-hand column). Once you understand how it is done, you will see how easy it really is.

Figure 15.1 Controlling the content of two frames with a menu in another frame.

Indirectly Nesting Frames Documents

To make this whole thing work you are going to use something called an indirectly nested frame. In our previous birds example, the frames document alone defined all of the frames and subframes to be arranged on the screen. Since every subframe was defined in the single frames document, it would be called directly nested.

You can actually make references within a frames document to another frames document. In other words, you can insert a frames document with multiple frames into a frame of another frames document. This is what you will do to create a document that updates two frames simultaneously. When you have frames documents integrated into other frames documents, it is called indirect nesting.

The code for our existing frames document from the last chapter looks like Listing 15.1. Figure 15.2 shows the results of the code in Listing 15.1. The revised code now looks like Listing 15.2 and the file is called indirect.htm. The new code again defines the columns first, but since no particular frame spans the entire document, either columns or rows could be defined first. Compare Figure 15.2 to Figure 15.1, as well as Listing 15.2 to Listing 15.1 to understand the differences between the two examples.

Let us take a close look at the code in Listing 15.2 compared to Figure 15.1. You will see that you have begun by defining two columns, a 25% and a 75% column. You see that the first 25% column is divided into a 22% and 78% row and that the HTML files associated to them are listed using the <FRAME> tags immediately following.

The next part is the important part. The 75% column is assigned to the file called split.htm. If you look at Figure 15.1 (indirect.htm) you see that the column should be divided into two rows, yet there is only one file referenced and only one <FRAME> tag. This column is named split. The reason it looks this way is because the row definitions for that column (split) are in the file called split.htm, rather than in the code for this document (in-

Figure 15.2 The previous frames example of controlling one frame with another frame.

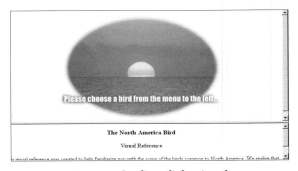

Figure 15.3 Loading split.htm into the browser reveals that it is a frames document.

direct.htm). In other words, it calls another file that defines two frames.

This is the technique to use to get two frames to update simultaneously. You update the indirectly nested frames document (split.htm) rather than focusing on the two files that appear in the subdivided frames within the main document.

Let us look inside the file called split.htm so that you will better understand how it is working. The code for split.htm looks like Listing 15.3. If you were to load split.htm into the browser by itself, it would appear as shown in Figure 15.3.

The code for split.htm (see Listing 15.3) contains definitions for the two rows you saw in the column of our main frames document, indirect.htm (see Figure 15.1).

Listing 15.1 The code for Figure 15.2.

```
<!DOCTYPE "HTML 3.2 //EN">
<HTML>
  <HEAD>
    <TITLE>Controlling One Frame with Another</TITLE>
  </HEAD>
  <FRAMESET ROWS=20%,80%>
    <FRAME SRC="banner.htm" SCROLLING="NO">
    <FRAMESET COLS=25%,75%>
      <FRAME SRC="menu.htm">
      <FRAME SRC="screen.htm" NAME="screen">
    </FRAMESET>
  </FRAMESET>
</HTML>
```

Listing 15.2 The code for Figure 15.1, called indirect.htm.

```
<!DOCTYPE "HTML 3.2 //EN">
<HTML>
  <HEAD>
    <TITLE>Controlling One Frame with Another</TITLE>
  </HEAD>
  <FRAMESET COLS=25%,75%>
    <FRAMESET ROWS=22%,78%>
      <FRAME SRC="sm_ban.htm" SCROLLING="NO">
      <FRAME SRC="menu.htm">
    </FRAMESET>
    <FRAME SRC="split.htm" NAME="split">
  </FRAMESET>
</HTML>
```

Listing 15.3 The code for split.htm reveals that it is a frames document.

```
<!DOCTYPE "HTML 3.2 //EN">
<HTML>
  <HEAD>
    <TITLE>Controlling One Frame with Another</TITLE>
  </HEAD>
  <FRAMESET ROWS=75%,25%>
      <FRAME SRC="s_screen.htm">
      <FRAME SRC="s_text.htm">
  </FRAMESET>
</HTML>
```

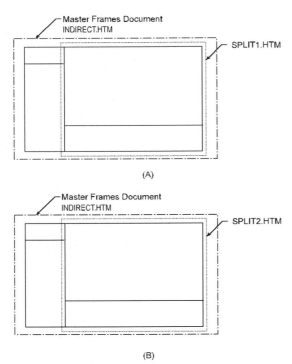

(A)

(B)

Figure 15.4 Using indirectly nested frames.

Through this example, you can see that a frames document can actually be embedded into another frames document, and so on. This means that when a user clicks on an option in the menu contained in the main frames document (indirect.htm), it updates the 75% column with another frames document, causing both windows to be updated simultaneously. Let us take a look at it graphically.

Figure 15.4 shows how this works. Note that the main frames document is the file called indirect.htm and it has indirectly nested the file called split.htm into its right-hand column. This file split.htm is also a frames document and contains the row divisions and the <FRAME> references to the content that will appear in the rows in that column of indirect.htm. When a user clicks on an item in the menu, the indirect.htm updates the right-hand side of the screen with a new file called split2.htm that contains the same row divisions as split1.htm; however it references two different HTML files. The code for split2.htm looks like Listing 15.4.

Listing 15.4 split2.htm has the same frames structure as split1.htm yet references different content files.

```
<!DOCTYPE "HTML 3.2 //EN">
<HTML>
  <HEAD>
    <TITLE>Controlling One Frame with Another</TITLE>
  </HEAD>
  <FRAMESET ROWS=75%,25%>
      <FRAME SRC="s_bird2.htm">
      <FRAME SRC="s_text2.htm">
  </FRAMESET>
</HTML>
```

Clicking on an item in your bird menu would update both the picture of the bird and the text associated with it by replacing split1.htm in the master frames document (indirect.htm) with split2.htm as shown Figure 15.5. For each menu item you have three HTML files: the nested frames document (split1.htm, split2.htm, split3.htm, and so on), the HTML file that contains the image, and the HTML file that contains the text describing the image. In addition, you have the main frames document (indirect.htm) and the files contained with its directly nested frames (sm_ban.htm and menu.htm). Using this technique requires many more HTML files but is extremely effective in Web pages where you want to update multiple pages based on user selections.

Note: *So why do we have to go through all this to update multiple frames? Well, to be able to have one frame update another, you must use the NAME attribute with the <FRAME> tag and the TARGET attribute with the <A> tag. Note that you can only have one TARGET in the <A> tag and each frame must be uniquely named. Therefore, to update multiple frames in any other way would require the ability to assign multiple targets for the <A> tag or the same name for multiple windows, which we cannot do. By using an intermediate frame document, you can allow an <A> tag's TARGET to (indirectly) update multiple frames.*

Real World Examples

Over the last three chapters you have been reading about how to implement frames documents at your Web site. Frames are a very effective way to design a Web site, assuming the site works when it is placed on the Web. When it comes to HTML programming (ignoring various scripting languages), it seems as if frames are the ultimate, yet most difficult feature for most people to work with. The remainder of this chapter will show you examples that implement frames into their site designs. Some frames sites are more complex than others, but all are notable. If you think frames are cool check out the sites shown in Figures 15.6 through Figure 15.9.

Figure 15.5 Both of the data frames are updated by clicking on a choice in the navigation frame.

Figure 15.6 Typographic treatments and other visual design elements are also important (http://www.subnetwork.com/typo/).

Figure 15.7 Do not be afraid to try different things. Often successful sites are those that are different (http://www.charged.com/).

Figure 15.9 Frames are often used for advertisements (http://expedia.msn.com/).

Next Steps

Now that you have looked at indirectly nested frames:

• Check out chapter 16, "Utilizing Vector Graphics," for information on using vector graphics on your Web pages.

• Examine chapter 17, "Utilizing Bitmap Graphics," for information on raster graphics use on the Web.

Figure 15.8 Here is a good example of a complex frames setup (http://www.filefactory.com/BROWSE/browse.htm).

Summary

In this chapter, you have taken a look at the concept of indirectly nested frames and how they can be used in your Web documents. You found that indirectly nested frames are quite effective. However, they require many more HTML documents for execution. You also took a brief look at the range of frames documents being used on the Web.

QUESTIONS

Q *Where can I find more information about frames?*

A Probably one of the most useful resources for frames documents is the Web itself. If you have not done so already, check out the sites in this chapter, as well as others strewn throughout the book and really digest the code behind the pages at the various sites. One of the best teachers is the technology itself!

PART FOUR

ADVANCED GRAPHIC TECHNIQUES

CHAPTER 16

Utilizing Vector Graphics

One of the best inventions for the publishing industry was vector-based illustration packages. As many will attest, high-resolution raster images often choke come print time, even on the fastest of computers. Raster graphics, which have to be large to support high-resolution prints, all but disable processing functions due to the amount of data.

Vector graphics are a resolution-independent alternative. These small, mathematically based files provide high-resolution printing without the severe overhead of high-res raster graphics. Vector graphics, due to the way they are defined, are resolution independent. This means that they can be output at a variety of resolutions and on a variety of devices.

The beginnings of vector graphics were based in Post-Script, a unique vector-based page description language developed by Adobe. Most of the sophisticated vector drawing programs available today are still based on the PostScript language because most were designed to print to PostScript printers. These include programs such as Adobe Illustrator, Macromedia FreeHand, and Corel-Draw!.

Much like HTML, the beginnings of PostScript drawing found people painstakingly programming in PostScript. Eventually, as will probably come true with HTML over the next couple of years, vector drawing programs evolved into powerful tools that no longer required any knowledge of the PostScript language itself. If you can draw a line or a circle, you can utilize a PostScript draw-

ing program. No need to bother with the monotonous task of searching or customizing a vector drawing by going to the code level. Anything you want to accomplish can be done within the vector drawing program. Visual HTML editors support true drag and drop capability, akin to the evolution of vector-based drawing programs.

Yet, vector drawing, which is widely used in print-based media, has not been extensively used on the Web up to this point. Vector drawings were never designed for 72 dpi display media, such as used with multimedia, hypermedia, or the Web. However, PostScript can be as much at home on the Web as anywhere and these files are generally smaller than raster-based graphics. Nonetheless, vector graphics on the Web have some negative considerations as well. This chapter will provide you with some insight into vector graphics, how they differ from raster graphics, and how they can be utilized on the Web.

OBJECTIVES

In this chapter you will:

• Develop an understanding of the difference between vector and raster graphics.

• Discover some of the advantages and disadvantages of vector graphics.

• Learn about one of the newest features of vector elements on Web page: dynamic fonts.

• Find out how plug-ins can be used to integrate vector graphics on the Web.

• Learn how to convert vector graphics to raster graphics without losing image quality.

Understand That the Web Is a Bitmap World

Although new technologies exist and are being developed on a daily basis, including advances that allow the developer to distribute vector-based illustrations, most of the graphics found on the Web today are raster-based bitmaps. Yet, most clip-art libraries exist in vector form as do many drawings used for traditional print purposes. Most would like to be able to integrate vector graphics on the Web with the ease and efficiency of raster graphics. Nonetheless, when displayed on the Web, vector graphics, as well as rasterized vector drawings, leave something to be desired. In general, raster drawings give the most photo-realistic appearance on the Web, as shown in Figure 16.1.

The comparison of bitmap versus vector illustration technologies shows some significant differences between the results generated by each. Raster graphics are defined pixel by pixel, whereas vector graphics are defined by objects such as points, lines, and polygons. By definition, raster and vector drawings are different due to elements that define the image. Vector and raster images differ both in the way they look and in the ways they are created.

The most notable difference between these types of graphics is the way that they display on-screen. Raster images are characterized by a more photo-realistic representation. Because raster images use anti-aliasing (blurring of edges), elements within them appear much

Figure 16.1 Bitmap graphics give the most photo-realistic representation (http://www.honda.com/cars/delsol/).

Figure 16.2 Most images generated using vector graphics reveal aliased edges (http://www.digitalcolour.com/intro.html).

smoother. Alternatively, vector images are characterized by jaggy or stair-stepped edges on the elements in the image. The text shown in Figure 16.3 is vector based. The images are raster. The jagginess of the text reveals its vector nature.

Most vector-based drawings do not give a photo-realistic representation as shown in Figure 16.2. As you can see from the figure, vector graphics are often typified by aliased edges and flat colors. Blends can be accomplished with vector graphics, but often they do not have the photo-realistic qualities found in raster-based graphics

when displayed on a monitor. This is because monitors are not PostScript devices.

Note *Although raster images present images in a more photo-realistic way, there is a price to pay for this characteristic. Because the smallest element in a raster image is the pixel, each pixel must be defined. A single raster image can contain hundreds of thousands of pixels and each pixel has data associated with it. This makes the raster image's file size quite large as compared to a vector drawing. A single 640 x 480, 1-bit raster image, can require up to 40 kilobytes of hard disk space. This file would then require approximately 11 seconds to download over a 28.8K modem, which does not seem too bad—until you compare it to a vector version of the same file, which may be less than 10 kilobytes.*

Integrating Vector Graphics

One of the reasons vector images have not been used exclusively on the Web is due to their poor quality at 72 dpi (monitor resolution). However, vector elements are the basis for much of the text that is used in Web pages due to the speed at which vector information can be delivered on the Web. In fact, the text specifications that are used in the HTML coding with tags such as <H1>, <P>, and so on, are actually specifications for the browser to create vector text on the Web page as shown in Figure 16.3.

Figure 16.4 shows a Web page that displays vector fonts in another Web page. Can you spot the vector items? Remember, look for the characteristic jaggies. Hint: Blocks of text are usually vector. Logo text and stylized headings are usually raster.

Although vector graphics are not yet extensively used on the Web, much of the text is vector based. All of the HTML tags that allow you to insert text is vector based. Knowing this, you can see that the larger the text is in the

Figure 16.3 Text defined with HTML tags is vector based—look for the jaggies. This reveals the vector text (http://city.ottawa.on.ca/eindex.html).

Figure 16.4 Can you spot the vector elements in this Web page (http://www.msnbc.com/)?

Web page, the more it will display the characteristic vector jaggies as shown in Figure 16.5.

One of the exceptions to the aliased nature of vector elements is a new feature being supported by Netscape Communicator and other browsers. This new feature, called dynamic fonts, allows the developer to embed font description files into a Web page. Upon download, the font file, which is based on TrueDoc technology developed by BitStream, is downloaded to the client machine. Because the font description is available to the browser, almost any font can be defined in the Web page, which is a definite plus. In addition, dynamic fonts are able to be displayed as anti-aliased, which makes them look very sharp and clear as shown in Figure 16.6. As you can see in the figure, dynamic fonts make it difficult to tell whether the font is a bitmap or vector element.

Note: Although the new dynamic font feature is a powerful browser extension, it will be some time before it is widely implemented because older browsers such as Navigator 3.0 or Explorer 3.0 (and earlier) will not support them. It will probably take at least a year before dynamic fonts, as well as other new features supported by the latest browsers become common.

In addition to the vector fonts that are used in Web pages, new technologies, such as Macromedia's Shockwave for FreeHand, can enable you to include vector images on the Web as shown in Figure 16.7. Macromedia's Flash technology can even be used to build vector-based animations, which are much smaller than raster-based GIF or Java animations.

Once an illustration has been created, including it on a Web page requires the use of a filter (Xtra as it is called in the application) called Afterburner, which preps the file for Web distribution. The filter gets rid of some information that is not relative to Web delivery as well as compressing the file.

The effects that can be achieved by the use of plug-ins are desirable, such as zooming capability and higher-resolu-

Figure 16.5 The larger HTML text is, the more it looks like vector text.

Figure 16.6 Dynamic vector fonts (http://home.netscape.com/comprod/products/ communicator/fonts/stockwatch_demo/index.html).

Figure 16.7 Macromedia's Flash technology allows vector- based animations to be integrated onto Web pages (http://www.launchsports.com/).

Figure 16.8 A cool Shockwave site, complete with audio to set the tone (http://www.iuma.com/IUMA-2.0/ pages/front_page/index-shock.html).

tion printouts; however, it does not get rid of the characteristic jaggies of vector illustrations. In Figure 16.8, you see a page that has included a Shockwave movie. If you have the Shockwave plug-in installed, check out this site.

Realizing the Characteristics of Vector Graphics

The biggest advantage to vector graphics is their flexibility. Unlike bitmap graphics, vector graphics are designed so that they can be output to many different types of devices with quality representative of the output device. To understand this statement, you need to understand the general term called resolution.

Note: Probably one of the most misunderstood graphic terms is resolution, mainly because it can mean many different things, depending on what you are talking about. In general, the term resolution *describes the quality of replication for any particular device. It also describes the quality of multimedia elements such as graphics, sound, and video.*

Printers, monitors, images, sounds, and even video have a resolution. Resolution simply describes the clarity or quality of any of these devices or objects. By the time you are finished with this book, you will have read how the term resolution relates to all of these items.

When you are talking about graphic images, resolution describes the number of dots per square inch (dpi) in the image. This is image resolution. The number of dots that are replicated on a monitor or on a printed page determine the quality of the replication of the image on the particular device. This is device resolution. The quality of image output is dependent on both the image and device resolution as shown in Figure 16.9.

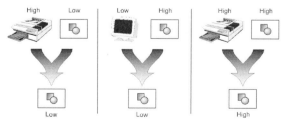

Figure 16.09 The quality of an image that is output from a device is dependent on both the image and device resolution.

Note in Figure 16.9 that three individual cases are shown. Again the Weakest Link Principle (presented in chapter 3, "Designing for Effective Content and Efficient Delivery") applies here. In the first case, a low-quality image is printed on a high-quality device, which yields low-quality output. In the second case, a low-quality image is output on a high-quality device, which yields, again, low-quality output. The last case, where both image resolution and device resolution are high quality, yields high-quality output. The quality of an image that is output from a device is dependent on both the image and device resolution.

Note: *To understand device resolution, let us look at a couple of devices. Most common desktop laser printers have a device resolution of 300 to 600 dots per inch. Most computer monitors display a device resolution of 72 or 75 dots per inch. The more dots that a device can print or display, the higher the quality of the reproduction. Using these two examples, printing an image requires better image resolution than does displaying for high-quality output.*

To see how image resolution affects quality, take a look at Figure 16.10. The left image has an image resolution of 300 dpi (dots per inch), while the right image has an image resolution of 72 dpi. Notice the significant degradation in the lower resolution image. You can see that the quality of the image is affected by its resolution. The lower the resolution, the less data is maintained about the image.

Note: *Whenever you are dealing with computer graphics, the perceived quality of a graphic is dependent on two things: the resolution of the image, and the resolution of the device. These two are completely independent. However, they can greatly affect the results you get from either vector or bitmap graphics. For optimum quality in your graphic images, you really want the resolution of your graphics to match the resolution of the device you are outputting it to. This will give you the optimum quality in your images.*

Figure 16.10 Seeing the effects of image resolution by comparing a 300-dpi image and a 72-dpi image printed on a 300-dpi laser printer.

Figure 16.11 Find a vector graphic with two objects that would be difficult to blend (http://www.leevalley.co.uk/uci/uci1.html).

Device Independent, Resolution Fluid

As you have seen, resolution plays an important part in the quality of graphic images. As you will see in the next chapter, "Utilizing Bitmap Graphics," resolution is one of the most important attributes of concern with bitmap graphics.

Note: *In bitmap graphics, the resolution is defined when the image is created and it can only be changed by adjusting the size of the image. Bitmap graphics are resolution (device) dependent. However, with vector illustrations, resolution is*

fluid, meaning that the dpi can be increased or decreased on the fly. It also means that vector images can be scaled without any concerns about affecting the resolution of the image.

When vector graphics are created, they are displayed on a 72-dpi monitor. The designer may then choose to proof the drawing on a 300-dpi laser printer. Finally, the finished product for which the image was created is produced on a 1200-dpi printer. For vector graphics, this does not create a problem. In most vector packages, resolution can be changed by either changing the target printer, in which case the application automatically senses what dpi is needed, or the desired dpi for the image can be set somewhere in the software.

Positive Points of PostScript

As you have seen, vector graphics present many advantages over bitmap images due to the way they are defined. Vector graphics are advantageous because:

• They are device independent, meaning that their dpi and size can be changed without affecting the quality of the image or the size of the file.

• They generally have a smaller file size than bitmap graphics, meaning that they can be downloaded much more quickly when incorporated into Web pages.

• A single vector graphic can be used for many different purposes and its quality can be manipulated to match the varying qualities of a wide range of devices. Keep in mind that optimum quality is obtained when the resolution of the vector graphic is set equal to the resolution of the output device.

• A vector graphic is often easier to create and manipulate, given a situation where a photo-realistic image is not needed.

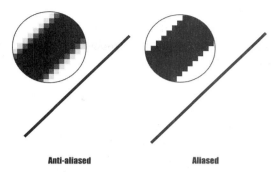

Anti-aliased Aliased

Figure 16.12 The comparison of an aliased line to an anti-aliased line.

Jaggies

As with anything, there are also disadvantages to using vector graphics. As you have seen, one of those disadvantages is that photo-realism requires painstaking work. Since each object in a vector graphic is self-contained and discrete, with its own properties and defined characteristics, it is very difficult to create blends and other graphic effects between objects. For example, in Figure 16.11, it would require much work to create blends among the various objects displayed in the vector graphic. This is one reason that vector graphics are generally less than photo quality.

Note: *It requires much more work to create smooth, photo-realistic blends in a vector environment. The biggest disadvantage of vector illustrations are aliased edges that appear stair-stepped within the graphic. This is the primary reason why vector graphics appear less photo-realistic.*

To understand what aliasing is, look at Figure 16.12. Aliased and anti-aliased lines appear different. This is one of the most significant details that clues you into whether a graphic is a vector or bitmap image. Notice that the aliased line looks stair-stepped or jaggy while the anti-aliased line looks smoother. Let us take a closer look at the lines in the illustration to understand why one appears more smoothly than the other.

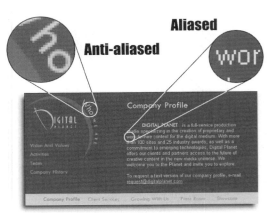

Figure 16.13 A closer look at a raster image reveals what is happening to the anti-aliased features.

Process	Advantage	Disadvantage
Conversion	Smoother blends	Larger file size
	Anti-aliased edges	Longer download
	Simple tag	Tricky to execute
		Low quality print
Plug-in	Smaller file size	Can cause browser lock
	Quicker download	Aliased edges
	Zooming capability	Requires <EMBED> tag
	High quality print	Requires client plug-in
	Animation capability	

Table 16.1. Advantages and disadvantages of vector to raster conversion and vector plug-ins.

Shown in Figure 16.13 is a closer look at a vector versus raster graphics. The anti-aliased lines of the bitmap graphic have pixels added that are a blend between the color of the edge and the opposing background. This makes the line appear smooth. Anti-aliasing occurs in raster environments to make objects look smoother and more photo-realistic. Since the raster environment is based on pixels, anti-aliasing is possible. However, in the vector environment, where the drawing is defined by objects rather than pixels, there is no anti-aliasing that occurs. All objects appear with typical "jaggies."

Knowing that this is a negative aspect of vector drawings on raster devices (such as a monitor) many of the Post-Script drawing packages are beginning to include anti-aliasing effects right within the vector environment. Vector programs that perform anti-aliasing are slower due to the amount of information that must be generated with the PostScript drawing.

Utilizing Vector Graphics

If you decide to use vector graphics in your Web pages, you basically have two choices for implementing them:

converting the vector image to raster or using a plug-in for browser interpretation. Realize that there are positives and negatives of both techniques, as shown in Table 16.1.

Task: Converting Vector to Raster

The biggest problem with the conversion of vector graphics to raster is that you end up with jaggies—edges that are often severely pixelated. However, you can get rid of the jaggies if you convert them correctly.

Most vector graphics can be imported or opened into either Macromedia FreeHand or Adobe Illustrator. These two tools are the predominant illustration packages that are used for vector illustration.

The first step in being able to utilize vector graphics is the conversion process from vector to raster. I am going to show you how to do it in Macromedia FreeHand because it has a very good filter that converts the illustration to a raster format. You can also import certain vector files (such as EPS or AI files) into Adobe Photoshop, which will also rasterize vector illustrations effectively.

1 Begin the conversion process by opening the image into the vector program. One of the pluses of Macromedia FreeHand on the PC is that it allows you to export a vector drawing as a tagged image file format (TIFF) file.

Figure 16.14 Scaling the image up in the vector program.

The program automatically converts the image to a pixel-based (raster) image. You also have control over resolution and bit depth. However, to make this work right you must scale the image up to a larger size than you need, as shown in Figure 16.14.

2 After scaling the image up, use the File | Export option and export it as a TIFF image. Make sure to use the Options button in the dialog box to set the image to 150 Line Screen and 24-bit. Now you have a raster file of your drawing, which you can open into Adobe Photoshop. However, as shown in Figure 16.15, the edges of the image are jaggy.

3 To solve this aliasing problem, select the background of the image using the magic wand tool with a tolerance of 1. This will cause the selection to only include the white portions of the image (Figure 16.16).

4 Once you have selected the negative portion of the image only, use Select | Invert to inverse the selection. This selects the positive portions of the image. Then cut the image and paste it onto a new layer, as shown in Figure 16.17 (next page).

Figure 16.15 Opening the rasterized TIFF image reveals aliased edges.

Figure 16.16 Using the Magic Wand selection tool with a tolerance of 1 selects only the positive portions of the image.

*Figure 16.17 Cutting the image to
a new blank (transparent) layer.*

*Figure 16.18 Because the image was copied to a new
transparent layer, it can be reused in another illustration
without the occurrence of an anti-alias halo.*

5 Once the elements are on the new layer, scale the image. Note that the whole reason you scaled the image up in the vector program was so that you could then scale it back down in the raster package. Use either the Layer | Transform | Scale option or the Image Size option. So what happens when you scale the image down in the raster package? The raster editor automatically blurs the edges of the image, resulting in an anti-aliased image.

6 Now that the image is scaled and anti-aliased, you can insert the image into another illustration. The added benefit is that the anti-alias around the edges is not fixed because it resides on a transparent layer. Subsequently copying the image to a new drawing with a different color background will not cause the dreaded anti-alias halo (Figure 16.18).

Summary

In this chapter, you looked at vector graphics on the Web. Undoubtedly, formats such as Flash will change the negative aspects of utilizing vector graphics, such as aliased edges and course blends, while keeping the advantages of small file size and quick downloads. As the Web moves away from the static to the dynamic, it will be interesting to see the new uses for vector graphics evolve.

Next Steps

Now that you have taken a look at how to utilize your vector graphics:

- Check out chapter 17, "Utilizing Bitmap Graphics," for more information on raster graphics.

- Read chapter 21, "Training the Page to Speak," for more information on Shocked Audio and other sound formats for the Web.

- Examine chapter 22, "Animating Your Web," for more information on Flash and vector-based animations.

QUESTIONS

Q *I created a FreeHand graphic with a linked TIFF file and I cannot get the Shockwave file to work right. What is wrong?*

A One of the things you should note about the After-burner Xtra, as well as the Shocked FreeHand format itself, is that it does not support all of the FreeHand illustration functions. Note that the Shockwave format for FreeHand:

- Does not support EPS format graphics. It prefers the Adobe Illustrator file format.

- Will only export the current page in a multiple-page document.

- Does not support textured or custom fills patterns.

- Does not support linked TIFF files. TIFF files must be embedded.

- Does not support text effects, tabs leaders, or range kerning.

Q *I noticed in FreeHand 8.0's TIFF export options that I could allow FreeHand to anti-alias the image as it is exported. Will this work for raster to vector conversion for the Web?*

A FreeHand 8.0's TIFF export does allow you to anti-alias the vector illustrations as you export them. However, the anti-alias is fixed between the object color and the background. Therefore, inserting the graphic over a different color background will reveal an anti-alias halo.

Q *I cannot get Flash movies to play properly in my browser. What should the MIME type be set to?*

A Currently, the MIME type for Flash movies should be set to a MIME type of application/futuresplash and a suffix of .spl. According to Macromedia, it will be changed to a MIME Type of application/flash and a suffix of .spl.

Utilizing Bitmap Graphics

Today, most of the graphics that you view in your surf sessions are raster, or bitmap, based. Yet, vector graphics are quickly making a name for themselves on the Web with the advent of technologies such as Macromedia's Flash technology. Nonetheless, for some time to come, bitmap graphics will continue to be the main vehicle for delivering graphics over the Web.

After surfing the Web since its sudden emergence, one of the most common problems that can be found is graphics that either take a long time to download or graphics that display poorly due to a developer's lack of understanding of bitmap graphics. This chapter is designed to take you into the three main characteristics of the bitmap image as well as to see how these characteristics impact quality and file size.

OBJECTIVES

In this chapter, you will:

• Develop an understanding of the base level, yet vitally important raster's fundamental element: the pixel.

• Take an in-depth look at the three bitmap characteristics: image resolution, image size, and image bit depth.

• Learn how file size is affected by the three imaging characteristics.

• Find out how to size images in your Web pages, without using the HEIGHT and WIDTH attributes of the tag.

• Discover the importance of a raster editor in page design and layout.

• Determine the necessary features of a raster editor.

Figure 17.1 Bitmap graphics are composed of individual pixels (http://www.electric.co.za/).

Understanding Advanced Imaging

As was established in the previous chapter, bitmap graphics are graphics in which the smallest elements in the drawing are pixels. Understanding computer imaging, regardless of whether you are talking about vector or raster graphics, requires knowledge about the base-level elements that compose those graphics. In the case of raster graphics, independent of its physical size, it is composed of many dots, or more accurately, pixels, as shown in Figure 17.1.

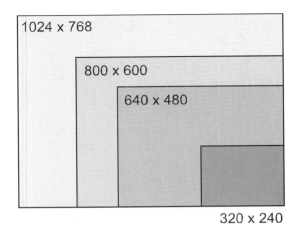

Figure 17.2 Standard image sizes used for raster graphics displays.

Some of the standard sizes of bitmaps include 320 pixels by 240 pixels, 640 pixels by 480 pixels, and 800 pixels by 600 pixels, as shown in Figure 17.2. However, the graphics you include on your pages will often be nonstandard sizes, customized to whatever size is needed and appropriate. Understand that when images are specified this way, these numbers represent the exact number of pixels such as an image that is 640 pixels in width by 480 pixels in height.

Note: *Computer monitors are also specified in a similar manner to images. However, the second number is interpreted as number of lines, or scan lines, in the monitor's screen area. For example, a monitor screen area that is specified as 640 by 480 means 640 pixels by 480 scan lines. Each vertical pixel represents one scan line of horizontal pixels.*

Pixels themselves are similar halftone dots that are used to create a printed picture (except pixels are the same size while halftone dots are infinitely variable...hence a computer monitor's failure at displaying photographic-quality images).

To be completely accurate, when you are talking about images that are displayed on a computer monitor, you are talking about pixels per inch (ppi). As you saw in the last chapter, when you are talking about output from a printer you are talking about dots per inch, or dpi. When talking about printed raster images (such as TIF graphics) or screen images, to be completely accurate you should use the appropriate acronym for the output device.

Making Pixels Perform

In the last chapter, you saw that vector images are device independent. This means that the dpi can change and the image can be sized without affecting either the quality of the image or the graphic's file size. In addition, there is no fixed relationship between the image's dpi and the image's physical size in the vector file. They are independent. Yet, bitmap images work exactly the opposite of vector files; therefore, they are said to be resolution dependent.

So what does resolution dependent mean? Device dependent means that when the raster graphic file is created, a fixed relationship is established between the image's size and its dpi. The image is created for a specific output size and device dpi (or ppi). In addition, the quality of the image is also affected by the bit depth at which it is created. These very important details are set when you create the bitmap image and they control specific parameters concerning the pixels that make up the image.

Once a bitmap's characteristics are set, the range of usefulness for the graphic becomes limited. One problem is with graphics that display with lower quality than was intended or those that require a significant amount of time to download. High-quality graphics, such as shown in Figure 17.3, have much careful thought involved with their creation and have been very conscientiously, and oftentimes painstakingly, created.

In the following sections, you will take a look at three vital attributes of all bitmap images. These attributes not only impact the quality of the displayed image, but also the size (in KB) of the graphic file itself. Therefore, these

attributes can either increase or decrease both the quality of the graphic and the efficiency at which it downloads. On the Web, everything is ultimately an issue of file size.

Working with Raster Characteristics

The biggest challenge for a designer is creating bitmap graphics that download quickly and display at the quality your audience expects. As you read in the previous chapter, bitmap graphics are much larger than vector graphics due to the way they are defined—pixel by pixel. Many of the following attributes directly affect file size; therefore, they also affect download speed. These attributes also affect image quality. Optimally, you want to design your graphics so that your audience can view them without waiting for long periods for your pages to download. However, if the file is too small, too little data are contained in the graphic file and the aesthetic results of the image can be self-defeating.

The goal of creating effective graphics for the Web is to arrive at a balance between quality and size. Unfortunately, quality and file size are opposing attributes. As quality increases, so does size. As you develop graphics for pages, the amount of each, quality and size, will vary because your audience will also vary. Yet, the optimum is to provide the highest amount of quality in your images that your audience's download limitations will allow. Figure 17.4 shows an example of a Web page with high-quality graphics designed around the audience.

Image Resolution

The first important raster graphic characteristic is dots per inch (dpi), also called image resolution. As you read, to be technically accurate this is generally called pixels per inch (ppi). However, in this section I will be calling it dpi for continuity between chapters. Keep in mind that dpi equals ppi. As you saw in the previous chapter, dpi is

Figure 17.3 High-quality graphics found on the Web often require conscientious acknowledgment of raster characteristics (http://www.mot.com/GSS/CSG/).

Figure 17.4 Design the quality of your graphics to your audience's expectations (http://www.rollerblade.com/site_menu.html).

commonly associated with graphics and desktop publishing output. Dots per inch or dpi is a measurement used to describe the number of physical, printable (displayable) dots per square inch of the image.

The resolution appropriate for an image, whether vector or bitmap, is dependent on the target output device. For most Web development tasks, all you need is 72 dpi because that is the maximum resolution of almost all computer monitors. Anything more and you are just wasting bandwidth on the Net.

Figure 17.5 A 72-dpi image versus a 300-dpi image.

Alternatively, if you want a graphic to print out very cleanly from the Web, the dpi must be higher because the output device is no longer focused at just a monitor. It has switched to a printing device. Figure 17.5 shows a 72-dpi graphic image printed at 300 dpi and a 300-dpi graphic image printed at 300 dpi. Notice the significant difference between the clarity of the two images. The image to the left is a 72-dpi image and the pixels that make up the image can easily be seen. The image to the right is much sharper and photo-realistic. It has more dots or pixels to represent the image at the given size on the given device.

Another difference between the 72- and 300-dpi images, one you cannot see in the displayed image, is the file size. Creating raster images at a high resolution exponentially increases the file size. In the previous chapter, you saw that adjusting the dpi of vector images does not affect the file size. However, with bitmaps, this is not the case. In Figure 17.6, the file size of the high-resolution image is about four times the size of the low-resolution file!

Figure 17.6 The greater the resolution, the larger the file size.

TIP: *When you are designing bitmap graphics, design for the lowest common denominator. Only include high-resolution files if you intend for the audience to download them and view or print them separate from the Web browser. Do not include high-resolution images, ones with a dpi greater than 72 dpi, as inline images in your pages. Provide links to high-resolution images.*

As you create graphics for the Web, you may choose to use bitmaps that were created for other purposes. For

example, you may want to utilize a graphic from a traditional brochure or other piece on a Web page. This is appropriate if the image is large enough or has sufficient resolution to support the intended display size.

If you want to display a graphic at a set size with sufficient visual quality, the dpi must be at least 72 at the size at which you want to display it. Most often, you will be using images that have more than an adequate resolution, assuming they are coming from a printed piece. So in most cases you simply need to reduce the dpi and scale the image for use on the Web.

Bitmap Scaling Example

Figure 17.7 Increasing the dpi on a low-resolution file does not increase the output clarity; it causes the image to become blurry and more pixelated.

Figure 17.8 Scaling a bitmap down relies on the Web browser to dither the raster image with unpredictable results.

But what happens if you want to display an image on your Web pages larger than its current size? For example, you want to display an image at a screen size of 200 by 200 pixels but find that the dpi (ppi) at that size drops to 52 (Figure 17.6). To solve this problem most people would simply attempt to bump up the dpi setting in an image editor. Unfortunately, in most cases, this will not work.

Bitmap graphics are resolution-dependent graphic files, meaning that once the graphic is created (or exists) at a certain resolution and image size, you cannot increase the dpi (and keep the same quality of the image) without reducing its physical size. The image is dependent on the size at which it was originally created. Figure 17.7 demonstrates this relationship. Notice that the smaller version of the image looks fine when displayed at its original size. But when you increase the size of the image, the image becomes fuzzy and unclear.

Let us take another look at scaling an existing bitmap, but this time, let us scale the graphic down. In Figure 17.8, you see a graphic created and inserted into a page at multiple sizes using the HEIGHT and WIDTH attributes of the tag. The graphic on the right has been inserted at its true, originally-created size. The graphic to the left has its HEIGHT and WIDTH attributes (of the tag) set at half the value, so the image appears 50% smaller than the true size. The

browser must create a new bitmap by dithering the original bitmap. Because this happens in the browser, you have no control over the final rendering. Most of the time the result is acceptable. Sometimes, the browser drops out pixels, degrading the image.

In the case of the small image in Figure 17.8, specifying a reduced size displays okay, although the image is a little rough due to too many pixels for too small of an area. Note that the browser is trying to drop some pixels to squeeze the image into the small area. But think about this for a minute. Using what you know about scaling an image up and down, is bandwidth being wasted here? For the image to be displayed this way, all the image data must be downloaded—more data than is needed to display it in this small area. The data being downloaded are enough dots to display the larger image. However, the browser is shrinking it so that it can display it at 72 dpi at the specified size. You could save downloading time, as well as have a more predictable graphic, if the image were sized (in a raster editor such as Photoshop) before inserting it into the page.

TIP: *Do not use the tags HEIGHT and WIDTH attributes to scale an image unless it is going to be used multiple times at different sizes. It may be better to pull a single image from cache memory multiple times and resize it rather than download multiple images that do not have to be resized.*

TIP: *Code your HTML so that graphics on pages use the exact or true size of the image. Only use the HEIGHT and WIDTH attributes of the tag to allow space for graphics, not to size them. When the browser sees these parameters, it composes the page, displays it, and goes back to fill in the graphics. This gives the illusion of a faster download because the browser does not wait until the entire page is rendered to start display.*

It seems appropriate to mention that the resolution dependency of bitmap graphics is the biggest single problem with using them. This is why vector images are appealing, up to a point. Vector graphics are resolution independent, meaning that the dpi can be increased or decreased based on the output device. This makes sense since vector files are based on objects rather than absolute pixel definitions.

Note: Because most Web developers design for screen use only, dpi may not be a great concern. It usually becomes a problem when you are using source images created for another purpose or involved in multipurpose documents.

Regardless of purpose or output device, develop all bitmap graphics at 300 dpi. This will give you flexibility—in case you want printable versions in the future. Again, you will notice an increase in file storage requirements as well as processing speed, but you give yourself more options of reusing the graphics later by designing at a higher dpi. Prior to inserting the images into your Web pages, decrease the dpi or image size to 72 dpi for Web distribution. A good file management technique is to maintain both high- and low-resolution versions of your graphics.

Throughout the previous section concerning image resolution, you have probably noticed that we suggested using 72 dpi for your Web images. There are also 96 dpi monitors. Yet, creating images at 96 dpi versus 72 dpi does very little for increased image quality. About the only thing that the higher resolution does is add approximately 25% to 50% more bits to your file. Stick with 72 dpi because the added file weight is not worth the small improvement in visual quality.

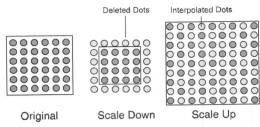

Figure 17.9 A 72-dpi, 2" x 2" image printed at true size and scaled size.

Image Size

A second bitmap characteristic directly related to dpi is image size. There is a fixed relationship between the image size and the image dpi once an image is created. As in the previous section, the resolution dependency of raster images forces you to plan your raster image sizes prior to creating any bitmap graphic.

Image size is the physical height and width dimensions for any given raster image. In Figure 17.9, you see a representation of a 2 inch by 2 inch, 72-dpi image. The first figure is displayed at true size and looks clear. Let us say you decided to print or display the image at that scale. Everything should be okay because you have more data in the original image than is needed in the reduced image. But let us say that someone wants to print or display it larger than 2 inches by 2 inches, say at about 4 inches by 4 inches. Could you simply scale the image up?

Unfortunately, scaling a bitmap image up, again, will almost always cause the image to break up as shown in right side of Figure 17.9. Anytime you scale an image up, you can only scale it up until the dpi equals the resolution of the output device. In the example, the image could be scaled up until its dpi equaled 72. As soon as the dpi begins to drop lower than 72 (or the resolution of the target output device) as a result of scaling, the image will begin to break apart and the pixels in the image become visually noticeable or the image becomes blurry (interpolation).

01010110
01000010
00101001

Digital Data Analog Data

Figure 17.10 Digital data is composed of a series of 0s and 1s, while analog data is composed of frequency variations (waves).

Why does it do this? Because the image is resolution dependent. In other words, there is a fixed relationship between the dpi and image size. Remember that dpi is related to the physical size of the image. As the physical size of the image changes, so does its area. As the area changes, the dpi must also change. As the area becomes wider or taller, the dots spread out and more data is needed. As the image becomes thinner and shorter, the area is lessened so fewer dots are needed.

The right hand image in Figure 17.9 shows that scaling or stretching the image causes the dots to separate and the resulting image becomes blurry. The reason it becomes blurry is because image editor must add dots to the image to maintain the dpi to size relationship (the ratio of 1 to 1). It adds dots by interpolating a dot (or more than one if need be) between two existing dots. Interpolation is the process of creating data based on the surrounding data. This is why edges and other features become blurry. Stretching or scaling a bitmap image to a larger size causes the fixed dots to separate, requiring interpolation, and the image becomes blurry.

Alternatively, shrinking or scaling the image down causes the dots to become more condensed, requiring some dots to be deleted or merged into surrounding dots. Often the image will become more sharp and clear as a result. However, when this happens, data is being deleted from the image.

Note: A final comment related to bitmap image size is a statement of the obvious. As either dpi or image size increases, so does the size of the file due to an increase in the amount of data or dots. As size or dpi decrease so does the file size. Most of the time you will want to create your bitmap images at true size—the size that they will appear in your Web pages. You may also want to create them larger than needed (for those multipurpose print purposes) and create reduced versions for inclusion on your Web pages.

Image Bit Depth

The final characteristic of bitmap images is an issue totally unrelated in vector graphics. This is the issue of bit depth. For most people, bit depth is a confusing topic, akin to the dpi and image size relationship. With the following discussion, hopefully, all misconceptions will be removed.

Bit depth relates to much more than just graphics, although that is what you are reading about right now. Bit depth is also an issue in digital audio and digital animation and video as you will see in chapter 21, "Training the Page to Speak," and chapter 22, "Animating Your Web." Bit depth defines the amount of data that can be used to describe a sample, whether it is graphic, sound, animation, or video.

Before beginning a discussion of bit depth and its relevance to raster graphics, let us look at the underlying reason bit depth is an issue at all when you are dealing with digital data.

Everything the computer deals with must be digital data. The only thing that the computer can understand is binary data, composed of 0s and 1s. However, everything that your natural senses can interpret, such as sound, video, and graphics, is presented to you as analog data composed of waves (Figure 17.10). What is the difference between these types of data?

Digital data is data that is represented mathematically as a series of 0s and 1s, or "OFF" and "ON" states. Analog data is data that is defined by a series of variations of frequencies. For example, the colors we see in graphics are perceived by the rods in our eyes. The colors actually emit waves that are specific frequencies that we can

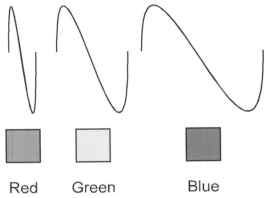

Red Green Blue

Figure 17.11 Colors that you see are composed of waves (analog data).

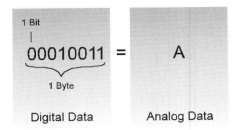

Figure 17.12 Binary data, such as an alphanumeric character, is composed of a series of 0s and 1s.

perceive as shown in Figure 17.11. This is one example of a frequency variation—analog data. Our senses interpret analog data, such as sound or visual imagery.

Binary data, on the other hand, does not mean much to us because our physical senses cannot directly intrepret the numbers. A long string of 0s and 1s makes little sense to us, but to the computer it means something. For example, a single alphanumeric character is represented with a series of 8 bits called a byte. The series of eight 0s and 1s means little to us; however, to the computer, it represents the letter A, as shown in Figure 17.12.

For you to be able to effectively work with computers, one of the two parties, either computer or human, must be able to "speak the other's language," so to speak. All of the various input and output devices you use on a daily basis are designed for this purpose—to allow communication between the computer (digital) and you (analog).

The computer's work then revolves around the conversion between analog data—that you can interpret—and digital data—that the computer can interpret. Computing is not just processing data, although this is a major part of it. Computing is also managing the digital-to-analog and analog-to-digital conversion processes that occur with everything that the computer operator wants to do. Special chips within the computer, called ADCs (analog-to-digital converters) and DACs (digital-to-analog con-

verters) handle the process of converting data between analog and digital and vice versa. The ADC is used in input devices, whereas the DAC is used in output devices. ADCs and DACs are not always actual chips, but sometimes they are a result of software. In any case, this is what makes computer use possible.

So what does this have to do with bit depth, you may ask? Anytime you want to represent analog data digitally, you must sample the analog data as a discrete number of data points. Sampling is the process of converting between the two data types.

For example, digitizing audio into the computer requires sampling the audio—converting it from an analog source, such as a tape recorder, to a digital file. The sampling process requires taking small chunks of that data, at specific intervals, and converting it to digitally represent the analog data (Figure 17.13). The smaller the frequency between chunks or samples, the more the digital audio is like its analog counterpart. The frequency or how often you take those samples is called the sampling rate. The higher the sampling rate, the more accurate the finished audio clip because you are more closely approximating the analog source.

Now to the issue of bit depth. Once you have a sample, you must digitally describe the sample. It does not matter whether it is graphic, audio, or video. Bit depth describes the quality of each sample.

Bit depth defines the number of data bits you can use to describe the sample. The more bits you can use to de-

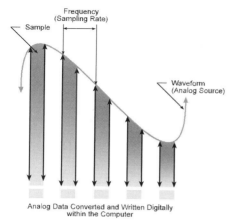

Figure 17.13 *The sampling process requires converting chunks or samples of data at specific intervals.*

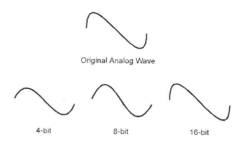

Figure 17.14 *Which waveform is most like the original analog source? The one with the highest bit depth (and sampling rate).*

scribe each sample, the more representative that sample is. In Figure 17.14, you see an audio sample from an analog source. Below are three representations of the analog sound using various bit depths. In the figure, which wave is more like the analog source? Answer: the one with the highest bit depth.

For any ADC sampling process, the higher the bit depth, the better the digital representation because you have more digital bits to describe the sample. This is true with not only graphics but also with audio and video. So the overall conversion of analog to digital data is dependent on (1) the sampling rate, how often you take a sample, and (2) the bit depth, how many bits you have to describe that sample. Sampling rate describes frequency of samples, bit depth describes descriptiveness of the samples.

Now that you understand what bit depth is, let us look at it in relationship to imaging. Most images that you will be working with will be either 24-bit or 8-bit images. These measurements describe the number of bits that you can use to represent the image. In a 24-bit (true color) image, each pixel in the image can be any one of 16.7 million colors; there are 16.7 million color possibilities for any pixel. In an 8-bit (indexed) image, each

color can be any one of 256 colors. Notice that a 24-bit image allows for a better representation of an image because it has more bits with which to describe the samples in the image.

Note: *A simplistic example from our childhood may serve to better explain bit depth. Imagine that you are given a set of sixteen crayons to create an image. A set of seventy-two crayons is given to someone else to draw the same image. Assume that sketching ability is exactly the same. Whose image will be more representative, the one with sixteen different colors or the one with seventy-two different colors? This is also how bit depth works.*

Note: *Why is 24-bit color referred to as "true color"? Humans, in general, are not able to distinguish anywhere near the 16.7 million colors this bit depth is capable of displaying. Indeed, the gamuts of most display mediums such as photographic film, ink on paper, or phosphors on a display monitor are smaller than 24 bits. 24 bits describes the true theoretical color space so it is referred to as "true color."*

The more bits you can use to describe the image, the more colors with which your image can be described. The more colors that can be in your image, the more representative or photo-realistic the image. Fewer bits, less descriptive, more bits, more descriptive. Note also, that if you decrease the bit depth of an image, you decrease the amount of data that can be retained about the image. Ultimately, decreasing the bit depth of an image decreases the image's quality (as well as file size).

File Size

The three primary attributes of raster images that you have looked at all contribute to graphic file memory size, not just how they look. On the Web, these are your two biggest concerns: quality and size. The smaller the graphic file size, the quicker it will download to your audience and the lower its quality. As image resolution, size, or bit depth increase, so does the file size. Shrink any one of these image characteristics, and the file size will also shrink.

The reason file size plays a role in Web development at all is due to the end-user connection. When you create graphics for Web pages, be aware of how your audience will be connecting to the Web. If most are connected via modems, be careful how many graphics you use. A good rule of thumb is that it will take approximately 14 seconds to download 50 K of data via a 28.8 modem. Double that figure for a 14.4 modem. If users have to wait too long, odds are that they will leave your site. Be careful about using large bitmap graphics in your pages. Most often these files require large amounts of time for modem users to download. Find the appropriate balance between graphic quality and file size.

Sizing Images (without HTML Code)

Probably one of the most misused features of HTML is the HEIGHT and WIDTH attribute of the tag. As you have seen in this chapter (see "Image Resolution"), using the HEIGHT and WIDTH attributes to scale an image will either waste bandwidth or result in the display of an image at a poor visual quality.

HEIGHT and WIDTH attributes should only be used to define the rectangular areas for the images (the same as their physical sizes), not to scale the images.

Another use of the HEIGHT and WIDTH attributes is to display blank rectangles for images as they are being downloaded. If you specify a HEIGHT and WIDTH as

a page is being downloaded, blank rectangles will display as the page is loading. Specifying a HEIGHT and WIDTH for an image so that blank rectangles appear during download may accomplish little more than having to write extra code.

Task: Sizing and Prepping Graphic Images for the Web

The area in which most people have difficulty with raster images is transferring graphics from a document designed for traditional print media to the Web. Often these graphic files are quite large in resolution, size, bit depth, and file size. The quality required for Web delivery is much less than for printed publications. Utilizing images originally created for print publication in most cases requires reducing the dpi (resolution), reducing the image's size, and changing the bit depth. In addition, most print publication graphics are stored in file formats that are not common to the Web. These may include CMYK Encapsulated PostScript (CMYK EPS) or CYMK Tagged Image File Format (CMYK TIF). As you know, utilizing these files on the Web is not standard.

To size, adjust, and utilize your print-focused files on the Web:

1 Begin by determining the image size that you need for your page. You can do this by either laying out your pages in a raster editor or by laying out your pages using grid paper.

2 Once you have determined your image size, open the existing image in a raster editor such as Photoshop.

3 Once you have opened the image, use the Image | Image Size menu option shown in Figure 17.15. As you can see in the figure, the size in pixels is quite large, as is the resolution. Change the height and width dimensions to the appropriate size that you need.

4 Once you have adjusted the size of the image, you can then adjust the bit depth. Note that you want to size the image before you adjust the bit depth. Sizing the image

before adjusting the bit depth will maintain a higher image quality. Whether you plan to use a high color image format (JPEG or PNG) or a low color image format (GIF or PNG) will determine which color mode you should use. As you will note in Photoshop 5.0, the color depth can be changed using the Image | Mode menu option. If you select 8-bit (256 color) you will find that Photoshop 5.0 has a new Web palette that is a browser-safe color palette, as shown in Figure 17.16.

5 Once you have changed the color mode, save the file in the appropriate Web file format and include it on your Web page, using the tag.

Figure 17.15 Using the Image | Image Size option adjust the height, width, and resolution of the image for use on the Web.

Saving Those High-Res Versions

Throughout the previous sections, you have seen that bitmap images are resolution dependent. Because raster graphics are resolution dependent:

• Bitmaps graphics have a fixed resolution (dpi) per given image size.

• Changing either resolution or image size changes the other.

• If you reduce the bit depth of an image, you decrease the amount of data that can be described, which in turn reduces the amount of data in the file. For example, if you have a 24-bit image and you convert it to 8-bit, you are decreasing the quality of the image. If you try to convert it back to a 24-bit image, in effect you will have 8-bit data in a 24-bit file.

TIP: *Make sure you keep high-quality versions of your images, those with color depths and high resolutions. It is frustrating to have to re-create a graphic because you did not keep a high-quality version of it.*

As you are working with bitmap graphics, be aware of the number of colors supported by various bit depths. Table 17.1 shows the various bit depths used in raster editing and the number of colors supported.

Figure 17.16 Use the Image | Mode menu option to adjust the bit depth of the image. Note that Photoshop 4.0 has a new browser-safe color palette for 8-bit images.

Image Bit Depth	Name	Number of Colors
1-bit	Bitmap Mapped	1 (black and white)
2-bit		4 colors
4-bit		16 colors
8-bit	Grayscale	256 grays
8-bit	IndexedColor Palletized Color	256 colors
15-bit	High Color	32,768 colors
16-bit	High Color	64,536 colors
24-bit	True Color RGB Color	16,777,216 colors

Table 17.1 Various bit depths and the color levels allowed within them.

Real World Examples: Laying Out Pages in a Raster Editor

No matter your design paradigm, one of the most frustrating functions is implementing a particular design in HTML. Once you have created a design in an image editor, such as shown in Figure 17.17, how do you break up the pieces and implement it on a Web page using HTML? More importantly, what parameters do you begin with (for the canvas) so that it is utilized on a page that is created for a specific resolution? As most have found, implementation is often more difficult than design, but this does not make either any less important.

When faced with implementing a design like Figure 17.17, often the quick solution is to place a huge image map on a page. However, assuming you are working within certain download constraints—such as modem users who would have to wait long to receive a large image map—this method of design implementation seldom works.

Using a single, large image map is a nontechnical solution to a technical problem and will likely push users away from your site rather than draw them to it. For example, even the page shown in Figure 17.18, which contains a relatively small image map, took approximately 30 seconds to download over a 28.8 modem.

Note: Often I have talked with designers who create an awesome, avant garde look for a page, only to find that it is nearly impossible to implement efficiently or effectively without modification. For example, at first glance the page shown in Figure 17.18 looks good, but is a little tricky to implement without a huge image map.

Using constructs of HTML, it is possible to create a look that cannot be effectively implemented on a Web page without significant wait times for end users. Yet there are situations where an image map can be used in part. If you use image maps, the idea is to make them as small as is possible, less than 30 K, thereby decreasing download time.

Figure 17.17 If you must use image maps in a page design, make them as small as possible (http://www.tech.purdue.edu/tg/faculty/mohler/irwin/tgc/).

Figure 17.18 Even small image maps can severely tax modems and their users if there are many other graphics on the page (http://www.ellemag.com/).

One of the predominant arguments concerning Web publishing surrounds the issue of appearance versus structure. Those on one side of the fence want to be able to design a page based on appearance. Similar to a page description language such as PostScript, many desire precise control over graphical elements. The other side wants technical structure to support universal interpretation and platform independence, mimicking HTML's big brother, SGML.

Nonetheless, with a little ingenuity and technical wherewithal, you can generate designs that fit the constructs of the language and still have visual appeal; delivering a page that has consistent design but is also reasonably deliverable.

Begin with the Appropriate Canvas

One of the first things that most people do when creating a design for a Web page is to casually open a blank canvas and begin drawing. Yet if you look closely at Figure 17.18 you will see that it is designed for a 640 x 480 screen size with no horizontal scrolling. You must think before you start laying out a design to be implemented in HTML for the sake of both time and money.

Before the first pixel hits the design canvas, an appropriate size for the canvas must be determined by looking at the target audience. It was determined that the target audience for this set of pages generally uses a resolution of 640 pixels by 480 pixels, so the dimensions around which this set of pages will be designed is 640 x 480. This does not mean that users cannot view the page at a larger size. It just means that 640 x 480 is the smallest size, or lowest common denominator, for viewing. In most cases, akin to multimedia CD-ROM development, it is the lowest resolution around which you design.

Also recognize that the browser cannot display page elements all the way to the edges of the screen (due to scroll bars, menus, etc.). After looking at the audience, you must then establish the real size of the displayable area in the browser—the screen size minus menu areas, scroll bars, and so on. A quick screen capture of a blank brows-

er reveals a real size of 637 pixels by 314 pixels. This is the real area into which the page will fit.

With Web pages, you cannot make body elements touch the horizontal edges of the screen (only the tiling backgrounds can do that). Therefore, to design this page in HTML, you need to allow a little cushion so your elements do not slam up against the sides of the browser area. For this design, use an effective working area of 600 by 314 pixels. It is assumed your page will extend beyond the vertical and that is okay. Horizontal scrolling is what most people dislike. Shrinking the horizontal measurement creates a cushion of space between the edges of the real area and the elements that appear within it. If you take a look at a Web page with horizontal rules or with full column text, you will see the natural horizontal cushion.

Note: *If you tried to place elements all the way to the edges of the real area, you would likely end up with trouble trying to get things to look the way you want. The "buffer zone" gives you some working room to lay elements on the page, not to mention making it look more pleasing.*

Note: *The main purpose for establishing the real size and the working size at the beginning is so that users will not have to do horizontal scrolling when you Webicize your designs. There may be times when you will be concerned with the vertical as well. Nonetheless, it is a bother to find out that the Web page you have just designed, the one that took hours to generate, requires horizontal scrolling when implemented. Prior to drawing anything, you must start on the right size canvas, which is based on the target audience's resolution.*

Once the canvas size is appropriately set, the design for the page can then be generated. A design should be created with the "constraints" listed earlier in this book in chapter 3, "Designing for Effective Content and Efficient Delivery."

In addition to the proper image size, the graphic was also started with a resolution of 300 dpi and a bit depth of 24-bit. The 300-dpi resolution makes it possible to go back and use the graphic for other purposes, such as for

publication in which the high dpi would be needed. In addition, the high bit depth was used so that as the design was created a maximum number of colors would be available for blends and colors used in the image.

Note: *Aside from beginning on a canvas with the appropriate parameters, there is a trick to being able to effectively integrate the design shown in Figure 17.18. This real world example will continue in chapter 19, "Understanding Formats and Conversion Issues."*

Summary

Throughout this chapter you have seen that the fundamental issues involved with raster graphics are image resolution, image size, image bit depth, and file size. Ultimately, these issues revolve around the base unit of the raster graphic: the pixel. As you work more and more with raster graphics you will find that the understanding of these issues will inevitably help you when you are creating raster images from scratch, as well as when you are repurposing graphic images.

Next Steps

Now that you have taken a look at utilizing bitmap graphics in your Web pages:

- Check out chapter 16, "Utilizing Vector Graphics," for more information on vector graphics usage.

- Read chapter 18, "Managing Color Differences," for more information on color palettes and related bit depth issues.

- Look into chapter 19, "Understanding Formats and Conversion Issues," for more information on file formats and conversion issues.

- Examine chapter 20, "Using Layered Web Pages and Other Effects," for more information on new and special features resulting from the latest browsers.

QUESTIONS

Q *I have a Macintosh PICT file that I would like to use on the Web. What is the best way to utilize these files on the Web?*

A One of the things that you should note about the PICT format is that it is called a metafile format. This means that the file can contain both vector and raster information within it. In addition, the PICT format is not readily understandable by most PC-based raster editors (except Photoshop). If you have a PICT file, you should be able to open it into Adobe Photoshop and save it as a GIF, JPEG, or PNG file. Note that a similar format ex-

ists on the Windows platform and is called a Windows Metafile Format (WMF). It too can contain vector and raster data and is not readily readable on the Macintosh platform.

Q *In the chapter you mentioned the PNG file format. I have never heard of it. What is so special about the PNG format?*

A The Portable Network Graphics format, PNG for short, is a new graphics format being introduced on the Web. In short, it supports all of the features found in the GIF and JPEG formats as well as lossless compression and some other additional features. The PNG format was created to overcome the copyright infringement issues associated with the GIF format. For more information on the PNG format, check out chapter 18, "Understanding Formats and Conversion Issues."

Q *I have a file in Photoshop and want to save it as a GIF file but GIF is not an option when I go to save the file. What is the problem?*

A One of the things that you will find in Photoshop is that whenever an image that is currently in memory contains information that cannot be supported by a particular file format, Photoshop will not show the file format

Format	Features
GIF	8-bit image data
	1 channel (transparency via GIF 89a)
JPG	24-bit image data
	lossy compression (variable quality)
	channels
PCX	24-bit image data
	RLE compression (automatic)
BMP(DIB)	32-bit image data
	RLE lossless compression (optional)
TIF	32-bit image data
	LZW or Packbits lossless compression (optional)
	channels
	layers
PSD	32-bit image data
	channels
	layers
	paths

Table 17.2 Major file formats and supported data types.

in the Save As dialog box. In the case of the GIF problem, more than likely you have an image that is either in 24-bit mode or contains layers and channels. Keep in mind that certain file formats only support certain image characteristics. Table 17.2 shows the features supported by the major file formats.

Managing Color Differences

With the variety of computers, operating systems, and hardware configurations that can be connected to the Web, not to mention the plethora of Web browsers available, variability can be expected. One important variable is the way color is displayed in the browser as well as how color is defined at low color display resolutions.

As you continue to design pages for the Web, you will inevitably find graphics that will shift in color from browser to browser and from platform to platform. Some of this variability cannot be avoided. Yet in many cases, with some insight into the workings of color, you can create consistent color across platforms, browsers, and operating systems. This chapter will give insight into the workings of color systems and color palettes and how they can impact the way your pages display. You will also see how to design pages that will give the best results even in the worst of color situations.

OBJECTIVES

In this chapter, you will:

• Develop a deeper understanding of bit depth as it relates to images, and how color depth is controlled by the associated bit depth.

• Look at high and low bit depth formats and how it relates to what is seen on the computer monitor.

• Understand how color palettes relate to images delivered over the Web.

• Examine system, browser-safe and super color palettes, as well as adaptive and custom palettes, and how they can be used within your raster images.

Take a Closer Look at Bit Depth

Anyone working on the Web will wonder why specific bit depths allow a specific number of colors. It may be easiest to just remember that 8-bit is 256 colors, 16-bit is 64 K colors, and 24-bit is 16.7 million colors. Better than this is to understand why each of these bit depths allows a specific number of colors.

In the previous chapter, you developed an understanding that everything the computer does is based on binary logic. In essence, you could say that the computer only understands electrical on and off states that represent binary 1s and 0s. This relates to the fact that a circuit or piece of hardware can only understand electrical on and off states.

As you may know, an electrical value of either on (denoted as a 1) or off (denoted as a 0) is called a bit. Yet, we humans do not use binary arithmetic and it makes very little sense to us when we try to read a long series of 0s and 1s. Note that humans use the decimal system, which is based on units of 10. More than likely this is because we have ten fingers. Therefore, you could say that the computer has to count using only one finger. It is either on or off.

Nevertheless, computers use a series of 1s and 0s (bits) to represent information. Typically, the computer groups 8 bits to represent something, which is called a byte. Bytes can be used to represent letters, numbers, or values. In bitmap images, a combination of bits and bytes are used to represent the colors for each pixel in an image. Note that the more bits, the more colors can be represented. Let us begin by using the bits to represent numbers so that you can understand how they work.

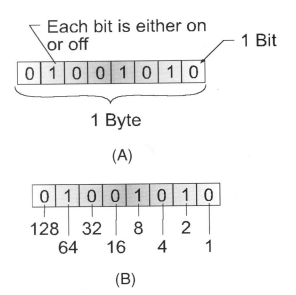

Figure 18.1 Using representing decimal numbers with binary on and off states.

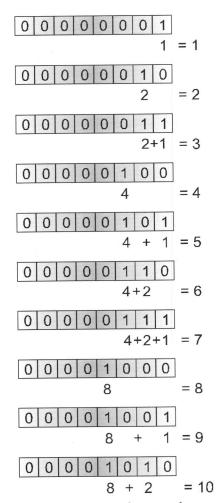

Figure 18.2 Counting using binary numbers.

In Figure 18.1A, you see a byte, which is 8 consecutive bits. Each bit can be either on or off (0 or 1). In Figure 18.1B, you can see that each bit corresponds to a decimal number. The first bit represents 1, the second represents 2, and so on. Any number from 0 to 255 can be represented using 8 bits (or eight consecutive on and off electrical states).

Notice in Figure 18.1B, the binary number can be translated to decimal. You could easily represent any number from 0 to 255 by turning bits on and off. Try it. Which bit would be turned on to represent the decimal 1? How about 2? What about 3? Figure 18.2 shows how you would count to ten using binary numbers in a single byte. Note that you could represent 256 numbers, or more interestingly, colors, with 8 bits. Do not forget with binary, all bits off, or zero, equals a number too. This gives 0–255 possibilities, or 256 possible representations.

Given this knowledge, how would you represent a higher number (color), such as 23,456? You would need more bits. Figure 18.3 shows what happens to the amount of numbers (colors) that can be represented when you add more bits. Note that to get the total number of colors that can be represented, you add all the corresponding decimal numbers shown beneath. For example, adding the entire angled decimal numbers for

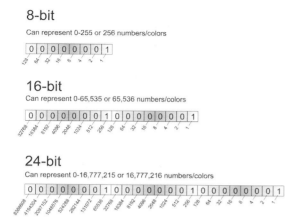

Figure 18.3 Adding more bits allows you to specify more numbers (colors).

Color Depth	Calculate	Number of Colors
1-bit	2^1	2
2-bit	2^2	4
3-bit	2^3	8
4-bit	2^4	16
5-bit	2^5	32
6-bit	2^6	64
7-bit	2^7	128
8-bit	2^8	256
15-bit	2^{15}	32,768
16-bit	2^{16}	65,536
24-bit	2^{24}	16,777,216

Table 18.1 Mathematically calculating the number of colors per bit depth.

16-bit, you get a decimal number of 65535. You must also add all off bits (zero for every bit), which gives you a total possible decimal number of 65,536. This is why 8-bit gives you 256 colors, 16-bit gives you 65,535 colors, and 24-bit gives you 16,777,216 colors.

Realizing that it is somewhat absurd to draw the little chart shown in Figure 18.3 every time you want to calculate colors per bit depth, you can calculate it mathematically. Since each pixel has an on and off state, you can simply raise the number 2 (2 possibilities for each pixel) to the appropriate power (which represents the bit depth) as shown in Table 18.1. For example, the colors for a bit depth of 2 is equal to 2^2, which yields 4 colors. The number of colors for a bit depth of 16 is equal to 2^{16}, or 65,535 and the number of colors for a bit depth of 24 is equal to 2^{24}, or 16,777,216.

Understand High and Low Bit Depth Formats

As you are browsing the Web, the two predominant image files that you will find in use are the GIF and the JPG graphics formats. The use of these files will probably decrease over the next couple of years due to the new Portable Network Graphics (PNG) format (see "Using Portable Network Graphics (PNG)" in chapter 19). However, GIF and JPG are the most prominent file formats used on the Web today.

These two formats, GIF and JPG, will clue you into the bit depth of a particular graphic. Each of these formats supports a different amount of descriptiveness for pixel data (different possible bit depths) and, therefore, can display different qualities of images due to the number of colors that are supported.

Without a doubt, the most widely used raster graphics file format on the Web is the Graphics Interchange Format or GIF for short (pronounced "jif"). It is no wonder that this format has become a Web standard as it was developed by CompuServe to deliver graphics over their online service. The GIF file format is a computer graphic file format that allows up to 8 bits of image. This means that it can only support up to 256 colors. However, it can also support something called transparency via the 89a version. Transparency was not available in GIF87a. Note that the different numbers denote the years in which the various versions were created. All browsers directly support both the GIF 87a and 89a formats, meaning that the browser can display them

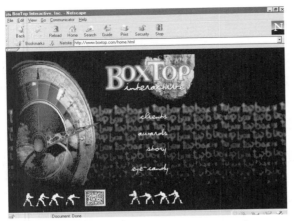

*Figure 18.4 A Web page that utilizes the GIF file format
(http://www.boxtop.com/index.html).*

*Figure 18.5 A Web page that utilizes the JPG file format
(http://www.softimage.com/).*

directly as inline images. Figure 18.4 shows an example of a Web page that utilizes GIF graphics. Because GIF files are limited to 256 colors, photographs will generally appear more grainey than JPG files.

The second most widely used format on the Web is the Joint Photographic Experts Group or JPG (pronounced "j-peg" and shortened to JPG) format. This format is much more robust than the GIF format, allowing 24-bit quality by using compression (see "Compression" in chapter 19, "Understanding Formats and Conversion Issues"). Only the JPG format allows you to create true color images that can be integrated as inline images in your pages, as shown in Figure 18.5.

Note: One of the things you need to accept is that your graphics can appear different when viewed by computers with different video adapters. Almost all computers will have adapters capable of displaying 8-bit (256 color) images at 640 x 480. But if a visitor chooses to set their monitor to more pixels, the number of colors is sacrificed. For example, a video adapter may be capable of 24-bit color at 640 x 480 but only 256 colors at 1024 x 768.

To achieve the highest quality output of your graphics on a computer monitor, the dpi must match that of the monitor, which is not a big deal since most monitors are

72 dpi. Nevertheless, the bit depth must also match that of the current video mode to achieve the highest quality output. If the bit depth of the image is greater than the bit depth of the monitor, the image will look poor as shown in Figures 18.6 and 18.7. Notice the 24-bit image displayed in the browser set at 24-bit (Figure 18.6) compared to the 24-bit image displayed in the 8-bit monitor (Figure 18.7). In the second case, the computer is having to interpolate for color information because the monitor cannot display all the colors in the image. Therefore, the browser must replicate the 24-bit nature of the image with only 256 colors. You will find that browsers do a poor job of interpolating color when compared to raster editors.

The color depth of all computer monitors is controlled using operating system settings and they usually are either 8- or 24-bit. Note that it is really a function of the video card but most people refer to it as the monitor setting. Probably 35% to 50% of the Web surfers use 8-bit monitor settings. For example, on Windows 95, the display's color depth is controlled through the Control Panels | Monitors | Settings tab. On the Macintosh, the display's color depth is controlled through the Monitor's Control Panel. Figure 18.8 shows both the control panel for Windows 95 (A) and the Macintosh OS (B).

Figure 18.6 The bit depth of your images must match the bit depth of the intended output device to get the maximum output: 24-bit image on a 24-bit display (http://www.teamoneill.com/).

Figure 18.7 The bit depth of your images must match the bit depth of the intended output device to get the maximum output: 24-bit image on an 8-bit display (http://www.teamoneill.com/). Note how the browser must dither the image.

Often when you display true color images on devices of lower bit depth you will get one of two results: banding of colors or color shifting. Sometimes you will get both. Banding is the result of too few colors for interpolation and it shows up as noticeable "bands" or "stripes" that appear in the image, as shown in Figure 18.9. Often bands occur in large gradations of color, such as an area that is blended from white to black or light blue to dark blue.

The second of these color problems, color shifting, happens when the interpolated colors look nothing like the original colors. When interpolation occurs, the browser does its best to approximate the colors of the image using the colors that it has at its disposal. In the next section,

(A)

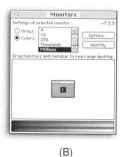

(B)

Figure 18.8 Monitor settings in Windows 95 (A) and the Macintosh (B).

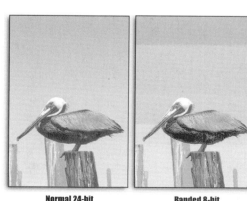

Normal 24-bit Banded 8-bit

Figure 18.9 Banding is a result of too few colors to represent high color images, which is exhibited as noticeable stripes or bands of color.

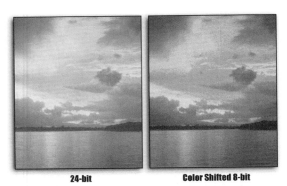

24-bit Color Shifted 8-bit

Figure 18.10 Color shifting, too, results from too few colors in the display bit depth, which is exhibited as severely discolored, or in this case darkened, pixels.

Figure 18.11 Each color in the image uses one of the colors from the palette, which is also called the Color Lookup Table (CLUT).

you will see where it gets these colors. However, when the colors in a 24-bit are so unique and so different from the colors available to the browser, often discoloration will occur in the image. The image will often have severely discolored pixels, as shown in Figure 18.10. But still, the browser is doing the best it can.

Note: Banding and shifting are a result of a lack of color. This is similar to traditional color print problems where colors in a particular image cannot be printed. Note that not all devices can display the same range, or gamut, of colors. It is possible to display colors that cannot be printed, just as it is possible to print colors that cannot be displayed. In both cases, the device does not have enough colors in its gamut for output. Therefore, it does its best to interpolate the colors, which often leads to less than desirable results.

Now you may be asking, "So how do I avoid this little problem?" Let us define the circumstances under which it occurs first.

The only time that bit depth problems occur is when the audience's machine is browsing the Web at a lower bit depth than what you designed the pages. Similarly, problems with printed images occur when you try to print colors that cannot be printed on the device.

If you design your pages and assume the audience is browsing at 24-bit, you will not notice any problems at all. In fact, if you browse the Web with your computer set

at 24-bit color, or even at 16-bit color, you probably will never run into this problem. However, many people do not have a video card that will support higher than 256 colors. If these individuals browse your pages that are designed for 24-bit, they will likely have a low opinion of the graphics due to interpolation and color problems.

Alternatively, if you design your pages focused at the 256-color audience, most individuals browsing your pages will perceive no ill effects. Why? When a 256-color image is displayed on a 24-bit monitor, there are more than ample colors to represent the image. You may notice some graininess because there are only 256 colors representing the image, but the images will not have any significant banding or shifting problems.

TIP: *When you are developing raster graphics for the Web, your biggest concern is the lowest common denominator. You must design around the lowest link in the chain that can be found among the majority of your audience.*

Before we leave the subject of bit depth, let us look at why 256 color (8-bit) images and devices cause problems. Note that with only 256 colors to work with, you must conscientiously choose those 256. As you will find, you can actually reassign only 216 because the other 40 are devoted to colors used within the rest of the operating system elements.

Figure 18.12 The palettes of two images that have varying colors.

Figure 18.13 All applications executed in the 8-bit environment get their colors from the System palette, which is specific to the operating system.

Realize the Color Palette Issue

As you saw in the previous section, the most troublesome part of designing effective pages is making sure you do not exclude the target audience by designing graphics that will display poorly for them. In this section, you will read more about palletized images, or those that are 256 color images.

Every 8-bit image is limited to 256 colors simply because the number of allotted bits to describe the image is only enough to allow each pixel one of 256 possibilities. Therefore, every 8-bit image has a range or palette of 256 colors from which every pixel in the image can be assigned color (Figure 18.11). This is also called the Color Lookup Table or CLUT. Figure 18.12 shows two images and their palettes. Both palettes have 256 colors, some the same, but most totally different.

The problem with palletized images as well as a palletized operating system (an 8-bit display system), is that not every image uses the same palette. The particular palette used for one image may not be used for another image because the colors in each image vary. For example, an image with many blue hues will have a palette with many blue hues. Yet, an image with many brown hues will have a palette with many brown hues. Figure 18.12

shows an image with predominantly brown hues, and an image with predominantly blue hues, and their respective palettes. Note how the palettes differ in the colors that are in them. However, as you might imagine, there are some colors that are the same across the images' color palettes.

The colors that are the same in the two palettes are special colors that are used for the operating system. In fact, an operating system that is set to 8-bit has a palette called the system palette, as shown in Figure 18.13. The system palette is where all the various applications get their colors when the machine is running in 8-bit mode. In Windows operating environments, there are 40 colors that remain stable from palette to palette. However, the remaining 216 colors can be anything. It depends on the palette. You must also be aware that these colors in a palette vary from machine to machine and platform to platform.

Note: *An 8-bit operating system uses a specific color palette and each 8-bit image also uses an 8-bit color palette. When the two palettes do not match, there are visible problems on screen. This is referred to as a "color flash" when an image is displayed using the wrong palette.*

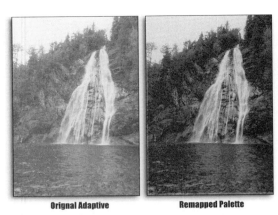

Orignal Adaptive Remapped Palette

Figure 18.14 Remapping palettes may cause discoloration due to a lack of similar colors between the old palette and the new palette.

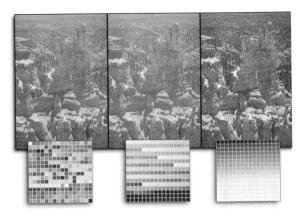

Figure 18.15 The differences exhibited between the original and remapped image are proportional to differences between the palettes that the image is based on.

In addition, you must realize several other important aspects about palletized color images. First, the palettes used for a particular image can be changed or remapped. For example, you can specify that a particular image stop using its own palette and start using the operating system's palette (or any other palette). Figure 18.14 contains an image where the palette has been remapped. Notice in the image with the new palette color shifting or discoloration is occurring.

Note: Much like dpi, once you change palettes you cannot go back to the image's original palette unless you have previously saved that palette. Remapping colors destroys the image's original palette. Even if you reverted to a saved palette, the colors would not reassign themselves perfectly. The resulting image would be of lower quality than the original.

When remapping palettes, the colors in the image must conform to the new palette and sometimes they will look extremely discolored, particularly if you change an image from one 8-bit palette to another. This happens because the new palette does not have the colors that the old palette did. Therefore, the imaging application must do its best to try to match colors from the old palette to the new palette and often it does not work well. Figure 18.15 shows another example of an image mapped to its

original and new palettes. Note the differences exhibited between the original and remapped image are proportional to differences between the palettes on which the image is based.

Seldom will you have to change an indexed color image from one palette to another; however, this example shows how palettes affect the image. In application, you will most often be reducing the bit depth from 24-bit to 8-bit for distribution. When you do this, you often have the option to specify what kind of palette to create for the image.

For example, in Adobe Photoshop there are several options when switching from 24- to 8-bit. Figure 18.16 displays palettes that were specified for each of the images and how it affects the resulting image.

The first image in Figure 18.16 shows the original 24-bit image. In the 24-bit image, there are so many colors (approximately 16.7 million) that no palette is needed; therefore, no palette is shown. The second image was assigned to an Adaptive Palette. In this case, during the reduction in bit depth, the software created a palette custom for the image. The custom palette contains only colors in the image. In the next instance, the image was

mapped to the system palette, which is defined in the operating system. Here, the image was remapped to the System Palette rather than adapting the palette to the image (as in adaptive). The last image assigns an arbitrary palette to the image using the Custom option. Notice in the later two images that the palette does not have enough colors to represent the image as descriptively. Therefore, the later images look less appealing because the palettes contain too few colors to support the given image.

One final note about bit depth reduction is that any time you reduce the bit depth you will have to choose a palette of colors for the image. One of the actions that will make your images look sharper during reduction is to use something called dithering. There are many types of dithering that can be used, but it will mostly depend on the imaging application you are using. Some give you a choice, while others do not. Figure 18.17 shows the dithering options in Photoshop 5.0. Notice the results in the image due to the dithering option selected as shown in Figure 18.18.

Task: Reduce the Colors in an Image

Reducing the colors of images in most raster applications is quite easy. The main thing that varies is how much control you have over the palette that is assigned to the image and how dithering is controlled (given that the application can dither during color reduction). In this task, I will be using Photoshop 5.0.

To reduce the colors in an image to 8-bit for use on the Web:

1 Begin by determining what palette you should use. More than likely you be using a browser-safe color palette. Yet, if you are designing a hybrid application, one that is a combination CD and Web product, you may be using some other palette. Here, let us assume a hybrid application and use the system palette.

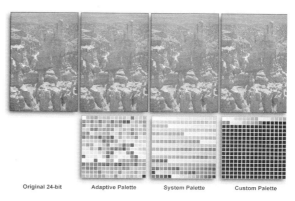

Original 24-bit Adaptive Palette System Palette Custom Palette

Figure 18.16 Using various color palettes during bit depth reduction.

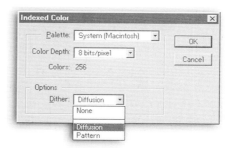

Figure 18.17 The dithering options available in Photoshop 5.0.

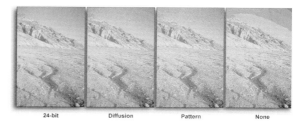

24-bit Diffusion Pattern None

Figure 18.18 The results of the various dithering options.

Figure 18.19 Select the Image | Mode | Indexed Color menu option.

Figure 18.20 Setting the parameters for the Indexed Color dialog box.

2 Open the image you wish to reduce. Keep in mind that after you reduce the colors, you must save it as a different name to make sure you retain the high color version.

3 Select the Image | Mode | Indexed Color menu option shown in Figure 18.19.

4 In the Indexed Color dialog box, set the Palette dropdown menu to Windows (System), the Color Depth to 8 bits/pixel, and the Dither to Diffusion as shown in Figure 18.20.

5 Select OK, which will cause the program to do the color conversion. Note that the quality of your image will reflect how closely the colors that are in the image can be adapted to the Windows System color palette.

Palettes, Palettes, and More Palettes

Be aware that in the 8-bit environment, whenever a PC displays an image, it attempts to use its own system palette to do so. With the Macintosh, it too tries to display the image with its own palette. However, what about the browser? Well, it also tries to utilize its own palette when displaying images in the 8-bit environment. Unfortunately, the browser has an independent color palette that is different from the operating system on which it is running.

Nevertheless, you may say, several different browsers may be trying to access my pages. How do I create a palette that works nicely for all of them? Although it has not officially been documented anywhere, there are sources that provide browser-safe palettes that you can use to define your colors. Most of the newer applications have browser-safe CLUTs that can be selected during color reduction. By using browser-safe color palettes, you can keep the browser from picking awkward colors with which to render your graphics. By specifically selecting colors from these types of palettes, you can ensure a more successful inline graphic.

So what graphics does this browser-safe palette improve? Photo-realistic graphics will not be helped much by the use of browser-safe palettes. Due to the complex blends and other features of photo-realistic raster graphics, there will always be some graininess as well as some banding or color shifting. Browser-safe palettes are most helpful for graphics that have smooth blends or flat fills. In general, you should strive to use a browser-safe color palette for whatever application you are using. Most often browser-safe color palettes help bitmap graphics that have been generated from vector graphics, as shown in Figure 18.21.

Figure 18.21 Browser-safe CLUTs have the greatest effect on flat colors and smooth simple blends.

Figure 18.22 Setting the parameters for the Indexed Color dialog box to use the browser-safe CLUT.

Note: If one of your design constraints is an 8-bit environment, you will certainly want to be aware of the browser-safe color palette and how it can help make the graphics on your pages look better. The CD that comes with this book has browser-safe color palettes for various applications. If you do not find one you need, try doing a Web search for a palette for your particular application. More than likely you will be able to find one.

Task: Use a Browser-Safe CLUT

Because of the Web option under Adobe Photoshop 5.0's Index Color dialog box, this task showing how to reduce colors is straightforward. To reduce the colors in an image to an 8-bit browser-safe CLUT:

1 Begin by opening the image you wish to reduce. Keep in mind that after you reduce the colors, you must save it as a different name to make sure you retain the high color version.

2 Select the Image | Mode | Indexed Color menu option.

3 In the Indexed Color dialog box, set the Palette drop-down menu to Web, the Color Depth to 8 bits/pixel, and the Dither to Diffusion as shown in Figure 18.22.

4 Select OK, which will cause the program to do the color conversion. Note that the quality of your image

will reflect how closely the colors that are in the image can be adapted to the browser-safe color palette.

A Super-what?

A common term that is a carryover from CD-ROM multimedia development is something called a super palette. A super palette is a color palette that is optimized for a range of images found within a particular multimedia application. Note that super palettes are often used when a variety of images must be integrated into a multimedia piece. In cases where a super palette is used, the normal Windows and Macintosh system palettes, and even the browser-safe color palette, yield undesirable results. This normally leads the developer to create this super palette: a palette optimized for an entire product rather than a device.

Note: Although this book is specifically about the design of interactive Web sites, you will note that hybrid applications are becoming more common. We are beginning to see the evolution of CD-ROM multimedia onto the Web. Hybrid applications give the advantages of both media in one package. Information that is stable or nontransient resides on a CD, while information that changes is delivered via the Web, all in one product. Because of the growing popularity of hybrid applications, it is important that you be aware that super palettes are commonplace in CD-ROM development and are important in hybrid applications.

*Figure 18.23 Selecting the Image | Mode |
Color Table menu option.*

*Figure 18.24. Sticking with colors found in the palette helps
(http://www.honda.com/).*

Task: Create a Super Palette

Creating a super palette is not necessarily fun but often it is a necessity. To create a super palette in Photoshop 5.0:

1 Open a large canvas in 24-bit mode (large enough to contain all or at least the most of the graphics with extreme color differences).

2 Begin copying and pasting your images to be displayed in the application into the new canvas.

3 Once you have pasted all (or most) of your images into the canvas, change the mode of the image to 8-bit using the Adaptive color palette selection.

4 Next, select the Image | Mode | Color Table menu (Figure 18.23).

5 In the Color Table dialog box, select the Save button and save the color table file. Note that the file will be saved with the .ACT extension (Adobe Color Table).

6 Now each time you reduce the colors to 8-bit in the individual images that make up your hybrid application, when you are prompted with the Indexed Color dialog box, select the Custom Option. Doing so will present you with the option to load a custom palette. You will use the palette file you just created.

Note: There are applications, such as Debablizer that will automatically calculate a palette based on a range of separate images. This will save you from having to manually create a super palette.

Real World Examples

One of the things that new developers often say is, "How can I create awesome designs with only 216 colors?" In this real world examples section, let us really show what can be done with 216 colors. Figures 18.24, 18.25, and 18.26 were all created using 216 colors from a browser-safe color palette.

Summary

In this chapter, you have taken a deeper look into the issues that surround color depth, palettes, and images. You find that as you work more and more with raster images and multimedia and hypermedia development projects, you will become more familiar with these issues.

Next Steps

Now that you have taken a look at the issues surrounding color, bit depth, and imaging:

• Read chapter 5, "Looking at the Curse of the Web Browser," for more browser-specific information.

Figure 18.25 Although it is quite small (in image size),
this site is impressive and it loads quickly
(http://www.nationalgeographic.com/main.html).

• Examine chapter 16, "Utilizing Vector Graphics," for information concerning vector graphics usage.

• Check out chapter 19, "Understanding Formats and Conversion Issues," for more information on file formats and conversion issues.

QUESTIONS

Q *Can I create my own palettes from scratch and use them in my Web pages?*

A In most raster editors, you can create your own palette from scratch by defining each of the colors that occur within it. However, you must note that using a custom palette may cause problems mentioned in the chapter in browsers that are running in 8-bit mode. If your audience is viewing in 24-bit mode, then it is no problem at all.

Q *I want to generate a bitmap graphic from an animation package and have it render using the browser-safe CLUT. How can I transfer the palette to the application? By the way, it is a DOS application.*

Figure 18.26 Cool site for a limited set of colors
(http://www.subpages.com/)

A For most people this is a problem, yet it is actually quite easy to fix. Realize that the palette itself is attached to the 256-color image. For example, let us say I want to transfer a color palette to a 3D Studio version 4.0—a DOS application. If I simply create a bitmap image, which is conformed to the browser-safe CLUT, and assign the bitmap as the palette in the renderer of 3D Studio, any resulting animation generated will use the 256-color palette of the image.

Understanding Formats and Conversion Issues

A couple of years ago, surfing the Web would have revealed a myriad of file formats. If you were part of the "in-crowd" who found this funny little piece of software called Mosaic and installed it, you would have found many, many file formats that could not be viewed (without the aid of a helper application). Today's Web is a little more "civilized." The predominance of graphics files on the Web are GIF and JPG, with PNG and Adobe's PDF quickly catching on. Yet, you still may find a straggling TIF, BMP, PICT, or EPS.

At this point you may be asking yourself, "What are all these file format acronyms?" In addition, you may wonder what the differences among them are. If so, this chapter is for you!

OBJECTIVES

In this chapter, you will:

- Examine the GIF and JPG formats to see how they are different and how they are used.

- Develop an understanding of progressive images and interlacing.

- Look at the new Portable Network Graphics (PNG) format and how it can be used in Web delivery.

- Read about other file formats that can be used for graphics and that you may run across on the Web.

- Develop an understanding of the two main types of compression: lossy and lossless.

Using GIF and JPG Formats

As most people are aware, the Graphics Interchange File format (GIF) and the Joint Photographic Experts Group (JPEG or JPG) format are among the most commonly used graphics formats found on the Web. As you saw in the last chapter, "Managing Color Differences," the biggest difference between these two files is the amount of color data that they can contain. In addition, the two formats provide some other unique features.

Note: Although the Web is designed to be open to all graphics formats, formats that can be delivered and received depend on the client as well as the server. Nonetheless, the even bigger issue is focused on whether a particular format is an open standard or a commercial standard. Open standards (formats) can be used without regard to copyright or patent considerations. Commercial standards, such as GIF and some varieties of the JPG format, have patent or copyright considerations that must be taken into account. As the developer of a Web site, program, or application, you become liable for fees associated with commercial standards. This is the main reason for the development of open standards such as the new Portable Network Graphics (PNG) format.

As you have read, the GIF format can be interpreted directly by the browser. This file format can support up to 256 colors (8-bit color data) as well as a special layer of data called the transparency layer. Yet, the GIF format was developed by CompuServe as a means of distributing display-quality images over their online service. GIF files were never actually intended for print and this is the main reason that they only support 256-color image

Figure 19.1 A transparent (GIF 89a) image allows the background color or background tile to show through the graphic (http://www.carnegiehall.org/).

Figure 19.2 Interlacing the file as it is saved allows the image to be progressively viewed.

data. They were designed to be lightweight files that could be exchanged electronically.

Note: Remember, at the time the GIF format was developed, 300 BPS (baud) was the common modem transfer speed and even the GIF format taxed this extremely underdeveloped technology.

However, the GIF format uses a proprietary compression scheme that has caused quite a copyright skirmish over the past couple of years. In short, Unisys Corporation, developers of the LZW compression scheme used in the GIF format (developed by CompuServe Information Services), announced they would be suing for patent fees from software developers using the format. This "problem" has led to the development of a new and unique file format, Portable Network Graphics (PNG), which is focused at quickly replacing both the GIF and JPG formats. Later in this chapter you will read more about the PNG format.

Much like the masking feature of Photoshop, the transparent GIF format assigns a single color in the image as being transparent. Therefore, when the image is displayed in the browser, specified tag, background elements appear in place of the assigned transparent color value. Figure 19.1 shows an example of a Web page

that uses transparent GIF files. The background color appears through the graphic.

As an alternative to the low color limit of the GIF format, the JPG format presents a standard that excels at delivering photo-realistic images. However, JPG delivers rasterized vector images poorly, especially images that have considerable linework. Only use the JPG format for high color raster images that have not been palettized or reduced in color depth.

Note: The biggest advantage to JPG is its lossy compression scheme (see "Compression" later in this chapter), which allows high quality images to be delivered with close to ten times the space savings as compared to GIF.

Progressive Images and Interlacing

Progressive JPGs allow the browser to create low resolution representations of the graphic, which become clearer and higher quality as the browser downloads more of the file. Much like focusing the lens on a camera, the image begins blurry and then becomes clear when the image is completely downloaded as shown in Figure 19.2. JPG files themselves can contain both 8- and 24-bit information, which makes them a good candidate for delivering graphics at greater than 256 colors.

To enable a progressive download, the image must be digitally recorded or saved in a special way. The interlace option in any graphic file format causes the data to be saved nonsequentially. Rather than storing each line of

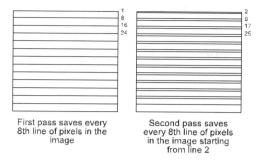

Figure 19.3 Interlacing saves the file a special way.

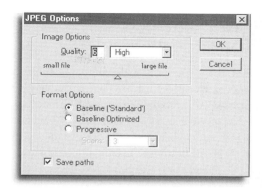

Figure 19.4 The JPG options dialog box in Photoshop 5.0.

pixels from top to bottom as they appear in the image, interlacing stores every 4th, 8th, or 16th line in that order. So rather than storing line 1, 2, 3 and so on, an interlaced file stores line 1, line 8, line 16, and so on. It then repeats at the top of the image with line 2, line 9, line 17, and so on as shown in Figure 19.3. This way the image can be progressively drawn as the image is downloaded.

Many of the latest imaging applications such as Adobe Photoshop 5.0 support this progressive JPG format. The progressive JPG is quite impressive but still data loss can be a negative because it uses lossy compression.

Task: Create GIF and JPG Graphics

To create a GIF graphic from Photoshop 5.0:

1 Save the image as a high resolution TIF or PSD file first. This allows you to go back to the original image if modifications are necessary.

2 Set the image color depth to 8-bit, using the Image | Mode menu option. Remember, the GIF format can only contain 256-color image data, and Photoshop will not show GIF as a Save As option unless the image is in 8-bit mode.

3 When prompted, choose to save the image as a Normal GIF or as an Interlaced GIF.

To create a JPG image from Photoshop 5.0:

1 Save the image as a high resolution TIF or PSD file first. Remember that JPG's lossy compression will lose some data during decompression. Saving a high quality version allows you to go back to the original image if modifications are necessary.

2 Verify that the image you are saving is a 24-bit image using the Image | Mode menu (The Mode should be RGB, CMYK, or Lab color). If the image is an 8-bit image, use the GIF or PNG format instead of the JPG format. By pushing Indexed Color up to 24-bit, you gain no color information.

3 Choose the Save As or Save option from the file menu. Set the Save As drop-down menu to JPG format.

4 When prompted with the JPG Options dialog box (shown in Figure 19.4), accept the default compression settings. You can test several lossy settings to get a desirable file size. Even the highest quality image is compressed. Remember that the "smaller" the file, the more data is lost and a larger number of artifacts will appear in the decompressed image. If you want the image to be progressive, select that option in the dialog box as well.

Using Portable Network Graphics (PNG)

One of the most noteworthy developments in Web graphics is the PNG format. The Portable Network Graphics (PNG, pronounced "ping") format has some very distinct advantages over both the JPG and GIF formats and seeks to better standardize the graphics found on the Web in addition to making it legally open.

The new PNG format supports up to 256 indexed colors (8-bit), true color (24-bit), progressive display, transparency, and automatic lossless compression. An additional feature is the use of pre-compression filters, which prepare the image data for optimal compression. In general, there are five filter types that can be applied to data within the image.

Note: Filters used with the PNG format are applied to the bytes that make up the image, and not the pixels or their colors. In addition, the filters work across individual scanlines that make up the image.

Note: The biggest reason for the introduction of the PNG format is to eliminate many of the problems associated with the LZW compression scheme. Another reason for the introduction of the PNG format is the need for an open standard (format).

The PNG format also includes several features that make it more advantageous than JPG or GIF. The PNG format supports RGB color images up to 48 bits, full masking (alpha channels), and image gamma information. It will be interesting to see how quickly this format catches on. The big two (Netscape and Explorer) currently support the new format. In addition, many of the latest image editors allow the developer to generate files in the new format.

TIP: *If you are using an older browser, you can probably find a plug-in that will allow your browser to view PNG images.*

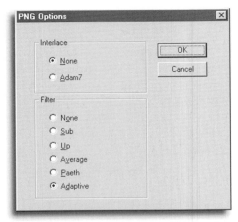

Figure 19.5 The PNG options dialog box in Photoshop 5.0.

Task: Create a PNG File

To create a PNG graphic in Photoshop 5.0:

1 Choose the Save As or Save option from the File menu. Set the Save As drop-down menu to PNG.

2 When prompted with the PNG options dialog box (shown in Figure 19.5), determine if you want a progressive image and select the appropriate option.

3 In the filter section, select one of the available filters. Since the filters affect the image's bytes, rather than pixels, you may want to try several of the filters to obtain better compression results.

Using Alternative Formats

Although GIF and JPG images are the most common graphic formats found on the Web, there are many others. You will find that each has its own quirks and advantages. Yet keep in mind that to use these formats, you must make sure the client and server support them.

TIF

Tagged Image File format or TIF (pronounced "tiff") is a special computer graphic file format that was designed to support the output of high-resolution raster images. This file format allows up to 32-bit data and is a very robust format. It is not uncommon for TIF files to be quite large. Since it is designed to hold image data for printing, the TIF format uses a special internal compression scheme called Lepel-ZivWelch (LZW) compression.

PICT

Most of the formats mentioned thus far are raster formats—holding only pixel data. The PICT format, used predominantly on the Macintosh, is a special type of file format called a metafile format. Metafile formats allow either raster or vector data within them. In fact, they can store both simultaneously. PICT files are very popular in both vector and raster imaging on the Macintosh due to their very small file size. However, take PICT to the PC and you will be lucky if you can find software that will be able to open it. If you are working cross-platform, PICT is not a good choice for a file format.

Compression

As you work with various graphics file formats you will find that there are a variety of compression schemes that can be used to reduce the size of a file. Actually, you will find that there are two main types of compression that can be used: lossy and lossless. These terms describe how the compression scheme works.

As you have read throughout this book, one of the biggest problems with raster images is their size. To overcome this hurdle, compression schemes have been developed to help reduce the file size of raster images. Almost every raster image has redundant data. For example, an image with many blue hues in it has redundant data due to the repeated definition of the blue pixels in the image. Compression schemes take the redundant or repeating data and substitute tokens or representative characters for the repeating data, thus reducing the file size. Most compression schemes, such as the ones used in BMP and TIF files, are transparent to the user. Many times you do not even know that the compression is occurring, but compression can significantly reduce the size of the file.

Compression schemes use an algorithm, or codec, to compress and decompress the image file. A codec stands for compressor/decompressor, which is an algorithm used to expand and compress the file. However, the compressibility of a file is dependent on how much redundant data there actually is in the file. A file with a lot of similar hues will compress more than an image with a wide variety of colors. Compression is dependent on the amount of redundant data.

Compression schemes are judged by the amount by which they compress the file, described by a compression ratio. The compression ratio is the ratio of the uncompressed file's size to the compressed file's size. A compression ratio of 2:1 signifies that a file originally 500k would be compressed to 250k.

You must be careful of products that claim significantly high compression ratios. You must make sure you are comparing two lossy or two lossless compression codecs. Comparing lossy to lossless is like comparing apples to oranges. To understand this, let us look at the difference between lossy and lossless compression.

Lossy Compression

When files are compressed, not all codecs reproduce an exact copy of the original file when they are uncompressed. Some data is sacrificed to attain smaller file sizes. This is the case with lossy compression. Lossy compression is a compression scheme in which certain amounts of data are omitted to attain smaller file sizes.

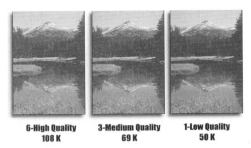

6-High Quality **3-Medium Quality** **1-Low Quality**
108 K **69 K** **50 K**

Figure 19.6 Adjusting the data loss in a JPG image.

Lossy compression schemes, such as those used with JPG images and many of the video formats, do not create an exact replica of the original file after decompression. They lose some of the original data. This may alarm you at first but lossy compression schemes are usually used when the files that are being compressed do not need the extra data.

For example, an image that you display on screen requires less data than a file that you are going to print (as discussed in chapter 17, "Utilizing Bitmap Graphics"). Therefore, you can sacrifice some of the display data for the sake of a smaller file size. This is also true in the digital video arena. Again, a certain amount of data can be sacrificed without significantly hurting the playback performance.

If you decide to use a lossy compression scheme, you do have a choice concerning how much data is lost. Most of these schemes allow you to choose a loss rate. For example, when you create a JPG file you can adjust how much data is lost as shown in Figure 19.6. The same is true if you are creating video snippets. As reproduced in this textbook, you may not be able to distinguish any difference at all between the three images, though the one on the right is more than 50% smaller than the one on the left.

TIP: *If you decide to use JPG images, keep two things in mind. First, after compression, if you ever try to print the JPG file, more than likely it will look bad. Second, you should keep a backup of your JPG images in a format that either does not use compression, or that uses lossless compression.*

Figure 19.7 The real world design to be implemented (http://www.tech.purdue.edu/tg/faculty/mohler/irwin/tgc/).

Lossless Compression

As its name implies, lossless compression can be used for image files that you want to print and use in situations where loss of data is detrimental. Lossless compression is a compression scheme in which a decompressed file creates an extract replica of the original file.

Lossless compression schemes do not sacrifice data. In fact, they create an exact copy of the original file when they are decompressed. Lossless compression schemes are often used with files that need to maintain the highest level of data, such as with desktop. Lossless compression schemes include the TIF and GIF LZW (Lempel-ZivWelch) and the BMP RLE (Run-Length Encoding) compression schemes.

Real World Examples

If you will recall from the real world example in chapter 17, you began looking at implementing the design shown in Figure 19.7. You have read about the importance of beginning with the appropriate size canvas as well as the effect of dividing a raster-based design appropriately so that you can create a set of consistent pages more easily.

This design was layered in Photoshop so that it could then be divided into pieces that could be integrated into the page. The layers are shown in Figure 19.8. Some channels were also defined to make some of the HTML code, such as the HEIGHT and WIDTH attributes of the tag, work across pages. The use of channels, or saved masks, allowed images to be divided up consistently across the multiple pages.

Coding the design from Figure 19.8 in HTML hinges on four important things: a long and very thin background tile, a transparent GIF image map, "glass bricks" (completely transparent graphics) for alignment, and a table for the anchors at the bottom of the screen. In this section, you will be reading about the last three of these, although the HTML for the page is also included so you can see how it is coded. For more information on table tags and attributes, check out chapter 7 "Using the HTML <TABLE> Structure."

Figure 19.8 This image required several layers and a couple of channels for creation and implementation.

Background Tiles

The task is to create the background tile used to create the two-colored background. Background tiles have been used on pages for a long time. Yet, trying to accomplish complex designs can be difficult due to issues related to anti-aliasing and background images. Laying inline images on top of background tiles or colors often reveals an "anti-alias halo," which is discolored pixels that appear around the edges of raster objects as shown in Figure 19.9.

For the design from Figure 19.8, the background tile is simple. The tile is 1 pixel high by 1024 pixels long, approximately 150 gray and 874 black—a total of 1024 pixels. This tile is then repeated all the way down the page to create gray and black columns.

Now you may ask, "Why highlight such a simple thing?" The complexity of this particular tile is related to its length. Imagine the tile shorter, say 640 pixels. A tile 640 pixels long would be enough to cover the length of the design size, right? Yet what happens if some

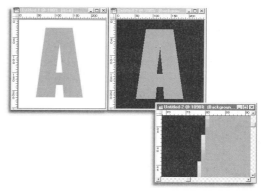

Figure 19.9 Anti-aliasing halos are the discolored pixels that commonly appear around objects as a result of designing on one background color and moving the object to another.

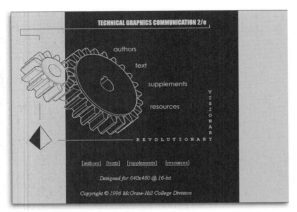

Figure 19.10 Using a background tile that is too short will be apparent at larger screen resolutions.

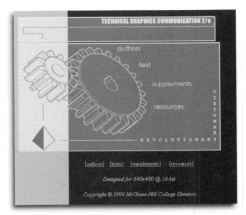

Figure 19.11 The Web page is composed of two image maps.

unsuspecting user accesses the page at a resolution larger than 640 x 480, say at 800 x 600? The result would look like Figure 19.10, which is not necessarily traumatic, but it is not what was desired.

As you can see, by making the tile longer than necessary you can avoid the changing canvas size problem. Note that the tile is set at 1024 pixels because you can assume that the largest screen size of most Web surfers is, at a maximum, 1024 x 768. The average is 800 x 600.

Large Image Maps

An image map is a single graphic with regions linked (anchored) to other pages, resources, or sites. Full-screen images take an eternity to download, sometimes locking up or crashing machines.

However, image maps are not always bad, as is the case with the design you are reading about. It is important to keep them small, less than 30 K is nice, which will take about 9 seconds on an uncongested Web connection.

In this design, there are two image maps. One contains the title bar for the pages and the other contains the gear image as shown in Figure 19.11.

The hardest part of this process is to get the tiled background lined up with the foreground images. It may require a little trial and error, but the way that you set up and store the first page's image (the Photoshop image you used to lay it out) will determine how fast you can create the remaining pages at the site.

To lay out this first page, begin by working with the title bar, since it is the object that is furthest up on the page. To get the alignment of the image correct, do not worry about making the image transparent at the beginning. You can take care of this once the alignment is worked out.

The first step is to define the area of the title bar you want to insert into the HTML page, as shown in Figure 19.12. Create a mask around the area and save it as a channel. Then save the Photoshop PSD file so the stored image file contains the new channel. Note that saving the file is important as you will see in a moment. After saving the image, crop the image to the mask and then export it as a plain GIF file.

TIP: *Make sure you do not save the cropped version of the PSD image because it will overwrite the original version.*

After saving the GIF file, insert it using the tag to see how it lines up with the background tile. As you can

Figure 19.12 Selecting the area of the title bar so that the image can be cropped and exported as a GIF.

Figure 19.13 Lining up the foreground image with the background image requires a little bit of trial and error.

see in Figure 19.13, it did not quite line up the first time. If this happens (and it probably will), go back to Photoshop and use Revert to obtain the stored image file with the previous channel.

The image did not line up because it did not have enough gray pixels to shove it over far enough from the browser border. To fix this, add more pixels to the left of the image mask so that when the image is cropped, there are more pixels at the left side of the image. Again, create the mask, save the mask, save the file, crop and export the image as a plain GIF. After a little trial and error you will get the image to line up correctly as shown in Figure 19.14.

Once the size of the tile is correct for the alignment, it is time to worry about transparency. Creating the transparent GIF image is easy in Photoshop 5.0. Open the last version of your PSD image, the one that has the correct mask, and flatten the image to prepare it for GIF export. To make this image work efficiently, fill the gray and black areas with white (because only one of the 256 colors can be assigned transparency). To fill it, choose the paint bucket and set its tolerance to 1 pixel, meaning that it will only fill adjacent pixels that are the same color. This retains the anti-alias around the text and the rule in the image. Figure 19.15 shows what the image looks like after filling the background with white. It is not

Figure 19.14 Finally the foreground image lines up with the tiled background.

Figure 19.15 The image prior to exporting as a GIF 89a image with white pixels assigned transparent.

Figure 19.16 The GIF 89a export dialog box requires you to define the transparent color.

Figure 19.17 A simple table wants to slam up against the left side of the browser.

pretty, but this is what it must look like for all but the text and linework to be transparent.

Once the background has been filled with white, change the image from a 24-bit to an 8-bit (for GIF to be an export option, the image must be 8-bit). Then select the GIF 89a Export option under the File | Export menu options. Choosing this export option presents you with the dialog box shown in Figure 19.16. The small eyedropper tool allows you to pick the color you want to be transparent. Select the white background, which will cause it to turn gray in the preview window. Click OK, name your file, and now you have a transparent GIF file.

Note: *Assuming you used the same file as you did when you created the plain image, you will not have to recode any of the HTML you have already created. Just replace the plain GIF file with the transparent (89a) GIF.*

TIP: *The Export option for GIF89a format can be found in Photoshop 4.0 and 5.0. If you are using Photoshop 3.X, you will have to download the GIF 89a Export filter from Adobe's Web site (www.adobe.com).*

To create and align the second image map in this page requires the same process as the title bar. However, in this image, all of the areas inside the gear, the logo to the bottom, and some of the text were also filled with white. Note that the more of the image that is transparent (the same "color"), the smaller the file will be and the quicker it can be downloaded.

Note: *To finish up these image maps required defining the hot areas and the links to them. I prefer to use a little program called MapEdit by Boutell.Com, Inc. to create my image maps, which is simple to use. If you are interested in it, check out http://www.boutell.com/. There are several other image map creation programs that are available as well. With most of these programs, if you can draw a line or a square, you can create an image map. The image maps for this page are client-side so the code and link definitions for them are stored in the HTML file that uses them (see Listing 19.1).*

Glass Bricks and the Little Table That Could

Two of the most widely used layout tools on Web pages are glass bricks and tables. To finish off this page, you will want to put some links at the bottom of the page that

Figure 19.18 Using a very thin glass brick within the table forces the text in the other table cells to flow over the black portion of the screen instead of the gray portion.

screen, as shown in Figure 19.17 (area highlighted). You need a way to move the table over a bit... enter the glass brick.

Earlier in this section, you read about transparent images and how they can be used to let background colors or tiles show through a graphic image. Transparent images can also be used to help with alignment. This is what is known by the semi-technical term, "glass brick."

The table at the bottom of this page design uses a thin tile-type graphic to force the table over the black portion of the screen. By inserting the graphic into the table, the text that appears in the table is shifted over the black area of the screen. Additionally, since the glass brick is only 1 pixel high, it does not add a lot to the cumulative size of the Web page. Let us reveal the magic by turning on the table borders and revealing the glass brick (Figure 19.18).

Glass bricks, particularly when combined with tables, provide a very efficient means of aligning objects in Web pages. As with any media element, it is important that the glass bricks you use be very thin. You only need enough to force the foreground elements to move. Remember file weight equals user wait.

contain the main topical areas for the site. This is for those in the audience who might stumble across this page with a browser that cannot read graphic pages (or do not want to by turning this option off in their browsers).

To create the text that appears at the bottom of the screen is not really anything too complex, except that the table wants to slam up against the left side of the

Listing 19.1 The code for Figure 19.7.

```
<!DOCTYPE HTML PUBLIC "-//W3C//DTD HTML 3.2//EN">
<HTML>
<HEAD>
    <TITLE>Technical Graphics Communication 2/e</TITLE>
</HEAD>
<BODY TEXT="#ADADAD" BGCOLOR="#000000" LINK="#A9A9A9" VLINK="#666666" ALINK="#880000"
BACKGROUND="stripe1.gif">
 <P>
 <IMG SRC="tgc.gif" ALT="Technical Graphics Communication 2/e" HEIGHT="76" WIDTH="570"
BORDER="0">
 <IMG SRC="map.gif" ALT="TGC Image Map" HEIGHT="310" WIDTH="564" BORDER="0"
usemap="#map">
 </P>
```

```
<TABLE>
  <TR ALIGN="CENTER">
    <TD ROWSPAN="3"><IMG SRC="space1.gif" HEIGHT="1" WIDTH="170" BORDER="0"></TD>
    <TD><A HREF="authors/index.htm">[authors]</A></TD>
    <TD><A HREF="text/index.htm">[texts]</A></TD>
    <TD><A HREF="supplements/index.htm">[supplements]</A></TD>
    <TD><A HREF="resources/index.htm">[resources]</A></TD>
  </TR>
  <TR ALIGN="CENTER">
    <TD COLSPAN="4"><BR>
    <I>Designed for 640x480 @ 16-bit </I></TD>
  </TR>
  <TR ALIGN="CENTER">
    <TD COLSPAN="4"><BR>
    <I>Copyright &copy; 1996 McGraw-Hill College Division </I></TD>
  </TR>
</TABLE>
<map name="map">
 <area shape="rect" coords="274,4,347,25" href="authors/index.htm">
 <area shape="rect" coords="335,50,376,74" href="text/index.htm">
 <area shape="rect" coords="371,102,488,133" href="supplements/index.htm">
 <area shape="rect" coords="373,169,469,199" href="resources/index.htm">
 <area shape="rect" coords="538,130,560,269" href="vision.htm">
 <area shape="rect" coords="331,269,538,291" href="revolt.htm">
 <area shape="default" nohref>
</map>
</BODY>
</HTML>
```

Leaving this real world example would not be complete without the inclusion of the code. The code for this page is shown in Listing 19.1.

Summary

In this chapter, you have taken a brief look at the three most common file formats for the Web: GIF, JPG, and PNG. Keep in mind that as time marches on, the PNG format will probably replace GIF and JPG, which will simplify things a little more. The other formats mentioned in this chapter are not necessarily the best formats to use on the Web, yet you may find them here and there.

Next Steps

Now that you have taken a look at the various file formats used on the Web:

• Check out chapter 6, "Using the HTML <TABLE> Structure," for more information on table tags and attributes.

• Read chapter 16, "Utilizing Bitmap Graphics," for more information about raster graphics.

• Examine chapter 17, "Managing Color Differences," for more information about color in digital imaging.

QUESTIONS

Q *What is a good application to use for graphic file conversion?*

A There are several applications that can be used to convert raster image files to various formats. Undoubtedly, it is best to be able to use a single application, but some applications do not support certain formats, functions, and so on. The biggest advantage of converter applications is that they often allow you to batch process functions, such as converting many files at one time. Nonetheless, applications such as Debabilizer and HiJaak are the best for file format conversion.

Using Layered Web Pages and Other Effects

In previous chapters you have become aware of how pages can be organized using two HTML tagging concepts: tables and frames. Used together, they can produce Web pages of extraordinary complexity—often too complex—both in terms of network response and in terms of communicativity. It is best to heed the suggestion "apply the lowest level of technology necessary to accomplish the task." This ensures Web pages that the greatest number of potential clients can use, that download in a respectable time, and that do a good job of communicating information.

In addition to tables and frames, you were introduced in chapter 11 to the concept of Web page stacking order (see Figure 11.1). Stacking order determines which page elements are displayed first. By manipulating background colors and background images that tile and a transparent color, you can achieve exceptionally creative results.

OBJECTIVES

In this chapter, you will:

• Understand how background tiles can be created that organize a Web page for later tables and frames.

• See how transparency can be used to achieve a measure of depth on your pages.

• Use progressive images to enhance the user's opinion of your pages.

• Get an idea of the potential for new browser features, ,such as layers.

Using Special Background Tiles

A background tile is a GIF or JPG raster graphic that is displayed over the background color. It can be as small as 1 pixel by 1 pixel (but that is not very practicable) or as large or larger than the maximum browser window.

The tile image is downloaded, cached, and displayed in the upper left corner of the browser's window, and continues to display left to right by row from cache until the page, as defined by the extents of the browser's window, is completely filled. Because the tile is downloaded only once from the server and then tiled from cache memory, a page background will appear rapidly, often instantaneously. Then, the page continues to display until the HTML file is completely interpreted.

If a background image repeats, it is referred to as a tiling background. If the tile is larger, then the maximum browser window will tile in only one direction. A tile that repeats but does not show any seams is called a seamless tile.

Note: *Even though you may completely cover up the background color with a repeating background tile, it is much more attractive to match, as best as possible, the general color of the tile with a background color. Because the background color is displayed first, a matching color gives the impression that the tile appears out of the background, rather than being displayed over a dissimilar color.*

A word of caution on tiled backgrounds. Once the novelty of having textured wallpaper behind your Web pages wears off, you will start to view tiles as page design elements rather than simply as a way to put a repeating

Figure 20.1 Possible repeating tiles.

company logo behind your Web page. Repeating background texture tiles can make reading page text extremely difficult. Do it once. Learn from it. Do not do it again.

There are several sources for seamless tiles, and most raster editors have the ability to create seamless tiles. Fractal Painter, for example, provides a very useful tool for doing this. Additionally, resources can be found on the Web itself. Try these sources for raster background files:

http://mars.ark.com/~gschorno/tiles/

http://mars.ark.com/~rhamstra/backgrnd.html

http://www.skoardy.demon.co.uk/bsoup/

http://imalchemy.com/

Repeating Background Tile

Repeating tiles should be kept small and square, preferably in multiples of 16 pixels. An appropriate tile size is 64 x 64 pixels. This is large enough to build an acceptable texture or pattern but not so big as to create download problems. Figure 20.1 shows several tiles from Guy Morton's Miles of Tiles (http://www.imalchemy.com/). Figure 20.2 shows what the Web page would look like after tiling.

Figure 20.2 Tiled pages from Figure 20.1.

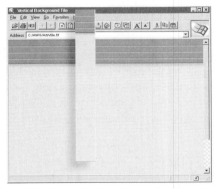

Figure 20.3 A vertical tile used to create a page header.

Figure 20.4 A one-pixel wide vertical tile page background.

Vertical Background Tile

A tile that is larger than the maximum vertical browser dimension will only tile horizontally. Figure 20.3 shows a typical vertical tile used to create a page header. Another use is to create a quick background grid, like that shown in Figure 20.4. In this case, a background image only one pixel wide is used to create a page of surprising complexity.

Figure 20.5 A one-pixel wide horizontal tile page background.

Horizontal Background Tile

A tile that is larger than the maximum horizontal browser dimension will only tile vertically. Figure 20.5 shows a one-pixel tall tile that makes a vertical information bar, the kind often seen on the Web. This technique is expanded in Figure 20.6 by increasing the vertical size of the tile, allowing a repeating shape to be formed.

Figure 20.6 Enlarging the tile's size allows you to be creative with its shape.

Task: Creating Background Tiles

Let us say I want to create a background for my home page that looks like a yellow legal pad. The finished page is shown in Figure 20.7, ready for content to be placed on top of the background. Here is how to make the tiled background:

1 Create a sketch of your page. Analyze what kind of a tile you need. In this case, elements repeat horizontally, making for a vertical tile.

2 Open your favorite raster program and create a canvas 32 pixels wide by 650 pixels tall. This will ensure that your background will not repeat in the vertical dimension on either a 640 x 480 or 800 x 600 display. We will make it 32 pixels wide so that a repeating texture can be created on the spine.

3 Using a browser-safe palette, choose a yellow and several green colors.

Figure 20.7 A tiled background in the form of a yellow legal pad.

Figure 20.8 The tile that creates the legal paper.

Listing 20.1 Create a simple HTML program that loads the background.

```
<HTML>
 <TITLE>Page Design with Tables.</TITLE>
 <BODY  BGCOLOR=#FFFFFF BACKGROUND="paper.gif">
 </BODY>
</HTML>
```

4 Create the legal sheet with a yellow background and green guidelines (Figure 20.8). Because the graphic contains solid colors, we will save it in GIF format: paper.gif.

5 Test this by creating a simple HTML program like that shown in Listing 20.1.

6 At the top of the tile, create the green spine (Figure 20.9). Notice that a texture has been added, as well as the shadow cast by the thick spine on the top sheet. I want to make the tile as realistic as possible. Test it as shown in Figure 20.10.

There are several things we can add to the tile to make the legal pad look even more realistic. Lettering cannot be part of the tile or it would repeat unrealistically across the top. To place lettering on top of the background, use a page table, sized to correspond to the dimensions of the background.

Figure 20.9 The green spine is added to the paper tile.

Lastly, add even more realism with the addition of staples and the depression in the spine that their insertion might cause. The top of the page with its final additions inside the table is shown in Figure 20.11.

Using Transparent and Progressive Images

GIF format raster graphics can have a single transparent color. This technique was explained in detail in the previous chapter. Transparency is normally used to place a graphic on top of a background image or color. Seeing how difficult it is to match colors from application to application, and from browser to browser, it is often easier to use transparency, rather than color matching. The particulars of transparency will be covered in the next section.

Photoshop and Painter both have the ability to identify a color in GIF format to be transparent, as does HiJaak Pro. Debabelizer has the added benefit of being scriptable. This way, you can batch process a number of images.

Note: *Remember, only one color can be identified for transparency. You may make a background a single color, only to realize later that the pixels around the object blend from the inside color to the background. These transition pixels will not be turned transparent. This results in a halo around the*

Figure 20.10
The finished
background tile.

Figure 20.11 The completed legal tablet spine.

Figure 20.12 The scanned text to
be placed on top of the legal pad.

object that can range from mildly irritating to really obnoxious. The solution is to make the background of the graphic as close to the background it is going to be placed on (if the background is a gradient, pick an average).

A progressive image loads in steps. In GIF format, this is called an interlaced GIF. In JPG format, this is called a progressive JPG. Again, these concepts were covered in detail in the previous chapter. Both have the effect of building up the image in steps, rather than wait for the image to completely download. This was paramount in the days of 14.4 dial-up Internet connections, but is something you see less and less of. For another reason, Web artists are much better at designing low resolution, low bit depth images that do not particularly need progressive display. Use this feature as a service to possible clients with super low-tech hardware.

Task: Creating Transparent Images

Normally, I fill up a legal sheet with lots of scribbling, usually in marker. To demonstrate this technique of transparency, I will put the scribbles on top of the legal sheet so that the guide lines show through. That way, it will look like the writing is actually on the page. To do this, I will:

1 Finish the page table used to put the text and staples on top of the background so that it will hold the content.

2 Scribble the content in marker on a white sheet (Figure 20.12). Scan this at 144 dpi (twice screen resolution).

3 Open in a raster editor in Indexed Color. Sample the yellow background color you used for the tile. Select some white pixels and "Select Similar." Fill with the yellow.

4 Because you have not scaled the scan, there should be no transition pixels. That is, you should have black and yellow—two colors. Choose RGB Color and scale the scan until it is the size you want. You will have transition pixels, but the transition is between yellow and black. You want this anti-alias so the line will look smooth. Because

Figure 20.13 Transition anti-alias matched to the background color.

Figure 20.14 The finished graphic with transparency.

the transition is between black and the background color, the anti-alias will not stand out. It will only make the lines look smoother. Figure 20.13 shows a detail of this transition.

5 Push the graphic back into Indexed Color and save in GIF format.

6 Either in the raster editor or in a separate program, identify the general background color for transparency. You will be left with a small fringe, but of an acceptable color.

7 Introduce the GIF into the page table. The result should look like Figure 20.14. If the fringe is small, the lines on the legal sheet will look like they run right into the notes. Inspect the anti-alias fringe on the enlarged detail and you will see that only one or two pixels cover up the green lines. This is acceptable and gives the impression of the note being on the paper.

Task: Creating Progressive Images

Rather than create a progressively displaying single image, let us have some fun with another feature of the GIF file format: animation. This will be covered in greater detail in chapter 22, "Animating Your Web." But

instead of creating an animation, let us create an image that builds from a line drawing to a rendering, something that progression or interlacing cannot do. To create a custom progressive display you would:

1 Decide where you want it. In my case, I want it on top of the yellow legal sheet so this is what I will do. First, edit the page table to provide a space for the image. Then, carefully screen capture the area. This will be the correctly sized canvas for your progressive image. Fill this with the background image.

2 In your raster editor, create a progression of images in GIF format that go from coarse to refined. I created the five images shown in Figure 20.15, showing my favorite car (a '68 AMX) from shadow to 72 dpi perfection. Make the backgrounds the same color as the paper and perform the same transparency operations that were demonstrated in the previous section.

3 In a product such as GIFBuilder or GIFAnimator, load the frames in order. Set the timing to about .5 second to start. Do not implement the looping feature.

4 Test the progressive image. Adjust the timing so that the image looks like it builds, rather than plays as an animation.

Figure 20.15 GIF frames used in a progressive image display.

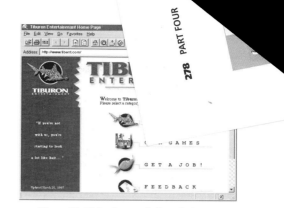

Figure 20.16 Background tile technique at
http://www.tibent.com/.

Looking at New Browser Features

We have already presented ways to circumvent HTML's limited abilities as far as layering is concerned. Makers of individual browsers (essentially Netscape and Microsoft) push the feature envelope by implementing a number of browser-specific features.

Within Netscape Communicator, Netscape 4.0 implements the <LAYER> tag, a powerful tool. Layers do several things:

1 Layers establish a logical hierarchy of associated content. This establishes a parent-child relationship so that actions such as movement, hiding-showing, and Z-index (stacking order) impact all objects contained within the layer, including nested layers.

2 Layers provide for the exact placement of layer elements on the X-Y page and along Z depth.

3 Layers provide the associative structure that can be acted on by JavaScript syntax. It is JavaScript that drives the layers.

Note: *Even if you work in a layer environment you should carefully justify the benefits of using this feature before taking the plunge. The modularity of the LAYER structure and the power of JavaScript may alone make this feature a standard when it is adopted into the HTML standard.*

As a Web page designer, you will be tempted to implement new and exciting features such as layers. The good news is that a browser that does not understand the LAYER tag will simply ignore the tag and its attributes. This can have between benign and disastrous results. At worst, content that relies on layer information for its position, visibility, background, or transparency will appear inline, just as they are pulled from the server. What ever formatting attributes are active will be applied to the content.

So should you use layers? If you are designing pages for an intranet that will be viewed by layer-savvy browsers, yes, consider it. If you are designing pages for general consumption, probably not.

Real World Examples

There are many examples of creative backgrounds on the Web. Shown in this section are three commercial examples that use interesting effects. For example, Tiburon Entertainment's Web site (Figure 20.16) uses an overlay of a shark bite in a table to modify the tiled background.

Webling's Cafe (one of my all-time favorite sites) uses a simple tiled background with overlaid table graphics—

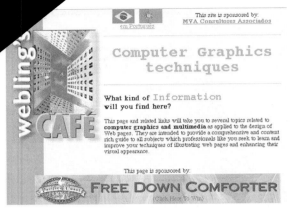

**Figure 20.17 Background tile technique at
http://www.mvassist.pair.com/Graphics.html.**

**Figure 20.18 Background tile technique at
http://www.internet2.edu/.**

simple but effective (Figure 20.17). Note the depth that is built up on the page by overlapping images with elements of the background.

The contrasting panel of the Coalition for Networked Communication's Internet2 site provides a main menu for the site (Figure 20.18).

Summary

A background tile can be a small repeating design that is displayed on top of page color and behind page content. When the image is smaller than the browser window's dimensions, it repeats until the window is filled. Rather than being used as a repeating pattern, background tiles are better used as structural design elements. Headers, footers, and vertical menu areas can easily be created that download quickly and display from cache.

When used in a background image, transparency allows the background color to show through. Because there is

no overhead for the BGCOLOR, a sophisticated page can be built from a simple tile.

The rationale for using progressive or interlaced images has been somewhat lessened by improvements in hardware and networking. Still, allowing a large image (like a full-screen, 24-bit JPG) to progressively display does pacify an impatient user on the end of a 28.8 dial-up connection.

The implementation of a LAYER structure in Navigator 4.0 foretells another tool for pushing Web pages to new horizons. Until this technique is adopted in the HTML standard, it should be used with care.

In the next chapters, you will be introduced to audio, video, and animation techniques that will enhance the design of your Web pages. To implement these features, chapter 24, "Utilizing Plug-in Capabilities," will show you how to equip your browser with supplementary resources so that you will have access to this rich world of Web media.

QUESTIONS

Q *I always end up with sharp edges on my tiled backgrounds. How can I avoid this?*

A You may be making your tiles too small. It is difficult to match edges on a 32 x 32 tile. Try going to 64 x 64 or 128 x 128. Remember, the pixelation at the edges of the tile has to match up both horizontally and vertically for the tile to be seamless.

Q *I like using a single background image rather than a tile, but the download times are horrible. What can I do?*

A Ask yourself if you really need a full page image for the background. You may not. Let us say that the general color of the image is black. You may be better off displaying pieces of the image (with black background) in a table on top of a black page color. I have seen a page described this way with 40% less overhead in file size. Additionally, check the file type of the background image. If the image has lots of variation in color and value, you might get away with a highly compressed JPG file.

Q *I have difficulty matching colors of table graphics when they overlay a background.*

A Do not try to match the colors! Use transparent GIF images with a transparency color close to that of the background. That way, any anti-alias fringe will closely approximate the background. If the image is a JPG, put a frame around it so it does not look like you are trying to match the background color.

Q *I tried to use layers but nothing seems to work. What is wrong?*

A First, you have to be using a browser that understands the LAYER tag. Right now, that limits you to Netscape 4.0. If that is the case, most of the functionality of layers is driven by JavaScript that acts on the content on the layers. You can find the latest information about layers at http://home.netscape.com/comprod/products/communicator/layers/layers_glossary.html.

PART FIVE

MULTIMEDIA TECHNIQUES

Training the Page to Speak

The addition of audio to the Web has satisfied Web multimedia developers, up to the point that sound can effectively be delivered over various bandwidths. Yet the biggest concern has been, and will be, the size of audio files. Akin to the concerns with graphics and other media elements, audio delivered over the Web can be a problem if it is not designed properly. That is what we will focus on in this chapter. As with graphics, you will read about the concerns of audio creation from a standpoint of the major characteristics involved, which are sampling rate, bit depth, and number of channels. In addition, you will gain a better understanding of the differences between digital audio and MIDI.

OBJECTIVES

In this chapter, you will:

• Develop an understanding of the two fundamental types of sound files: digital audio and MIDI.

• Understand that much like raster graphics, digital audio also has sampling attributes: sampling rate, bit depth, and channels.

• Examine the hardware and software needed for sampling audio, as well as how to do it.

• Read about audio file formats as well as how to create Shocked Audio and RealAudio.

• Find out about MIDI and how it differs from digital audio.

Understanding Audio

You read about the differences between digital and analog data in chapter 17, "Utilizing Bitmap Graphics." As with graphics, audio also deals with the conversion of data—analog to digital. As you have read, digital data does not mean much to humans. However, when data is presented as waveform (analog) data, our human senses are able to perceive the data, either with our eyes or our ears.

Developers have two options at their disposal for representing and distributing audio. Much like the choice for graphics (vector or raster), audio too can be represented in one of two ways—as digitally recorded audio or as MIDI. You will find many similarities between vector and raster graphics and MIDI and digital audio.

Digital audio is probably the more frequent type of audio used on the Web and it is much more realistic in its playback. Digital audio is sound that has been sampled and recorded to a digital storage medium such as a disk, CD, or DAT tape through analog-to-digital (ADC) conversion.

A few years ago, to create digital audio required significant investment in hardware and software. But today most computers have the capability to create digital audio very easily. Sound cards are available that have a special chip or processor called a Digital Signal Processor or DSP for short. The DSP was specially designed to be able to deal with audio processes.

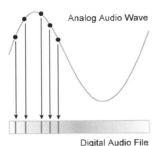

Figure 21.1 Digital audio is a digital description of multiple instances (points) of an analog sound wave.

Figure 21.2 MIDI describes various instruments and the sounds each instrument plays over time.

The second type of audio is MIDI or Musical Instrument Digital Interface. MIDI was actually developed and was used in the early 1980s by musicians and other audio professionals. With the emergence of synthesizers, drum machines, and other digital devices, MIDI was developed to allow these various devices to communicate with one another. Using MIDI, a sound played on a synthesizer or other device could be "recorded" and then used on another machine. You will find that most MIDI devices are used to input music to a computer or other device. Realize that MIDI is a generic or universal language whereby various devices can communicate and share data. It is like networking for musical devices such as synthesizers, drum machines, or sequencers.

Most sound card DSPs not only support digitized audio but MIDI devices as well. More often than not, one finds MIDI integrated within the DSP. Prior to today's direct support of MIDI, older sound cards required add-on cards, or daughter cards, be purchased for MIDI to be supported.

Types of Audio Files

The fundamental difference between digital audio and MIDI is the way in which the audio is defined and played back. Although any lengthy discussion of these differences would require a discussion of acoustical physics, more information than most developers require, the basics are relatively simple.

When a digital audio file is created through the process of sampling, each sample taken from an analog source is described digitally. Each pitch and volume characteristic in the audio is descriptively written in the file. A digital audio file is a description of multiple points on an analog sound curve. These points describe the audio that is playing at specific instances in time as shown in Figure 21.1. Digital audio files are detailed descriptions of the analog waveform.

MIDI sound, on the other hand, describes audio much differently. Instead of describing the audio as digitized samples of analog data, MIDI describes the various notes and instruments that should play at any given time as shown in Figure 21.2. MIDI files describe a specific instrument, or patch, and the notes it should play over time. The MIDI description can also contain information such as sets of notes that should get louder or softer as well as special effects such as distortion.

Every instrument in a MIDI sound has information that pertains to it. A MIDI sound file of an orchestra playing Beethoven's Fifth Symphony would have detailed information about each and every instrument, and how to sequence those instruments.

As was mentioned, the differences between digital audio and MIDI are akin to the difference between raster and vector graphics. By the time you finish this chapter, you will understand the significant difference between digital audio and MIDI.

Sampling Digital Audio

Most of the audio that is utilized in the digital world stems from an analog source. In times past, desktop computers were unable to be used in commercial audio production. With most computers being sold including a capable sound card, the desktop user can sample audio files and easily create digital audio files.

A basic understanding of computer audio, much like the understanding of vector and raster graphics described in previous chapters, stems from understanding of the basic attributes or characteristics that affect it. Let us begin with a look at the first major characteristic of digital audio: sampling rate.

Sampling Rate

As you recall, to sample an analog source requires converting chunks of analog data to digital representations as shown in Figure 21.3. The frequency of the chunks is called the sampling rate. The more frequent the chunks, the more representative the digital representation of the analog source, but of course, the larger the file.

Digitizing analog audio concerns two different frequencies: the frequency at which you convert chunks of data, and the frequencies that occur within the analog sound itself. Note that there is a relationship between the frequencies that occur in the analog source and the frequency with which you take chunks in the digital sampling process. Keep in mind that analog audio is composed of frequencies, and the digital sampling process also has a frequency called the sampling rate.

The relationship between sampling rate and sound frequency requires that for a specific frequency from an analog source to be captured, the digital sampling rate

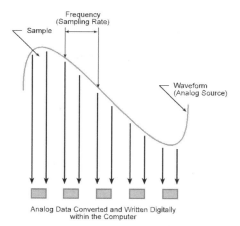

Figure 21.3 Sampling requires converting chunks of analog data to digital. The frequency of those chunks is called the sampling rate.

must be twice that of the analog frequency. To capture a 22 kHz frequency, the digital sampling rate must be 44 kHz. Realize that the highest frequency that the human ear can hear is 22 kHz. This is why most audio software packages have the highest sampling at 44 kHz because it is the highest that is needed. Recording at a sampling rate higher than 44 kHz records sounds over 22 kHz, which cannot be heard by the human ear. This is why an audio CD's sound is crystal clear, because they are recorded at 44 kHz and include the entire range of sound perceivable by the human ear.

Note: To make the comparison between digital and graphic digital data clearer, consider sampling audio at higher than 44 kHz, a technique that records sounds outside normal human hearing. Capturing 24 bits of color information creates a file containing many colors that most people simply cannot see. Both techniques result in data files unnecessarily bloated—a serious handicap when delivering interactive Web pages.

In most computer sound packages, there are three standard sampling rates available: 44 kHz, 22 kHz, and 11 kHz. At each of these levels, the perceivable amount of sound is half the sampling rate. For example at 44 kHz, the entire 22 kHz range of sound is digitally captured.

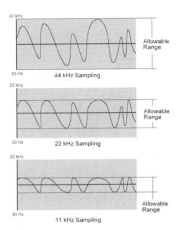

Figure 21.4 By comparing sampling rates and seeing the digital representation, you see that the lower the sampling rate, the lower the quality of the digital representation.

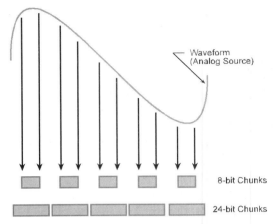

Figure 21.5 The descriptiveness of the digital file is based on the sampling rate and the bit depth.

With a sampling rate of 22 kHz, the recorded range is up to 11 kHz, and with 11 kHz, the perceived sounds are up to 5.5 kHz.

To better understand the effect of sampling rate, let us look at three samples, one at 44 kHz, one at 22 kHz, and one at 11 kHz so that you can see that the described range of highs also describes the range of lows. Figure 21.4 shows three samples of the same sound, one at 44 kHz, 22 kHz, and 11 kHz. Note as the sampling rate decreases, so does the range of frequencies captured in the audio. The sampling rate not only describes the number of highs that can be sampled but also the lows. In addition, as the sampling rate decreases, the digital representation becomes less representative of the analog source (the waveform flattens out).

As you can see, the sampling rate affects the fidelity of the digital sample. The lower the sampling rate, the lower the quality of the digital sound clip. If you could listen to the sound clips shown in Figure 21.4, you would hear that the 44 kHz sample sounds clear and crisp, just like "being there." The 22 kHz sound is lower quality, yet adequate for playback in multimedia and hypermedia. The final sample at 11 kHz is noticeably different. It sounds "scratchy" and has little depth of sound.

Bit Depth

The second attribute of sound is bit depth, sometimes called sampling depth. As you will remember from chapter 17, bit depth describes the number of physical computer bits that can be used to represent part of a sample. Figure 21.5 shows the sampling process. Remember that once the chunk is converted to digital data, it must be written in a digital file. The number of bits that the computer can use to describe the chunk is the bit depth. The higher the bit depth, the more descriptive and representative the digital file.

When you were reading about raster graphics, you saw that the bit depth of a raster image controls the number of colors that can be used to describe an image. When you are dealing with audio, the number of bits you have describes the number of various decibels (dB) available. These decibels are variations not necessarily associated with loudness.

For example, an audio clip written at 8 bits has 256 different variations from which to describe the samples of the clip. A clip written at 16 bits, can use any one of 65,000 decibel variations to describe the samples of the clip. Keep in mind that a decibel does not automatically mean the loudness of a sound. In this setting, it is more

descriptive of pitch than anything else. CD quality sound is representative of 16-bit quality.

Channels

Another consideration with digital audio is the specification of mono or stereo sound: the number of channels of sound. Although this parameter is being discussed here, hypermedia and multimedia sound is mono—a single channel.

Stereo sound creates differences between what is played in one speaker and another, which gives greater depth to the aural experience. Normally, stereo sound describes a sound track that has a left and right component as shown in Figure 21.6. When it is sampled into the computer, dual clips are recorded, one representing the left speaker and one representing the right speaker. As a more complex variation, there is also surround sound, which may have from 4 to 8 different channels in a clip, each designed for a specifically placed speaker.

Monaural sound, often called mono sound, is sound in which there is a singular channel or track. Both speakers play the exact same thing (Figure 21.7). In multimedia and hypermedia, mono sound is used due to the tremendous storage requirements of stereo sound clips. Recording or playback of a stereo clip requires twice as much storage space and processing power.

Acknowledging Realistic Delivery Parameters

Up to this point you have been concerned with three primary determiners for the quality and size of a sound clip: sampling rate, bit (sampling) depth, and number of channels. Although it would be nice to use 16-bit, 44 kHz, stereo sound on the Web, this is unrealistic. One minute of digital sound with these settings would require approximately 10 megabytes of disk space—completely absurd for Web delivery. A quick look at various numbers for different settings will help you understand the effect of these variables on digital file size, as shown in Table 21.1.

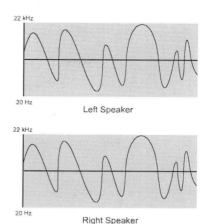

Figure 21.6 Stereo sound has both a left and right component.

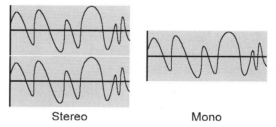

Stereo Mono

Figure 21.7 The comparison of stereo and mono sound.

Sampling Rate	Bit Depth	Channels	Disk Space for 1 min of sound
44	16	stereo	10.5 Mb
44	16	mono	5.2 Mb
44	8	stereo	5.2 Mb
44	8	mono	2.6 Mb
22	16	stereo	5.2 Mb
22	16	mono	2.6 Mb
22	8	stereo	2.6 Mb
22	8	mono	1.3 Mb
11	16	stereo	2.6 Mb
11	16	mono	1.3 Mb
11	8	stereo	1.3 Mb
11	8	mono	.6 Mb

Table 21.1 The comparison of stereo and mono sound.

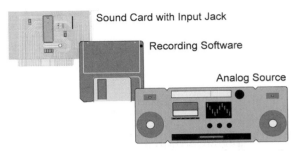

Figure 21.8 Things you need to be able to record analog sound.

Figure 21.9 Various types of audio connectors.

As you can see, the size of digital sound files is dramatically impacted by the sampling rate, bit depth, and number of channels. Most often sound clips you use in multimedia will be 22 kHz, 16-bit, mono files. For Web distribution, you may have to drop the bit depth down to 8-bit.

Note: There are many more attributes of sound that can be analyzed, that were not discussed in this chapter. The primary concerns with digital audio are sampling rate, bit depth, and number of channels.

Acquiring Equipment for Digital Audio

As you have read, converting analog sound waves to digital audio presents significant challenges. To create digital audio requires that you have three things (Figure 21.8): a sound card with recording capability (an audio inline in jack), software that allows you to record an analog source, and an analog source such as a microphone, stereo, or CD or tape player. Any device that can play audio and has an "audio out" connector can be digitally sampled.

Sampling audio on your PC or Mac is a relatively easy task assuming you have a sound card that can sample audio and an appropriate software application. Most PCs and Macs have some type of system software that will allow you to sample audio. The basic scenario for sampling audio is to connect an analog device, such as a microphone or a tape recorder to your computer. You will find that a microphone will most generally give you the poorest results, particularly if it came with your machine. If you want to do serious microphone sound recordings you will probably have to invest in a better microphone than the one that came with your computer.

The most frequent desire is to record audio using a tape recording or an audio CD. However, do not forget about copyright considerations! Just by using a small percentage of the original sound recording does not protect you from possible copyright liability.

To sample audio from a device such as a tape recorder or boombox, you need to interconnect the two devices so that the device is playing through the sound card of the computer. Find the output jack on the back of the sound card to see what type of jack it is. Most often it will be a "patch" type connector. Figure 21.9 shows an example of the three main types of connectors: ⅛" patch, ¼" patch, and the RCA connector.

Next, look at your tape recorder or whatever device you want to sample from. Look for a "line out" connector. If none exists, you can also use a headphone jack. Now all you have to do is get what is normally called a "patch" cable with the proper connectors for your card and device, interconnect the two, and you are ready to begin sampling.

Note: One note about sampling sound. Any unique and creative digital work is copyrighted from the moment it is set in tangible form. Just as with graphics, make sure you have the right to use any audio that you sample. This is especially true of sound clips available for download over the Web.

Many sites advertise "free downloads" when they actually make use of copyrighted sounds (like movie tracks) that they do not have permission to distribute. Do not assume anything. Get permission.

Tips for Digital Audio

After you get the connection established between your device and card, here are some suggestions for digitizing audio:

• Prior to playing any sound from the device to your computer, make sure the device (boombox or whatever) volume level is on zero. Insert a tape or other media and let it start playing. Then increase the device volume to 1. This keeps you from overloading or blowing your computer's speakers. If you do not hear sound at a volume level of 1, do not turn it up. Check the operating system's sound levels.

• Check your settings for the audio levels on the computer. Often there will be separate audio levels for the master volume, line in, CD, line out, and any other connections for your sound card. Set the volume of these on 50% if possible. Then you can control the volume using the device's volume adjuster.

• Check in your recording software to see if you can adjust the recording level. If your software has monitor level indicators (Figure 21.10), as the audio plays through the card you will see the "LEDs" light up. You want the audio volume level coming in to average at the lowest yellow. If the audio peaks in the red as it is playing that is okay. Generally, you want the average volume level to be close to lowest yellow level.

• As you are sampling audio, you will only be able to record as much audio as you have disk space or memory. Some audio packages only allow you to record in RAM. Others write the recording audio directly to the hard disk. Prior to buying any software, make sure it can record audio directly to the hard disk. If it cannot, you will only be able to record a couple of minutes worth of audio at a time.

Monitor Level Indicators

Figure 21.10 Monitor level indicators.

• Strive to sample your audio at the highest quality possible—4 kHz, 16-bit, stereo. This gives you a high-quality digital source from which you can down-sample to 22 kHz, 8-bit, mono. Having a digital source file at the highest quality will allow you to manipulate it, such as adjusting the lows or highs, if you need to. Sounds just like graphics, does it not?

• Use the lowest quality sound necessary in your interactive Web pages. More than likely, the highest quality you will be need to use is 22 kHz, 8-bit, mono sound clips.

Note: *We are often asked by our students, "Can I sample a clip from an audio CD using the CD-ROM that is in my computer?" This depends on the capabilities of your sound card and how it interfaces with your system architecture. Some CD-ROM drives, ones that are directly attached to the sound card, have this capability. Yet, most often you will have to sample sound from an external source (such as a boombox or stereo). See the previous note in this chapter on copyright concerns.*

Task: Sample Digital Audio

To sample digital audio using Sonic Foundry's Sound Forge (part of the Macromedia Studio bundle):

1 Establish the connection between your sound source and the computer (with a patch cable or other appropriate cable).

Figure 21.11 Note that it is all right if the LEDs peak every now and then, but you really want the average volume level to run at the top of the green.

2 Start your sound software and set the recording attributes to 44 kHz, 16-bit, stereo. If you do not have significant hard drive space, you may have to create the raw original source file with lower characteristics. I generally sample high, then down-sample for multimedia or hypermedia inclusion.

3 Next, test the volume settings by playing a track from your source. Sound Forge has interactive monitor levels that allow you to see if the sound is too loud. The optimum is to have the LEDs running right at the top of the green (Figure 21.11). Note that it is all right if the LEDs peak every now and then, but you really want the average volume level to run at the top of the green.

4 Once you have tested the sound levels, you can begin recording. Realize that with the sampling characteristics at the maximum, you will rapidly use all available hard drive space. The solution is to use a secondary hard disk or removable media drive.

Note: If you decide that a separate hard disk or removable drive is needed to record audio, consider a SCSI drive. The transfer rate is considerably faster than that of drives that connect to a parallel printer port.

5 Once you have sampled a clip, save the raw file in the program's native format, more than likely WAV (on the PC) or AIFF (on the Macintosh).

Task: Preparing Digital Audio for the Web

Once you have a raw, high-quality sample, to down-sample it for Web, deliver in an application such as Sonic Foundry's Sound Forge:

1 Once you have a high-quality sound clip open, you will probably want to begin by editing the digital file. Often you will find that digitized audio will sound somewhat "tinny" (lots of highs, few lows) or that the sound level is quite low. Before creating the Web-ready audio, use the Normalize option, under the Process menu. This will balance out the sound wave.

2 Next, you may also want to use the Tools | Graphic EQ menu option to adjust the clip so that the bass tones are a little more pronounced and the high tones are less pronounced. Often you find that raw digitized sound lacks in the bass end. The Graphic EQW option works like the equalizer of a stereo. Figure 21.12 shows the settings normally used. However, depending on the original analog source, settings may vary.

3 Next you must resample the sound clip at 22 kHz (assuming you are working from a high resolution 44 kHz sound clip). Choose Process | Resample and resample the clip at 22,050 Hz, which is 22.05 kHz.

4 Finally, choose Save As from the File menu. Set the Attributes drop-down menu to the appropriate setting. For the Shock Audio, the sound file should be 22.050 kHz, 16-bit, mono, as shown in Figure 21.13. For RealAudio, the sound file should be 22.050 or 11.025 kHz, 8-bit, mono. Other formats for Web distribution may have other attributes.

Analyzing Digital Audio Formats for the Web

Just as with graphic files on the Web, there are many file formats that you can use to distribute your audio files. More than likely, your choice of format will depend on

Figure 21.12 The Graphic EQ can be used to adjust the amount of low and high tones in the sound clip.

Figure 21.13 The audio settings for a sound clip to be distributed as Shock Audio.

the platform on which you are generating it. Nonetheless, keep in mind that the Web is a worldwide medium and that platform-specific file formats can limit the audience able to listen to your sounds.

Digital audio file formats for the Web include:

• Shockwave Audio (SWA) - one of the predominant formats for Web distribution. This format allows various qualities and is a streamable format.

• RealAudio (RA) - a format commonly found on the Web. RealAudio files require special server software (for real-time delivery) and client-side plug-ins.

• Audio Interchange File Format (AIFF) - predominantly used on Macintosh and Silicon Graphics machines. This format supports various sampling rates, bit depths, and multiple channels.

• Sun Audio (AU) - predominantly used by UNIX users on workstations. This format is special in that it writes its data differently from the other sound formats. However, it is usually prone to background noise and external sounds.

• System 7 Sound Files (SND) - predominately used for sounds associated with the Macintosh Operating System.

• Sound Blaster Vocal Files (VOC) - an older sound format originally introduced by Creative Labs' Sound Blaster sound cards.

• Windows Waveform Files (WAV) - originally designed for Windows System sounds but is now widely used across the Internet.

Compressing Digital Audio

Due to the size of digital audio files, many of these formats are not feasible to deliver directly to interactive Web pages. The only files that are currently being directly utilized within browsers are MIDI files and special streaming audio files such as SWA and RA.

If you want to distribute digital sound files other than those previously mentioned, compress the files using external file compression programs, such as PKWARE'S PKZIP or Aladdin's Stuffit Deluxe, and allow your audience to download the files outside their Web browser. The current Web bandwidth cannot support direct distribution or integration of raw digital audio files (WAV, AIFF, or AU).

TIP: *The best way to integrate digital audio files directly into your pages is to use a streaming technology.*

Streaming

One of the most recent advances in Web technology centers on the principle of streaming. Understanding the concept of streaming is easy, yet its implications are quickly increasing. Much like a progressive image (which could also be classified as "streamed media"), a streamable audio file is one in which the browser can immediately begin playback even though the entire file has not downloaded. Once a sufficient amount of the streamed piece is downloaded, the file can begin playing. In essence, the

file is played directly from the Web, within the browser, as it downloads.

There are several technologies that allow audio and video data to be streamed and played back simultaneously from the Web. RealAudio and Shocked Audio are the most common. However, streaming technology is relatively new and is still limited by bandwidth. Most RealAudio files are relatively low quality—11 kHz, 8-bit, mono files. Shock Audio files are a little better at 22 kHz, 16-bit, mono. You will find that some other formats tout a higher quality, but quality/download time is still dependent on the speed of the network connection.

Note: There are two types of digital audio that can be delivered over the Web: real time and prerecorded. When audio is delivered in real time, special server software is required. More often than not, a server aimed at delivering real-time audio or video will not be able to provide any other services. The server software that is installed for audio and video to be delivered often requires that the server be dedicated to only the task of delivering audio and video.

Note: Streaming technologies require that the client's browser have a plug-in to view media elements. This will probably not change in the coming months. If you decide to utilize streaming technologies, make sure that your home page acknowledges that specific plug-ins are required to view the site. Keep your site audience centered.

Task: Create a Shock Audio File

To create Shocked Audio in either SoundEdit 16 or Sound Forge, you will use the Shockwave Audio filter from the export (or Save As) dialog box. You will also use the Xtra for Shockwave Audio settings so that the compression options are correct.

To create a Shocked Audio (SWA) file:

1 Open the file you want to export as Shocked Audio.

2 Choose Shockwave for Audio Settings from the Xtras menu so that you can configure the compression options for the file.

3 Select the bandwidth you want to design the file around from the Bit Rate drop-down menu. Note that this setting determines the quality of the output as well as the streaming rate for the file. Suggested bandwidth rates include:

• 8 kbps for 14.4 modem clients

• 16 kbps for 28.8 modem clients

• 32 kbps – 65 kbps for ISDN clients

• 64 kbps – 128 kbps for T1 clients

Note: Keep in mind that other Internet variables, such as number of connected users, length of connection, and so on, may affect delivery. See chapter 3, "Designing for Effective Content and Efficient Delivery," for more information.

4 Check the Convert Stereo to Mono checkbox so that the output file is a single channel and select OK.

5 Choose Export from the File menu and choose SWA from the Export Type pop-up menu. Name your file and save it.

You must make your server aware that it can distribute Shocked Audio files by adding the SWA MIME type to the server configuration files. In addition, make your audience aware that they need the Shockwave Plugin to hear the audio.

Task: Create a RealAudio File

To create a RealAudio file you must first have the RealAudio Encoder, which can be downloaded from http://www.realaudio.com. Once you have installed the encoder:

1 Start the RealAudio Encoder program and begin by selecting a file on the Source side of the program using the Browse button (Figure 21.14).

2 On the destination side of the program, select a destination for the file (using the browse button). Then give the file a name. Note that the extension will be .RA (Figure 21.15).

3 Next, choose a Compression scheme based on the client connection you will be delivering to (Figure 21.16).

4 Select the Start Encoding button to create the RealAudio file.

TIP: *Try different compression schemes to get an appropriate quality for your audience.*

You can check out http://www.sfoundry.com for more information on Sonic Foundry's Sound Forge or http://www.macromedia.com for more information on SoundEdit 16.

Figure 21.14 Selecting a source file to convert to RealAudio format.

MIDI

MIDI audio is akin to black magic. Most people do not understand how it works, much less create it. In this section, you will take a brief look at MIDI. You will not learn all the ins and outs of it because it is not as widely used as digital audio on the Web—mainly because most people do not understand it or know how to create it. However, it is important that you have a basic understanding of how MIDI files work.

You can think of MIDI as sort of a "vector description" for music. As you will recall from chapter 18, "Utilizing Vector Graphics," vectors (as defined by PostScript) describe drawings as objects or mathematical descriptions rather than as individual pixels or samples. MIDI describes a musical performance as object elements rather than bit streams of information. Akin to PostScript, MIDI is device independent and has no bit depth or sampling rate.

Figure 21.15 Setting the destination information.

Figure 21.16 Choose a compression scheme based on the client connection.

Synthesized Sound

The premise of MIDI sound is based on the concept of synthesis. Synthesis simply refers to the way in which a waveform is generated. In the case of digital audio, the waveform is described bit by bit in relation to time. With MIDI, the MIDI processor is capable of generating the wave based on a description of the notes that should play and the instrument that should be used to play it. This is why MIDI is similar to PostScript. A MIDI file does not describe the wave in relation to the bits that describe the wave, it actually generates the wave based on pitch and instrument descriptions.

Note: Synthesis also refers to one other element concerning the wave that is generated. Not only can a MIDI chip generate a sound wave, but it can also manipulate that sound wave over time. Using filters, the sound can be emphasized, de-emphasized, distorted, or any range of other effects.

The advantages to MIDI are many. Because of the way data is described in a MIDI format, MIDI files are significantly smaller than digital audio files. Much like the huge differences between vector and bitmap files, a MIDI representation of a digital audio file may be one-tenth the size of the digital audio file—a definite advantage both in storage and delivery.

A second advantage to MIDI files is that they are malleable. MIDI sound clips can be constructed an instrument at a time. If you were creating a MIDI file of Beethoven's Fifth Symphony, you could add each instrument definition and the representative notes for that instrument one at a time to the file. The final composite (of all the defined instruments) could be played, edited, and rearranged at any time. Each instrument in the piece is a discrete object.

Yet with all the apparent advantages of MIDI files, there is one significant flaw. In a MIDI file, there are over 128 different instruments that can be used to play a series of pitches or notes. As the MIDI format became more widely used, there was no standardization of what num-

bers (1–128) represented what instruments. Consequently, a musician could define an entire piece of music that is supposed to be played using the acoustic piano. However, figuring out what instrument number should be used was a problem because there was no standardization. Instrument number 1 on one machine might be the right one, but on another machine, which may use a different sound card, it may be instrument 75. This has been the biggest flaw of using MIDI sounds.

Note: One of the latest developments related to MIDI sound is the new DLS (Downloadable Sound) specification developed by the IASIG (Interactive Audio Special Interest Group of the MIDI Manufacturers Association). The idea behind this new specification is to allow a more standard approach to delivering MIDI sound files. For more information, check out http://home.earthlink.net/~mma/index.html.

Real World Examples

Check out the following sites for more examples of audio in Web pages:

http://www.whoopie.com/

http://www.webcorp.com/realaudio/

http://www.brooks.af.mil/realaudio/newsbyte.html

http://www.realaudio.com/contentp/npr.index.html

http://www.shu.edu/~martelfr/contents/music/index.html

http://www.cybercomm.nl/~sytze/startrek.htm

http://golf.capitolnet.com/

http://www.realaudio.com/contentp/abc.html

http://www.webthumper.com/midi/

http://www.tst-medhat.com/midi/

http://www.harmony-central.com/MIDI/

Summary

In this chapter, you have taken an in-depth look at the two forms of Web audio: digital audio and MIDI. Audio on Web pages is still in its infancy; only now are we starting to see the beginnings of CD-ROM-type multimedia on the Web. Undoubtedly over the next few years, we will see more and more and it will get even better.

Next Steps

Now that you have taken a look at adding sound to your page:

• Check out chapter 22, "Animating Your Web," for more information on utilizing animations at your Web site.

• Read chapter 23, "Integrating Multimedia in Your Pages," to find out more about HTML related to Web multimedia elements.

• Examine chapter 25, "Interactive Pages Using HTML, Tables, and Frames," for information on other Web media applications.

QUESTIONS

Q *Can QuickTime, QuickTimeVR, or AVI be used to distribute audio-only movies?*

A Yes. Programs like Adobe Premiere are capable of creating digital video files that only have an audio component. However, the codec used in the common digital video formats does nothing for compression of the audio portion of the file. It may be better to use a format such as RealAudio or SWA that actually compresses the audio.

Q *Why do MIDI files sound fake? Am I doing something wrong?*

A The reason MIDI files sound fake is because they actually are. The quality of playback of a MIDI file is based on the quality sound card that is replicating the sound file.

Animating Your Web

For a long time, animation has been construed as something only masters could create, but today this is not the case. Almost anyone with basic knowledge and an artistic eye can make animations.

Animation is really nothing more than a series of images with changing contents. Each frame represents a single instance in time. The compilation of images, with changing contents, creates "life" in the animation. For the most part, computer animations contain a series of raster. The end result is usually a single digital animation file that contains many raster images within it. Sometimes, Web animations may be stored as a series of individual images files, rather than a single large one. In either case, both are based on raster images.

Yet, you can also use vector graphics as a basis for Web animations, using programs like Macromedia's Flash, as shown in Figure 22.1. In this type of Web animation, a plug-in is used to interpret the media so that it can be displayed within the page. Some raster animation formats

also utilize plug-ins. Vector animations are interesting because, as you read in chapter 16, "Utilizing Vector Graphics," vector graphics are much smaller in file size than raster images. Technologies like Flash do not have the characteristic vector jaggies, reducing the largest drawback in using them.

Web animations may also utilize advanced external applications or scripting languages such as Macromedia Director, as shown in Figure 22.2, Java, as shown in

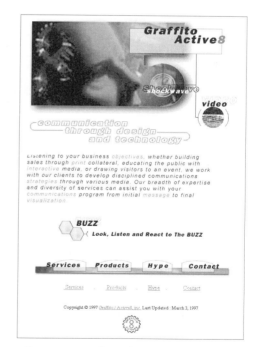

Figure 22.2 A Web site that utilizes Shockwave for Macromedia Director (http://www.gr8.com/).

Hello, Captain Brainless here to explain WebTrips Network.

We have over 30 tour guides, each with interests and hobbies just like you. Personally, I like fun, geography, humor and trivia sites. We take you to the best web sites on the internet, which are **updated weekly**.

Click the next button and see the different ways to choose a guide.

NEXT

Figure 22.1 A Web site that utilizes Macromedia's Flash technology (http://www.webtrips.com/home/detect2.htm).

Figure 22.3, JavaScript, or VBScript. Yet, the predominance of today's Web animations are simple GIF animations that do not require special plug-ins or languages (Figure 22.4).

Since most Web animations are composed of raster images, this chapter will deal with raster animations. In this chapter, you will take a look at the main ways of creating Web animations and the issues surrounding them. You will also spend some time reading about vector animation, which is becoming more popular with Flash, as well as animations created with Shockwave for Director. If you are interested in integrating Web animations into your pages, read this chapter first (for some background knowledge), then go to chapter 23, "Integrating Multimedia in Your Pages," to see how to make them and put them on your pages.

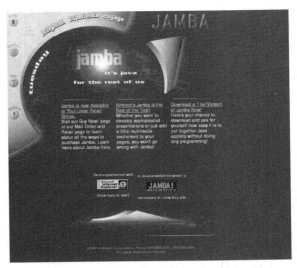

Figure 22.3 A Web site that utilizes a Java animation (http://www.jamba.com/).

OBJECTIVES

In this chapter, you will:

• Develop an understanding of the basics of Web animation and realize the limits of animations over the Web.

• Look at the main concerns with animation files themselves.

• As with raster graphics, you will examine the characteristics that affect the file size of Web animations.

• Read about the various file formats that can be used for delivery over the Web.

Being Realistic with Animations

The single biggest constraint with Web animation, as with other media elements, is file size. In previous chapters, you have seen that file size is an important attribute of any static media element. Yet, with animations, it is even more important that you be conscientious of file size. For example, using what you know, the page shown

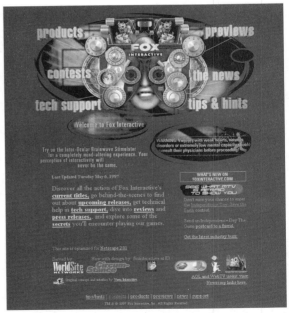

Figure 22.4 A Web site that uses GIF animations, which do not require plug-ins (http://www.foxinteractive.com/).

in Figure 22.5 weighs in at about 244 kilobytes. How long will it take to download using a 28.8 modem? Yet, the real question concerning size is whether you can realistically expect your audience to accept a possibly lengthy download time.

Today's Web limits what we can create. If there was no bandwidth limitation, we would undoubtedly be using the Web for full-blown, full-screen, audio-visual experiences for almost any content. Yet, the Web still does not support this type of rich multimedia environment. However, there is much we can do with the Web today as it relates to Web animation limitation, as shown in Figure 22.6, even with the bandwidth limitation.

Types of Animation

If you look at the history of Web animation from primitive server-push and client pull scenarios to the more advanced methods we have today, you will see that there have been dramatic improvements in the technology over the past three years. Again, we will continue pushing the technology, finding better means of creating what we want, and ways to deliver it over the Web. All of the advancements thus far have predominantly dealt with reducing the size or amount of data. As you will recall from chapter 3, "Designing Effective Content for Efficient Delivery," one of the primary means of making the Web faster is to push less data (or compressed data). Most of the innovations have been via being smarter about the data and how it is packaged.

There are several methods to produce and deliver animations over the Web. The most logical way to describe the possible types of animation is by looking at the way in which those animations are created. In this chapter, you will read about planning Web animation. Animation is created using authoring programs, animation programs, and browser scripting. In this chapter, we will not be concerned with actually implementing them into the Web page. You will find more information on implementation in the next chapter.

Figure 22.5 This Web page weighs in at 244 k, which will require approximately 68 seconds to download over a 28.8 kbps modem (http://www.intel.com/proshare/videophone/demo.htm).

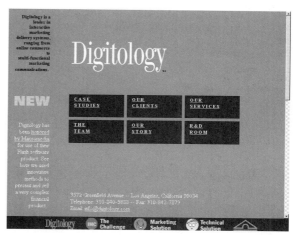

Figure 22.6 Even with limitations, the effects you can do with animation can be quite impressive (http://www.digitology.com/).

Authored Animations

The first type of animation is authored animation. Authored animation includes any animation that has been created using an authoring program. These include animations generated via Shockwave for Director or Authorware, as well as Flash.

What makes authored animations unique is that they often allow a variety of media elements to be inserted into the final animation. For example, with Director,

Figure 22.7 Authored animations can include a variety of media elements, including sound.

Figure 22.8 Director Shockwave movies can include special rollovers, such as a highlighting button (http://www.macromedia.com/shockzone/).

Figure 22.9 Creating authored movies requires the authoring application, such as Director, shown here.

Authorware, and Flash, you can insert sounds into the timeline of the animation as shown in Figure 22.7. This is what makes an authored animation different from a composite animation, which you will read about shortly.

In addition to the various media elements, with authored animations you can also include interactive effects and other features. For example, if you are familiar with Director's Lingo scripting language, you can use rollover functions (Figure 22.8) as well as the ability to have interactive elements jump to extrasite or intrasite links.

To create authored animations or movies, you must have the appropriate application. For example, to create a Shocked Director movie for a Web page, you must have Director, shown in Figure 22.9, and then use the Afterburner filter (called an Xtra) to prep it for use on the Web. A similar process is used for Flash and Authorware.

Lastly, authored animations are special because they can be full-running multimedia experiences. Probably one of the most interesting is a production by Digital Planet called Madeleine's Mind (Figure 22.10). Using authored animations, you can create truly interactive multimedia experiences, yet you have to be careful about the sizes of these files. For example, Madeleine's Mind weighs in at

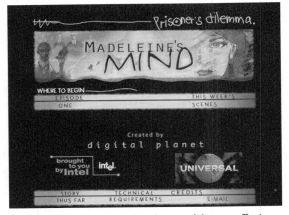

Figure 22.10 Madeleine's Mind is one of the most effective Web multimedia experiences (http://www.madmind.com/).

about 720 kilobytes, which may not be suitable for most 28.8 modem users.

Composite Animations

The second type of Web animation is called a composite animation. In general, these files are created from applications that only have the ability to deal with either video or audio data. Composite animation files do not have the ability to create interactive elements found in authored animations. Specific animation types include GIF animations as well as most digital video formats. Figure 22.11 shows an example of an animation generated from a composite application.

Scripted Animations

The last type of animation is a scripted animation. Using scripting languages such as JavaScript, VBScript or JAVA applets, you can create animations that are a function of the Web page or an external application. Most animations created this way use external GIF files from the server (or user's cache). The GIF files are external to the page and the programming or scripting is internal to the page. Figure 22.12 shows an example of a scripted animation.

Raster Animation Concerns

In chapter 17, "Utilizing Bitmap Graphics," you read that there are three attributes of a raster image that affect both the file size and quality of the image. Since animations are nothing more than a conglomeration of images, these imaging attributes also affect raster-based animations (e.g., GIF, scripted, and some of the Shocked animations). In addition, the number of frames (images) in the animation also impact the final file size and delivery parameters. In the next couple of sections, let us revisit these attributes and see how they affect the delivery of animations over the Web.

Note: *Keep in mind that these attributes only affect animations that are based on raster images. Animation formats*

Figure 22.11 Composite animations predominantly include animation-only files, but can also include audio (http://www.universalstudios.com/main.html).

Figure 22.12 External scripting can also be used to play back Web animations (http://www.mydesktop.com/internet/javascript/).

Figure 22.13 Most Web animations are composed of a series of raster images. This one contained 32 frames and weighed in at 21 kilobytes.

Figure 22.14 Web animations must be small enough to download quickly over the audience's connection to the Net (http://www.nbn.com/people/espresso/gif/gif.html).

such as Flash are based on vector descriptions and are therefore not affected by some of the imaging attributes.

Image Size

Since most Web animations are composed of many raster images (Figure 22.13), image size also affects the quality and size of an animation. Note that the larger an animation's image size, the larger the images that make up that animation. However, when you are working with animations, image size is most often called frame size and it affects all the images in the animation, rather than an individual frame.

When you are working with digital video and animations outside the Web, frame sizes are specified using standard increments so that they can be used for various purposes. Standard sizes include 160 by 120, 240 by 180, 320 by 240, and 640 by 480. Various other sizes may be used depending on the intended output (such as broadcast digital video).

When you utilize animations on your Web pages, more than likely you will be using sizes that do not conform to the standard sizes for animation and video. In fact, they will probably be quite smaller than 160 by 120 to get optimum playback over the Web. Figure 22.14 shows an example of a typical Web animation as well as a site to view examples of GIF animations.

Note: Small sizes for Web animations are predominantly due to the file sizes that occur when you use the standard animation and video sizes. Keep in mind that animation on

the Web must be small for it to download to the audience's machine in a reasonable amount of time. An animation that is the smallest size, 160 by 120, will probably be too large to integrate directly into the page. Animations such as these will probably be integrated using hotlinks, as opposed to being integrated in inline.

Web-delivered animation is designed around the bandwidth limitations that exist for the client. Files must be small. Most users are connected to the Internet via modem. With a 28.8 modem, it takes about 1 second to download 3.6 K (kilobytes) of data. So a 50 K file (1 raster image at 160 by 120 pixels) will take 14 seconds. An animation file will have many frames, hence the concern over download time. This is also assuming that the server that is feeding the information is not being accessed by other users. If a particular Web site is being accessed by many users at a time, it may take longer to download a 50 K file since the server tries to serve everyone equally.

Note: One of the best ways to decrease download times is to reduce the frame size of the animation. Akin to changing the image size of a raster image, changing the frame size of an animation will reduce the size of the digital animation file. As you will read shortly, you can also decrease download times by decreasing the number of frames (images) in the animation. These are the two main factors that affect the size of the animation file: frame size and number of frames.

Figure 22.15 This Web page is 174 K, which will require approximately 49 seconds to download over a 28.8 kbps modem (http://mmx.com/mmx/shock/shock/default.htm).

Bit Depth

With animation or video, bit depth normally plays a role in development. However, with Web-based animation, you are very limited concerning the bit depth.

Almost all animations that efficiently and effectively play on the Web are 8-bit or less. This means that you are not working with millions or even thousands of colors. However, you can get effective results with animations that are 8-bit as shown in Figure 22.15. A 256-color palette or 8-bit animation has sufficient colors to create effective animations given that the frame size is appropriate for Web use.

Granted you cannot create smooth-color, full-screen (640 x 480), or even quarter-screen (320 x 240) raster-based animation using a 256-color palette. You will see some color shifting and banding using 8 bits for animation of this frame size. Delivering animations with frame sizes over 160 x 120 is just essentially wasting bandwidth. If you try to deliver animations larger than 160 x 120 on your Web pages you are probably asking for trouble. The animation will likely play poorly for your audience, if they do not exit your site before the animation plays. The bandwidth of today's Web through a modem connection, and even through most direct network connections, will not be able to deliver the data fast enough to play the animation in real time.

Frame Number

One of the most important attributes that affects the size of a Web animation is the number of frames that compose the animation. Generally, you want your animations to have less than 100 frames (although we have seen sites that utilize more). Try to keep animations less than 25 frames. Again, this varies depending on the audience. Keep in mind that every added frame adds one more static image to the file, thus increasing the file size.

TIP: *The best way to find out if you are trying to deliver too much is by testing. Once you have created an animation, test it using the constructs under which your audience will be accessing your page. If they are using a 28.8 kbps modem, test using a 28.8 modem. Tests should reflect the end users' hardware and software settings.*

Frame Rate

Every animation has a certain number of frames that play per unit of time. The more frames that play per unit of time, the more smoothly the actions occur within the displayed animation but the more data that must be transmitted. Smoothness is a function of the number of frames that play per second (fps), called the frame rate.

With cel animation (such as cartoons), 24 frames are generally played per second. The frame rate of video is generally 30 frames per second. However, on the standard computer, you cannot display a frame rate of 30 fps. Frame rates of video and animations not delivered over the Web are generally 15 frames per second. On the Web, most animations play at a frame rate of 8 to 10 frames per second.

The speed at which animations play on the Web is dependent on two variables: frame size (image size) and number of frames. Bit depth really does not play a role because the Web cannot support high color raster images.

Note: With Web animation you do not need to be concerned with dpi. Almost all Web animations are created at 72 dpi because they are intended for output on 72 dpi display devices.

Applying Animation Attributes

As you have read in this chapter, there are several issues you must be aware of if you want to deliver animations on your Web pages. You must realize that:

• The main issue of delivering raster-based animation is the size of the file or files that are used to represent the frames of an animation. It takes approximately 1 second for 3.6 K of data to download over a 28.8 modem, assuming the server you are accessing is not extremely busy.

• Since animations are based on the accumulation of individual images, the number of frames in the animation is important. You should strive to include animations that can be used as looping segments with a minimum number of frames.

• The frame size is generally 160 x 120 pixels or smaller. Anything larger than this will require lengthy download time and will play back with unappealing results.

• The frame rate of most animations delivered over the Web is significantly less than those associated with broadcast video or animation. If you can attain a frame rate of 8–10 fps, your animations should be effective.

• The file size of an animation delivered over the Web is dependent on the frame number and the frame size of the animation (assuming an original bit depth of 8 bits for each of the raster frames).

• Animation in which the file size, frame number, or frame size make it impractical to deliver in an inline fashion should be linked to the page as independent, compressed file. This allows the user to download them for viewing independent of the Web browser. These types of animations should never be used in an inline fashion (coded directly into the HTML of a page), forcing the user to wait for them.

Using Various File Formats

Web animation requires numerous file types and MIME types. As a developer, you must be concerned with MIME settings, not just in your browser but also with your server.

Over the past year, end user MIME types have gotten easier to work with, although not always smooth running. Usually when a plug-in is installed, the MIME types are added automatically for the user. This works as long as two plug-ins are not vying for the same file extension. This can often be fixed but requires knowledge of what .DLLs go with what plug-ins.

TIP: *If you inadvertently install a plug-in that "takes over" your browser's MIME settings, you can fix it by using the Help | About Plugins option to figure out which .DLL goes with which plug-in. By process of elimination you can get rid of offending plug-ins. However, once you get rid of a plug-in, you will have to manually restore the original MIME settings so that the proper plug-in is associated with the proper extension.*

If you are using Windows 95 or Windows NT, to see .DLL files you must go to the View | Options menu and select the View tab. Then turn on the Show All Files option.

Keep in mind that as a developer, you must be certain that your server's preferences recognize the extensions of the type of files you want to deliver. For example, to deliver Flash animations, the server must know that it can deliver .SPL files. Common Macromedia MIME types include:

Director:	.dcr, .dxr, .dir
Authorware:	.aam, .aas
Illustrator:	.ai
FreeHand:	.fhc, .fh7, .fh8
Audio files:	.swa
xRes:	.swx
Flash:	.spl

For server-specific information, see the end of chapter 16, "Utilizing Vector Graphics."

Summary

In this chapter, you have seen how various types of Web animations are created. Undoubtedly by the time this book goes to print there will be more options (this always seems to be the case). However, the main animation types that are found in this chapter—Shocked, Java, GIF, and scripted animations—will still exist and still be used. The only one that may fade into the background is the GIF animation, predominantly due to the patent problems with the LZW compression scheme. In any case, do not be afraid to test some of the various animation capabilities of today's Web. You can overcome the bandwidth limitations by designing around them.

Next Steps

Now that you have taken a look at the various ways animations can be created for the Web:

• Check chapter 23, "Integrating Multimedia in Your Pages," for more information on multimedia implementation.

• Read chapter 24, "Utilizing Plug-in Capabilities," for more information about other plug-ins that can be used in Web delivery.

QUESTIONS

Q *How can I calculate the cumulative size of my pages?*

A Keep in mind that the cumulative size of your pages is basically a process of adding the file sizes of all the elements in your page. This is the real number that counts. If you are browsing the Web and want to calculate the size (for posterity or whatever), once the page has downloaded, access your browser's cache folder. Do a sort by date and you will find that you can easily calculate it. Note that the HTML file is the first thing that downloads. All the files between two HTML files belong to the previous HTML file.

Integrating Multimedia in Your Pages

Throughout this book you have been reading a lot about the various media elements that can be utilized within your interactive Web pages. In the final chapters, you will take a look at integrating multimedia into the Web page as well as a few more methods for creating a few of these media elements.

You will have to admit you have covered a lot of ground since chapter 1 of this book. From raster and vector graphics to audio, video, and animation, you have taken a look at these media elements. In addition you have taken an in-depth look at tables and frames and how they can be used in your Web pages. However, you are not done yet.

In this chapter, you will focus on implementing items such as audio and video into your Web pages as well as create specific media elements such as GIF, Shockwave, Flash, and JavaScript animations.

OBJECTIVES

In this chapter, you will:

• Take a closer look at the HTML tags for integrating audio directly and indirectly into your Web pages.

• Read more about specific animation types, including GIF JavaScript, Shockwave, and Flash Animations.

• Look at the "finer side" of animation creation, using JavaScript and Java.

Integrating Audio on the Web

Depending on the type of audio files you choose to use, the HTML coding required to integrate the audio will vary. In this chapter, you will read about the three predominant audio formats available: RealAudio, Shock Audio, as well as MIDI. You can simply use standard audio formats (such as WAV, AU, and AIFF) by providing hyperlinks, which either download and play within a helper application or that download and play within the browser using some plug-in that understands the file type. Most effective pages use either RealAudio, Shock Audio, or MIDI, but you can do what you want. Again, as long as your audience is satisfied, it really does not matter.

Note: Since integrating WAV, AU, or AIFF files is easy, all we will say about them is that you can either use the <A> tag or the <EMBED> tag. Note that using the <A> tag with the HREF attribute will attempt to utilize a plug-in. If no plug-in is found, it will try to use a helper application.

The <EMBED> tag will only try to use a plug-in. If none is found, you can get any range of undesirable results. If you use the <EMBED> tag, make sure you also include a <NOEMBED> tag for those who are not using version 3.0 or later of Navigator or Explorer.

RealAudio

In chapter 21, "Training the Page to Speak," you read about creating RealAudio files. Creating them is easy,

but understanding how they can be implemented is a little more difficult. Here you will read about the various ways that RealAudio files can be delivered over the Web. Keep in mind that the RealAudio Encoder will accept the sound file formats shown in Table 23.1.

Note: Due to the amount of time it would take to discuss real-time delivery of audio (live feed), you will not read about it here. For more information, check out RealAudio's home page at http://www.realaudio.com.

RealAudio is capable of bandwidth negotiation. Simply stated, bandwidth negotiation allows the server to find out how the browser is connected to the Internet (or other information). The server can then deliver appropriate media elements for the user's connection. Several software companies are enabling bandwidth negotiation, including Microsoft and Netscape, but this technique gives you one more way of customizing and centering on the audience.

Note: There are really two major types of intelligent delivery on the Web. The first is called bandwidth negotiation. The second is called content negotiation. Content negotiation is being used by Microsoft to overcome the problem of screen size variations of the audience through Active Server Pages. Using content negotiation techniques, the server can act intelligently about the requesting client by checking the resolution of the client's browser. It then delivers the appropriately sized pages. The focus of both types of negotiation is efficient and more effective delivery. Content negotiation focuses on more effective delivery whereas bandwidth negotiation focuses on more efficient delivery. Undoubtedly, we will see more of this type of intelligence in Web delivery in the near future.

As it relates to RealAudio files, bandwidth negotiation allows you to create several RealAudio files and distribute them to the user based on the user's connection. If the user connects using a 28.8 modem, the server will deliver a file appropriate for a 28.8 modem. If the user connects via ISDN or comparable, the server will deliver a file that is appropriate for the connection. The faster the

Type	Platform	Attributes
.wav	Windows, UNIX	16-bit or less stereo or mono
.au	Windows, UNIX, Macintosh	8-bit μ or stereo or 16-bit linear mono or stereo
.pcm	Windows, UNIX	16-bit or less stereo or mono
.snd	Windows, Macintosh	16-bit or less stereo or mono
.sd2	Macintosh	16-bit or less stereo or mono
.aiff	Macintosh	16-bit or less stereo or mono
Live Feed	Windows, UNIX, Macintosh	16-bit or less stereo or mono

Table 23.1 Formats that can be encoded with the RealAudio Encoder.

connection, generally, the larger the file and the higher the file quality.

Bandwidth negotiation with RealAudio files requires the use of a metafile. In general, a metafile is a file that can contain multiple types of data or information on multiple files. The metafiles used with RealAudio negotiation are simple text files that describe the RealAudio files to be delivered based on the current user connection and have the extension .ram or .rpm. The .ram file makes the browser launch the RealAudio Player while the .rpm file launches the RealAudio Plugin. The player is a helper application while the plug-in embeds the sound controls into the Web page.

Note: One other feature of RealAudio is a product called Cevents, which allows you to create synchronized multimedia presentations with RealAudio. These presentations can be as simple as a set of slides with narrated comments or as intricate as a frames-based training presentation.

To use the bandwidth negotiation feature of RealAudio, not only do you need the metafile, but you also need several versions of the sound you want to deliver. In chapter 21, "Training the Page to Speak," you saw that the RealAudio Encoder allows you to create several dif-

ferent qualities of RealAudio files. For bandwidth negotiation, you simply create various versions of the RA file, typically one for 14.4, 28.8, and ISDN, and then create a metafile that lists each file. When the user accesses the metafile, RealAudio negotiates the proper file to deliver to the client.

To integrate RealAudio files into a Web page, use the <A> tag with the HREF attribute, which will utilize either an external helper application or a plug-in. You can also use the <EMBED> tag, which will attempt to embed the RealAudio control directly within the Web page. You can simulate various aspects of the RealAudio controller by using the CONTROLS attribute of the <EMBED> tag. However, if you use the <EMBED> tag make sure you also include a <NOEMBED> tag, for obvious reasons.

Note: *With most of the multimedia elements described in this chapter, you could also choose to use the <OBJECT> tag for inclusion. However, the <OBJECT> tag is only supported by Internet Explorer; therefore, it will not be discussed further.*

TIP: *To be able to deliver RealAudio files (.RA) as well as files for bandwidth negotiation (.RAM and .RPM) make sure that your server has the MIME types set up correctly so that it knows that it is supposed to let clients have those files. The MIME types server settings for RealAudio files should be as follows:*

> *MIME Type: audio*
>
> *Subtype: x-pn-realaudio*
>
> *Extensions: RA, RAM, RPM*

Shock Audio

Embedding Shock Audio files into a Web page is not much different from embedding any other source file. In general, you will use the <EMBED> tag with several different attributes. The attributes set several options for the Shocked Audio file as well as the Shocked Movies that normally accompany them. Figure 23.1 shows an example of a Web page that utilizes Shocked movies and audio.

Figure 23.1 Shocked audio is typically used in conjunction with Shocked Director movies or Authorware pieces (http://38.248.229.6/deepforest/df.html).

When you include Shocked Audio, you will have two important files that must be linked with the SRC attribute: the DCR file (assuming a Shocked Director movie) and SWA file (the Shocked Audio file). Yet, you probably know you cannot have two SRC attributes in the <EMBED> tag. Therefore, there is an SRC attribute (for the Director movie) and an swURL attribute for the Shocked Audio.

Let us use an example to better explain how the HTML should be written. Let us say you have a Director movie, called damovie.dcr, located at www.somesite.com/mysite/. You also have a Shocked Audio file, called dasound.swa, in the same directory on the server. In this scenario your HTML code would look like the following:

```
<EMBED
SRC="http://www.somesite.com/mysite/damovie.dcr"
swURL="http://www.somesite.com/mysite/dasound.swa"
swTEXT="Sample HTML Code for SWA Files" swPre-
LoadTime="5">
```

As you can see from this example, two source files are defined: the Director movie and the Shocked Audio file. In addition, two other attributes are shown, which are the swText and swPreLoadTime attributes. The swText attribute is the text that will be displayed in the Shocked Audio control bar and the swPreLoadTime is the amount of prebuffering time before the sound starts

playing. You will find that the higher the preload time, the more of a delay before the sound starts playing.

Note: You can also link a Shocked Audio file without an accompanying Director or Authorware movie so that sound simply plays in the background of your page. For more information about Shocked Audio as well as other features included within it, check out Macromedia's ShockZone at http://www.macromedia.com/shockzone/.

Integrating MIDI Files

Probably one of the coolest things to come along is the inclusion of MIDI files in Web pages. As you saw in chapter 21, "Training the Page to Speak," MIDI files are of interest because of their size. However, due to differences in standardization, MIDI may not always play using the same instrument across different computers.

Nevertheless, if you want to utilize MIDI files in your Web pages, as with RealAudio and Shock Audio, use the standard <A> tag or the <EMBED> tag. Remember that the <A> tag will attempt to use either a plug-in or a helper, depending on which is defined. The <EMBED> tag alone will only try to utilize a plug-in.

If you want to use the <A> tag your code will look something like this:

where HREF is the linked file. Note that the TARGET attribute simply tells the browser to open a new window. This will cause a new small window to be opened, which will contain the controller for the file. This is the quickest and most considerate method of including MIDI files. Often people get testy about having to wait long periods of time for a MIDI file to download.

A second method of integrating MIDI files is through the use of the <EMBED> tag. With an embedded MIDI file, you have a couple more options for how the file plays. The general structure for a MIDI file in the <EMBED> tag is:

<EMBED SRC="www.somesite.com/myMIDI/damidi.mid" TYPE="audio/midi" HIDDEN=TRUE AUTOSTART=TRUE LOOP=TRUE">

Note that the SCR attribute contains the URL, path, and name of the file. The TYPE attribute denotes to the browser the MIME information about the file. The HIDDEN attribute controls whether a controller is visible in the page. The AUTOSTART attribute controls whether the sound automatically begins playing, and the LOOP attribute controls whether the sound replays after it has finished.

TIP: *Again keep in mind that the <EMBED> tag utilizes a plug-in. The various attributes that are needed with the <EMBED> tag may vary, depending on the plug-in that you assume the user has installed. You may want to tell the user (in the page) what plug-in your page is designed for. Also, do not forget the <NOEMBED> tag!*

The last method (not that you cannot also use JavaScript, as well as other scripting languages to embed MIDI files) is the use of the <BGSOUND> tag. To use the <BGSOUND> tag to include a MIDI file (or WAV or AU), you would enter code that looks like this:

<BGSOUND SRC="http://somesite.com/myMIDI/damidi.mid" LOOP=INFINITE>

where the SRC attribute denotes the URL, path, and file name, and the LOOP attribute equals the number of times the sound replays. Note that the LOOP attribute can be set to a numeral.

Integrating Advanced Elements on the Web

As you saw in the last chapter, "Animating Your Web," a variety of means are available for creating and distributing animations over the Web. As always, the primary concern is file size. Animations are only effective if they do not take an eternity to download and only when they contribute to communication or visual appeal.

Note: *Everyone has been known to put an animation on a page without a good reason, but unless it communicates something or adds to the visual appeal of a page, the animation is a waste of bandwidth. An animation's value is proportional to the ratio of download time to communicative or visual value. You must evaluate whether the animation contributes enough to warrant the added download time. If it does, include it. If it does not, use a static image or do not include an image at all.*

One of the widest uses of animations is in Web advertising. To most people, banner advertisements are irritating. In general, the rapid increase in the development of the Web as a communication medium is a result of commercialization. The positive side of commercialization is the rapid leaps in the technology over the last three years. The downside—advertising banners. Nonetheless, I can accept a couple of advertisements per page.

Because banners are one of the most common means for Web animation, that is where we will start. In the following sections, begin by taking a look at an advertising banner as a GIF animation example. Then continue by looking at integrating Shocked Director movies into your pages, as well as Flash animations.

GIF Animations

As you saw in chapter 18, "Utilizing Bitmap Graphics," and in chapter 20, "Understanding Formats and Conversion Issues," GIF files are common on the Web. Yet one of the capabilities you have not directly looked at is the ability to create a single GIF file that actually contains multiple GIF files, which is called an animated GIF.

Creating an animated GIF is really quite easy. There are several shareware and commercial applications that can be used to generate them. However, in the following examples you will be seeing how to do it in a commercial application, Ulead's GIF Animator, which comes with Ulead's imaging application called PhotoImpact.

A GIF animation simply requires a series of frames and software that can be used to create a single GIF file from

Figure 23.2 The individual images that will be combined to create the GIF animation.

these sequential images. Here you will be seeing how to take the images shown in Figure 23.2, to create a banner advertisement for Mohler's Aquarium shop, using a GIF animation.

Creating the individual images (frames) is the hardest part of creating a GIF animation. In addition, coming up with a unique idea is equally challenging. You can use any number of tools to create the individual frames. Here, I simply used Photoshop and a layered image to create the individual frames. You could also generate those frames from 2D animation or 3D animation packages, and then save the rendered frames as individual files for import into a GIF animation program.

TIP: *One of the tools that can help you when you create a GIF animation is a storyboard of what it is you are going to create. Storyboards are simple planning sketches of each frame of the animation. They are helpful when creating any type of animation.*

Task: Create and Use a GIF Animation

To create a GIF animation:

1 Begin by creating a series of images that you would like to compile into a GIF animation. The more in-between frames (more frames per movement in the animation), the smoother your animation will be. Unfortunately, the more frames, the bigger the file will be too. Try to find the balance between enough frames and smooth animation. Do not be afraid to test it with your GIF animator.

2 Once you have your frames, open the GIF animation program, and set the canvas size. Here, the banner is 460 by 68 pixels. Set the canvas size appropriately as shown in Figure 23.3.

3 After setting the canvas size, in Ulead's GIF animator choose Layer | Add Images to add your individual images to the file. GIF Animator is slick because it allows you to choose all of the files at once (Figure 23.4). Then you click OK.

4 After clicking OK, you will be asked how the colors should be reduced on import. Make sure at this step that you choose the Safe Palette shown in Figure 23.5. For more information on browser-safe color palettes, check out chapter 18, "Managing Color Differences."

5 Once you have imported your images, choose to view your animation using the Preview button. In this example, there needs to be a pause at the beginning of the animation so the fish takes a break. If you select a1.tif in the left window, you can easily duplicate it so that the fish does not constantly swim back and forth. Here, select the a1.tif, and then choose Edit | Duplicate (Figure 23.6). In the Duplicate dialog box, set Copies to 2 and hit Okay (see Figure 23.6 [top]). In the left side of the Window you will see that two more copies have been added (23.6 [bottom]).

Figure 23.3 Setting up the canvas size for the animation.

Figure 23.4 Ulead's GIF Animator allows you to import all your images at once.

Figure 23.5 When you import the images you will be prompted for how the colors should be reduced to 8-bit.

Figure 23.6 Duplicate the first frame so that the fish does not constantly swim back and forth.

Note: *In GIF animations, duplicate frames do not use differencing (a method of reducing redundant information between two successive frames). Subsequently, the frame you just copied (a1.tif) is in the file twice, which increases the file size.*

6 Once you have the animation the way you want it, save a new GIF file. You may have to check your file size and make sure it is not too big for the Web. Often, you may have to reduce your frame count so that what is delivering is reasonable. This 8-frame file is approximately 105 K or 30 seconds over a 28.8 modem.

7 Now that you have created a GIF animation, integrating it into your page is relatively easy. To integrate the animation you just created, the code would look like this:

```
<IMG SRC="fish.gif" HEIGHT="60" WIDTH="468"
BORDER="0" ALT="Mohler's Aquarium Banner">
```

where fish.gif is the name of the file. Note that the HEIGHT and WIDTH attributes have been set so that space is allotted to the image as it is downloaded, and that the BORDER attribute has been set to zero so no border will show. In addition, the ALT attribute has been designed for those who choose not to view images. Note that using animated GIFs does not require any special tags, just the tag.

Note: *Ulead's PhotoImpact and GIF Animator (Web Extensions) bundle has many more capabilities than is listed here. If you are interested in it, check out their site at http://www.ulead.com.*

Shockwave Animations

To deliver Director or Authorware multimedia requires the application (to generate the movie or piece) and the use of the <EMBED> tag. Once a movie or piece has been created in either of these products, a special filter (Xtra), called Afterburner, is used to convert the movie to a Webicized format (Shockwave for Director, Web Player for Authorware). In general, the Web format is compressed and often strips out items unnecessary for Web delivery. Interactive Web multimedia from Director and Authorware utilize the <EMBED> tag with several of the previously mentioned attributes. For more information, refer to Macromedia's site about Director and Authorware movie integration.

Flash Animations

Finally, vector-based animations can be used in Web content. Macromedia's Flash allows you to create complex animations without the massive file sizes associated with bitmap animations. Flash anti-aliases the vector animation so that it is almost impossible to tell that it is vec-

tor based. It also allows you to integrate and synchronize music to your animations! This is definitely a technology we will see more of in the future as the major browser companies include the Flash plug-in in their products.

Task: Create and Use a Flash Animation

As you get ready to create a Flash animation, realize that there are two ways to do it. The Flash application itself has many vector-based drawing tools, so you can create the vector elements right within it if you want. However, if you are a FreeHand user you can import your vector drawings into Flash, which is a nice integration capability. In this task, I will import a drawing that was originally created in FreeHand and then animate it in Flash.

To begin this task:

1 Open the illustration you want to animate into Free-Hand. Figure 23.7 shows the illustration that will be used in this task.

2 Once you have the image open, select Xtra | Create | Flash Image to create an image file you can open into Flash (Figure 23.8). One of the things to note is that you may have to do some editing on your image before it is Flash ready. Some features supported by FreeHand are not supported in Flash (see Note).

Note: When using FreeHand as a basis for Flash animations, some of the FreeHand illustration capabilities are not supported in Flash. These include some gradient fills, tiled, textured, patterned, and PostScript fills, as well as linked bitmap images. Items such as these are ignored when the Flash file is exported out of FreeHand.

3 Once you have exported the file from FreeHand, open Flash and import.

4 Proceed to create the actions for the animation within the timeline of Flash. Laying out the animation requires defining the key frames (major motions) of the

Figure 23.7 The illustration being animated in this task.

Figure 23.8 Exporting a Flash image out of FreeHand may require some minor editing because some features are not supported (see Note).

Figure 23.9 Once the file is imported, define the key frames of the animation in the Flash timeline.

animation, which appear as symbols within the Flash timeline (Figure 23.9).

5 After creating the key movements, use the File | Export option to save the file as a .SWF file. This file can then be integrated into a Web page.

6 To integrate a Flash animation into your Web pages, you would enter the following HTML code:

<EMBED SRC="cyberoutpost.swf" HEIGHT="300" WIDTH="300" PLUGINSPAGE="http://www.macromedia.com/shockwave/">

where the SRC attribute defines the URL, path, and file name of the Flash animation. Note that the HEIGHT and WIDTH attributes are defined so space is reserved, and the PLUGINSPAGE attribute is used to prompt the user if they do not have the plug-in.

In addition to the information provided here, you will find that Flash provides other features that would require its own book for proper explanation. In the previous task, I have attempted to present a basic overview of creating animations with Flash. Some of the other notable features of Flash include a full set of vector drawing tools, the ability to create interactive elements such as buttons and hot items, the ability to use custom fonts (akin to the new dynamic fonts—yet the fonts are contained internally), and the capability of synchronized sound. All in all Flash is quite impressive and it will, I believe, greatly impact what can be delivered via the Web.

TIP: *If you want to deliver Flash animation, make sure you have the MIME types set up for it. The MIME information for Flash should be:*

> *MIME Type: application*
>
> *Subtype: futuresplash*
>
> *Extensions: spl*

Note that since the original applications (FutureSplash) were acquired by Macromedia, the MIME information will probably change to:

> *MIME Type: application*
>
> *Subtype: flash*
>
> *Extensions: swf*

I would include both sets of MIME definitions to be sure you have no problems.

Other Methods for Animation

In addition to technologies such as GIF animations and Macromedia movies and pieces, you can also create similar effects using scripting languages such as VBScript, JavaScript, and Java. For most people, scripting languages and programming languages seem to be like brain surgery, but it is not really that difficult. It takes some time to learn the constructs of the language and the specific code names and such, but it is really not that difficult.

Case in point is the small JavaScript code below (Listing 23.1) that can be used to create something similar to a GIF animation. Note that although I have heard that Explorer supports JavaScript and Navigator supports VBScript, both browsers seem to have difficulty with the other's scripting language. Is somebody holding out? Suffice to say it will probably be some time before all scripts work in all browsers. But to show you how easy it is to do a little scripting, try the next task.

Task: Create a JavaScript Animation

To create a JavaScript animation:

1 Begin by creating a series of images that you would like to use (similar to preparing for a GIF animation).

2 Assuming you are using JPG images, name your files animX.jpg where the first frame is anim1.jpg.

Listing 23.1 The JavaScript code for an animated GIF effect.

```
<SCRIPT LANGUAGE = "JavaScript">
timedelay = 1000; //in 1000ths of a second
temp = 0;
NumberOfImages = 8;
animation = new Array();
for (i = 0; i < NumberOfImages; i++) {
animation[i] = new Image (60, 60);
animation[i].src = 'anim' + (i + 1) + '.jpg';
}
function AnimateImages()
{
NextImage();
setTimeout("AnimateImages()," timedelay);
}
function NextImage()
{
document.animatedimage.src = animation[temp].src;
temp++;
if(temp >= NumberOfImages) temp = 0;
}
</SCRIPT>
```

3 Enter the code shown in Listing 23.1 inside the <HEAD>…</HEAD> portion of your document.

Note: You can adjust the number of images by changing the variable NumberofImages at the beginning of the code from eight to whatever number you want. In addition, you can make the animation play faster or slower by changing the timedelay variable.

4 Finally, to utilize the animation, use the tag to call the JavaScript code using:

Summary

As you can see from this chapter, the hardest thing about integrating multimedia elements into your pages is actually creating them. Since the creation of these elements, particularly animation, can be time-consuming, developers will often use resources such as clip animation, which is similar to clip art. These types of resources, and for that matter any resource that you do not create, requires permission for use. Just make sure that you have permissions to use elements such as animation, video, or audio before integrating them into your pages. All of these elements are copyrightable and, therefore, require permission for use.

Next Steps

Now that you have finished looking at multimedia integration in Web pages:

• Examine chapter 10, "Using Multimedia in Tables," for more information on using multimedia in tables.

• Review chapter 20, "Using Layered Web Pages and Other Effects," to review some of the new features found in the latest browsers.

• Check out chapter 24, "Utilizing Plug-in Capabilities," for a discussion of other Web plug-ins and resources that can be used for the Web.

QUESTIONS

Q *How can I know what types of media elements to use and what types of scripting to use in my pages?*

A The best case scenario is to know your audience. Unfortunately, even if you know your audience, they may be on a variety of platforms. It is not unusual to have to create various versions of a page for various audience members. This is the focus of content and bandwidth negotiation on the Web: more efficient and effective delivery through customization focused on the end user. The best way is to know your audience and test everything you deliver.

Utilizing Plug-in Capabilities

Web browsers are still in a relative state of infancy—or like the 1982 state of word processors (remember Word-Star 1.1? I do, it was horrible!). Only now, with the most recent releases of Navigator and Internet Explorer, do Web browsers offer a suite of supported media and content extensible enough to make real multimedia (animation, video, sound, interaction, and feedback) a Web reality. These modern browsers have the programming to do this built in.

If you are not fortunate to have one of these modern browsers, you must add capabilities to your browser by assembling the necessary helper applications and plug-ins (or DLLs and Active-X on the Windows side) that display or play the file type you want. This is still necessary with our two most popular browsers because data comes in so many different formats that it would be impossible to handle all of them.

Note: Why is there no super browser? Would Photoshop be the success it is if it only recognized three file formats? Would Microsoft Word or Quark be successes by reading three file types? Come on developers! We need a browser with the power of Debabilizer.

Armed with the graphic, design, and HTML skills you have gained in the previous twenty-three chapters, approach what follows as the opening of new horizons, opportunities for expanding the richness of content you include on your Web pages.

OBJECTIVES

In this chapter, you will:

• Understand how plug-ins and helper applications extend the functionality of your browser.

• See the range of media that can be displayed as part of a Web page.

• Be able to match the appropriate plug-in to a media or content file type.

• Know how to design Web pages specifically for users who do not have a necessary plug-in.

• Know where to go to find plug-ins appropriate for a variety of Web applications.

Plug-ins and Helper Applications

Browsers are extensible. That is, a browser's functionality can be improved with the addition of small programs called plug-ins that are designed to play or display a specific file type, or even better, a range of file types, not supported naturally by the browser. Some plug-ins support only one file type. Others are more flexible, working on a multitude of file types.

A plug-in is different from a helper application, and more satisfying to you, the Web designer. A plug-in can be embedded, nonembedded, or hidden. When the browser encounters a nonsupported file type, a plug-in will play the content as part of the Web page. Helper applications, on the other hand, are full stand-alone programs that launch in their own application window and play or display the file off the Web page. It is like watching a movie with the sound off while following along (carefully) with a written script. It can be very unnatural.

Note: There are times when it is better to open a Web media in a separate helper application. For example, if you want to make actual data available (text, numbers, spread-

sheet, database, CAD) you would not want to just display a picture of the data. Conversely, if you want to protect the actual data, publish only a picture and keep the actual data off the Web.

But there is a method to the madness of plug-ins, and that is in the economy of using them. At browser boot time, the contents of the plug-in directory (folder) is inspected and a map created of its contents and the file types supported. Then, when a non-native file type is encountered (essentially any other than .htm, .gif, or .jpg), the browser will first check this map. If the file type is supported by one of the plug-ins, it runs the file either in embedded, separate window, or hidden modes, depending on how the call to the file was coded. The plug-in is then flushed from memory when the next page is loaded and it is not needed. So it is kept in memory only long enough to do its job.

If no plug-in was found, the browser displays an iconic representation of the file and consults a table created in the Preferences Menu. The user must manually match file types to installed applications, creating paths that will be followed to run files in a separate application window. You will have to explicitly close the application when you no longer need it.

Still no match? The browser will show the resource as an icon and prompt the user to either identify an application that will run the file or download the file to the local hard disk. Then you can try to open it yourself. This is the antithesis of interactive Web design and something you should avoid making your clients do.

The strength of plug-in technology is that the code for a few, or even hundreds of plug-ins, does not load until it is needed. It makes for a smaller, tighter, more responsive browser, and the reason why the super browser has not been developed.

Which plug-ins should you have and which ones should you design for? You will want a plug-in for graphics, audio, multimedia, and text. It is best if the plug-ins you use recognize more than one file type. Also, stay on the lookout for new plug-ins that yield even greater functionality. See Table 24.1 for a short list of downloadable plug-ins.

Note: It is better to design for universally accepted file types unless there is an overpowering reason to use a proprietary format. More people can make use of the content with general-purpose plug-ins, oftentimes plug-ins that are freely downloaded.

Other Types of Media on the Web

There are abundant resources on the Web for publishing specialized media. Additionally, more and more software applications come with Web plug-ins and DLLs to promote the use of their proprietary formats on the Internet.

Specialized formats, such as the Fractal Image Format (FIF), Computer Graphics Metafile (CGM), Envoy Portable Document Format (EVY), Voxware (VOX) audio, and OpenScape's support for Visual Basic applications are available for further enriching your Web pages.

You can find the Fractal Image Viewer at http://www.iterated.com/fracview/info/fv-info.htm. If you use Intercap for your technical illustrations, look at http://www.intercap.com/blackened.html for a CGM viewer. Electronic publication files in Envoy format can be read with the resource at http://www.twcorp.com/plugin.htm. For audio files in Voxware format, use Toolvox found at http://www.voxware.com/voxintro.htm.

The Good and Bad About Plug-ins

Supplementary resources like plug-ins extend the functionality of a browser and free it from having to include the specialized code to deal with the multitude of content formats that might end up in Web publications. This

Graphics

Figleaf Inline	(http://www.ct.ebt.com/figinline/)	A can opener for EPS, GIF, JPG, WMF, PBM, PNG, and TIF files.

Text

Acrobat Reader	(http://www.adobe.com/acrobat/)	Opens a Portable Document Format (PDF) interface in your browser window.

Video

Cool Fusion	(http://webber.iterated.com/coolfusion/download/cf-loadp.htm)	Plays real-time streaming Video for Windows (AVI) files.
MovieStar	(http://130.91.39.113/moviestar/plug-ins/)	Streams QuickTime movies over the Web with the benefit of playing MIDI music.

Audio

Real Player K2	(http://www.realaudio.com)	Streams audio in real time in proprietary (but widely distributed) Real Audio RPM format. Also plays RealVideo.

Multimedia

KM's MultimediaPlug	(http:www.wco.com/~mcmurtri/KM_sMultimedia_plug.bin)	Plays QuickTime, MPEG, MIDI, WAVE, AIFF, and Macintosh PICT files.
Shockwave for Director	(http://www.macromedia.com/ tools/shockwave/index.html)	Displays Director multimedia movies.
Web Player for Authorware	(http://www.macromedia.com/tools/web_player/index.html)	Plays Authorware multimedia files.
Flash	(http://www.macromedia.com/tools/flash/index.html)	Plays Authorware multimedia files.

Virtual Reality

Netscape Live 3D	(http://home.netscape.com/comprod/products/navigator/live3d/)	Plays Virtual Reality Modeling Language (VRML) files in WRL format.

Table 24.1 Short list of plug-ins.

browser design methodology places the onus of responsibility for making sure clients are able to view or play a certain content format on you, the Web page designer.

The good is that hundreds or thousands of creative individuals are at work right now creating these extensions. Browser manufacturers simply could not put that many people on such tasks. The bad is that for the typical and casual Web user, downloading, expanding, installing, and configuring these resources are beyond their technological abilities or interests.

Designing for Plug-ins

You can do a lot yourself to make the process of designing Web pages that require plug-ins easier. The best design is one that does not require plug-ins at all. Internet Explorer is more robust than Netscape Navigator on this measure because of its support for the PC-popular BMP raster graphics format, AVI video, and WAV sounds. Navigator still requires plug-ins for sound and video and only recognizes GIF and JPG naturally.

Some of the problem with Web pages that use plug-ins is your fault. What I mean is that it is your responsibility to publish data in formats appropriate for the medium. For example, there is little reason to publish TIF files on the Web because TIF is a continuous tone process color halftone file format. JPG is 24-bit smart and has more capable compression than TIF, hence, better for the Web. EPS would only make sense if you were publishing for display PostScript, because EPS vectors make no sense for display on PCs, regular Macs, or UNIX. On the Mac side, PICT vector graphics (like from PowerPoint) are not understood on any but Apple's QuickDraw operating systems. Raster objects in PICT are just as easily handled in GIF or JPG without plug-ins.

If a plug-in is required, remember these points:

1 Always ensure that your pages run with alternate media. If a client chooses not to download a specialized plug-in, they should not be locked out of your site completely. This may go all the way to designing two (or more) parallel sites and an entry that lets the client choose the version they want to see.

2 Provide links to URLs where appropriate resources can be found. It is best if these resources are free. Nothing irritates a client more than to have to purchase a resource online in order. If your page requires a commercial for-fee plug-in, you will probably lose 90% of the potential visitors to your site.

Of course, this interruption happens only once, the first time the resource is needed. After that, your site will run without interruption.

3 After download (and successful expanding with PkunZip or Stuffit Expander, another step in the process), your client will have to quit the browser and restart so that the resource is recognized, then reload your site. Make sure your client knows this.

Task: Utilizing Plug-Ins

As a designer, you will want to include the richest content on your Web pages you can. This often means making use of content not directly supported by your browser. You could translate the files into supported formats, but what do you do about multimedia and video?

To design for the use of plug-in technology follow these steps:

1 Analyze the impact of using an unsupported format. What is gained by its use? Does the benefit outweigh the interruption in reading the pages that will be caused by jumping out to a linked site to download, expanding, installing, restarting, and reloading your site?

2 If you plan serious supplements like Java, Visual Basic, or Shockwave, provide alternate pages for clients who do not have, cannot get, or do not want this experience. Do this on a splash page with links to the various versions. You also may want to put links to the necessary resources here.

Link to the smallest, cheapest, most responsive resource you can find. It is better to use a resource provided by a software application company, rather than "Bob's Plug-in Garage" that might not be around next week.

3 Design your page with alternate pages for the unsupported content. For example, rather than using EMBED to force the content directly on the page, use an inline graphic linked to the content. That way the content is available but not forced on the client. (This is a good suggestion in general, whether for unsupported content or not. The same can be said about large JPG images and GIF animations—do not force them on your clients; give them control.)

4 Test your pages with alternate resources. Because there are numerous resources that play or display the same data, your client may not choose to download the

resource you suggest, relying instead on a favorite of their own. This is a good justification for using a standard alternative content format rather than a proprietary one.

Sources for Plug-ins on the Web

Visit the following URL to find supplementary resources for your Netscape browser:

http://home.netscape.com/comprod/products/navigator/version_2.0/plug-ins/index.html

Visit the following URL to find supplementary resources for your Internet Explorer browser:

http://microsoft.com/msdownload/default.asp#addon

And for information on Active-X controls for Internet Explorer, visit:

http://www.shorrock.u-net.com/index.html

Summary

As a Web designer, you are, to some extent, only as good as your tools. On the Internet, the difference between success and failure often rests with something as simple as providing the right content at the right time. It may also rest on providing content that the typical browser does not recognize. To do this, you must provide access to the resources necessary to view your pages. If your client cannot (or will not) get to the plug-in, your pages are dead.

To facilitate your interactive sites, you need to assemble a suite of browser add-ons that cover all the bases—graphics, text, audio, video, multimedia, and virtual reality. Armed with these, you should be able to meet the needs of practically 100% of your clients.

Be smart! Do not publish data in formats inappropriate for the Web. Remember that the Web is naturally an interactive visual medium. It publishes other data only reluctantly.

If you spend much time designing interactive Web pages, you will find little time for surfing, finding new and productive resources that help make you effective and efficient. Kind of like a "Busman's Holiday" (what bus driver wants to take a vacation by riding a bus). Still, put yourself on an early morning schedule, looking for new resources.

Always design for the least capable browser anticipated. It may mean that you will have to compromise some of the bells and whistles, but you will get much more traffic and success. Remember, in the long term it is content, content, content that makes for lasting value on the Web.

QUESTIONS

Q *I want to play my videos right on the page but they always open in a separate window. What is wrong?*

A Use the <EMBED> tag to run the resource right on your Web page. Make sure you provide enough room for the video frame.

Q *I have heard that vector graphics take up much less room than do bitmaps. How can I use vector graphics in my Web pages?*

A It is true that vector graphics require less memory than do bitmaps. However, vector graphics will not compress as efficiently as do raster graphics because there is not the amount of repeating data to represent. Also, you have little control over how the vectors are rasterized at the browser because they are not in pixel form. Contrast this to GIF or JPG where you have a good idea of what they will look like, because you are displaying raster

images on a raster display device. Try Figleaf Inline to display WMF or EPS vector art.

Q *I have included PageMaker (PM6) files in my Web pages as instructional resources but no one seems to be able to get to them.*

A Talk to your server administrator and make sure that your server is configured with the correct MIME type for PM6 files. The server needs to know how to send the data contained in this specialized file format. However, are you sure that you want to use PageMaker native language files? If you are delivering coursework on the Web and your students need access to PM6 files, then that is great. But if you want them to see the pages as reference, be more creative. Print the files to Adobe's PDF format and students can see and print the pages.

Interactive Pages Using HTML, Tables, and Frames

In the preceding chapters you have acquired the tools you will need to create effective interactive Web pages. Now, it is time to apply those skills. You should have noticed that a "lowest common denominator" approach has been stressed throughout this text. This is for a number of reasons. By applying the lowest level of technology necessary to complete a task you guarantee:

• The use of the least costly development tools, hardware, and software.

• The shortest development cycle.

• The lowest level of client resources, including available bandwidth, and thereby

• The broadest possible audience.

Still, in designing for interactivity you will have to make certain assumptions. For example, you will assume that anyone wanting interactivity will have hardware and software capable of displaying such interactivity or be able to get it. This problem has somewhat taken care of itself with the ready availability of frame and JavaScript-capable browsers and with even the most inexpensive personal computers having more than enough computing power. The greatest inhibitor to Web interactivity is trying to push media requirements that exceed available bandwidth, hence, the lowest common denominator approach.

But like most things in life, you need to learn to walk before you run. In this chapter, you will see how an interactive interface is designed, executed, and delivered as a Web site. If you have flipped to this chapter first and need more of the basics concerning tables and frames, you might want to glance back at chapters 8, 9, and 10.

OBJECTIVES

In this chapter, you will:

• Understand what interactivity can realistically be accomplished using HTML, tables, and frames.

• Appreciate the level of planning necessary to create effective interactive pages.

• Become aware of the methods for creating interactive interfaces for use on Web pages.

• See how the FRAMESET structure controls the placement of interactive elements on the page.

• Plan for the integration of interactive media such as digital movies into the interactive interface.

What Can You Realistically Accomplish?

On first observation, you might think that it would be impossible to deliver a high level of interactivity without involved multimedia resources. But as you will quickly see, it is indeed possible to create a highly interactive Web experience using minimal resources. In fact, it is entirely possible to deliver near-video-game-level interaction using only HTML, frames, and tables. And if you add a few JavaScript enhancements like those found at the end of this chapter, the effect can be stunning.

Let us review the role each of the three basic elements will play in planning our interactive Web pages. These elements are presented in structural order, from the most global to the most specific.

Frames
(Review chapters 13–15.)

The FRAMESET structure establishes regions of the browser's window that will not change while the user interacts with the information being displayed. This is the underlying structure of your interactive interface. By itself, the FRAMESET structure does not do anything. It needs additional internal structure in the form of tables to make sure interactivity is consistent.

To make an interface believable, all borders, spacing, scrolling, and resizing must be removed.

Note: Take care to design your interactive page using only the minimum number of frames necessary. Although frames can be nested within frames, results can become unpredictable—just the opposite of what you want in an effective interaction! The key is planning. Quite often an interactive interface must be redesigned because its elements do not adhere to a workable FRAMESET structure. Remember: simple design + simple interaction = simple frame structure.

Tables
(Review chapters 7–12.)

If frames define general regions of the browser window that do not change, tables define the structure within frames that do change. Because the table is an HTML document, a change to one cell of the table requires the entire table to be redisplayed. For that reason, tables can and should be nested. That is, the content of a cell of a table can be an entire new HTML document defining a separate table.

To make an interface believable, all cell padding, cell spacing, and borders must be turned off so that table contents appear seamless.

Into the FRAMESET structure you will define FRAMEs. These can be thought of as bins or boxes that hold content.

HTML
(Review chapter 6.)

The Hypertext Markup Language is used to code the pages, establish page limits, code frames and tables, and call the graphic and media resources to the correct position on the page at the right time. The most naturally interactive aspect of HTML is its built-in linking function.

Note: The greatest limitation of delivering interaction using straight HTML is that only one HTML file can be displayed in a window at a time. This means that if you create your entire interface as one HTML document, and each change brought on by user interaction is loaded as a separate HTML document, natural smooth interaction will be ruined.

An Example of Interactivity

The Web site that will be used in this chapter can be found on the accompanying CD-ROM. Copy the entire directory titled "interface" from the "examples" subdirectory. In that directory you will find the entire Web site that we will be developing in this chapter.*

From your browser, open the file interface.html. You should see the device displayed in Figure 25.1.

Go ahead and interact with the functions in the interface to see how it works. Make note of what part of the interface changes as options are selected.

Now that you see where we will be going, let us back up and see how to get there.

* This interactive device was created by Mohammed Armia as part of the course requirements in CGC 494—Interactive Web Media at Arizona State University and is used with his permission.

Planning the Interactive Process

The visual appearance of an interactive Web site is directly related to the functions or options that are available for the user. The visual appearance is guided by what you want the interface to do. For example, if you have both text and graphics to display at the same time, you may want separate areas of the interface dedicated for each of these data types.

Figure 25.2 shows a planning sketch for a digital interface intended for Web delivery. Every interactive Web page starts out as a sketch. Notice that it has been divided into rectangular areas conducive for frame and table description. The main functions of forward, backward, menu, and quit are arranged along the right side. It contains a main graphic screen, as well as an area for topic text and a preview viewer.

You can see that an alternative way of displaying the main functions has been entertained in a side sketch.

The graphic for the interactive interface can be created in a number of ways. Probably the most common method is to use a raster editor such as Photoshop to create the interface from scratch, using any number of filters. This was the way the ADT interface was created in Figure 25.1. Another way is to use a digital camera to take pictures of actual real-world devices. These pictures can then be combined in any number of ways to create a custom interface. Natural materials (such as rocks or textures) are more difficult to build into interactive experiences because natural objects tend to be amorphous, and do not adhere to the rectilinearity of windows, frames, and tables. It is not impossible—you just have to be more creative.

For those with modeling and material mapping skills, an alternative method is to create the interface in a modeling program, assign lights and materials, then render

Figure 25.1 The American Digital Telephone (ADT) interactive device is used in this chapter to demonstrate the effectiveness of HTML and frames in creating an interactive Web site.

Figure 25.2 A typical planning sketch for an interactive interface. The planning sketch organizes functional requirements into logical areas.

the interface. Figure 25.3 shows the interface sketched in Figure 25.2 modeled in 3D Studio Max. Figure 25.4 shows the realism of the interface after rendering.

Creating the interface in a modeling program has the added advantage of easily creating alternate states for elements in your interaction—lights that glow, depressed buttons, and the like—as well as small animations that make parts swing out, rotate, or disappear all together. If you want to see the animated interface, load model.avi from the "examples" directory on the CD-ROM.

Because these alternate states will be small table cells within frames, they will change without the rest of the interface redisplaying. This gives the impression of smooth interaction—just what you want.

The ADT interactive Web site shown in Figure 25.1 was created as artwork in Photoshop. This approach takes more artistic ability than modeling and rendering abilities, but once you get the hang of it, effective results, like that in Figure 25.1, are attainable.

Note in our ADT example the controls or options are grouped on the left of the device while separate areas are dedicated to text and graphics. (A directional control device has also been provided though in its current stage of development, this function is inactive.)

Task: Designing an Interactive Page

The first step is to translate preliminary sketches into a final sketch that can be executed, in this case, in Photoshop. At this point it is important to plan for efficiency. For example, assume you have five control buttons. You could create five different GIF or JPG files that would be individually downloaded from the server. Better, you could create a single button graphic, load it into the background of the first frame and pull the same image from local cache for additional buttons. HTML text

Figure 25.3 The interface displayed as a sketch in Figure 25.2 modeled in 3D Studio Max.

Figure 25.4 The front viewport rendered showing materials and lighting.

*Figure 25.5 The ADT interface divided
into basic functional areas.*

*Figure 25.6 The ADT interface redivided
into more descriptive areas.*

could then be displayed over the background. It does not sound like much of a difference but every time you use a cached image, interactivity is smoother and more realistic.

Note: *To get the ADT interface to work smoothly, nested FRAMEs and FRAMESETs will be used. Most designers would avoid the level of nesting used in this example but when you understand how to control the placement of elements using these two structures, you will see frames as a powerful ally in designing interactions.*

Before actually starting to code the interface for display in the browser's window, plan how the interface will be subdivided according to its functionality. Figure 25.5 shows the interface divided into functional areas that will correspond to frames.

Area 1 is a static graphic along the left edge of the interface. Area 2 contains all of the interactive controls necessary to operate the interface. Area 3 is a static graphic buffer. Area 4 is a display screen inside which static

graphics and animations will be displayed. Area 5 contains the edge of the interface with the animated GIF showing that the device is running. This gives us a good idea of the frame design necessary to create the interactivity.

Step 1: Set Up Overall Interface

On further review, it may be necessary to more tightly divide the interface into areas that will and will not change. Figure 25.6 shows how this is done.

Area 1 is now the left edge of the interface, up to the edge of the buttons, an area that will never change. Area 2 is the button area. Area 3 is a spacer (again that never changes) separating the button area from the screen area. Area 4 is the screen area (individual graphic and text screens). Area 5 defines the right edge of the interface. Listing 25.1 (next page) shows the code for the file interface.html that sets up the overall frame structure.

Listing 25.1

```
<HTML>
<HEAD></HEAD>
  <FRAMESET BORDER="0" ROWS="450,*" FRAMEBORDER="0" FRAMESPACING="0">
    <FRAMESET BORDER="0" COLS="67,87,16,148,132,*" FRAMEBORDER="0"
     FRAMESPACING="0">
      <FRAME NAME="edge" SRC="edge.html" NORESIZE SCROLLING="NO"
      MARGINHEIGHT="0" MARGINWIDTH="0" FRAMEBORDER="no">
  <FRAME NAME="buttons" SRC="buttons.html" NORESIZE
SCROLLING="NO" MARGINHEIGHT="0" MARGINWIDTH="0" FRAMEBORDER="no">
      <FRAME NAME="spacer" SRC="spacer.html" NORESIZE SCROLLING="NO"
      MARGINHEIGHT="0" MARGINWIDTH="0" FRAMEBORDER="no">
      <FRAME NAME="screen" SRC="screen.html" NORESIZE SCROLLING="NO"
      MARGINHEIGHT="0" MARGINWIDTH="0" FRAMEBORDER="no">
      <FRAME NAME="edge2" SRC="edge2.html" NORESIZE SCROLLING="NO"
      MARGINHEIGHT="0" MARGINWIDTH="0" FRAMEBORDER="no">
    <FRAME>
    </FRAMESET>
      <FRAME>
  </FRAMESET>
<HTML>
```

Listing 25.2

```
<HTML>
<HEAD></HEAD>
  <FRAMESET BORDER="0" COLS="67" FRAMEBORDER="0" FRAMESPACING="0">
    <FRAMESET BORDER="0" ROWS="450,*" FRAMEBORDER="0" FRAMESPACING="0">
      <FRAME NAME="device2" SRC="device2.html" NORESIZE SCROLLING="NO"
      MARGINHEIGHT="0" MARGINWIDTH="0" FRAMEBORDER="no">
    </FRAMESET>
  </FRAMESET>
</HTML>
```

Listing 25.3

```
<HTML>
<HEAD></HEAD>
  <IMG SRC="device2.jpg" HEIGHT="450" WIDTH="67" BORDER="0">
</HTML>
```

In Photoshop, drag ruler guides out to correspond to these five divisions and cut the areas into separate files. Check the image sizes of each strip and record these somewhere. In our ADT file, the strips are the following sizes:

- Area 1 (edge). Height=450 pixels, width=67 pixels.
- Area 2 (buttons). Height=450 pixels, width=87 pixels.
- Area 3 (spacer). Height=450 pixels, width=16 pixels.
- Area 4 (screen). Height=450 pixels, width=148 pixels.
- Area 5 (edge2). Height=450 pixels, width=132 pixels.

To understand how interactivity is built with nested frames, we will look at Area 1 first, starting with the outside definition and ending with the HTML file that displays the actual graphic.

Compare Figure 25.6 with Listing 25.1. The first FRAMESET defines a row, 450 pixels tall, inside which the interface will be displayed. All of the strips are the same height (450 pixels) so this works perfectly. This outside frame has two objects: another FRAMESET (inside which the interface will be displayed) and an empty FRAME that pushes the interface to the left of the browser window (it is at the bottom, above the last </FRAMESET> tag).

Note: *With nested frames, it is important to use descriptive names for the frame definition document (FDD), the frames themselves, and the resources that are displayed within the*

frames. If you do not, you will quickly get lost. In our ADT example, you will note some files that could have been named better. For example, the Power button is called "device4" and the display screen is called "device13b."

The second FRAMESET defines five columns corresponding to the widths of the five vertical pieces of our interface. This is where you need the exact pixel widths to set this up. Notice that all spacing and borders have been turned off, as well as scrolling and resizing.

Inside this second FRAMESET are five frames that call HTML documents corresponding to edge, buttons, spacer, screen, and edge2.

Step 2: Subdivide the Overall Areas

The first frame "edge" contains a single graphic but in order to lock its position into the overall frame definition, the frame is defined within a row, within a column. This requires two FRAMESETS and one FRAME. This is shown in Listing 25.2. The outside FRAMESET defines a 67-pixel wide column. Its object is a 450-pixel tall row containing a frame that actually calls the HTML file containing the graphic. Hard work, but this is essentially how the contents of every frame will be defined.

Step 3: Call the Individual Graphic

The FRAME's object is a file titled device2.html. The code for this file is shown in Listing 25.3.

This final HTML file does nothing but call device2.jpg and put it into the frame that called it. Note the size of the image and the dimensions of the FRAMESET that called it are identical. This, along with the lack of any spacing or borders, allows the elements of the interface to be contiguous. When the contents of one frame are replaced with another, the effect is seamless.

Step 4: Continue with the Other Areas

Figure 25.7 shows how the entire interface is subdivided into nested frames. To better understand this, the "button" area will be described in detail. This area is important

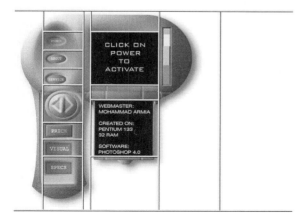

Figure 25.7 The ADT interface
further divided into nested frames.

because its frames are linked to either the graphic or textual portions of the screen, creating the actual interactivity.

Looking back at Listing 25.1, you can see that the frame named "buttons" calls the file buttons.html. Buttons.html is actually another frame definition document, describing the nesting of frames within buttons. Listing 25.4 displays buttons.html.

The same approach of defining outside column and row FRAMESETS is employed as before, using exact pixel sizes. If you count the number of frames in the buttons area of Figure 25.7, you should end up with eight. Count the number of FRAME structures in Listing 25.4 and it should be the same.

These frames fulfill one of two functions. First, they can call a static graphic to the frame. This is the case in the first (device3.html) and fifth (device7.html) frames. This is just like Listings 25.2 and 25.3. The other function is to display a graphic (the button) and link it to an image, movie, or text in either the text or graphic display areas.

Let us look at the first button titled "Power." Its frame is named "device4" and calls the file device4.html, as shown in Listing 25.5.

The button itself is displayed as a background image, device4.jpg. Over the top of this background a 1 pixel x 1 pixel transparent GIF graphic is displayed and scaled to the exact pixel dimensions of the frame definition. This transparent GIF, when clicked, sends device13b.jpg to the frame defined as "device13." Device13 is the name of the frame describing the display screen.

Listing 25.4

```
<HTML>
<HEAD></HEAD>
  <FRAMESET BORDER="0" COLS="87" FRAMEBORDER="0" FRAMESPACING="0">
    <FRAMESET BORDER="0" ROWS="52,41,40,37,84,38,38,120"
    FRAMEBORDER="0" FRAMESPACING="0">
      <FRAME NAME="device3" SRC="device3.html" NORESIZE SCROLLING="NO"
      MARGINHEIGHT="0" MARGINWIDTH="0" FRAMEBORDER="no">
      <FRAME NAME="device4" SRC="device4.html" NORESIZE SCROLLING="NO"
      MARGINHEIGHT="0" MARGINWIDTH="0" FRAMEBORDER="no">
      <FRAME NAME="device5" SRC="device5.html" NORESIZE SCROLLING="NO"
      MARGINHEIGHT="0" MARGINWIDTH="0" FRAMEBORDER="no">
      <FRAME NAME="device6" SRC="device6.html" NORESIZE SCROLLING="NO"
      MARGINHEIGHT="0" MARGINWIDTH="0" FRAMEBORDER="no">
      <FRAME NAME="device7" SRC="device7.html" NORESIZE SCROLLING="NO"
      MARGINHEIGHT="0" MARGINWIDTH="0" FRAMEBORDER="no">
      <FRAME NAME="device8" SRC="device8.html" NORESIZE SCROLLING="NO"
      MARGINHEIGHT="0" MARGINWIDTH="0" FRAMEBORDER="no">
      <FRAME NAME="device9" SRC="device9.html" NORESIZE SCROLLING="NO"
      MARGINHEIGHT="0" MARGINWIDTH="0" FRAMEBORDER="no">
      <FRAME NAME="device10" SRC="device10.html" NORESIZE
      SCROLLING="NO" MARGINHEIGHT="0" MARGINWIDTH="0" FRAMEBORDER="no">
    </FRAMESET>
  </FRAMESET>
</HTML>
```

Looking at Listing 25.6 (screen.html), you can see that the file defines the second frame to be "device 13" and calls it device 13b.html. The file device13b.html (Listing 25.7) displays the ADT logo (device13.jpg) on the screen.

Let us see if we can summarize what happens in one sentence:

"Interface.html" describes "screen.html," which describes a frame "device13" into which device13.jpg is displayed when the transparent GIF is clicked inside the "device4" frame inside buttons.html. Got it?

More simply, the result is that when you click on the button titled "Power," the ADT logo is displayed on the graphics screen.

Listing 25.5

```
<HTML>
<BODY BACKGROUND="device4.jpg">
  <A HREF="device13b.jpg" TARGET="device13">
  <IMG SRC="trnsprnt.GIF" HEIGHT="40" WIDTH="87" BORDER="0"></A>
</BODY>
</HTML>
```

Listing 25.6

```
<HTML>
<HEAD></HEAD>
  <FRAMESET BORDER="0" COLS="148" FRAMEBORDER="0" FRAMESPACING="0">
    <FRAMESET BORDER="0" ROWS="52,118,33,127,120" FRAMEBORDER="0"
    FRAMESPACING="0">
      <FRAME NAME="device12" SRC="device12.html" NORESIZE
      SCROLLING="NO" MARGINHEIGHT="0" MARGINWIDTH="0" FRAMEBORDER="no">
      <FRAME NAME="device13" SRC="device13b.html" NORESIZE
      SCROLLING="NO" MARGINHEIGHT="0" MARGINWIDTH="0" FRAMEBORDER="no">
      <FRAME NAME="device14" SRC="device14.html" NORESIZE
      SCROLLING="NO" MARGINHEIGHT="0" MARGINWIDTH="0" FRAMEBORDER="no">
      <FRAME NAME="device15" SRC="device15.html" NORESIZE
      SCROLLING="NO" MARGINHEIGHT="0" MARGINWIDTH="0" FRAMEBORDER="no">
      <FRAME NAME="device16" SRC="device16.html" NORESIZE
      SCROLLING="NO" MARGINHEIGHT="0" MARGINWIDTH="0" FRAMEBORDER="no">
    </FRAMESET>
  </FRAMESET>
</HTML>
```

Listing 25.7

```
<HTML>
<HEAD></HEAD>
  <IMG SRC="device13.jpg" WIDTH=148 HEIGHT=118 BORDER="0">
</HTML>
```

Finishing Up

Once you test one button and are satisfied with the results, you can copy the code and quickly enable all the other interactions. Three other features bear mentioning: the animated GIF status bar, the JavaScript rollover on the "About" button, and the digital movie this button calls to the display screen.

Listing 25.8 shows that part of interface.html that describes the right edge of our interface. This is followed by the code from edge2.html and finally the animated GIF, led.GIF from the file device17.html.

Suffice to say, the rollover state on the second button adds considerably to the feeling of interactivity by giving feedback about the selection. Pass the cursor over the button. Click on the button. Just like a video game!

If you want to look at the code that does this, open device5.html where a JavaScript rollover function is defined.

The last interactive touch is the product movie, displayed on the screen when you click the "About" button. Listing 25.9 shows the specific code from the different files, describing how interface.html describes buttons.html, that in turn describes device5.html that finally brings movie.avi to the screen (device13).

Listing 25.8

```
<!- From interface.html>
<FRAME NAME="edge2" SRC="edge2.html" NORESIZE SCROLLING="NO"
      MARGINHEIGHT="0" MARGINWIDTH="0" FRAMEBORDER="no">
.
.
.
<!- edge2.html>
<HTML>
<HEAD></HEAD>
  <FRAMESET BORDER="0" COLS="132" FRAMEBORDER="0" FRAMESPACING="0">
    <FRAMESET BORDER="0" ROWS="450,*" FRAMEBORDER="0"
    FRAMESPACING="0">
      <FRAME NAME="device17" SRC="device17.html" NORESIZE
      SCROLLING="NO" MARGINHEIGHT="0" MARGINWIDTH="0" FRAMEBORDER="no">
    </FRAMESET>
  </FRAMESET>
</HTML>
.
.
.
<!- device17.html>
<HTML>
<HEAD></HEAD>
  <IMG SRC="led.gif" HEIGHT="450" WIDTH="132" BORDER="0">
</HTML>
```

Listing 25.9

```
<!- interface.html>
<FRAME NAME="buttons" SRC="buttons.html" NORESIZE SCROLLING="NO"
  MARGINHEIGHT="0" MARGINWIDTH="0" FRAMEBORDER="no">
.
.
.
<!- buttons.html>
<FRAME NAME="device5" SRC="device5.html" NORESIZE SCROLLING="NO"
  MARGINHEIGHT="0" MARGINWIDTH="0" FRAMEBORDER="no">
.
.
.
<!- device5.html>
<A HREF="device13.html" TARGET="device13" onMouseOver="act()"
    onMouseOut="inact()">
<IMG WIDTH=87 HEIGHT=40 SRC="device5.jpg" NAME="device5" BORDER=0></A>
.
.
.
<!- device13.html>
<HTML>
<HEAD></HEAD>
<EMBED SRC="movie.avi" WIDTH=148 HEIGHT=118 AUTOSTART=true LOOP=true>
</HTML>
```

Summary

This chapter demonstrated methods of building interactivity into Web pages using the HTML structures TABLE and FRAME, as well as simple JavaScript to enhance feedback. A well designed interactive site makes use of all the concepts discussed in the previous twenty-four chapters—from page design and HTML tags to graphic formats. It is easy to go overboard and attempt to make your pages as interactive as possible. Unfortunately, this almost always leads to disaster. There is a movement to return design into Web sites, pages and documents, the same effective document design that has guided communications for the past centuries. We invite you to join that movement, armed with the new technology, to create even more effective communications.

QUESTIONS

Q *In the chapter, you advised that high bandwidth multimedia elements should not be used on the Web. Does that mean I should not integrate audio, video, and animation?*

A Briefly, no. The major concern with anything you deliver over the Web is how long it will take your audience

to download the information. The main thing concerning large media elements is allowing the audience to choose whether or not to download the information. Before you automatically insert audio, video, or animation into your pages you must look at the target audience to determine how long it will take them to download the information.

Glossary

8-bit see indexed color.

24-bit see RGB color.

256-color see indexed color.

abstract a brief purpose and summary statement describing a Web site.

achromatic colors include hues that have no true color, such as black, white, and gray.

adaptive a means of creating an 8-bit color palette within Adobe PhotoShop.

address field the portion of a browser where a Universal Resource Locator (URL) can be typed.

Adobe Illustrator a vector-based illustration program.

Afterburner a filter created by Macromedia that compresses Director files for use on the Web; file extension is .DCR.

Aladdin's Stuffit Deluxe an external compression program for the Macintosh.

algorithm mathematical code that performs a task; another name for a codec.

aliasing characteristic stair-stepped nature of vector lines on a display screen or in an extracted bitmap.

alignment refers to the physical location of a paragraph or string of text.

alpha channel a special extra level of data that stores that amount of opaqueness for a particular pixel; values range from 0 to 255.

ambient light the amount of light present without a light source; also known as atmospheric light.

analog data that is based on continually changing frequencies.

analog degradation the decay of analog information as a result of copying an analog source to another analog device.

analog to digital converter (ADC) a chip or chips that convert analog frequencies to digital bits.

animation the perception of movement over time caused by a progression of changing frames.

anti-alias the process of slightly blurring the edges of bitmap objects to produce a more visually pleasing image.

anti-alias halo discolored pixels that occur around the edges of an object as a result of prior anti-aliasing.

Appletalk a Macintosh network protocol.

applets small applications programmed in Java or JavaScript that are automatically downloaded and played.

ASCII American Standard Code for Information Interchange. A file format in which HTML programs are saved.

ATM Adobe Type Manager. A program for managing, installing, and deleting Adobe PostScript fonts.

Audio Interchange File Format (AIFF) a digital audio file format predominantly used on Macintosh and Silicon Graphics machines.

author the creator of a creative work who holds the right of copyright from the date of creation.

avant garde something new or radical to push our paradigm of thinking; a sans serif font family.

banding the visual stripes that can appear in 256-color images as a result of interpolation.

bandwidth the amount of information that can flow through a specific network connection over a period of time; measured in kilobits per second.

bit depth the number of physical bits used to describe a sample; higher bit depth describes a higher quality sample.

bitmap a graphic image composed of pixels. Each pixel is defined by a certain number of bits (see also bit depth).

BMP Windows bitmap format. A graphic file format that can contain up to 24-bit color and can be compressed using RLE (Run-Length Encoding).

bookmark a special function in browsers that stores the name and URL location of http servers in a menu list.

browser-safe a palette of colors matched to the colors a browser will display without dithering.

byte a series of 8 bits; equals a single character.

cache temporary storage space for Web images and pages on the user's hard drive; used by Web browsers such as Netscape to reduce download times.

canvas normally connotes a blank work area in a bitmap application; analogous to an artist's canvas.

cascading style sheets (CSS) an HTML structure that embeds layout and font information in the page code currently unsupported in the HTML 3.2 specification.

cel a single frame in an animation.

cel animation the process of drawing and painting each and every frame to create an animation.

CERN Conseil European pour la Recherche Nucleaire; the European Laboratory for Particle Physics.

CGM computer graphics metafile. An intermediate file format that stores object-oriented data.

channel a saved selection or mask in PhotoShop; also called an alpha channel; a track of music in an audio program (mono versus stereo).

chroma keying a special video effect that allows two separate pieces of video to be overlaid; a special color acts as transparent.

cinepak a common codec used in digital video formats; good at compressing images with solid color information.

client pull a Netscape extension that causes the browser to jump from one URL location to another without the intervention of the user.

clip art special "prefab" graphics that can be bought and used in page designs.

clipboard a special location in memory that allows you to copy the contents of one document and paste them in another. The copy is stored in the clipboard.

Codec Compressor / Decompressor. An algorithm that compresses and decompresses a digital file in real time.

color depth see bit depth.

color look-up table (CLUT) a special matrix of color values used in palletized images. Each image pixel is referenced to the matrix by numerical values.

color shifting an unappealing visual affect in which colors shift from proper to inappropriate colors. Generally occurs when the computer has to interpolate colors.

common gateway interface a special UNIX scripting language that can be used to extend a browser's capabilities.

Communicator Netscape's new 32-bit browser.

compression the process of substituting for redundant data in a digital file; results in the decrease of file size.

compression ratio a description of the relative worth of a codec. It is the ratio of file size before and after.

continuity consistency in Web pages; items that contribute to creating a common look.

contrast the amount of value difference between two adjacent colors.

copy the process of replicating an object to the clipboard.

copyright the method of protecting creative works in the United States.

copyright infringement illegally using the materials of others for professional gain.

Corel DRAW a vector-based illustration program.

creativity the process of developing a unique new idea, concept, or process.

CYMK cyan, yellow, magenta, and black. The colors used in four-color process printing. Also a color mode in PhotoShop.

data rate the amount of data that can be moved from a device over a period of time; measured in kilobytes per second.

Debabilizer a graphic utility for translating between formats and batch processing sizing, sampling, and palette operations.

debug the process of finding bugs and errors in program code.

decibels a measure of frequency variations that is not necessarily associated with loudness.

delimiter a special symbol of code that marks the end of a command.

device dependent a media element that has a fixed resolution; designed for output on a specific device.

device independent a media element that does not have a fixed resolution; can be adjusted for output on any device.

device resolution describes the number of output quality for a specific device at a specific output size.

dial-up access Internet access that uses a modem to connect to a computer that is in turn connected to the Internet.

dial-up connection Internet access that uses a modem to connect to the Internet.

diffusion dither a dithering process in PhotoShop that uses similar colors and scatters them randomly to create unavailable colors.

Digimarc a digital watermarking technology.

digital data that is binary in nature, composed of on and off states.

digital audio an audio file that describes a waveform bit by bit as it occurs over time.

digital video connotates captured live action footage combined with audio.

digital watermarking the technology that embeds an identification code into a raster image. This code remains even when the image is cropped, resized, or resampled.

direct network connection Internet access that is obtained via a network card connected to a LAN.

Director an authoring tool created by Macromedia that allows the creation of sophisticated interactive multimedia products.

dither the process of randomly scattering pixels to create the appearance of missing colors.

Domain Name Service (DNS) a naming method used with World Wide Web sites such as www.somesite.com.

DoubleSpace Microsoft DOS's drive doubling software.

dpi dots per inch. A measure of the visual fineness of an output device.

drive compression compression that occurs over a total storage device.

e-mail electronic mail; the ability to send and receive text messages via the Internet.

embedded content on a Web page that runs in place on the page.

embedded programs self-contained applications that can be included in a Web page.

encoders the ability to sample video or audio from an analog device.

environments connotates various operating systems such as DOS, Windows, Macintosh, or UNIX.

EPS encapsulated PostScript. An intermediate file format that stores image information by vector-based descriptions.

Explorer a Web browser created by Microsoft.

extensible the characteristic of a Web browser that allows its functionality to be supplemented with additional features such as plug-ins.

external file compression compression that occurs that is oblivious to the contents of a file.

external graphic a hypertext link to a graphic that is opened into a helper application.

eye flow the process by which the human eye is directed across a page design.

feather the process of dithering or blurring a selection in a bitmap image.

field a specific location on an HTML form that accepts text data from the user.

file compression the process of decreasing file size by substituting for redundant or acceptably lost data.

filter a special algorithm that processes data to create some type of special effect or outcome.

Flash a technology from Macromedia that brings resolution-independent vector graphics to Web pages.

font families a set of characters with similar and specific attributes such as Helvetica, Geneva, or Avant Garde.

forms specially designed Web pages that allow the user to collect data through the use of enterable fields.

fps frames per second; the playback speed of an animation or video segment.

Fractal Painter A bitmap paint program.

frame a single instance in an animation; a special HTML tag that allows the user to divide the browser screen into separate windows.

frame number the total number of frames in a digital animation or video.

frame rate see fps.

FreeHand A vector-based illustration program by Macromedia.

frequency a method of describing a particular sound; measured in Hertz.

frequency variations the fundamental basis for analog data composed of waves.

fringe a blurred or tattered edge remaining after anti-alias.

FrontPage an HTML generator and site management tool created by Microsoft.

FTP File Transfer Protocol. A program that allows a user to log into another computer for the purpose of uploading or downloading files.

general protection faults (GPF) a Windows error caused by two programs overlapping in memory.

genré an accepted style or way of doing something.

GIF graphic interchange format. A bitmap file format that allows up to 8-bit color depth and uses automatic LZW compression. Can have a transparent channel and multiple images in animation format.

GIF 89a a special GIF file that can contain transparency data.

Gopher a text menu-based Internet browser.

graphic image headers the beginning of a graphic image file; tells the application what type of file the image is and if it uses compression.

helper application applications that are external to the browser and extend the capability to view various file types.

Hertz a measure of waveform cycles per second.

hexadecimal base 16 mathematical description used in HTML to describe RGB colors.

hidden content on a Web page that runs in the background, such as a sound.

high resolution generally accepted as image sizes greater than 640 x 480 with image depths at 24-bit and higher.

home page a WWW site's main content page.

horizontal space the width of the letter M in the font.

host computer a computer from which one is receiving information or gaining access to something.

hotlinks text or graphic-based items that allow the user to jump to new places in a document or to a new http site.

hotspots an area of a page that is linked to a new place or location.

HTML Hypertext Markup Language. A structural formatting language characterized by embedded tags commonly used to describe Web pages.

HTTP servers computers dedicated to providing HyperText Transfer Protocol access to HTML documents from remote sites.

human-computer interaction the dynamics of how humans interact with computers in a virtual environment. This interaction is characterized by both parties (human and computer) making interactive demands on the other.

hypertext text with associated links to other text, graphics, video, or sound resources.

icon an abstract graphical representation of an object or action. The level of abstraction depends on the connection between the icon and the referent and familiarity with both.

image dimensions the physical size of an image. In the case of raster images, dimensions are usually expressed in horizontal pixels by vertical pixels.

image map a map of screen coordinates regions assigned to functions or links. The image map usually is defined over a graphical image that gives the user cues (both graphical and textual) as to the linked action.

image resolution a description of an image's dpi.

image size a description of an image's physical size in pixels.

in-betweening the practice of filling in missing data by interpolating between known values such as the values between two shades of green.

Indeo a common digital video compression codec that is best used for video such as live action footage that has a wide range of colors.

indexed color color adhering to 8 bits of color data, resulting in 256 discrete colors; the color depth required of GIF-formatted graphics.

ingenuity the process of repurposing or reusing specific parts of a design or process in a new way.

inline graphic a graphic displayed within the lines of HTML code. An inline graphic requires no helper applications to be viewed and uses HTML formatting commands for its position and scale.

instructional icons graphic abstractions that represent decisions and choices in contrast with navigational icons that represent movement from one page or resource to another.

intellectual property an entity of unique creation; an expression of unique visual, textual, or auditory nature that makes one product different from another.

interactivity a process characterized by direct manipulation of a virtual environment and a two-way flow of information.

interlaced GIF a 256-color raster image that when loaded is displayed in increasing resolution.

internal file compression a technique that removes redundant data from a file automatically without explicitly postprocessing the data. The result is a file with less storage requirements.

internal link a technique that moves the user from one place in an HTML document to another or from one document to another or another resource within the same Web site.

interpolation the process of creating color based on surrounding colors.

intranet a network of computers and servers within an organization typically used as an advanced communication device.

intra-site link a technique that moves the user from one place in a Web site to another in the same site.

IP Address a series of numbers separated by periods that denotes the location of a computer on the Internet.

ISMAP the HTML parameter within the structure that alerts the HTML parser that an image map is being used.

jaggies the coarse pixelation characteristic of raster images. Jaggies can be minimized by increasing resolution (dpi) or by the technique of anti-alias.

Java the technology that provides programming resources for delivering small applications over the Web.

JavaScript a scripting language that is a simplified derivative of the Java programming language.

JPEG the Joint Photographic Experts Group specification for 24-bit color raster files with lossy LZW compression.

jump list a list of text items, usually formatted with the unnumbered list structure, linked to Web pages or resources.

kbps kilobytes per second; a measure of the rate of transmission of data over networks or phone lines; baud.

key frame a frame in an animation where lights, cameras, geometry, and materials are set, allowing the animation program to create the in-between frames.

keying the process of creating key frames.

kilobyte one thousand bytes; a measure of digital data.

kilohertz (kHz) 1000 Hertz.

layer an HTML tag implemented in Netscape 4.0 but currently unsupported in the HTML 3.2 specification.

layering the capability of a graphics application to store objects distinctly and separately.

leading the space between successive lines of type measured in points. Type 12 points in height with two extra points of space between lines is said to be "12 points leaded 14" or 12/14.

Lepel ZivWelch compression (LZW) a lossless compression scheme most often used in the TIFF file format.

letter spacing the characteristic of how much space exists between adjacent letters. Letters can be monospaced (where every letter uses the same space) or variably spaced.

levels the description of the hierarchical organization of a Web site. Each successive level is further removed from the home page of the Web site.

license a permission to use a copyrighted item in which a fee is paid based on various parameters for use.

light surfaces surfaces on 3D objects illuminated by a light source. Light surfaces are contrasted with shaded or shadowed surfaces.

link a logical association of a text string or object in an HTML document with another Web page, resource, or site.

local area network a collection of computers within a small distance, such as in an office or a department, that are interconnected.

logical style HTML tags that leave the actual rendering and style to the browser.

lossless compression data compression characterized by no degradation in image quality when the data is restored to its original condition; compression with no adjustment of the amount of compression.

lossy compression data compression characterized by degradation in image quality when the data is restored to its original condition; degradation based on the amount of compression specified.

LZW see Lepel ZivWelch Compression.

MacTCP Macintosh network driver software.

map definition file the file of screen coordinates that defines which actions (links) will be performed when a mouse action is detected within a region.

mask a current selection of pixels in a bitmap editor.

mbps megabytes per second; a measure of the transmission rate of digital data.

megabyte one million bytes; a measure of digital data.

menu bar descriptive text in HTML code linked to their actions often arranged with vertical separators to look like a button bar.

MIME type Multipurpose Internet Mail Extension. A scheme that defines a specific file type and respective application.

mono-aural describes a single-channel digital audio file.

monospaced fonts fonts in which there is no letter spacing variations from character to character.

montage a graphic collection of different images assembled such that the edges of one image smoothly blend into the edges of other images; a graphic often used as the basis of an image map.

Mosaic a software browser used for accessing information on the Web.

movie a digital movie produced in QuickTime format; a file produced in Macromedia Director in MOV format.

MPEG the Motion Picture Experts Group specification for the format of digital video.

multiprotocol the capability to utilize and communicate using various network protocols.

Musical Instrument Device Interface (MIDI) a method of digitally describing audio using instrument and note descriptions.

native format the format used by an application program to save both data and program-specific settings.

navigation bar a graphic used to control navigation throughout a Web site. Navigation bars are usually consistently designed, formatted, and located to increase effectiveness.

navigational icons icons used in a navigation bar; see also icons.

Navigator a software browser used for accessing information on the Web; with Netscape Gold, a Web development tool.

NCSA the National Center for Supercomputer Applications; where the first Web browser, Mosaic, was developed.

network protocol the description of how data is organized and transmitted over a network. The identification of this protocol in the address of a Web site alerts the host computer as how to interpret the data.

news service a site on the Web providing frequently updated information.

node a remote computer on a network.

noise anything that disrupts a message from being received or interpreted.

NTSC National Television Standards Committee. Developer of the television resolution standards for the United States.

Packbits compression scheme used in black and white image files.

Page Mill an HTML generator and site management program created by Adobe.

PageMaker a page layout and composition application capable of filtering its pages with text and graphics into HTML code.

palette the collection of colors used within a graphic file.

palette flash the sudden and unexpected flash of discolored pixels caused by the use of multiple palettes in a multimedia application.

palletized see 8-bit color.

Pantone colors the specification of color using the Pantone PMS Colormatch system primarily used for single (spot) color designs as a way to visualize colors.

paste the action of reading selected data from a temporary memory location and adding it to current data.

pattern dither a method of representing more colors than the monitor is capable of displaying by creating small lines, crosses, boxes, and such that when viewed from a distance (arm's length) give the illusion of a full range of colors.

PCX a 24-bit raster format by PC Paintbrush capable of saving nongraphic settings such as layer information.

PDF Portable Document Format by Adobe Systems; a description of text and graphics in a highly efficient compressed raster format capable of containing hyperlinks and font outline information.

PhotoShop a raster editing program by Adobe Systems.

physical style HTML tags specify the precise format of display text.

PICT Apple's graphic picture description format capable of containing 24-bit raster data, calls to PostScript fonts, and QuickDraw graphics routines.

PictureMaker a digital watermarking technology.

pixel the smallest object that can be manipulated in a raster program.

pixels per inch (ppi) the number of pixels per square inch; ppi equals dpi.

Pkzip a flexible file compression and decompression utility with the ability to compress data over multiple diskettes; native to the PC.

platforms computers of unique manufacture, operating system, or model.

plug-in an addition to an existing program that increases its functionality. The plug-in is recognized when the program is loaded and brought into memory when needed.

point size a measure described in points; one point is equal to 1/72 inch or .0393701 millimeters.

portable network graphics (PNG) a new graphics format designed to unify the formats used on the Web. Boasts all of the features of both JPEG and GIF in a single format.

PostScript an interpreted page description language usually resident in an output device. A PostScript driver translates the native format into a PostScript ASCII text file, which is sent to the output device where it is interpreted line by line.

PostScript outline font a text font described mathematically by curves and lines. When text characters are converted to their outlines they become a graphic and lose all text characteristics.

PPP A dial-up TCP/IP extension program.

Premiere a digital video editing program created by Adobe.

progressive JPEG a way of saving a JPEG raster file so that is loads sequentially in bands, allowing cancellation of the load in midstream.

public domain the body of work not under copyright protection; work for which the copyright protection has expired; work done for the public by the government; work of no unique creative value, of common industrial design.

QuickDraw Apple's screen imaging language.

QuickTime Apple's digital video standard.

RamDoubler Connectix's productivity utility that efficiently manages memory so that your computer's operating system believes it has twice as much RAM memory than is physically installed.

raster a graphic file type containing a matrix of data points; a display monitor employing raster scan technology.

raster dimensions the number of horizontal and vertical data points in a raster graphic.

raster resolution the density of data points in a raster graphic measured either in dots per inch (dpi) or in the spacing in millimeters from dot center to adjacent dot center (pitch).

rasterize the process of creating a raster image; usually when vector data is turned into raster data.

RCA a type of video cable connector.

release a permission to use a copyrighted item without payment or fees; often, usage has certain limitations.

remapping pertains to changing the color palette of an image.

resolution independence the condition of a graphic whose resolution is not fixed; a PostScript graphic.

RGB color an additive color model based on red, green, and blue light. The absence of color (R0, G0, B0) produces black. Full color components (R255, G255, B255) produce white.

rule a graphic used to separate areas of a page, usually a horizontal line, vertical line, custom line, or box.

sampling the process of converting analog data to digital data.

sampling rate frequency of the intervals at which continuous data is broken into digital data.

sans serif type characters that lack small horizontal extensions from the end of straight strokes.

saturation the intensity of a color; the amount of pigment in a color; the purity of a color; the presence of a color's complement.

seamless tile a background image that as it repeats shows no distinction between adjacent tiles.

section unity the characteristic of a section of a Web site tying it to other sections and to the home page by the use of graphic, color, or textual elements.

serif small horizontal extensions from the ends of straight text strokes; a font that has these extensions.

server push the method of sharing Web resources characterized by the Web server making resources available without the direct demand of the client.

SGML Standard Generalized Markup Language. A platform-independent, embedded tag, structural formatting language used to build technical documents.

shade the portion of an object shielded from direct illumination and on which no shadow can be cast.

shadow the intersection of light rays touching an object in only one place with an intervening surface.

Shockwave Macromedia's plug-in that allows for viewing Director, Authorware, and Flash movies over the Web.

site diagram a graphical representation of the structural relationships of pages and resources in a Web site.

SLIP a dial-up TCP/IP extension program.

spacer GIF a 1 pixel by 1 pixel GIF file used to size table cells and position text and graphics; a glass brick when transparent.

span the grouping of table data such that it includes multiple rows, columns, or both.

splash page the opening page of a Web site containing a graphic that draws your attention; can also serve as the home page of a Web site.

Stacker a product that automatically compresses and decompresses data on storage media.

Standard Generalized Markup Language (SGML) an advanced markup language that is commonly used for electronic encyclopedias or dictionaries.

standards manual a document that established the exact manner in which a company's logo, name, or identity will be used. Current standards manuals are just now addressing Web publications.

stereo a multiple channel digital audio file.

streaming the action of using data as it is transmitted as opposed to waiting until all data has been transmitted.

subordinance the ordering of information; the placing of data in importance by position, color, size, shape, or resolution.

S-VHS a type of video cable connector.

swipe file a collection of visual elements used to promote creativity.

synthesis the ability to create a waveform (analog data).

table the structure created with the HTML <TABLE> tag; the structure that forms the basis of a Web page's design.

tag an instruction in HTML delimited by special characters. The HTML parser calls the function between the delimiters <FUNCTION>, and acts on the text string between the opening <> and closing</> tags.

TCP/IP Transfer Control Protocol/Internet Protocol. A set of standards that allows for the transmission of data across the Internet.

text menu a string of words in HTML linked to other HTML pages or resources. A text menu should always accompany graphical buttons so that nongraphical browsers can navigate your Web site.

thumbnail a miniature of a graphic, often at reduced resolution, linked to the richer file.

TIFF tagged image file format. A raster file format developed by Aldus and Adobe for the efficient transmission and printing of raster graphics on PostScript printers.

tile a graphic repeated across the background of a Web page.

topology the three-dimensional terrain of a Web site.

transparent GIF a 256-color raster file where one color has been made transparent, allowing the background color of the Web page to show through.

TrueType an outline font technology that creates accurate screen fonts on the fly.

unity the characteristic of a Web page where text, graphic, and page design work in harmony.

Universal Resource Locator (URL) the unique naming address scheme used on the Web.

value the relative lightness or darkness of a color independent of its hue.

VBScript a Web-based scripting language.

vector a line of length and direction; a graphic file type that describes geometry as lines, curves, arcs, and polygons.

Video for Windows Microsoft's digital video format; the .avi format extension.

VRML Virtual Reality Markup Language. A text-based structural tagging language used to pass three-dimensional information and movements to a virtual reality engine.

VTR Video Tape Recorder. The industrial-strength version of your home VCR.

webmaster a person responsible for creating and maintaining a Web site.

weight (of a font) the boldness of a font character; in HTML, emphasis established with the or tags, or by using default heads.

white space areas of your page without text or graphics. White space helps organize the page and divide areas of data.

winsock.dll the dynamic link library driver for Windows-based networking and Internet access.

WMF Windows Meta File. A meta file capable of containing raster and object data used as the standard Windows imaging format. WMF files moved to the Macintosh platform are translated into PICT.

Yahoo! a clearinghouse Web site with a powerful search engine used for locating Web resources; generally your first stop on the Web.

Index